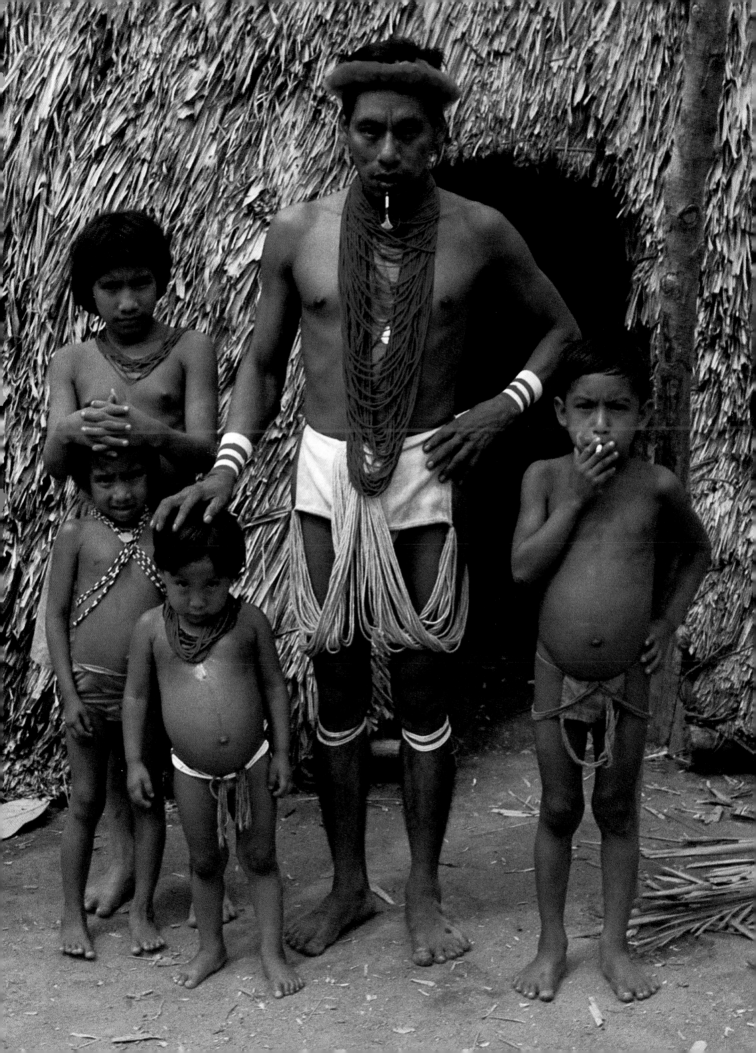

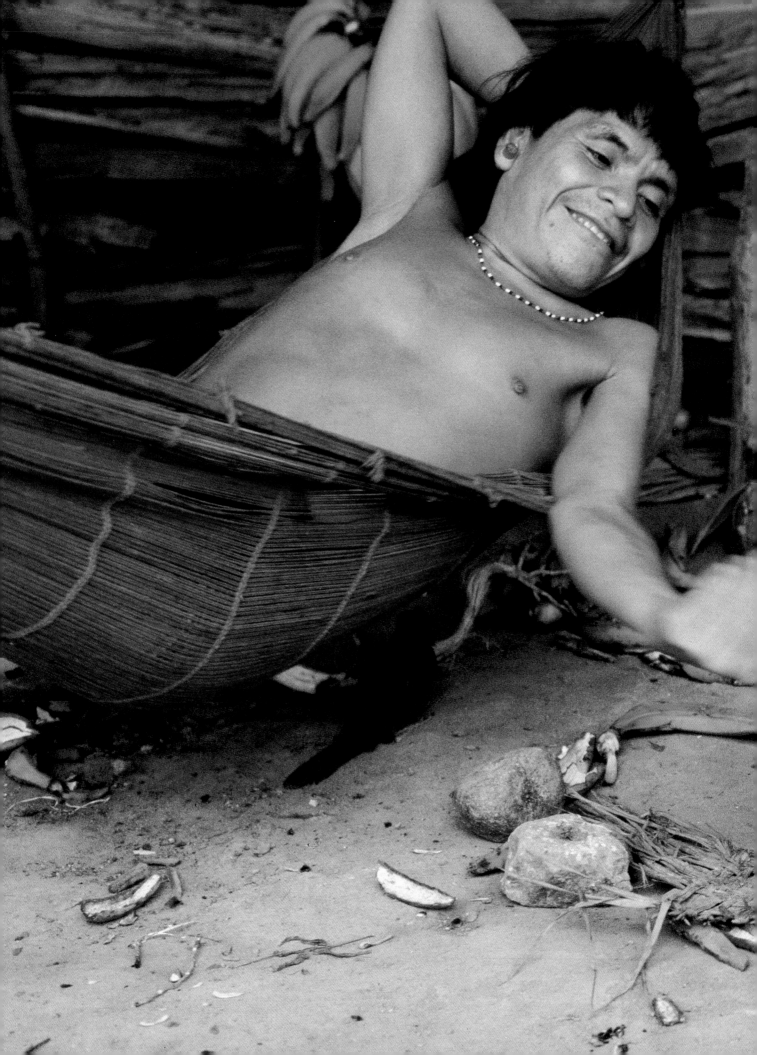

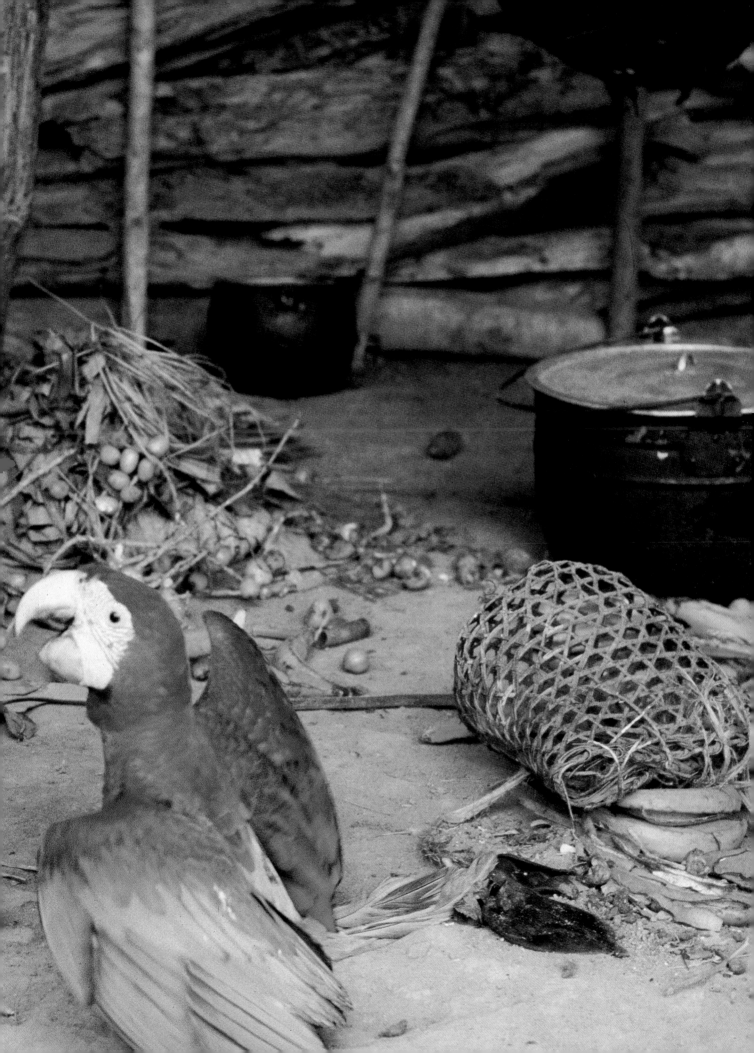

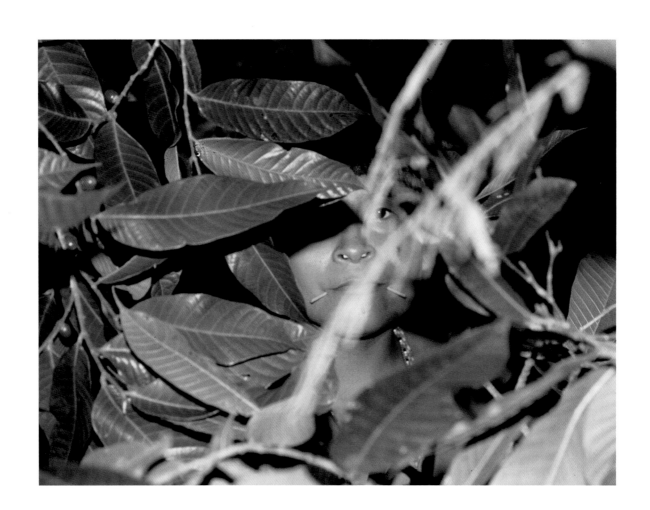

ORINOCO – PARIMA

Indian Societies in Venezuela

The Cisneros Collection

Hatje Cantz Publishers

Published on the occasion of the exhibition *Orinoco – Parima. Indian Societies in Venezuela. The Cisneros Collection* shown from 6 August 1999 to 27 February 2000 at the Kunst- und Ausstellungshalle der Bundesrepublik Deutschland in Bonn.

Kunst- und Ausstellungshalle der Bundesrepublik Deutschland GmbH, Bonn

Director: Wenzel Jacob
Curators: Gabriele Herzog-Schröder, Stephan Andreae
Project Director: Stephan Andreae
Project Assistant: Martina Haag
Exhibition Design: Martina Haag
Exhibition Manager: Susanne Wichert-Meißner
Transport and Insurance: Marla B. Manna
Restoration: Karin Weber
Construction: Michael Haacke, Axel Wupper
Lighting: Gerd Graef
Press Office: Maja Majer-Wallat
Forum: Bernd Busch
Media / Communications: Petra Kruse
Educational Department: Hanns-Ulrich Mette
Public Relations: Maria Nußer-Wagner
Technical Media: Ulrich Best
Library: Laura Held
Administration: Wilfried Gatzweiler
Technical Department: Rudi Link

We wish to thank the following institutions for their friendly support: Humanethologisches Filmarchiv der Max-Planck-Gesellschaft, Andechs
Rheinische Friedrich-Wilhelms-Universität, Bonn
Geologisches Institut
Sparkasse Bonn
Zoologisches Forschungsinstitut und Museum Koenig, Bonn

Published by: Kunst- und Ausstellungshalle der Bundesrepublik Deutschland GmbH

Catalogue Conception: Gabriele Herzog-Schröder
Catalogue Coordinator: Petra Kruse
Text Editors: Gabriele Herzog-Schröder, Ulrike Prinz
English Translations: Ingrid Nina Bell, Basel (Yanomami, Exchanging and Sharing, Decked Out in Borrowed Plumes, E'ñepa, Basketry, Arawak, Appendix). Craig Reishus, Munich (Foreword, The Rain Forest as a Garden, Flow and Ebb, The Presentation of the Cisneros Collection, Ye'kuana, De'áruwa, Warime, Híwi, Hodï, Puinave)
Design: Julia Wieland, Dusseldorf
Maps: Alexander Schmid, Cologne
Lithographs: C + S Repro, Filderstadt
Production: Heiko Seitz, Thomas Uehling
General Production: Dr. Cantz'sche Druckerei, Ostfildern-Ruit

Page 1: Carlos, shaman of a De'áruwa settlement with his own and related children
Pages 2–3: In a Yanomami dwelling house
Pages 4–5: A curassow in front of the E'ñepa communal house
Page 6: Young Yanomami woman gathering wild fruit
Front cover: Assemblage of ethnographic material from the Cisneros Collection
Back cover: The Orinoco winds its way over more than 2700 km through Venezuela
Front inside cover: Territories of the Indian societies represented in the Cisneros Collection
Back inside cover: Detail from a map of the Upper Orinoco region

Fundación Cisneros
Founding President: Patricia Phelps de Cisneros
Director: Luis Miguel La Corte

Proyecto Orinoco:
Curator: Lelia Delgado
Co-Curator: Andrés Ortega
Restoration: Zuleima Jiménez
Publishing: Juan Luis Delmont

Patricia and Gustavo Cisneros would like to take this opportunity of thanking the following persons: the members of the expedition teams: Johnny Fanjul, Charles and Fanny Brewer, Dr. Maximiliano Ravard, Courtney Neeb, Harry Gibbson, José Miguel Pérez, Chayo Brewer, Efrén Díaz Rojas, Miguel Ramos, Nicholas Bauman, François Benedetti, Francisco Díaz, Alfredo Cohen, Tamar Gámez, Henry Hoyos Jr., Carlos Llorente, Freddy Magno, Francisco Pacheco, Eladio Roca, Edgardo Salom, Adib Seguías, Juna Semidey, Pedro Semidey and Robert Sonderman.

They would also like to thank the following persons from Venevision, the Venezuelan Station Network of the Cisneros Organization: Miguel Dvorak, César Linares, Raúl Primo, José González, Alfonso Quintero, María Viloria and Elisa Esqueda as well as the craftsmen José Acuña, Emilio Carrasquel, Daniel García, Jesús Marcano, Gilberto Morgado, Wiliam Muñoz, Manuel Padilla, Maira Quintero, Yovanny Sánchez.

Mention must also be made of the collaboration of the following persons: Maestro Eduardo Marturet, Alfonso Montes, Professor Laurin Raiken, Rodrigo Benavides, Stella Blanco, Noraya Celarayán, Lydie Faustinelli and Fireli Malaver.

The Internet page of the Proyecto Orinoco has been produced thanks to the commitment of Hillary Leone. Luis Miguel La Corte, Susan Ainsworth, John O'Keefe, Carrie Cooperider, Betsy Bickar and Juan Luis Delmont played a decisive role in the coordination between the Fundación Cisneros and the Kunst- und Ausstellungshalle der Bundesrepublik Deutschland.

Distribution in the US
DAP, Distributed Art Publishers
155 Avenue of the Americas, Second Floor
New York, NY 10013
Tel. 0 01/2 12/6 27 19 99
Fax 0 01/2 12/6 27 94 84

Published by
Hatje Cantz Publishers
Senefelderstrasse 12
D-73760 Ostfildern-Ruit
Tel. 00 49/7 11/4 40 50
Fax 00 49/7 11/4 40 52 20
Internet: www.hatjecantz.de

ISBN 3-7757-0872-3 (German edition)
ISBN 3-7757-0873-1 (English edition)
Printed in Germany

WENZEL JACOB

FOREWORD

Orinoco—Parima is our museum's first exhibition devoted to a culture of South America. At the same time it marks the beginning of a series of projects treating themes from this continent. Of special mention in this regard is an exhibition which will open in the coming weeks: *Alexander von Humboldt. Networks of Knowledge.*

Humboldt set off on his famous expedition some 200 years ago. He visited many countries in Latin and South America, as well as traveled to the United States. During his journeys he compiled a great wealth of information, work which for generations was the sole established reference regarding many countries and peoples. He did not set off with the intention of conquering or doing missionary work but instead with the purpose of earnestly studying the lands he visited. He treated the cultures he encountered with great respect. Simón Bolívar, the great liberator who led Venezuela to its independence, once said: "Alexander von Humboldt is the true discoverer of South America! The New World has more to thank him than all the conquistadors put together."

Humboldt was also the first to systematically investigate the Orinoco, the mighty river of Venezuela, which more or less divides the country in half. The river, its source lying near the southern border with Brazil, forms a major portion of the western boundary with Colombia, then turns east to range across the country until, reaching its wide delta, it flows into the Atlantic. "Parima"—the second portion of the exhibition's title—is on the one hand the name of a range of mountains located in southern Venezuela, and on the other hand the name of a legendary locale, a lake as large as a sea and the dwelling place of El Dorado, the fabled man of gold. The objects stem from various indigenous peoples living in the region defined by the exhibition's title. Their lifestyles are almost exactly the same as those Humboldt encountered on his travels. That these peoples have so largely succeeded in preserving their traditions and ways of life, when one considers the widespread annexation of their territories and exploitation of their natural resources, begs explanation. The objects and artifacts gathered in the exhibition provide a splendid overview of the material cultures of these Indian societies, which, although often inhabiting similar environments, can differ so drastically from one another. Here, however, we shall dwell more on the similarities than on the differences. The work utensils, ritual objects, ornaments, pottery, and basketry are entirely fashioned from the vegetable and animal materials native to the immediate surroundings of these peoples. Nature furnishes everything they need to live. One is led to imagine human beings living in an intact relationship with nature—though, here, one's thoughts are unavoidably colored by the romantic ideal of a paradisical original state. This has little to do with reality. Everyday life in these Indian societies is not without care or worry—quite to the contrary, life amidst nature can be quite arduous. All the same, we can observe among these

peoples an astoundingly intimate connection with their surroundings. They are much more reliant, more placed at nature's mercy, than the people we know from our culture area. After many years of painstaking research, Humboldt, a pioneering mentor of the ecological movement, came to the realization that everything participates in a state of mutual interaction, that our world is an "intricate webbing of all natural forces." For the ethnic groups of South America this, as experienced everyday, is a self-evident truth.

Edgardo González Niño grew familiar with the lifestyles of many ethnic groups living in Venezuela. Over a long period of time he gathered the artifacts which today largely comprise the Cisneros Collection. Only because he was able to win the lasting trust of the Indian populations could this collection come together. I would like to take this opportunity to thank him first and foremost.

The collection today belongs to Gustavo and Patricia Cisneros. S.E. Erik Becker Becker, the Venezuelan ambassador, not only brought the collection to our attention, but also established contact between us and the Cisneros family. For this we are extremely grateful. Quite early on, Gustavo and Patricia Cisneros noticed what an important national heritage is preserved in this collection. They made the far-sighted decision to acquire the collection when the opportunity arose. In both conservatorial and scientific regards, the collection is in excellent hands. The Fundación Cisneros has continued to expand the collection by continuingly acquiring new objects. Patricia and Gustavo Cisneros made available their treasures in a splendidly generous fashion. To make possible our plans, they and their employees worked with us in close cooperation and support. I would like to therefore extend to them our heartfelt thanks. At this time I would also like to single out for special mention the work of Luis Miguel La Corte, the director of the Fundación Cisneros. With his overflowing energy and helpful advice he accompanied this project from its very inception.

The presentation follows in its structure the stages of life, from coming into being to departing. The team of curators who put together the exhibition consisted of: Lelia Delgado, archaeologist and anthropologist at the Fundación Cisneros; Gabriele Herzog-Schröder, cultural anthropologist and ethnologist working at the Humanethologisches Filmarchiv der Max-Planck-Gesellschaft in Andechs; and Stephan Andreae, a veteran curator and project director at the Kunst- und Ausstellungshalle der Bundesrepublik Deutschland, Bonn. I would like to extend my sincere thanks to each of these people for the contributions which made this exhibition a reality. I would also like to thank Martina Haag, the project assistant, who energetically supported the curators in all of their demands, as well as significantly contributed to the exhibition's architecture.

And finally I would like to thank Ulrike Prinz from Munich, who furnished and helped edit many of this catalog's texts, as well as Marie-Claude Mattéi-Müller, our "correspondent in Caracas", who, among her other contributions, conducted the interview with Edgardo González Niño.

ORINOCO – PARIMA

INDIAN SOCIETIES IN VENEZUELA
THE CISNEROS COLLECTION

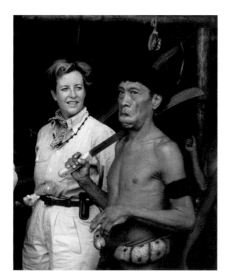

Patty Phelps de Cisneros visiting a Yanomami shapono. She talks with Doshamoshatheri, the leader of the settlement on the upper Rio Siapa.

From childhood in Venezuela I was struck by the fact that ninety per cent of our population clung to the northern coast of our country. It has been that way ever since our country was discovered by Europeans. The vast natural interior of Venezuela was, for most of our history, untouched by European settlers. Yet this was the territory were most of the indigenous populations of our country made their home in harmony with the magnificent natural surroundings. When I first began to discover the many indigenous communities that populated our interior, it was as a result of my own fascination with the savannas, tepuys, llanos (lowlands), and jungles that make Venezuela the home of so many natural wonders. Indeed, my own great-grandfather came to Venezuela in the nineteenth century in search of birds and left the greatest ornithological collection of tropical birds in the Americas.

During the many expeditions to the southern and out-of-the-way parts of the country beginning in the 1970's, we became aware of the richness and variety of our indigenous cultures. They were able to retain much of their authenticity, while Venezuela was becoming a modern state. I sought to find ways to inform others of the aesthetic energy and the belief systems that were seeking to retain individuality in the interior of a nation evolving as a modern democratic state. Together with my husband Gustavo and our three children, Guillermo, Carolina and Adriana, we began to collect recent and early examples of the art, artifacts, and objects of daily life of these peoples. This quest became my passion and my mission. Then we learned that we could acquire a unique and comprehensive collection from Edgardo González Niño, a friend with whom we had traveled to many indigenous areas south of the Orinoco. The collection I had dreamt about became a reality with this one providential development.

This exhibition in Bonn, *"Orinoco-Parima. Indian Societies in Venezuela"*, for the first time, will make it possible for a significant part of our collection to be seen by a large public. It is a particular pleasure for Venezuelans that this first display be in Germany. German scientists were among the first to explore the Orinoco, providing an understanding of the vast interior spaces of Venezuela and all of South America. Of course the most acclaimed of all was Humboldt, whose work is legendary in my country. His exploration of the Amazon territories of Venezuela contributed to our knowledge of an area in many ways still a wilderness.

The dedication and commitment of the director, Wenzel Jacob, and the curators from the Kunst- und Ausstellungshalle in Bonn added immeasurably to the articulation of this complex material from many different cultures. This is neither an art exhibition nor an anthropological treatise—it is both, and yet more. The

curators have chosen to congregate the material around themes such as love, work, fighting, and magic. These are universal themes that permit the viewer to appreciate the similarities and differences among these twelve ethnic cultures while relating them to concepts we each understand in our particular way.

One of the basic missions of the Fundación Cisneros is to foster the awareness of our Latin American cultural heritage. Gustavo and I hope, therefore, that this exhibition will provide a deeper understanding of the nature of some of the most spiritual indigenous people still clinging to the heritage of the New World. This is not a story of Arcadia or of noble savages, but a story of a large human dimension of Venezuela that is little understood. It is also a tribute to these peoples and their lands, which are among the most beautiful in the world.

Gustavo and I would like to extend our warmest thanks to some of the many wonderful people who have accompanied us in these twenty-five years: Edgardo González Niño, Ambassador Erick Becker Becker, Ambassador and Mrs.William H. Luers, Archbishop José Ignacio Velasco. To our children whose love for the Venezuelan Amazonia continue to motivate us to document and to preserve the collection for succeeding generations. Our son Guillermo has photographed and documented many expeditions; our daughter Carolina is a key member of the Proyecto Orinoco web site team, and our daughter Adriana has written and lectured on her experiences among the indigenous communities in Southern Venezuela.

Many devoted people of the Cisneros Organization have helped us through the decades: Sandra Zanoletti, Steven Bandel, Alexander Behrens, and Ricardo Valladares.

Finally, our deepest gratitude and respect go to Lelia Delgado, Andrés Ortega and Zuleima Jiménez for their many years of professional and passionate contribution to the formation, documentation and preservation of the Proyecto Orinoco collection.

GABRIELE HERZOG-SCHRÖDER

THE RAIN FOREST AS A GARDEN

PRELIMINARY REMARKS

When the Yanomami Indians clear new garden plots in the jungle, they sometimes find polished stone blades. The Yanomami themselves fashion no such implements. When asked from where the stone blades come, they answer: "The mythological ancestors laid out these blades here for us. That is how they let us know that this is a good place for a garden."

Forest-dwelling societies, as presented in the *Orinoco—Parima* exhibition, evoke a special fascination for members of Western civilization. The mere mention of forest dwellers creates within us a feeling of ambivalence, uneasiness, and sentimental desire. For some reason, these people appear to have "missed out" on a vital stage of human evolution that would have released them from the so-called "primitive state". But on the other hand they seem to have managed to remain part of nature.

The forest Indian—a relative of the trees? This is a construction—and the primeval forest itself a place of mystification!

Indeed, the jungle represents the antithesis to Western civilization's craving to colonize, to cultivate, to subdue and to squeeze profit from earth's environment. How different primeval man, who knows how to live in unity with his native surroundings! He succeeds without all the material goods our economy dictates as indispensable. Imagining living in harmony with the natural environment represents our desire for something that seems lost to us.

The tropical wood crates used to transport the Indian artifacts.

Natural human beings – were they ever real? Those residents of the forest, not distinguishing between human, animal, and plant worlds? Those who do not perceive themselves as individuals, but whose lives are ruled by the rhythm of days and seasons?

Recently, ethnobotanists and ethnoecologists have demonstrated convincingly that the indigenous occupants of the tropical rain forest have for centuries now understood how to utilize their land. They have altered it considerably—but without surrendering it to devastation. The concept of the primeval tropical forest of the Amazon is seriously debated nowadays. There is evidence that wide areas of this immense ecosystem are not pristine jungle but instead are "cultural landscapes", the shaping, maturing and maintaining of which was achieved only by many generations of people who played a conscious and active role in this process.[1]

Our image of forest Indians living in their often quoted "harmony with nature" flatters our arrogance about our cultural achievements while at the same time condoning our "discontent with culture."

But what if we freed ourselves of our projections about primeval forest people? Surely this would give us the chance to see the rain forest through new eyes, to comprehend it as a living space for human beings with their own needs and their own abilities.

The Yanomami find polished stone blades in their cleared garden plots. The ancestors have put them here. An old cultural landscape reveals itself in the guise of myth!

1 see Posey (1985, 1990)

FLOW AND EBB

REGARDING THE UNSEEN

There was once an English magician who performed naked on stage. Out of principle. Why should he restrict himself with any material props when they could be conjured from mid-air? He was a magician celebrated for his believability; however, his trick concealed a "material" flaw: his clothes were already charmed to mind by the display of their absence. Or better said, their invisibility, for the magician worked in a sealed cabinet on an unlit stage. The transformation of things is always consummated unseen in fog or darkness.

When I first heard stories about the Indian tribe of the Yanomami, what most captured my curiosity was to learn of their bashful hesitancy in the face of strictly delineated forms and solidly defined materials. They shied from tales with clearly established beginnings and endings. The Yanomami confuse their listeners by saying, for instance, "moon" when they mean "sun." They begin a culture myth somewhere in the middle (much to the despair of the budding ethnographer), sing about objects which they do not possess, burn objects they find useful. True reality for them exists in the spiritual fantasy. The appearances and disappearances they daily observe are such a powerful given that it permeates all aspects of their life. The spirit world is accepted as life-determining, its shadowy presence reverenced in every act. For the Yanomami, the vital energy which keeps the world in constant metamorphosis is to be sought among the spirits.

The key to understanding indigenous Indian societies lies, for Westerners, precisely in appreciating their relationship to the spirit world. How else can I approach such "foreigners"?

We are confronted with a splendid reincarnation whenever we fish out a Brazil nut (a favorite snack during some televised sport spectacle): reportedly, its seed only becomes fertile after it has been digested by a tapir. This goes to show: there is no coming into being without preceding disappearing.

This is not an ethnological exhibition. Its collector followed no academic goal. He collected indigenous handcrafted objects, yes. But yes, he also collected—perhaps without conscious realization—the spiritualism infused in these objects. From a Western point of view, this collection is not as exotic or splendidly colorful as one might expect from an accumulation of Indian artifacts. The ethnic groups the collection encompasses are rather simple in terms of their material cultures. This exhibition will disappoint those who seek comprehensive explanations making indigenous rites and ceremonies understandable. Because these objects in their authenticity are so near to life, we made the conscious decision to include nothing outside of the collection. The material was rich enough to fit the whole into a structure tracing the cycle of coming into being and passing. This came with a price: the various cultures could not be displayed in isolation from one another. For a natural scientist scrutinizing the objects minutely, the differ-

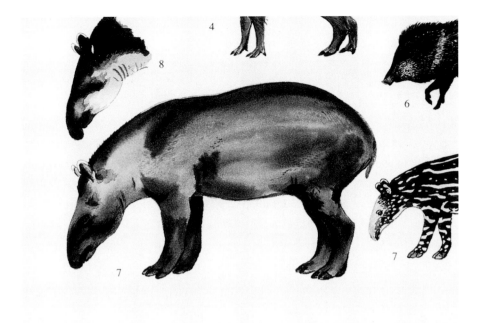

Tapir
Tapirus terrestris

ences between these groups are of enormous interest; for those who view the objects from a slight distance, the energy displayed by these cultures becomes powerfully immediate. From an ethnological point of view, this might lead to a few inaccuracies.

Because in each of these objects an entire cosmos comes into being, because each of these objects, besides its utilitarian meanings, is also a signifier of political and religious meanings, the following question arises: how can an exhibition make this clear?

I believe it can only happen,

1. by simply saying that it does,

2. when the viewer practices that same respectful attention the magician required—to refer to the anecdote at the beginning—to become celebrated for his believability.

One of the reasons our forefathers journeyed to South America was to spread the "true belief"—but only because they "knew" it was true (and some people are still convinced). In the year 1927, Werner Heisenberg, a natural scientist, formulated the "Uncertainty Principle," which essentially states that no one can know everything at any one time. This thought opens, perhaps unwillingly, a door to "the unseen beyond." Here the clearly established differences between a religious society and the community of science dissolve.

Brazil nut
Bertholletia excelsa

GABRIELE HERZOG-SCHRÖDER AND LELIA DELGADO

ON THE PRESENTATION OF THE CISNEROS COLLECTION

The *Orinoco—Parima* exhibition marks the first time the Gustavo and Patricia Cisneros Collection appears before the European public. The collection comprises a rich assortment of Amazonian ethnographic objects from twelve southern Venezuelan societies.

For many years Amazonia—as well as its northern region near the Orinoco River—was an unexplored portion of the globe thought of as hostile and remote. It was utterly unimaginable that human societies could choose such an inhospitable territory as their homeland. Interest in these remote tropical forest regions was limited solely to the purposes of exploiting its mineral and other natural resources. Over the course of the last two decades, however, ethnological and ecological investigations have fully altered our view of these "hostile" South American lowlands. The sad irony is that, parallel to this evolution of thinking, broad sweeps of rain forest were being destroyed. Gradually, the opening up of this territory—an annexation rarely accomplished by polite means—awakened a broad interest in the lifestyles and art of the region's native inhabitants. Especially the discovery of the traditional feather adornment of Amazonian societies won the appreciation of a wide audience.

The palette of over 1400 objects which make up the Cisneros Collection is lavish. The collection comprises everything from such shamanistic ceremonial objects as masks, feather ornaments, wooden benches shaped like animal figures, ceremonial scepters, ritual weapons, and bone mortars, to such examples of body adornment as arm bands, necklaces, earrings, and aprons woven with colorful glass beads. Here can also be found a wide variety of whistles, flutes, drums, rattles and other musical instruments, as well as such everyday implements and utensils as boats, paddles, graters, pottery, textiles, poisons, torches, and much, much more. The collection also includes the raw materials out of which these objects were fashioned: wood, rushes, seeds, fruit pits, bark fibers, creepers, resins, and waxes, as well as such animal products as pelts, claws, beaks, teeth and bird skins. Worthy of especial mention is the large and aesthetically powerful assortment of handcrafted basketry. The exhibition *Orinoco—Parima* displays roughly half of the objects which make up the entire Cisneros Collection.

In this, the *Orinoco—Parima* exhibition catalog, the various societies from which the Cisneros Collection possesses examples of material culture are individually described. The articles contain scenes drawn from the daily lives of these indigenous peoples; objects which characterize their cultures are illustrated in the color section of the catalog. The ethnological essays sketch the traditional territories, economic activities, forms of communal living, divisions of labor, and religious and cosmological concepts of the individual societies, as well as describe their present-day situations.

Beyond this, four additional essays take as their themes important aspects of South American indigenous life. The contribution by Gabriele Herzog-Schröder examines the exchanging of objects between different settlements belonging to the same ethnic group. The value of these objects cannot be reduced to their material worth, but incorporate other social meanings. This essay reveals how the idea of reciprocity plays a conspicuous role in social relations.

The contribution by Ulrike Prinz offers reflections about exchanges between gods and humans. The cultural knowledge people owe to their mythical ancestors and culture heroes manifests itself in everyday objects. The significance of an object lies in its relationship to the world of myth. The designs and drawings decorating objects or bodies recall the mythical time and cause a continuing exchange between the spirit and human worlds.

Marie-Claude Mattéi-Müller concerns herself with an analysis of basket-weaving, one of the oldest human artistic crafts, which in the lowlands of the Amazon enjoyed and enjoys such unique, accomplished expression. The author describes how the Ye'kuana, Yanomami, and E'ñepa, as well as various groups of the Arawak, have managed to at least partially preserve their traditional basketry artisan crafts, or through new impulse and innovation have even managed to expand them. When we consider all the ills the process of cultural adaptation in South America has augured—unfortunately, not the term "cultural adaptation" but "cultural loss" too often rings true—such exceptional and creative examples bring encouraging hope: here we have peoples that, alongside their growing, intensive interactions with the white world, are undergoing a transformation of culture that does not rob them of their Indian identities.

In his essay about the Warime Ritual, Luiz Boglár, a Hungarian ethnologist who during the sixties and seventies observed this ritual firsthand, recalls the course of events that makes this celebration the central, most important event in the lives of the De'áruwa (Piaroa). He describes the transformation of raw material into sacred masks, masks which for the time of the ritual transform their wearers into god-like beings.

The twelve Venezuelan ethnic groups assembled here can be—following a convention practiced by ethnologists at work in South America—distinguished according to the language family they are attributed to.[1] The Ye'kuana and the E'ñepa (Panare)[2] belong to the Carib-language family. The De'áruwa, often called the Piaroa, traditionally speak the ancient, almost vanished Saliva language, and the small group of the Puinave speak a language related to Maku. Members of the so-called unclassified ethnic groups, those practicing forms of speech which cannot be attributed to the larger language families, are the populous Yanomami, the small group of the Hodï, as well as the small Híwi groups living in Venezuela. The Híwi are—especially in Colombia, where most members of this ethnic group reside—also known as the Guahibo. Other groups represented in the collection are the Baniwa, Baré, Wakuénai, Piapoco, and the Warekena—societies that belong to the Arawak language family. Because these five societies possess nearly identical cultural attributes, and because the process of cultural adaptation proceeds so similarly among them, they are treated together in one essay.

Interestingly, an ethnic group's language family classification may shed some correlative light on the genesis of other cultural attributes. This becomes evident with regard to the cultivation and processing of manioc, a tuber rich in starch used by many of the indigenous ethnic groups assembled here. Manioc especially plays an important role in the Carib cultures of the Ye'kuana and the E'ñepa (Panare). The special processing utensils these peoples developed first allowed manioc to be used as a foodstuff. Among these utensils is firstly the grater which is used to pulp the hard tuber of the bitter manioc. The pulp is then fitted into a large, tubular basketry press to be squeezed of its juice, which contains poisonous prussic acid. The manioc tortillas are stored in plaited basketry trays.

These baskets are often woven with designs articulating the specific iconography and the mythic background of the "manioc-culture". Many of these designs recall the culture heroes who first imparted to mankind the gift of cultural knowledge. Manioc processing and the special implements it requires teach us a number of important aspects about the economic life in Amazonia, which is profoundly connected with the world of ideas of these Indians: their spiritual concepts are manifested in the objects of their material culture, and the special worth these objects carry lies in the threefold values of function, symbolic meaning, and aesthetic quality.

Outside of the Carib-societies, it is first and foremost the De'áruwa (Piaroa) who either, to process the bitter manioc, practice complicated techniques of their own devise, or employ assimilated techniques which they have revised. The process of transforming the poisonous raw pulp into a nutritious foodstuff plays a central role in their world of ideas. This idea of transformation finds an echo in a variety of other connections: for instance, the meat of game is inedible until a shaman purifies it with his song and breath.

Of those societies with artifacts represented in this collection, it is the Arawak ethnic groups and the Híwi which have undergone the greatest cultural adaptation. By and large they have given up their own languages, and—in terms of external appearance—have adopted the lifestyle of southern Venezuela's Hispanic-American population. This advanced stage of cultural adaptation explains why, in the exhibition as well as within this catalog, artifacts and photo material gathered from these societies—in comparison with the other ethnic groups represented here—are far less abundant. The lack of photo documentation of these superficially largely assimilated ethnic groups evidences the preference of photographers and researchers to pictorially assess "native" Indians. When confronted with people who are difficult to differentiate in terms of external presentation from the typical Venezuelan mixed population, there is much less impulse to pull out the camera. Among the best documented societies in the exhibition and within this catalog are the Ye'kuana, Yanomami, E'ñepa, and the De'áruwa. Photographic records of their spectacular ceremonies, or examples of their striking architecture, evidence a yearning on the part of the Western observer for something exotic—a yearning rarely satisfied by those groups which are much more integrated into Venezuela's multicultural society. Providently, Edgardo González Niño, who almost fifty years ago laid the fundament to this collection, had gath-

ered traditional objects from the Híwi and the Arawak clusters, groups at present widely sharing the lifestyle of the criollos, to add to the collection. The uniqueness of these objects, González Niño admits, only became apparent to him with the passage of time.

While the catalog introduces the individual ethnic groups, focusing on such important aspects as exchange, transformation, and ritual, the exhibition is laid out according to a totally different conceptual framework. This publication, then, is meant as both a guide to the exhibition, as well as a source of supplementary information.

The exhibition reflects the daily life-cycle—or even full life-circuit!—of the Orinoco Indians. Each of the fifteen exhibition rooms takes on a separate theme illustrating some universally significant aspect of human life. At the beginning stands creation, birth, and becoming. Ordering, crossing, hunting, healing, and nurturing, are the ensuing themes. The exhibition is rounded off by the themes of celebration of rituals, exchange, sleep, and finally, passing away.

The items of the collection, presented as aesthetic objects, are arranged throughout the rooms to help portray the cycle of life experiences. With reference to the given themes, they are placed on display as objects from single ethnic groups, or, to invite a comparison of styles, arranged in inter-ethnic clusters. The ethnographic objects are explained in terms of function and transcendental meaning. Of importance to the exhibition curators is that these objects, which so often are truly archaic, be approached with respect and be granted the integrity of their uniqueness. Too much explanation would serve only to reduce these objects to our cultural level, and to deaden the mythic or magic-religious knowledge component infused in their creation. Photos arranged in display cases supplement extend pictorial commentary. They provide a frame of reference, a way of viewing the artifacts as related to the room's reigning theme. Collecting itself, too, is placed on display: the heavy, wooden cases in which the objects are stored and transported present another aspect of the exhibition worthy of appreciation.

1 Linguistic categorizations as well as the spellings of the names of ethnic groups are largely adopted from a manuscript by Marie-Claude Mattéi-Müller, which the author kindly placed at our disposal. Mattéi-Müller was commissioned by the UNESCO organization, "Society for Endangered Languages," to analyze the contemporary state of Venezuela's indigenous languages, assess their "survival" probabilities, as well as outline their chances of preservation.

2 Because some of the names by which the ethnic groups are known contain discriminating or derogatory meanings, we decided to employ as ethnonym the name with which the ethnic group members refer to themselves. At the same time, to afford more transparency, we have included where needed the more common term in parenthesis.

THE SOURCES

Southern Venezuela with its forested highlands, heavily eroded sandstone cliffs, and bizarre stone formations, lies on the western slope of one of the world's oldest geological massifs, the Guayanese Shield. In its northern and western districts spread out the savannas of the Orinoco valley; much of the rest of the territory is covered with rain forest, its nearly impenetrable vegetation constantly renewed by the alternating climate. During the rainy season the rivers wash over their banks to transform the landscape's appearance. Then, the small forest paths linking the Indian settlements become torturous trails of mud.

It is not surprising that from the world of the South American lowlands, one of the newly discovered continent's most remote and awe-inspiring regions, exciting tales of treasures would emerge, legends of fantastic riches. The first European pioneers, Francisco de Orellana and Fray Gaspar de Carvajal, without a doubt imaginatively colored their experiences along the Amazon with snippets of Greek mythology. In all earnestness they reported of their encounters with a tribe of women warriors, the Amazons. South America's greatest river is the namesake of a mythical, "Old World" nation of female warriors.

The Orinoco is also a source of mysterious tales. Called by the Indians dwelling along its banks the *Uriaparia, Uyapar, Parawa,* or *Baraguan,* the Orinoco is one of the largest rivers of the subcontinent, traveling in its length some 2700 kilometers. When, upon his third great voyage to the "New World," Christopher Columbus first set eyes upon the South American continent, he immediately apprehended the enormous dimensions of the Orinoco and the land it drains, for nowhere else in the ocean as at the river's wide delta mouth had he discovered such stores of fresh water.

The Orinoco first made its appearance on a map in the year 1529. The map was charted by Diego Ribeiro, in the service of Karl V., the Emperor of the Holy Roman Empire, "upon whose Kingdom the sun never sets." Until the middle of the eighteenth century the region of the upper Orinoco was visited only rarely. In 1745 the most southern of the Orinoco mission stations—under the direction of Padre Gumilla—lay on the Rio Méta, a western tributary of the Orinoco, located to the north of today's Puerto Ayacucho. During the second half of the eighteenth century explorations of the middle Orinoco began. Under the command of José Solano, a boundary charting commission attempted to enlarge Castile's South American territorial claims. Solano and his allies managed to penetrate as far as the Rio Negro in the upper Orinoco valley. En route they founded the settlements of San Fernando de Atabapo, San Carlos de Río Negro, San Felipe (1759), and La Esmeralda (1760).[1] At that time, in the area beyond the dangerous river rapids, the Jesuits had already established two settlements: San Juan de Atures and San José de Maipures. With their expulsion in 1767, the Jesuits were forced to leave behind their missions. During his exploration of the territory in 1800, Alexander von Humboldt discovered the old missions, their ruins testifying to the early Jesuit pioneering efforts.

The Capuchins, Franciscans, Dominicans, and Augustinians continued to missionize the territory. They constructed new or extended old routes of travel, founded settlements, built churches, and charted maps. Among these churchmen were Manuel Román, José Gumilla, Fray Antonio Caulin, and Filippo Salvatore Gilij, gifted chroniclers who left us with vivid descriptions of the native lifestyles they encountered.

The next wave of outsiders arrived during the second half of the nineteenth century in response to the economic demand for latex, chiqui-chiqui fibers, and other raw materials found in the forest. They increasingly settled the Orinoco basin.

In 1800, Alexander von Humboldt, together with the French botanist Aimé Bonpland, arrived at the mouth of the Rio Apure in the Orinoco valley. We have Humboldt to thank for his important geographical and astronomical contributions. Humboldt not only charted new maps and corrected older ones, but also grounded cartography as an independent geographical discipline. His meticulous scholarship and discoveries played an important role in expanding the botanical and zoological knowledge of his time. Humboldt was also the first to confirm the existence of the Casiquiare, a natural canal running between the subcontinent's two great northern river systems. Until his findings became public, the legend of a way of passage along the Rio Negro between the Orinoco and the Amazon was as dubious as the fantastic stories of El Dorado and his magnificent domicile on Lake Parima, which was sometimes pinpointed as lying in the Andean highlands, and sometimes in the northern reaches of the Amazon. Allegedly, during a majestic ceremony on the water, a great Indian chief was powdered in gold dust by the blow-tubes of his subjects before he dove into the sacred lake. As far back as the beginning of the seventeenth century, Sir Walter Raleigh, in the service of the British Crown, conducted an expedition to locate this fabled land of gold. Gradually, as the knowledge of South America's interior increased, Lake Parima's dimensions dwindled. Finally, with the appearance of Alexander von Humboldt's first modern map,[2] the lake disappeared entirely, vanished into legend to be replaced on maps by the reality of the western range of the Guayanese Shield.

Alexander von Humboldt's investigations of the Orinoco region ushered in a new epoch of serious scientific inquiry. In the service of the British Crown, Richard Schomburgk, a German botanist and explorer, between the years 1835 and 1844 traveled across the boundary region between Guyana and Venezuela, accompanied by his brother Robert Hermann across great stretches. In 1853 and 1854 the English botanist Richard Spruce explored the Amazonian region of the Orinoco valley and described much of its rich native flora. His anthropological, archeological, and linguistic notes are also highly valued. Jean Chaffanjon, a Frenchman, in the years 1886–87 set off to discover the origins of the Orinoco— in truth, however, he never really arrived anywhere near its source. All the same, Chaffanjon's descriptions became a source themselves for a work of fiction: they were used in Jules Verne's novel, *The Proud Orinoco*.

On their journey from the Orinoco to the Amazon, Alexander von Humboldt and Aimé Bonpland encountered indigenous peoples.

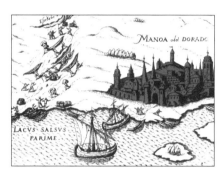

This copper etching from the sixteenth century pinpoints the legendary city of Manao as existing on the shores of mysterious Lake Parima. El Dorado was said to live there, the powerful Indian ruler who as part of a majestic ceremony was powdered with gold dust by his subjects.

Almost 70 years after Humboldt, another German scientist, Theodor Koch-Grünberg, arrived in the Brazilian-Venezuelan region of Guyana where he compiled meticulous scientific notes. The work, *Vom Roraima zum Orinoko*, as well as the sound and film material he recorded, are invaluable sources of information about the traditional cultures of this region. From Koch-Grünberg, who possessed an extraordinary language talent, we have the excellent indigenous language studies and extensive word lists which first made possible the linguistic categorization of the Orinoco-Parima peoples.

In January of 1920, Alexander Hamilton Rice, a geographer from North America, set out on an expedition to discover the source of the Orinoco. At the Raudal de los Guaharibos, hostilities with a group of Yanomami men brought his expedition to an unhappy close. The scientist interpreted the greeting of the Indians—they appeared ready to shoot with their bows and arrows—as a sign of aggression. The expedition members, firing off warning shots, turned around to set back downstream. For many years in the aftermath of this incident, this region was considered impassable.

The sources of the Orinoco were finally discovered at the beginning of the fifties by a large French-Venezuelan expedition. In November of 1951, after many months of laborious travel, the group successfully located the river's source at a mountain of the Sierra Parima range located at precisely 2.18 degrees north, and 63.15 degrees west. At a height of 1100 meters above sea level, the mighty river begins as a modestly trickling rivulet.

Since the forties and the fifties, a great deal of ethnological and anthropological information regarding the inhabitants of the Orinoco-Parima region has been collected. Laying the foundation to the modern anthropological studies was the research of Johannes Wilbert and the geneticist Miguel Layrisse, who worked in cooperation with the Venezuelan research institute, IVIC. Since the sixties, in numerous publications, Wilbert has presented important information about the groups living in the Orinoco and Rio Negro region. The Frobenius-Institut of Frankfurt, Germany, commissioned Otto Zerries and Meinhard Schuster to undertake a twelve-months research expedition in order to shed some light on the "cultural-historical standing of the Waika." Waika was the name by which the Yanomami were referred to at the time. The Yanomami were also the subjects of research by such scientists as Napoleon Chagnon and Jacques Lizot. Meinhard Schuster assembled valuable ethnological information on the Cuntinamo about the Dekuana, a group of Ye'kuana living in the western portion of their territory. Numerous excellent, international scientists then descended on the Orinoco-Parima region, scientists such as—to name but a few—Nelly Arvelo-Jiménez, Daniel Barandiarán, Ettore Biocca, Marc de Civrieux, Walter Coppens, Omar González Ñañez, and Joanna Overing Kaplan. Over the course of the past twenty years, the number of publications dealing with the people of this region has rapidly increased. The ethnographic essays and bibliographical listings contained in this catalog provide further information about the important publications of authors who have studied the individual ethnic groups.

During the fifties, at the beginning of the era in which the first systematic ethnological and anthropological research of southern Venezuela was undertaken,

Edgardo González Niño traveled to Puerto Ayacucho. At the time Puerto Aya-
cucho was the young capital of Venezuela's Territorio Federal de Amazonas,
which has in the meantime become a federal state. During his stay in the Orinoco
and Rio Negro region, Edgardo González Niño collected a vast assortment of
Indian artifacts. The Cisneros family, heading a foundation dedicated to further-
ing and making known traditional Iberoamerican culture, purchased Niño's col-
lection in 1988. While at the same time preserving the artifacts for others, the
Fundación Cisneros is actively engaged in enlarging the collection through new
acquisitions, and in organizing public exhibitions. The Cisneros Collection docu-
ments not only the results of nearly fifty years of consistent collecting activity, but
the outstanding patience and devotion of Patricia and Gustavo Cisneros. Their
personal mission is not only directed towards keeping alive in a respectful man-
ner the memories of traditional indigenous lifestyles, but also, during these
changing times, towards helping these peoples achieve the largest measure of
self-determination possible.

1 Eden (1974)
2 Humboldt himself believed Lake Guatavita near Bogotá furnished the background to the El
 Dorado myth.

MARIE-CLAUDE MATTÉI-MÜLLER

AN ENCOUNTER WITH EDGARDO GONZÁLEZ NIÑO,
A PIONEER OF VENEZUELAN ETHNOGRAPHY

Wearing *alpargatas*, flat sandals, eighty-year-old Edgardo González Niño lives
today in Puerto Ayacucho, the capital of the state of Amazonas in Venezuela.
Coming originally from the Andes, and having spent his formative years in Cara-
cas, Edgardo González Niño returned two years ago for good to the same small
city where fate had landed him some 43 years previously. This authority of
Venezuela's Amazon region is no academically schooled ethnographer. One could
more readily characterize him as a free spirit driven by his passionate curiosity to
learn about the region on his own. The Indian settlements and territories, which
for the majority of city-dwelling Venezuelans make up a nameless unknown,
awoke in him a spontaneous interest, or better, a calling. He was of course an
adventuring sort, a man with "a rebel spirit." This much is certain: the land
Edgardo González Niño was destined to call his home was the Orinoco valley with
its dense forests, hills, savannas, and deep rivers with majestic waterfalls and
shooting rapids.

 "I was a public civil servant," he remarks about his young adulthood. "I worked
as a veterinary technician in the Department of Agriculture. When the terrible
foot-and-mouth disease broke out, I had just been promoted to the position of
Supervisor of Immunization and Pest Control for the cities of Puerto Cabello and
San Felipe. The director of the harbor of Puerto Cabello was a brother of the

Edgardo González Niño

dictator at the time, Pérez Jiménez. He wanted to ship a cute little lamb to the children of his brother living in the capital. But I," so Edgardo González Niño continues, "didn't allow the little thing through, because the regulations stipulated that no sheep could leave the quarantine zone. Revenge from the higher authorities didn't take long, and I was sent to a little dump in the Llanos,[1] where there was nothing to do. I wrote a short report and quit my position.

You have to realize that I grew up in an area filled with 'Gomez-followers.' My parents and my grandparents had left their home state of Táchira in order to actively support the regime of General Gómez, the earlier dictator, whom everyone in my family called, 'the little father.' All this and then that thing with the lamb was enough to get me persecuted by the police. They finally banished me to Puerto Ayacucho. I had no idea where they were sending me, and knew just as little, before I arrived, about the Territorio Amazonas[3]."

January 8, 1956, marks the day González Niño arrived in—as he jokingly calls it—the "Siberia of the tropics." A condition of his banishment was that he check in daily with the regional police. Paradoxically, what was meant as a punishment turned out to be, as if transformed by magic, a boon of freedom, or, to put it in González Niño's own words, the start of his "happy life in paradise." Puerto Ayacucho had been founded only thirty years earlier. Nestled along the eastern bank of the Orinoco directly opposite from Colombia, Puerto Ayacucho was more village than city. The roads were unpaved, and the river, not far from the impressive Atures rapids, was the most important transportation link, the point of contact with the outside world. From here practically the whole of South America could be reached, and González Niño immediately considered escaping to Colombia or Brazil. One day he actually did ship out on a large Colombian freighter in the direction of the Rio Negro. He felt more frightened than happy, however, for it was his first time on a ship, and despite its large size he didn't quite trust it. This detail he relates with a grin, because only a few months later a *bongo*, a large dugout canoe, would be his new home—and that for many years. Today he still feels homesick for his old life in the river. "I should have remained on the river," he says with a smile. "I don't know what I'm doing here."

In the meantime, as he puts it today, he had come down with a bad case of the "jungle virus"—a feverish craving for the untamed jungle. He was also curious about the peoples who lived there. "On a sandy road I saw a group of men and women go by", he says, telling a story. "Their faces were very serious and they weren't wearing clothes, though some of them had a white cloth wrapped around them. They were Indians from the Piaroa tribe [De'áruwa]. I tried to greet them, but they didn't pay any attention to me. So I followed them, and they went into this house with a huge inner courtyard where criollos[4] were living. I followed them because I was curious to hear what they'd say, see what they'd do. The woman who owned the house came out, and the Indians took some feathers out of their bags, and in exchange for the feathers they were given glass beads. That was the first time that I ever saw criollos and Indians barter. Then I talked with the woman, Doña Camila de Mariño, since then a noble friend, and I found out about these strange peoples with their different languages who lived further down to the

The infamous Ature rapids south of Puerto Ayacucho kept intruders from reaching by river the region of the upper Orinoco. Beyond this rushing cataract the river is again open to navigation towards the Rio Negro and the Amazon.

south. At the time you'd often hear about the Guaharibos, whom we call the Yanomami today. They were supposedly dangerous, but for me there was nothing more dangerous than the police. That's why already I had this desire to make my new home in this other land. I got off in San Fernando de Atabapo, my favorite town on earth, because that's where my life really began, and I mean my happy life. The people there weren't frightened of me, instead, on their narrow little streets, they'd call out to me real friendly-like and offer me some of their watery coffee. Every afternoon someone would bring me a grilled fish. They were all like a big family, with different groups from along the Rio Negro all living together, the Baré, the Baniwa, Kurripako and Puinave. The Ye'kuana from the Ventuari would come there from La Esmeralda, and sometimes Yawarana[5] or a few of the feared Guaharibos, or Waika, or Yanomami—whatever you want to call them— would show up. There I became acquainted with the drinks they make from the fruit of manaka and seje palms. And there I met as well a criollo who came from Caicara on the Orinoco. His name was Sixto Sequera and he had already lived a long time with his wife and his kids together with the tribe of Yanomami on the Ocamo. He agreed to be my guide, and so one early morning we set out together. We traveled far up the Orinoco with this little ten-horsepower motor. From San Fernando de Atabapo to Ocamo it took us fourteen days. A two-week boat trip on the Orinoco, for me, a city slicker from Caracas, was something simply fantastic! I didn't know the first thing about Indians, and nothing about the jungle. When we'd almost reached the mouth of the Ocamo River, there was a group of people standing along a river bend, and I saw them waving and pounding each other on the backs and across their breasts. 'They're greeting us, my friend,' I said to Sixto. And he said, 'No, no, that's no greeting, they're killing mosquitoes!'.

On the Ocamo I moved into a little hut not far from my friend. At the time there were no missionaries on the Ocamo. That's where I lived my life. I bought a dugout and a motor, and I started helping the Yanomami search for wood for their new settlement *(shapono)* and for leaves for their roofs. The Yanomami liked Sixto Sequera very much, and the best proof of this was that they would leave their women alone with him. For them he was 'Sito' and I was 'Niño'. First I visited the Yanomami, then later the Piaroa (De'áruwa) and the Mako, who were already doing flourishing trade with the criollos.

"The Piaroa produced latex—Indian rubber—from the pendare tree. They already had dugout canoes with outboard motors, just like the Ye'kuana. They were skilled with their hands. One time they made me a guitar out of a box and some nylon fishing line and sold it to me. I always had some trading goods with me, like nails, hammers.

In the Yanomami territory my friend Sixto Sequera was the only one who knew anything about the chewing-gum tree—pendare—and the Yanomami from Ocamo learned about it from him. They helped him to process and knead the mass. He obtained the milk by making a cut, then would let the sap pour into a bag specially prepared out of canvas, then would empty it into a gasoline drum filled with water. It stood on a couple of stones over a wood-fire. This would get the pendare milk to turn into a lumpy pulp.

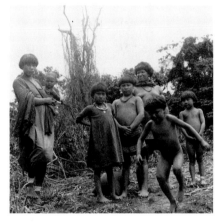

Venezuelans, who live for the most part along the ocean coastline, know very little about the Indian cultures of the South.

As soon as the milk would congeal, you'd scrape it out with a spatula, then pull and stretch it until the strings broke. The strings would then be laid out over a flat rock or a piece of wood to be kneaded as long as they still were warm. As soon as the mass was firm again, it would get put in a wooden mould to form a hundred-weight gum-block. And that's how it would be sold."

"I went everywhere", Edgardo continues, telling about those times. "I had a reputation as 'the lone knight of the Amazon territory.'[6] At the time there was no shortage of gasoline, if anything there was a lack of outboard motors! I undertook long journeys with the Ye'kuana—they really are the lords of the river, and make the best travel companions. The Yanomami on the other hand climb the first tree the second they hear some tiger roar,[7] simply leave you there to fend for yourself. The Piaroa, who worship the tiger as a sacred animal, lay down on the ground like some Mohammedans during prayer, and that's how they wind up as tiger victims so often.

I spent a long time with the Yanomami in the deep rain forest not far from the Ocamo. In the meantime the Salesians had founded a mission station nearby. One day I found a scrap of newspaper at the station with a headline. It told about the demonstrations in the streets of Caracas following the 'fall.' That's how I found out that General Pérez Jiménez two or three months earlier had been driven from office! Since that time some deputies had been trying to locate me. They wanted to relieve me of my banishment, but for the time being I stayed in hiding. The Governor sent for me too. Then, following the advice of Pater Cocco, the missionary at the Salesian station at Ocamo, I turned up again. I traveled more than 500 kilometers downstream on the Orinoco and arrived again at Puerto Ayacucho, just as the regional voting commission was being assembled. At the time I had a rather impressive full beard and long hair. They were prepared to elect me, a victim of the fallen regime, as a member. Anyway, I left the election meeting as its President.

As the representative of the people of the Territorio Amazonas, I returned to Caracas. My political office forced me to travel back and forth between Puerto Ayacucho and Caracas. But I couldn't be happy, because I still had the jungle virus! Some time or other I came to the decision to go back to the Yanomami.

At the time they were founding a regional coordinating center for natives. I was able to work a while for their commission. A serious problem at the time were the imported diseases like measles and chickenpox. Hepatitis in those days was as good as unknown.[8] There were some cases of malaria, but very few, and a couple of other diseases caused by parasites."[9]

"So I was living again out in the forest, living again my life as a 'discoverer', and a 'dropout'! Some people even started calling me González 'Indio.' That was around the time when I started buying and bringing home ethnographic objects. It was enough for me if it was simply something that the Indians had made. I bought everything that was characteristic of daily Indian life. Also the things that had to with processing interested me. That's why I didn't just buy the baskets for the *casabe* tortillas, but also the plant fiber strips used to produce the basketry trays

Much of the territory in which indigenous populations live is nearly inaccessible. A government commission arrives by helicopter to investigate the local situation among the Indians.

and sieves. With the Yanomami I traded for an entire hunting outfit with bamboo quiver and arrowheads, and for the raw materials as well. From the Ye'kuana I obtained a few nice wooden benches the shamans had used, and a roughly hewn hunk of wood intended to be turned into a shaman's bench.

Finally I was given the job to do a census of the natives, and for the period of three months I had the opportunity to visit many remote groups. I used this occasion to trade for numerous ethnographic objects. I made many friends among the Ye'kuana, and so I was able to undertake a six-months trip with them down to Brazil. For a while I lived with them in La Esmeralda."

"In the collection there are two types of *curiaras* dugouts, one from the Ye'kuana and one from the Piaroa. The second one is lighter and more maneuverable. The Piaroa are elegant in everything. Their dugout looks quite fragile, like it'll probably break apart, but no, it holds. The Yanomami at the time didn't build any dugouts, but they would strip the bark off a huge tree, which they call *thõmoro*, and build a tub-like barge they could float downriver.

"For the Ye'kuana the manufacture of the *curiara* or the large *bongo*, from the moment they fell the tree to the point where it is completed by hollowing it out with fire, is a sacred process. Before the felling the medicine man conducts a ceremony. It has to be a suitable tree. It wasn't easy to watch the whole procedure, because the Ye'kuana actually don't want to have outsiders watching. Women can't take part in the burning procedure. There are rules to follow, from the felling to the burning. They hew the wood with an ax as long as it is still warm and open it up very slowly.

Actually, I never had in mind putting together a huge collection. But with time my room in the house of my family in Bella Vista (Caracas) started to overflow. There was so much accumulated that there was no more open space on the walls, and so I started hanging the basketry trays from the ceiling. It was beautiful! At the time when I was in Caracas, I used to get visits from all sorts of people. It maybe sounds a little strange, me just coming right out and saying it, but they believed that I was a great medicine man. They used to come to have me heal them! Through this sort of talk I almost became a living legend. Well fine, I was always interested in the use of medicine herbs and I had learned a lot from the Indians! Now these people were asking me about these things, then together with a couple of young anthropology students, we came up with the idea of organizing an exhibition about the Indians. It was our idea to show the life and customs of these peoples. But neither the museum of natural sciences nor the students nor I had the money, so we had to put the whole thing together with our own hands. It was in 1964. We filled an entire exhibition hall. At the time I had already been on the Rio Negro, but the items came mostly from the Yanomami, the Ye'kuana and the Guahibo [Híwi], whereby I only had a few things from the Guahibo. These people I saw so often in Puerto Ayacucho that I didn't find them very impressive. But then I noticed rather quickly my error, and I really wanted more objects from the Híwi and the other groups. It was truly the first ethnological exhibition in Venezuela—it was supposed to be shown two weeks, but then it became part of the museum's permanent exhibition! I went there to give lectures and offer

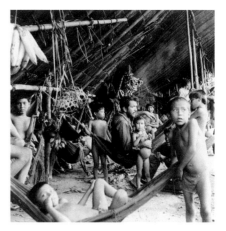

Edgardo González Niño lived many years in intimate contact with the Yanomami and shared their lifestyle.

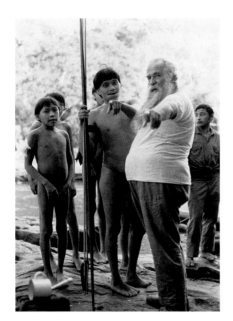

Padre Cocco, founder of the Salesian mission on the Ocamo, developed a deep understanding for the Yanomami.

supplementary explanations. Later there was a photo exhibition by an organization called Provenezuela. At the end of the Caldera regime in 1974[10], the exhibition traveled to Cuba. It met with a great deal of interest, especially among students. The exhibition was supposed to last for eight days, but remained in Cuba for two months.

After Cuba it went on a long journey through Europe: it went to Vienna, Stuttgart, Munich, Moscow, where it was shown in the wonderful Museum of History, and to Saint Petersburg, and Prague, Warsaw, Budapest, Sofia, Belgrade, Ljubljana. And now it is again in this beautiful exhibition in Bonn!

After it returned to Caracas the collection remained a few years here at the Museum of Natural Sciences, but I never wanted to leave it in the hands of a public institution, because I was afraid it would be damaged. There's never any money for this sort of thing! I had received a few offers, even from presidents of the Republic, but I always thought that the collection would be better off in the hands of a private institution. When Mrs. Patricia Phelps de Cisneros told me that the Cisneros family was interested in my collection I was enthusiastic. It was not a question of money. I had been travelling with them to the Orinoco. I knew that it would be well taken care of. They added what they themselves had collected. I continue to help acquire new objects and they go on completing the collection. That's already a long time ago [...]".

Edgardo González Niño could continue for hours relating his countless adventures and vivid memories, or describe at length his many extraordinary friends—friends such as Awakë, the proud Yanomami chief from the Ocamo, among whose wives was Helena Valero, a Brazilian who was kidnapped by the Yanomami at the age of twelve; or Parature, the rebellious Ye'kuana chief, who refused any contact with the criollos, but who became Edgardo González Niño's trusted friend and guide; or the generous Salesian Father Cocco, and Doctor Anduze, governor of the Amazonas, who shared González Niño's enthusiasm for the cultures of the Indians; and of course Sixto Sequera, his unforgettable companion through thick and thin... the list goes on and on. Edgardo González Niño never broke off contact with any of his friends. Still today on the streets of Puerto Ayacucho he greets and talks with the children and grandchildren of the friends who have passed away.

To this day, however, Edgardo González Niño has yet to find a "successor". No one can describe the landscape of the territory better than he can, the rapids, the hills, the boulders, the riverbanks, the places where turtles lay eggs, the watering holes of the tapir, the regions roamed by tigers, the fertile lands where orchids bloom in everywhere, the Indian cemeteries and deserted settlements, the best places to hunt or fish. When he goes it will all go with him—including a secret he has never disclosed: the locations of the small, deep brooks and sandy beaches where he saw nuggets of glimmering gold. With a humor all his own, Edgardo González Niño says of his life, "I walked across the land of diamonds and gold, but it didn't mean anything to me—I'm just happy wearing my *alpargatas*."

1 Large plain of central Venezuela.
2 The Andean state of Táchira, from which Edgardo González Niño also stems, brought
 forward a number of politicians between 1899 and 1957. General Gomez governed
 Venezuela from 1908 to 1935 with a firm hand. Between the followers of
 Gomez and those of then-President Pérez Jiménez, strong animosities raged.
3 Today's federal state of Amazonas was formerly a territory, a kind of province.
4 Hispanic-American Venezuelans; "criollo" here is employed as a distinction from
 Indian populations. But those Indian populations would be called "criollos" as opposed to
 non Americans.
5 The Yawarana are a small Carib-society.
6 Edgardo González Niño was called this in a commentary by Pater Grossa.
7 In the entire Amazonian region, large ocelots, jaguars and panthers are referred to as *tigre*,
 tigers. The puma on the other hand is called a lion.
8 In addition to malaria and tuberculosis, various forms of hepatitis today threaten the
 population.
9 Lat. *Onchocercavolvulus.*
10 Rafael Caldera, of the Social Christian Party, elected Venezuelan president, entered office
 in 1969 and opened diplomatic relations with Cuba.

YANOMAMI

GABRIELE HERZOG-SCHRÖDER[1]

YANOMAMI

THOSE BORN-FROM-THE-CALF

The huge trees form an impenetrable wall rising above the labyrinth of granite rocks. This is where the Orinoco has its source, a small rivulet meandering through giant ferns. It makes its way past multicolored orchids resembling insects clinging to humid trunks only rarely touched by a ray of sunshine. According to myth, it was in a clearing in this region that, a long time ago, the first Yanomami woman was born from the calf of a man.

The settlement area of the Yanomami lies on the watershed between the Orinoco and the Amazon tributaries Río Negro and Río Branco, along the mountain range of the Sierra Parima which also forms the border between Venezuela and Brazil. In the Brazilian part of the Yanomami territory, the world has changed drastically over the last 20 years. Droves of gold-diggers pushed into the land of the Yanomami, poisoning their rivers and lakes with mercury, raiding their gardens and bringing in diseases up to then unknown among the Indians. At times, the unmarked border cutting right through the Yanomami land was crossed illegally, this becoming public knowledge when it turned out that the small settlement of Haximu where, in 1993, Brazilian gold-diggers committed a massacre among the inhabitants, is not on Brazilian but on Venezuelan territory.[2]

In contrast to their neighbors, and in spite of far-reaching changes that are no doubt taking place here too, the Venezuelan Yanomami still lead a comparatively traditional life, at least in the hinterland. However, a rapid increase in serious, at times fatal diseases such as tuberculosis, hepatitis and malaria, affects the population here as well. Entire groups have been wiped out as a result.

The Yanomami continue to be one of the most numerous ethnic groups of the northern Amazon lowlands. All in all, the Yanomami population is estimated to number over 20 000 people divided into several hundred individual communities.[3] The names Yanoama and Yanomamö are also used synonymously for the term Yanomami; in older publications, they have been described bearing a number of other names such as Waika, Shiriana or Xiriana and also Guaharibo. The Yanomami living on the Upper Orinoco are also called "the central Yanomami" or Yanomamö. Using the terms Yanomami or Yanoama to mean the whole ethnic group follows a useful convention to distinguish them from other groups of the

region as well as from internal subgroups. In the end, both names—Yanomami as well as Yanoama—as names for the whole ethnic group are artificial terms.[4] The Yanomami do not see themselves as having an ethnic identity distinguishing them as a whole from neighboring Indian groups. Thus, in this respect, they have no proper name in use everywhere. All non-Yanomami are *napë*. This name is given to members of neighboring ethnic groups as well as to criollos or white people.

"Yanomami" or "Yanoama" means "human being" or "people". *Yano* means house or roof and can be seen as the central idea of Yanomami culture. The ability and willingness to build a *yano* and thus to distinguish oneself from the wild — the uncivilized—sphere of the forest, is the essence of being human. "Yanomami" can thus be roughly understood as "occupant of a house".[5] The house does not have to be a permanent dwelling: a shelter made of a few branches and leaves between three trees, where a hammock can be strung up and a fire lit, can be completed in a few minutes and is sufficient accommodation, at least for one night.

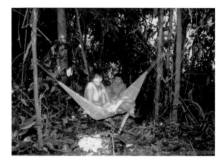

The Yanomami feel at home not only in their fortified villages but also in temporary camps in the forest.

Every two to seven years, a new *shapono* is built in a clearing called a *thëka* (hole).[6] The *yahi*, the large lean-to roofs of the communal house, are arranged in a circle around the cleared space. The *shapono* gives the impression of a uniform construction. In fact some of the roofs put up by the individual families overlap and together form the circular structure of this characteristic communal dwelling. All the men participate in putting up the basic scaffolding. The women help by fetching the building material, especially the palm fronds needed to thatch the roof and the long lianas to join the crossbeams. Building a *shapono* takes several weeks; the construction of a *shapono* partition is technically simple. A few posts a good meter in height are rammed into the ground in a row. The low back crossbeam rests on them. Other posts, several meters high and standing between the back ones at a distance of four to five meters, support the front crossbeam which is mounted much higher. Several strong, long poles link these two bases, i.e. the back and the front horizontal beams. The roof thatched with palm leaves rests on this grid.

The hearth occupies a central position in the individual living quarters. Around the hearth, the hammocks of the family members are suspended from

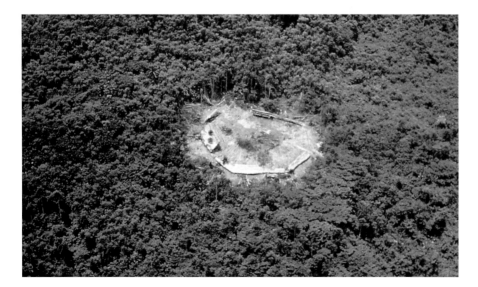

The *shapono*, the typical settlement of a Yanomami group in the Orinoco region.

the vertical posts. This space is the private area of the family, here the meals are prepared and eaten, here the people rest and manual work is done.

Apart from a few savannahs in the north, the rough hilly mountain area where the Yanomami live is almost completely covered by tropical rainforest. In the south, the settlement area is bordered by the headwaters of the left tributaries of the Río Negro, in the southwest it reaches beyond the catchment area of the Río Siapa to the Middle Cauaburi. In the west we find remote villages in the plain between the rivers Mavaca, Siapa and the legendary Casiquiare. In the northwest, the Yanomami—here called Sanema—live between the Upper Ventuari and the Río Cunucunuma as well as in the north of the Sierra Parima. The climate of the Yanomami land is characterized by tropical heat with lashing showers and large differences in temperature between day and night. The regions along the banks are often flooded during periods of heavier rainfall. During the drier months, between March and October, the water level of the rivers and streams often drops considerably and exposes crystalline sandbanks.

Coming from the Sierra Parima, the Yanomami presumably only arrived in the regions close to the Orinoco, the Río Padamo and the Río Mavaca approximately 150 to 200 years ago. Until the middle of the 20th century, they lived largely secluded from the European civilization since their dwelling areas were always difficult to reach. Since 1950, contact between the Yanomami and the criollo population has increased steadily; the presence of missionaries has changed their way of living as well.

The language of the Yanomami continues to be seen as an isolated language; at least so far, it has been impossible to definitely assign it to any of the South American language families.[7]

BANANA GARDENS, HUNTING AND RELEVANT TECHNIQUES

The Yanomami live on the produce of their simple gardens and on what the forest offers, that is, on hunting, gathering and—closer to the larger rivers—increasingly also on fishing. In addition to their life in the *shapono*, for some months of the year they lead a non-sedentary life when they go on *wayumï*, moving from camp to camp in the forest. On the way, they visit allies and friends, they hunt and gather more frequently and occasionally harvest fruit still borne by old, no longer cultivated gardens. During the *wayumï*, the current gardens are left to regenerate and parasites lodging in the roof of the communal house are starved out.

But the Yanomami still spend a major part of the year living a a sedentary life in their *shapono* and cultivating their gardens in its vicinity.

As in all neighboring societies in this region, the fields are cleared by the slash-and-burn method. This simple way of opening up land, also called "swidden agriculture", is performed in two steps: first, the undergrowth and smaller to medium-sized trees are removed. Large trees are left standing to offer shade. Once the brushwood has been dried by the sun, fire is set to the ground vege-

tation. In former times, the clearing was done with stone axes and larger trees which had to make way for the productive land were felled with fire lit around the trunks stripped of their bark. With the introduction of metal axes and bush knives, gardening has become easier. Long before the first personal contacts with white people, the Yanomami had bartered small numbers of metal objects from neighboring ethnic groups such as the Ye'kuana in the north and thus had already come into indirect contact with the world of the white people. However, the adoption of metal tools to any significant extent only started towards the end of the 19th century. This and the simultaneous introduction of new cultivated plants made more productive agriculture possible and led to an increase in population. The outcome of this was the migration of individual groups from the original settlement area in the Sierra Parima to the vicinity of the large rivers.

In their gardens, the Yanomami grow many sorts of cooking banana, so-called plantains, as well as sweet bananas. Tropical tubers such as ocumo, mapuay, sweet potatoes, yams and sweet manioc are also important for their nutritive value. Through their contacts with the Ye'kuana, a few decades ago the Sanema also became familiar with the bitter, prussic-acid-containing manioc with its complicated preparation. To this day, the Yanomami acquire tubular manioc squeezers and manioc graters from their northern neighbors. In the southern part of the settlement area of the Yanomami, the preparation of *casabe* and *mañoco* continues to be of relatively little importance. In the Upper Orinoco region, cooking bananas and also the fruit of the pijiguao palm are the most important of the starchy fruits, with the pijiguao palms—although planted at the edge of new plantations—only growing nutritious fruit when the garden has already long been given up.

The Yanomami also grow "magic" plants, narcotics, tobacco, cultivated cane as well as *Bixa orellana* shrubs that supply the red *onoto* pigment and at the same time keep the garden free of leaf cutter ants. They also plant cotton later to be

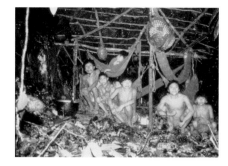

More than ten people often live in the temporary camp on a few square meters underneath a windbreak.

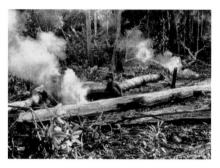

The gardens are cleared by the slash-and-burn method.

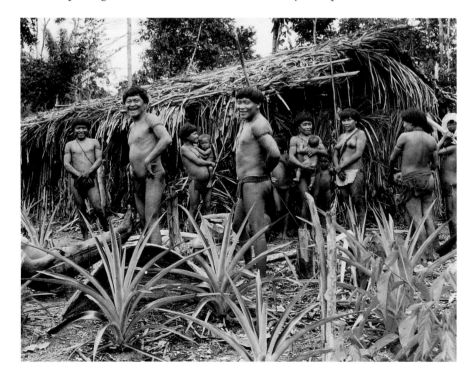

The gardens are often found directly behind the settlement, at times, however, also several hours on foot away.

made into hammocks and also used to make their simple dress. Yanomami women spin the cotton with the help of a simple palmwood spindle with a flat piece of tree gourd attached to the lower end.

It is remarkable that gardening, although highly important in many respects, does not receive much emphasis as a custom: there are thus no rituals to enhance the fertility of the cultivated plants. In contrast, the other important subsistence technique, hunting, carried out with great enthusiasm, ranks very highly in the Yanomami world of thoughts. This lets us assume that, despite a greater emphasis on agriculture—which, by the way, has probably always been practiced—a fundamental orientation towards hunting has survived in their cultural code.[8]

Almost every day, one or another of the men sets out for the forest, on his own or in a small group, with his palmwood bow and several arrows about two meters long. The arrows consist of light, flexible reeds with large, trimmed curassow feathers at the end to stabilize them in flight. Arrows are made with three different heads: the harpoon point *ātāri* with a barb of carved bone, the lancet-shaped *rahaka* made of bamboo, or the *huso namo* impregnated with curare, a thin spear carved from palmwood with notches that break off thus allowing the poison to penetrate the animal more deeply. The *huso namo* is mainly used to hunt monkeys sitting on trees as the curare, a muscle toxin, relaxes the hold of the dying monkey, causing the prey to fall to the ground. The *rahaka* is used to hunt larger game such as peccaries, anteaters, tapirs and crocodiles. The bamboo points are painted red, some are also decorated with black geometrical patterns. The Yanomami

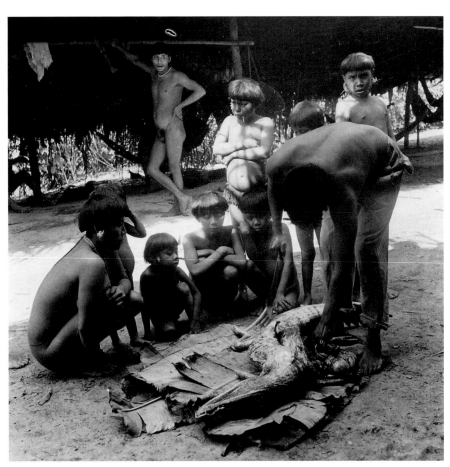

The caiman is eaten by the Yanomami but cannot be used as a ritual gift. The mythical caiman guards the fire in his mouth.

shoot at larger birds with the *ātāri*, the barbed arrows; for hunting small birds later used as decoration, special arrowheads are sometimes used made from small forked sticks. These do not externally damage the animal and the magnificent plumage remains intact.

The quiver, *thora*, carried down the back from a string around the neck, consists of a piece of bamboo tightly covered with a lid made of animal hide. In this container, the loose *rahaka* arrowheads are taken along, as well as twine and resin to repair the arrows, tinder and matchsticks, a shafted rodent tooth used as a knife and maybe a few bone splinters to make new arrowheads. On the outside of the quiver hangs a small amulet made of pieces of the root of magic plants to bring good luck in hunting.

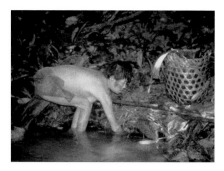

Catching crawfish, a favorite delicacy, is women's work.

In the vicinity of mission stations, guns have partly changed the traditional hunting methods. But in the hinterland, people still mainly hunt with bows and arrows.

Distinctions are made between several kinds of hunting: one is called *ramī* and serves to provide the daily food for the immediate family. The *ramī* expeditions also function as inspection rounds in the closer vicinity of the village at a radius of about 10 to 15 kilometers. The hunters always hope to shoot larger game since, apart from the greater amount of meat, this also brings them recognition. But frequently they only bag small animals or gather plant food or wild honey. After their return, the men give an account of their observations, for instance that they have seen trees soon to bear fruit or that they have come upon strange tracks. The other form of hunting, *heniyomou*, is celebrated prior to major feasts. Almost all the men of the group—sometimes even some of the women—participate in this enterprise lasting several days. At night, the women and girls remaining in the village stage the *hëri* hunting ritual: they sing songs accompanied by dancing. One of the women sings first one verse at a time and dances the corresponding skipping or stomping steps, then the others imitate her in chorus.[9] In this way, they placate the game and entice it to surrender itself to the hunters.

Groups of women with their little children often roam the forest for a few hours while also doing some sort of modest hunting. They go after small fish, crawfish and other small animals and gather cocoa beans, the fruits of wild palms, birds eggs or termite larvae. On their walks, they mostly move along a stream while enjoying the pleasant coolness of the forest. The older sons accompanying the women practice target shooting by aiming at tiny fish with small bows and fine arrows made of thin, rigid palm leaf ribs. Although this happens in play, they nevertheless contribute to feeding the family. At the age of approximately 14 years—before they even become women—the daughters master all the hunting-, gathering- and production skills necessary to survive in the inhospitable environment.

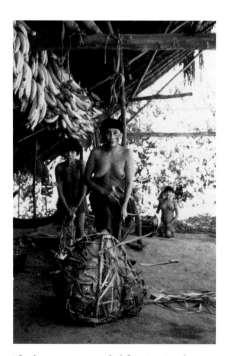

The bananas suspended for ripening have already turned yellow and the ceremonial hunt has also been successful. Everything is ready for the arrival of the guests.

Even though most of the work is carried out separately according to sex, there is hardly any realm exclusively reserved for men or for women. The difference between the gathering expeditions of the women and the *ramī* of the men is small and all the grown-up members of a family also feel responsible for the cultivation of the gardens. Only the clearing of new garden land is exclusively the men's job

The inside of a Yanomami dwelling. All the possessions, pots, baskets and other household goods, are within reach of the hammocks.

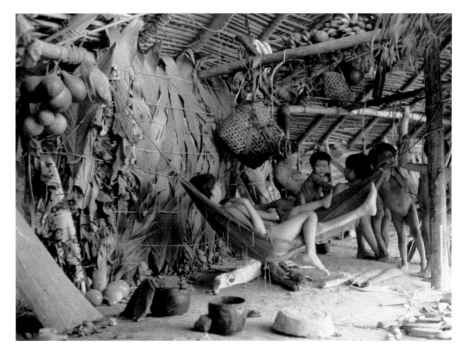

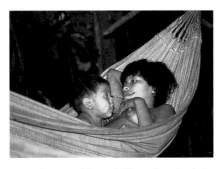

Up to the age of four, children sleep in their mother's hammock.

since this work might endanger the small children always accompanying the women. All those working in the garden are joint owners of the yield. Every day, the mother or an adolescent daughter harvests a sufficient ration of fresh produce, takes it to the living quarters, prepares the food and distributes it among the relatives and close neighbors. Prior to big feasts, the men usually harvest enormous amounts of bananas or fruits of the pijiguao palms. About ten days before the event, the bananas are suspended in the *shapono* until fully ripe. In the meantime, the men go on the ritual hunt *heniyomou* to obtain the necessary game.

The material culture of the Yanomami is simple and geared to usefulness rather than to durability and decoration. The hammock is the only piece of furniture. Traditionally, it was made from spliced lianas secured at both ends with resin. The more recent cotton hammock is woven on a simple frame consisting of two posts rammed vertically into the ground. The only household utensils are calabashes, simple vessels made out of bottle gourds, and spoons and larger bowls from fruit skins whose interior surfaces are made waterproof with a shiny black resin.

In former times, the Yanomami produced *hapaoka*, clay pots without handles made using the coil technique; these were firmly held by their conical base in a hollow of the fireplace. Today, these pots have been replaced almost completely by aluminum pots.

In contrast to the Ye'kuana, before first contact with the missionaries the Yanomami only rarely used rivers as travel routes. Since they traditionally settled in the higher regions and preferably by small streams, they had not especially developed any skill in boat building or swimming. In general, moving around to them means walking along trails through the jungle. Rivers are crossed at fords or on simple suspension bridges. Only occasionally do they let themselves drift down river on rafts they fashion from tree trunks. In former times, they sometimes built boats out of tree bark which, however, were hard to maneuver and only suitable

for going down river. Today, the Yanomami living on the Orinoco, the Ocamo or Mavaca have learned from the missionaries or from the Ye'kuana how to build boats themselves. With great skill, they steer these dugout canoes, sometimes even equipped with outboard motors, on the rivers.

The traditional dress of the Yanomami is simple. A thin cord around the hips is sufficient to give the feeling of not being naked. The men tie their penis at the foreskin to lift it upwards and attach it to the cord around the hips. Thus the glans, on which the sense of shame focuses, is hidden.[10] In the old days, the men sometimes wore a bulging belt tied around the loins over the cord encircling the hips. This *wao* was regarded as gala dress and only worn at feasts and on visits. These days, it is only occasionally seen in the hinterland. Since the middle of the 20th century, the *guayuc*, the pubic apron of the Ye'kuana, has come into fashion among the Yanomami. In many places today, especially near mission stations, men have adopted shorts and only the old people are still walking around more or less without clothes.

Girls and younger women wear little fringed aprons made of cotton dyed white or red, held together around the lower back with a belt. During the months after the first menstruation ceremony, young women wear a wide cotton belt without a fringe but partially ornamented. The upper body is decorated with strings and skeins of cotton. Nowadays many women prefer skirts made of industrially woven material they obtained by barter.

Both sexes wear their thick black hair shaped in a round style. To cut it, they formerly used sharp bamboo splinters or reed, today there is always someone in the *shapono* to borrow a pair of scissors from. Women and men alike have a tonsure shaved at the back of their head which may vary in size between the different local groups. For festive events, the tonsure is painted red.

The Yanomami paint their skin with various pigments but above all with *nara*, raw or cooked *onoto*. By mixing *onoto* with the balsamic *warapa* resin, a further, purple hue is obtained; a blue tone of the skin is achieved by rubbing genipap fruits onto it. At feasts, the Yanomami occasionally also color themselves with white clay. When the men go to war, they paint themselves black with charcoal; but also at feasts, for the festive dance when entering the *shapono* of the hosts, the men often use this war paint. However, this painting, which otherwise signals aggression, is then contrasted with white down feathers they glue to their hair or the *wisha shina* headband, the skinned monkey-tail. The white feathers have a placating effect, they neutralize the august warlike impression and indicate the actual, peaceful intention.[11] At such ceremonies, the body painting is combined with an abundance of feather decorations.

A multitude of decorative patterns are used in body painting: vertical, horizontal, diagonally crossing straight or wavy lines; in addition, circles, dots and roundish spots imitating the fur of the jaguar. The painting is either done with the fingers or with a small wooden stick whose end is chewed until it resembles a brush. The look of many of the Yanomami is characterized by the thick wad of tobacco inside their lower lip. Chewing tobacco is a pleasure hardly any Yanomami older than seven years denies him- or herself. The dried leaves are soaked

Part of the traditional look of the women and the men is the tonsure at the back of the head.

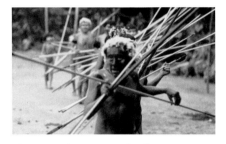

The guests dancing into the *shapono* present themselves to their friends' village as warriors signaling their peaceful intentions by the white down decorating their bodies.

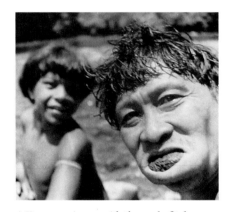

A Yanomami man with the wad of tobacco inside his lower lip. All Yanomami chew tobacco after the age of about seven.

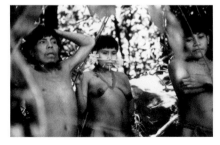

Women wear polished wooden sticks in the perforations around their mouth and in the nasal septum.

in water, rolled in ashes and—shaped into a wad—shoved between the lower lip and the bottom teeth.

Cotton ornaments not only decorate the hips and the breast, the women also tie narrow bands around their upper arms and thin cords around their calves. Prior to feasts or also for everyday use, the women insert fragrant blossoms and radiant white bushels of palm fibres into the bands around their upper arms. The same decoration is also stuck into the perforations of their earlobes. Men also wear bands around their upper arms but these are made of the skins from the heads of the curassow. Feathers of toucans, curassows, sparrow hawks or parrots dangle in thick bushels from the fastening of these armbands. At feasts, the representatives of the hosting and visiting groups, responsible for organizing the meeting, also wear bundles of macaw tail feathers inserted downwards into the bands.

The men's ear ornaments are mostly reeds with feathers or small dangling birdskins inserted into the front end.

Women and girls wear thin little wooden sticks in the perforations of the nasal septum, the lower lip and the corners of the mouth. This decoration sometimes makes them look like cats or otters.

ALLIANCES, TIES AND FICTIVE KINSHIP

A *shapono* houses between 45 and 120 people divided into several extended families of the same status which in turn consist of nuclear families. The individual nuclear families each live under a *yahi* roof where the hammocks are suspended in a triangle around the hearth. Adult sons and daughters as well as second or third marriage partners in polygamous families have their own hearth. Up to the age of four, the children sleep with their mother in her hammock. Then they move into that of the father for a few months before getting their own hammock above that of one of the parents. The individual living quarters are not separated by dividing walls. The Yanomami live sociably and have a pronounced sense of community. The kinship self-definition is bilateral which means that a person considers both the relatives from the father's and from the mother's side as his or her closest relations.[12] Next to the nuclear family, the relatives-in-law play a special role. Thus considerably more respect is given to the parents-in-law than to the natural parents.

The most capable man of every extended family represents the group in a kind of council of elders where joint decisions are reached by consent. Women influence the political events discreetly and more from the background but nonetheless effectively. In contacts with other village communities, a charismatic and generally respected man—quite often a shaman—represents the group formally. However, the position of this leader does not give him imperative command. He is acknowledged in a casual manner; regarding material gains, this position does not mean any privileges for him. Yet as a rule, such leading figures have larger garden areas since they supply a major part of the food whenever guests arrive for a feast.

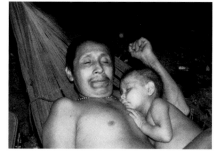
A father dozes with his youngest daughter. The men often lovingly look after their children.

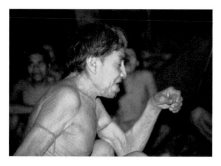
Every family group is represented by an adult man in talks where important decisions concerning everyone are reached.

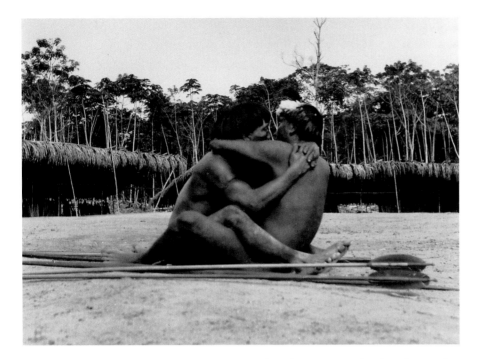

The local group represents the highest political structuring level. Relations between the various local groups are often characterized by friendship and alliance. Many Yanomami communities are also more closely connected through ties of marriage. However, the alliances are fragile and local groups frequently carry on a feud. Due to their wars and their aggressive behavior, the Yanomami have occasionally been described as exceptionally violent.[13] In actual fact, although they cultivate ideals like the virtue of courage and present themselves as intrepid and reckless warriors, in the artistic discourses, where they compete rhetorically, the issue is always balance and mutual responsibility.

Marriage forms the basis of any political consideration yet does not necessarily have to be realized as an actual union between a man and a woman but frequently stands metaphorically for a political and social alliance. On the other hand, in-law-relationships are often formed in a classificatory way, i.e. by calling each other for instance "father-in-law" or "daughter-in-law" without any existing marriage links. A variety of this convention is to promise small or even unborn girls as wives. In this case, it may well be intended to realize this marriage connection between two families later, once relationships have become more stable, but it does not happen anything like everytime. The system of terminology suggests a strategy to form alliances via virtual marriage links since in the Yanomami language one and the same term is used for friend and brother-in-law. The fundamental logic in this assumes that a man marries the sister of the other man and they thus become brothers-in-law. In actual fact, this logic is often followed.

All the people address each other exclusively by kinship terms. The Yanomami do have names but they are taboo as mutual forms of address. It is relatively easy to integrate strangers into the terminological system and thus declare them to be "relatives".

Within the kinship system, the marriage between cross-cousins is the favorite kind. This means that the marriage partner is a descendant of one's own mother's

brother or father's sister. This cultural recommendation may, however, be applied to more or less unfamiliar persons as well. The system of mutual terms assigns to all the personally better known people within the kinship structure a concrete position within the social network.[14]

THE POWER OF THE SHAMANS AND THE HEKURA SPIRITS

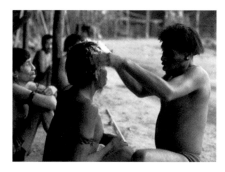

Numerous, at times painful, sessions are necessary before the transfer of power from the instructing shaman onto the person to be initiated becomes possible.

As in almost all cultures, the strictest separation of competence is found in the religious sphere. At some stage in their life, practically all Yanomami men undergo the initiation rite to become a shaman. These *shapori* have to be able to cope with all the misfortunes not controlled by man: diseases, infirmity, infertility, snakebites, thunderstorms and a wide variety of accidents. They have to look for the cause and find a cure.

The initiation period stretches over several months or even years during which the novice has to submit himself repeatedly to instructions lasting for days. During these instructions, the person to be initiated is under the influence of the drug *epena*. The teachers mime the *hekura* spirits whose abilities and powers they want to transfer onto the candidate. According to the cosmic vision of the Yanomami, the *hekura* originally lived in the forest, on rocks or in large trees. They correspond in character to specific animals, plants or phenomena of nature. In an act of inauguration, these spirits are guided into the chest of the person to be initiated where —quasi tamed—they continue to live. After completion of the inititation, the new medicine man has to live prudently for quite a while in order not to lose his *hekura* again. He has to abstain from sexual intercourse and to avoid the smell of fried meat. All the phenomena of life can be interpreted by the *hekura* spirits and their explanations are declared loudly by the shamans. But the *hekura* do not merely interpret the phenomena; the fact is rather that the world comes into existence through the *hekura* interpreting the phenomena: matter only comes into being through being named by them. Under the influence of the hallucinogenic snuff powder *epena*, the *shapori* work themselves into a trance where they identify with the powers of the *hekura*, i.e. they feel the potency of the *hekura* as their own. Thus they are able to evoke the spirits' presence and activity and their own identity merges with theirs: the *shapori* become *hekura*.

The *hekura* have existed since the beginning of time and they were the ones who formed the world as it presents itself to us now. The *hekura* often appear as couples with the female spirits being particularly powerful. Even non-initiated people are sometimes able to see *hekura*. Whenever a strong wind lashes the rain diagonally from the heavens, even the children are certain that this is the work of the *hekura*.

Bad weather clouds hide disease-carrying spirits.

At the break of dawn the wind tears vehemently at the leaves on the trees. This is a bad omen! Mothokariwë, the Sun Demon, with his glinting eyes observes from the heavenly *shapono* the life in the village. When the sun is at its zenith, the *shapono* square grows hotter and hotter and Mothokariwë's rays make the bodies

and the souls of the children glow. If a child then raises his feverish eyes and his parched mouth to the sky, his mother must fear that the soul has left the little body. People at once set out to look for it so that it will not be found by harmful beings and devoured. The older, experienced women of the group leave the village with their large baskets and by calling lure the lost soul onto the path leading to the water. The day before, the child had been playing here and cried out in terror when a bird flew up from a nearby bush. At that moment the little soul, that delicate little sliver, must have hopped out. At this same spot, the women now sweep the ground with branches and lift the invisible into their baskets. Having returned to the house, they empty these over the little patient and in this way restore his soul to him. Then the *shapori* set out to fight the still threatening danger. They themselves have become monkey-*hekura* and they prance across the central *shapono* square. Their spirit-helpers hurry down from the highest mountains and rocky cliffs to assist them. From all sides loud calls are heard: "Spirit of the toucan, here we come, spirit of the anaconda, we banish the evil powers by throwing lightning at them!"

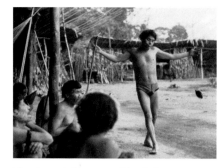

The *shapori*-shaman and his *hekura* spirit-helpers merge into a unity in the shamanistic act.

The *shapori* have transposed Mothokariwë's *shapono* onto the central village square. They now start the relentless fight against the armies of the sun-*hekura* whose excrement burns hotter than fire. But despite the sweltering heat and thanks to the dexterity of the *hekura*, they defend themselves successfully against the wild attacks of the malevolent spirits shooting their red-hot arrows to win the tender soul of the little one. They succeed in defeating the Sun Demon and in cooling the child down.

In his hammock, the sick child softly whimpers with fear and exhaustion as the most respected *shapori* turns to his hammock and with bizarre gestures intones a fierce song: "*Sharu, sharu, sharua wa. Kreti wa*!!!" With martial authority he banishes the last messengers of the Sun Spirit, who are threatening to dry up the child from the inside, and with massaging movements draws them out of the small body. Turning away from the child, with a sweeping gesture he smashes them onto the ground of the *shapono*. Gradually, his singing becomes more monotone, allowing the exhausted child to fall asleep. Only then does the victorious shaman withdraw.

IN THE SMOKE OF THE FUNERAL FIRE

When a member of the local group dies, the whole village community, feeling threatened by the arrival of death, starts to lament and weep violently. It is not uncommon for relatives to fall ill through sorrow and fear of the terrifying spirits of death. As soon as possible after the event of a death, in the *shapono* a funeral pyre is erected on which the body is burned. If a corpse does not burn easily, people attribute this to violation of the incest rules. Pregnant women and small children are sent out of the village during the cremation as people fear that the smoke might harm the children and the unborn. Once the ashes have cooled, a close relative of the deceased carefully gathers the bones from the hearth. At first,

The community overcomes the trauma of death in collective rituals or through the solitary singing of mourning songs.

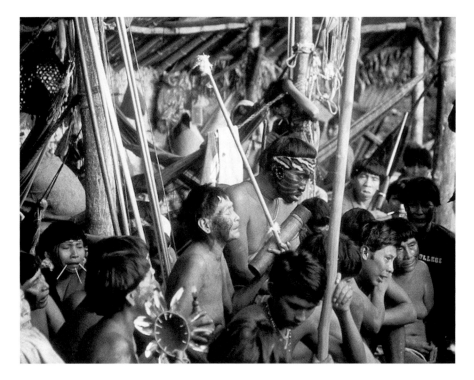

the bones are kept in a small basket. In a ritual taking place several weeks after the cremation as part of a feast, to the accompaniment of renewed lamentations, the remaining bones are ground to a fine powder—*yupu*—in a wooden mortar. Afterwards, the first *reahu* ritual takes place where the friends and relatives present demonstrate their social ties and their solidarity with the deceased as they stir the *yupu* into plantain soup which is drunk by many of those attending. Only in this way can the deceased be spared the misfortune of having to wander around in the jungle forever, which in turn would be extremely frightening for the survivors. The ashes not consumed at this first endocannibalistic meal are stored in a calabash by a close female relative of the deceased until the next mortuary feasts. It depends on the social rank and the age of the deceased how many remembrance ceremonies are celebrated. After the demise, the name of the deceased is no longer mentioned and, as soon as the ashes have been completely consumed, the people try not to remember the loved ones anymore. The ceremonies and the singing of laments during the hours of dusk and dawn help them to forget—this is the aim of mourning. The memories cause fear since they hurt and threaten to call the deceased back from the world of the dead. In order to escape the memories, all the dead person's possessions are gradually destroyed over the course of the feasts. Sometimes, the relatives even ruin whole gardens and thereby get themselves into serious difficulties.

If the person mourned was killed by enemies, his ashes may only be eaten by women. The grieving men give way to their feelings of revenge and vow to retaliate together.

The Yanomami concept of the soul consists of several vital attributes. Every human being possesses one of them from birth. It never leaves the body. It is known by the name *pei kë mi amo*—"the inside"—and represents a life energy inherent in all organisms.[15] A further principle has to develop gradually. It is sus-

ceptible to being stolen and is easily lost during infancy. Disease is the result and one has to look out for the inimical and predatory *hekura* who might do harm to the lost soul.

Noreshi is the shadow- or image-soul. It corresponds to a dual concept: *noreshi* lives in human beings and at the same time as an animal in the jungle. Parallelism of life exists between a person and his or her *noreshi* alter ego. Both act in the same way and both die at the same moment. When the Yanomami kill an animal of the forest, they take into consideration that at the same time a human being may die whose alter ego they have killed. For particularly noble animals, such as the harpy bird, the hunter submits himself to a cleansing ritual corresponding to the ceremony after killing a person.[16] The *noreshi* soul rises into the sky in the smoke of the funeral fire after both parts of the "self" have united.

The *pore* souls come into existence at death, as it were as the personification of the memories. They roam the forest as malevolent spirits. Only through the consumption of the ashes are the *pore* set free. The thought of not being burned after one's death and not being given an endocannibalistic funeral following the traditional customs is the worst fate for the Yanomami.

THE BIG FUNERAL FEAST

Having been invited several days earlier, relatives and friends from allied *shapono* gather for the feast. Upon their arrival, they first camp outside the dwelling place, they wash, paint and decorate themselves and wait for a signal calling them into the village of their friends. The actual festivities start when a richly painted and decorated messenger welcomes the guests in their forest camp and brings them meat and bananas or palm fruits as refreshments.

In the meantime, preparations have been going on in the village: the village square has been cleared of weeds and swept, large amounts of plantain soup and fruits of the pijiguao palm have been cooked; ample amounts of meat are hanging in the smoke over the fires.

First, the decorated visitors dance two at a time into the *shapono* square; later on, the dancers arrive in larger groups. In their hands, they hold and brandish weapons and palm fronds. They make a brief halt in front of the individual living quarters while making dancing steps and singing little songs in which they present themselves. After finishing this *praiaï* dance, the male visitors remain standing in the center of the square and wait until they are invited under the roof of their relatives or friends. But first, the young people of the hosting group display themselves by howling and dancing in the round. This demonstration may also develop threatening traits. However, one after the other the men are called to the individual living quarters where they lie down in the hammocks assigned to them and are allowed to rest. Then their wives, only some of whom participated in the dance, together with their children, join the respective host family.

After informal talks and before the sun goes down, the *reahu* takes place, the endocannibalistic funeral meal. Later in the evening, the men start a *wayamou*, a

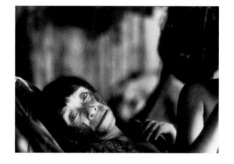

As a sign of mourning, the women blacken their cheeks and go without decoration.

ceremonial dialog between each guest and one each of the hosts. These half-sung, half-spoken duets serve only partly to exchange information. In the first place, this is an opportunity for self-presentation; the mastering of this rhetorical art form fills the men with pride. The *wayamou* does not end until the break of dawn. Soon, the guests will set out on their way home. Before leaving, all the adults meet for a lively palaver: it is about the exchange of goods already discussed the evening before. Now dogs, bushknives, axes, pots, glass beads, arrowheads, bows and *epena* are exchanged. In the end, the guests receive meat and vegetables as ritual gifts. Abruptly, the visitors set out, the women put the baskets on their backs and the carrying band made of bark around their heads, call their children to their sides and follow their husbands on the trail leading outside where they quickly and noiselessly disappear into the forest.

1 The text is based on several years of research funded by the Max Planck Society. The contribution has been supplemented with several passages of text by Lelia Delgado.

2 Cf. Albert (1993: La massacre de los Yanomami de Haximu)

3 Colchester (1985)

4 Lizot (1988, p. 489)

5 Zerries (1964, p. 4)

6 Preference is given here to the transcription by Marie-Claude Mattéi-Müller. But see also Steinvorth Götz (1970, p. 19), here: "teca"

7 Lizot (1988, p. 489)

8 In the 60s, a polemic discussion arose about the original economy of the Yanomami. Cf. Lizot (1980), Chagnon (1968), Zerries (1976).

9 Zerries in Disselhoff/Zerries (1974, S. 136)

10 Cocco (1972, p. 121–140)

11 Eibl-Eibesfeldt (1971)

12 Zerries/Schuster (1974, p. 196); Alès (1990)

13 Chagnon (1983, 1988), Harris (1996)

14 Further explanations of the kinship system are to be found in the contribution by Gabriele Herzog-Schröder: "Exchanging and sharing—The importance of giving among the Yanomami" in this catalog.

15 Lizot (1988, p. 569)

16 Zerries (1964, p. 256)

GABRIELE HERZOG-SCHRÖDER

EXCHANGING AND SHARING

THE SIGNIFICANCE OF GIVING AMONG THE YANOMAMI

In many simple, non-hierarchical societies, generosity and magnanimity rank high among the virtues. For the Yanomami, generosity is the opposite of *shiimi*— to be mean—and finds its legitimacy in the concepts of the hereafter: after their death, the souls of mean people are sent into a blazing inferno.[1] The social norm of giving away goods is tied up with a whole series of social consequences some of which are to be described here, such as the distribution of food, the significance of reciprocity within the kinship system and the role of exchange in funeral rituals.[2]

Among the Yanomami, many objects are used collectively even though they are clearly recognized as individual property. Individual possession is the prerequisite for giving to others. Only he can be generous who owns something and whose right to it cannot be disputed. Giving and sharing, exchanging and presenting are thus significant social acts. The request for specific objects, often made whenever Yanomami meet, might easily be interpreted as begging by outsiders. However, such a request gives the one who is asked the opportunity to be generous which in fact makes him feel flattered. For these forest-dwelling Indians, the requests, just like the giving of objects, make it possible to define social relationships. Whenever—after an absence of months or even years—I returned to the Yanomami group where I had lived, I was again and again effusively welcomed. My friends then insisted they had missed me very badly, yes, they had even cried from longing for me and I, the foreign friend, therefore had to give them knives, fabrics and other goods. What may appear to be greed here is only partially so. The Yanomami know of course that "the white people" have numerous goods and many of the desired objects are without doubt very useful. Some of them make coping with everyday life considerably easier. Yet the gifts handed out only remain with the recipients for a very short time. Then, friends from neighboring villages arrive and leave with a major part of the gifts. Those who at

first were the recipients are now the donors. And the new owners in turn will only keep the smallest part for any length of time since they as well will welcome visitors, giving them a chance to be generous.

It goes without saying that it also happens that goods are kept hidden from the eyes of the guests so they do not have to be passed on too quickly, however, amassing goods is very much frowned upon by the community. Although, due to the mobile way of life, a pronounced accumulation of goods would have little advantage, the maxim of the "open hands"[3], as generosity is paraphrased by the Yanomami, is indeed taken surprisingly seriously: thus respected and politically influential personalities frequently own the least goods. The most important speakers of the local group often own neither an arrow nor a quiver; some of the other men, however, own up to three quivers and call more than half a dozen arrows their own. Even more than his comrades-in-arms, the leader of a group is under pressure to give away his possessions to visitors from other communities. This explains why possession in a non-hierarchical society, as represented by the Yanomami, correlates with status in a negative way. Within one's own local group as well, the rule of giving and sharing prevents people from reaching special positions of status through material wealth. The social pressure of having to show generosity results in a constant redistribution and thus prevents the development of marked differences between the members of the group. This tendency to again and again restore material balance and equality of status goes with the lack of insignia, badges or other symbols for dignitaries. Prestige and respect are attained through charisma and rhetorical skills. At the same time, life within the group is determined by a constant equalizing of the social balance.

Exchange or the distribution of objects may take on different forms. At times, one definite object is exchanged for another object. Others remain uncompensated for a while, they are, so to speak, given as credit or—to follow Bourdieu—gifts are repaid with symbolic capital.[4] The donor may then ask for a gift in return or also for help whenever he needs it. This help may consist of protection against enemies, of loyalty in a dispute with others or also of requests for support in predicaments such as thunderstorms or crop failures. In political transactions between two local groups, the balance between gifts and gifts in return is always stressed in the negotiations. Yet, at the same time, an actual balance is often prevented. It may in fact be the goal of astute exchanges to place the partner under an obligation. In some instances, he may be put dangerously under pressure to produce certain results if he has repeatedly been the beneficiary without in any way offsetting the donations. The necessity to equalize what has been given lies in the rule of reciprocity, fundamental to all exchanges and placing both partners participating in the exchange in an actual relationship with each other or, respectively, reinforcing their already existing relationship.

This principle of reciprocity already applies in the everyday distribution of food. Since the Yanomami do not have any kind of storage methods, any surplus is redistributed. The women, responsible for a major part of the daily provisions, always share what they gather and the harvested garden produce with more distant relatives as well. It is one of the effects of this distribution practice that—

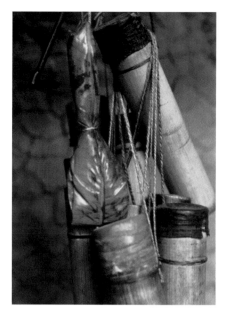

Quivers made of bamboo are popular objects of exchange between men.

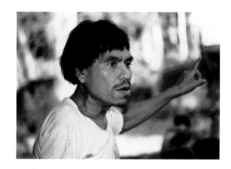

With rhetorical skill, politically important men wield great influence over the community.

One bone of the animal killed must always be kept. This respectful attitude towards the game brings future good luck in hunting.

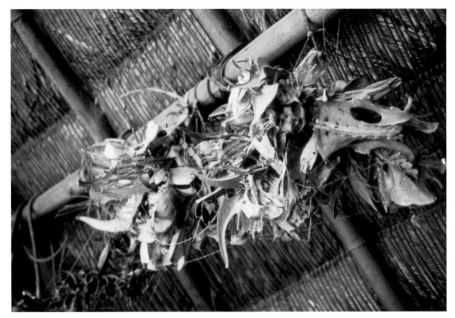

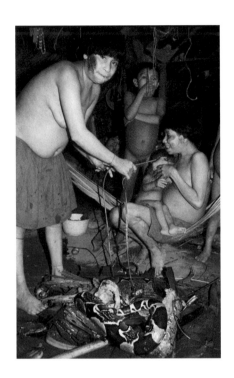

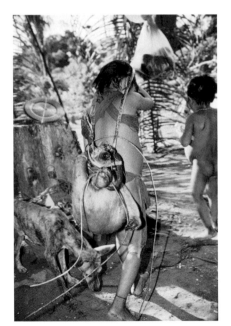

Snakes and anteaters are also on the menu of the Yanomami. The hunter himself is not allowed to carry what he has killed.

although the menu in general is highly varied—most of the people in the village community frequently eat the same food.

Strict taboo regulations prevent the emergence of egotistical tendencies: it is impossible for a hunter to secure for himself any of the larger game he has killed. If at all, he may only eat the smallest part of the bag. The hunter hands the game over to a relative, most often a relative-in-law. He even has to ask the latter to carry it into the village for him.

Whenever game is killed, there is also an exchange between the wild sphere of the forest and the zone of civilized life. Transitions between the two realms, such as represented by the killing of an animal, are dangerous and require special care. The relationship to the world of the forest is out of balance, meaning that a lot is taken from the forest without in fact anything essential being returned to this sphere. The people feel this dependency and are careful not to strain the relationship with the forest in any way. This taboo is the cultural attempt to face this imbalance. The Indians believe that the hunter, if he were to break the taboo rules, would have no luck in hunting since he would get no further chance to encounter any game. This attitude is expressed in the idea of a "Lord of the animals" who owns the game and puts it at the hunters' disposal. The people show respect for this being; the "Lord of the animals" has to be placated and compensated for his gifts with rituals or songs.[5]

EXCHANGE OF ARROWHEADS

For a good ten years now, the activities of a nominally autonomous cooperative have had an effect on the material living conditions of the Yanomami. The cooperative is under the control of the SUYAO (Shaponos Unidos de los Yanomami del alto Orinoco)[6], an independent Yanomami organization also representing their interests in the National Indian Council of Venezuela. Through the cooperative,

everyday goods like baskets, calabash bowls, arrows or quivers are sold as handicrafts. In the provincial town of Puerto Ayacucho, 680 km away by river, and in the larger cities on the coast of Venezuela, buyers are found among the criollo population and the tourists seeking exotica. With the proceeds from this outside trade organized with the help of the Catholic Salesian missionaries, the Yanomami buy fabrics, fishing gear, machetes, knives or other metal tools, a few of them also buy gasoline for outboard motors.

In large areas, the Yanomami conduct these new, purely economically motivated, transactions as barter. Only in the immediate vicinity of the four mission stations which have been established on Yanomami territory on the Upper Orinoco, money is used as payment.

In the hinterland, where many Yanomami still hunt and fight with their traditional weapons, bows and arrows, this currency has hardly any significance. In contrast to doing business with the cooperative, the traditional forms of exchange are characterized much more strongly by social or symbolic aspects. This can be explained with the example of the ceremonial exchange of arrowheads between men.

Of the four different types of arrowhead used by the Yanomami, the lancet-shaped bamboo points of the *rahaka* type are most frequently used. A *rahaka* arrowhead consists of a blade, 20 to 25 cm long and pointed at both ends, which is inserted into the wrapped end of an arrow shaft.[7] With the *rahaka*, the Yanomami kill preferably large animals such as wild pigs, tapirs, anteaters or sloths. The *rahaka* point is also used in war. It is not poisoned; depending on the bamboo species used to make it, however, it may also have a toxic effect.[8]

Every Yanomami man masters the technique of carving arrowheads, and bamboo for their manufacture is in ample supply in the settlement area of the Yanomami. The fact that the exchange of *rahaka* is nevertheless an important ritual element on the occasion of a visit is proof that it has no economic significance.

Rahaka are mainly exchanged when visitors are not yet very familiar with a village, when, after a first visit, the relationship starts to stabilize. If unknown people appear in the vicinity of a village, they first try to draw attention to themselves in order not to be taken for aggressors. Following this, a small group enters the village. The first stage of the ritual greeting consists of the visitors "confronting" the hosts. They position themselves standing up straight on the open square in the middle of the village to demonstrate fearlessness while being ritually threatened with bows and arrows by the hosts. Eventually, they are invited personally by the individual men of the village community into their private sections of the circular communal house, the *shapono*. There the guests remain immobile for about an hour in the host's hammock. In the meantime, the villagers have a chance to get used to the presence of the unfamiliar visitors. Finally, the guests are given something to drink and to eat; now people start "exchanging words"—they begin to talk.

In the meantime, several villagers have gathered around the hearth of the host and they ask one of the adult visitors to show his arrowheads. He spreads out the contents of his quiver in front of them and accounts for the arrows' origins, for

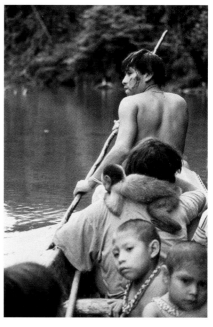

A Yanomami family, together with children and a tame monkey, on a river trip to visit an allied group.

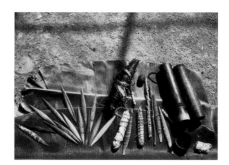

Two quivers and their contents of finished and half-finished arrowheads, resin and bone splinters.

While giving their accounts of the arrowheads, the guests also reveal their social relations to other groups.

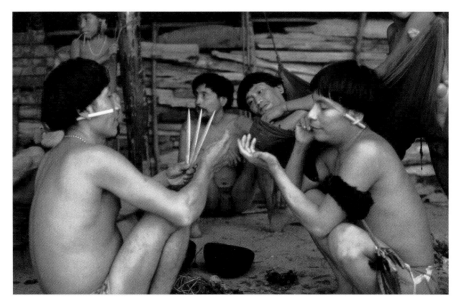

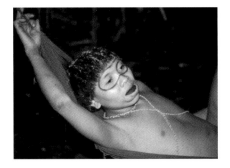

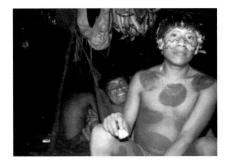

The guests rest after the ritual dance on entering the *shapono* of the hosts.

instance their previous owners. If the group of visitors includes several men, the others then also take out their arrowheads and together they "trace the route of the *rahaka*". Based on the spectrum of the *rahaka* shown and the explanations given, the participants in the talk are able to get an idea of their unfamiliar visitors' network of political alliances.

Then follows a conversation in the strongly ritualized form of a duel-like reciprocal speech where some passages are also sung. At the end of the visit, mostly lasting for one night only, in addition to other goods, *rahaka* are also exchanged between the guests and the hosts. These arrowheads symbolize the confidence that the recipient will not use them against the donor and are a promise of solidarity. This ritual exchange demonstrates what is generally true of exchange among the Yanomami: the material value of an object cannot be separated from its non-material value and the exchange itself increases the material value of an object.[9] But the concept of exchange determines other important processes as well which are found in the organization of kinship.[10]

MARRIAGE

In the classless Yanomami society, social and political structures are closely linked with what is generally circumscribed by the term "kinship". This kinship organization regulates how marriages are arranged and how they are negotiated. Since in Yanomami culture marriage means something completely different from what it means in our own culture, it is necessary to explain some additional aspects of the logic according to which kinship among the Yanomami is organized. The most important prerequisite for understanding it is that the Yanomami do not address each other by their names. These are taboo. For mutual address, kinship terms are used exclusively. All social relations are classified by kinship terms. This means that all the people who know each other refer to each other with terms corresponding to mother, father, sister, brother-in-law, daughter, son-in-law and

so on.[11] Classificatory relatives are those who address each other as 'sister' or 'father' without the other person being the actual sister or the actual father. No doubt, the relationship with one's real mother is closer than that with a classificatory or nominal 'mother'. However, in the form of address no distinction is made between the real mother or sister or the real father or brother-in-law and those persons in a classificatory or nominal relationship to an individual.

In order to understand the kinship system of the Yanomami, it must also be explained how the various kinship positions are classified. The terms for uncle and aunt we use in our European kinship system cannot be transferred. The uncle on the father's side has a totally different significance from the one on the mother's side.[12] For the Yanomami, the father's brothers are called 'fathers', but his sisters are 'mothers-in-law'! In the same way, mother's sisters are all 'mothers', her brothers, however, are 'fathers-in-law'. Within the kinship network, the crucial difference between these positions is that father's brothers and mother's sisters – the siblings of the same sex – are all so-called cognate relatives. It is forbidden to marry cognates or enter into an in-law-relationship with cognates.[13] On the other hand, mother's brothers and father's sisters, the parents' siblings of the opposite sex, are the so-called affines. For these opposite-sex siblings in the parents' generation, the anthropological jargon uses the expression that kinship is traced "crosswise" where sex is a criterion. (See diagram 1).

The distinction between affines and cognates is meaningful since the affines are those relatives with whom one may enter into a marriage relationship; this is not possible with cognates since, within this group, a union would be deemed incestuous in the cultural understanding of the Yanomami. Seen from any specific person (Ego), the children of the father's brothers and those of the mother's sister are 'siblings', those of the father's sisters and of the mother's brother, on the other hand, are thought to be husbands, brothers-in-law or sisters-in-law.

This brief theoretical digression helps in understanding the preferential marriage rule, the cross-cousin marriage. According to it, a man should preferably marry the daughter of a mother's brother or the daughter of a father's sister. This maxim is in fact followed though at times at more distanced degrees, for instance if a woman marries a man who is her "father's father's sister's son's son" (see diagram 2). The terminological kinship system places this bridal couple in the position of potential marriage partners. This can be shown in that the two address each other by the terms of husband and wife, these being the correct terms for male and female cross-cousins, independent of whether the two do indeed get married.

Seen from the standpoint of a female and a male Ego, the marriage system is symmetrical. The two family units where the two originate refer to each other as affines and they exchange brides or grooms respectively. This exchange which legitimizes marriage and thereby reproduction, forms the basis for the continuation of the social organization. This logic is indeed very frequently observed in actual practice. After all, the kinship network offers a whole series of potential husbands or wives. It is not rare for two pairs of siblings to marry each other in such a way that a man is married to the sister of the husband of his own sister.

A young couple just before the birth of their first child.

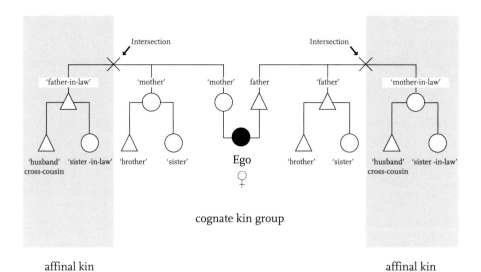

Intersection Intersection

'father-in-law' 'mother' 'mother' father 'father' 'mother-in-law'

'husband' 'sister-in-law' 'brother' 'sister' Ego 'brother' 'sister' 'husband' 'sister-in-law'
cross-cousin cross-cousin

cognate kin group

affinal kin
group
 affinal kin
group

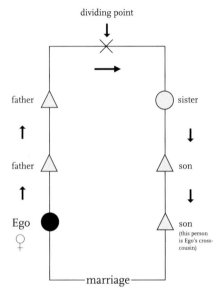

dividing point

father sister

father son

Ego son
(this person
is Ego's cross-
cousin)

marriage

Diagram 1 explains the Yanomami kinship system from the viewpoint of a female relative (Ego): The brackets opening upwards signify marriage relationship, those opening downwards stand for sibling relationships. The marked crossover line shows the switch from cognate to affinal kinship. Same sex siblings of the parents are cognate relatives, opposite sex siblings, on the other hand, are affines.

It is possible to develop in-law relationships with persons from the affinal sectors, and from these sectors a marriage partner is chosen. In contrast, a marriage relationship is not allowed with persons from the affinal kinship section; this would be seen as incest. The sister of the father and the brother of the mother — so to speak the "cross-aunt" and the "cross-uncle"— are affines, i.e. in-laws. Their sons (father's sister's son or mother's brother's son), thus the cross-cousins, are the ideal marriage partners.

This logic works in a symmetrical manner for a male Ego. The ideal marriage partner is the cross-cousin (the mother's brother's daughter or the father's sister's daughter).

Diagram 2 shows the cross-cousin marriage in the second degree, to a "father's father's sister's son's son". The direction of this diagram is to be read following the arrow starting with the protagonist (Ego). The classificatory husband, cross-cousin in the second degree, is addressed like a husband and is a potential marriage partner. This order may be extended infinitely and leads to the same result as long as, at the generation level "above"Ego (meaning older than Ego), the sex goes "crosswise". In this diagram, this switch occurred in the generation of the grandparents. The switch is marked by the cross (cf. diagram 1).

Seen from the viewpoint of the individuals, however, the, in fact, very closely linked kin group is still divided into the semantic units of cognates and affines.

Of course, it is also possible to circumvent the system. The most common kind of deviation is the integration of outsiders into the kinship system. With the help of kinship terms, the stranger is put into a specific position within the kinship system.

These principles of kinship organization are mainly applied to marriages within one's own village community. But the system of affinal or cognate reference reaches far beyond the narrow limits of a local community which, anyway, is quite instable in its composition. If two persons from different villages marry, this is also understood as a kind of exchange between affinal relatives—the family of the husband and that of the wife. A man courting a young woman from a friendly village, undertakes for her family a "bride service" lasting at least two years before he is allowed to take the woman back with him to his own group. In actual fact, not all the men return to their original group with their wife. The prospect of marrying a younger sister of the wife as a second wife in order to stay longer or forever in the wife's community is often very tempting. If, on the other hand, the bridal couple leaves too soon or if the wife follows the husband without him

having done sufficient bride service for his in-laws, the departure is thought of as stealing the woman. The family will try to win her back and can in this attempt also count on the support of many members of the group who see this scandalous act as a village affair. Such quarrels are very risky and, if the two groups are even in their strength of arms, the deficit between them has to be made good as soon as possible. The woman has to come back or attempts will be made for compensation to be paid in valuable goods.

All this means that the exchange between the kinship spheres of the cognates and the affines regulates marriages—and therefore reproduction. Most of the time, this happens in a peaceful way, yet it is an inflammatory subject and at times causes critical clashes between alliance partners. However the marriage connections are formed, it always holds true that social reproduction itself is based on exchange. But this maintenance or continuation of the group does not only apply where marriage and reproduction are concerned but also finds its symbolic expression in the way the Yanomami overcome the trauma of death.

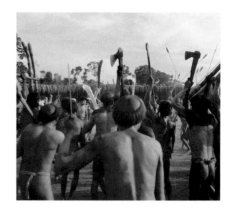

Hosts and guests present their weapons with imposing gestures.

FUNERALS

The Yanomami have no concept of death as an ontological figure. They do not know death "as such". For them, death is always the result of an aggressive act. When a person dies, the Yanomami see this as a magic killing by malevolent beings, by evil monsters or bad spirits sent by hostile communities. Immediately after a person has died, the corpse is burned. The charred bones are gathered, in the course of a later ceremony crushed in an oblong mortar and, stirred into plantain soup, consumed by the relatives.[14]

During the various stages of the funeral, the two kinship groupings described above take on different tasks. As a rule, an affinal relative of the dead person's own local group is responsible for the cremation of the corpse. A cognate, however, organizes the joint hunt lasting several days where the meat needed to arrange the feast has to be procured. The large amounts of bananas, manioc, or pijiguao palm fruits necessary for the ritual come from the gardens of cognates as well. The guests arriving from other *shapono* to participate in the funeral are also made up of cognates and affines. At the festive start of the ceremony, those who have been invited, above all the classificatory affinal relatives, lavishly decorated and painted, dance into the hosting village and present themselves to the inhabitants with short songs. They parade their weapons by lifting them up to the sky with imposing gestures and then briefly put them on the ground in front of the individual living quarters while making the rounds of the *shapono* with mincing steps. They also utter growling animal noises. This entrance represents the invasion of strange and hostile beings in a playful and, in part, grotesque way. The approaching dancing warriors imitate the cannibalistic monsters and enemies who have caused the death of the person who is mourned. The primary funeral by cremation has already been organized by an affine; this man also plays a central part in this second act of the funeral. He brings the decorated basket with the bones, dances

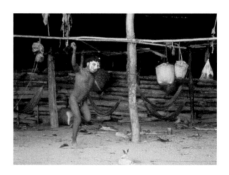

At the *praïaïa* entrance dance, the guests display themselves as bizarre beings, here with facial masks with bird down stuck on.

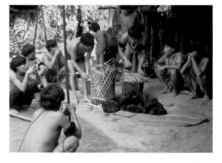

On parting, the guests are given meat and vegetables as a ceremonial meal.

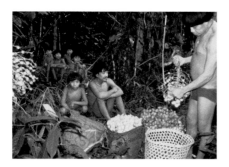

The pijiguao palm fruits are harvested in old, no longer cultivated gardens. Large amounts of them are offered to guests on the occasion of feasts.

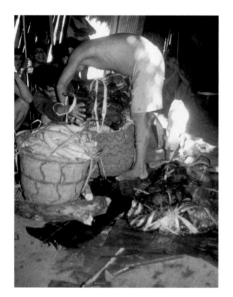

The ceremonial meal is presented to the guests by the men using women's carrying baskets, *wïï*.

up and down the village with it, and he also destroys the possessions of the deceased.[15] During the ritual, he and the other affines now mime the enemies responsible for the death by symbolic "devouring". Their performance and imitation of the tragedy allows the mourning relatives to experience the magic act of the killing. It is also the affines who, next to the children and other close relatives of the deceased, consume the ashes. At the end of the feast, before setting out on their way home, the friends from the other groups are presented with meat and vegetables to take home. Thus the symbolic killing of the deceased is compensated with real food. The ritual brings closely together the relatives and classificatory friends and acquaintances. The logic of the division of the tasks corresponds to the marriage rules. One's "own" people—the cognates—may not marry each other and neither may they organize the funeral. On the other hand, the semantically more distant relatives—the affines—are not only those who may marry each other or with whom an in-law relationship is possible, they also play an important part in the overcoming of the death of a close relative. The kinship groupings exchange these services which come under the category of social continuity—reproduction and overcoming death—and carry the idea of reciprocity to an extreme of mutual incorporation when consuming the ashes of their respective opposites in an endocannibalistic funeral meal.

The sharing of food in everyday life, the presentation of arrowheads to potential friends and future in-laws, marriage and the exchange of services and symbolic acts at the funeral of the deceased, all these various forms of social act serve one single purpose: to safeguard the society, to continue and confirm it. Thus the Yanomami can give us a lesson in how—by exchanging and sharing—the continuity of life is guaranteed, absolutely directly, even in times of need.

1 Cf. Zerries/Schuster (1974, p. 157); Chagnon (1977, p. 48); Lizot (1982, p. 254)

2 In these explanations, the author refers to what she experienced during her own research.

3 Marie-Claude Mattéi-Müller came upon this metaphorical expression when translating ritualized dialogs between Yanomami men.

4 Bourdieu (1979)

5 Cf. Zerries/Schuster (1974,p. 265)

6 United Shaponos of the Yanomami of the Upper Orinoco.

7 For the other types of arrowhead, see the chapter "The Yanomami – Those born-from-the-calf" in this catalog.

8 Further information on the significance of the *rahaka* arrowheads is to be found in Herzog-Schröder (1993).

9 In 1925, Marcel Mauss was the first to point out the significance of exchange as a social act, occurring in almost all societies, in his "Essai sur le Don". This trail-blazing text was published in German in 1968 entitled "Die Gabe".

10 With his anthropological theory of marriage as an exchange of women, Claude Lévi-Strauss went beyond the approach taken by Mauss (Lévi-Strauss 1981).

11 Kinship terms are written in single quotation marks if they are used in a classificatory sense: 'sister', 'father', etc.

12 This has not always been the case in our culture, either: not so long ago, 'Oheim' (an archaic German term for uncle) was the current term for the uncle on the mother's side only and this relative—in contrast to the brother of the father—had to fulfill certain social and caring obligations.

13 Traditionally, the term "cognate" is often equated with "related by blood", a fact not in agreement with the logic of the Yanomami kinship system since then the brother of the father would be "related by blood" but not so his sister

14 Cf. also the chapter "The Yanomami – Those born-from-the calf" in this catalog; for a more detailed discussion of the subject see Albert (1985).

15 In some cases, variations of the pattern here described may also be observed.

Feather bushels for inserting into upper
arm bands—*ara-shina*
YANOMAMI
Heron, curassow and macaw tail-feathers
cotton thread

The men wear this decoration at feasts
during the festive dance when entering a
friendly village.

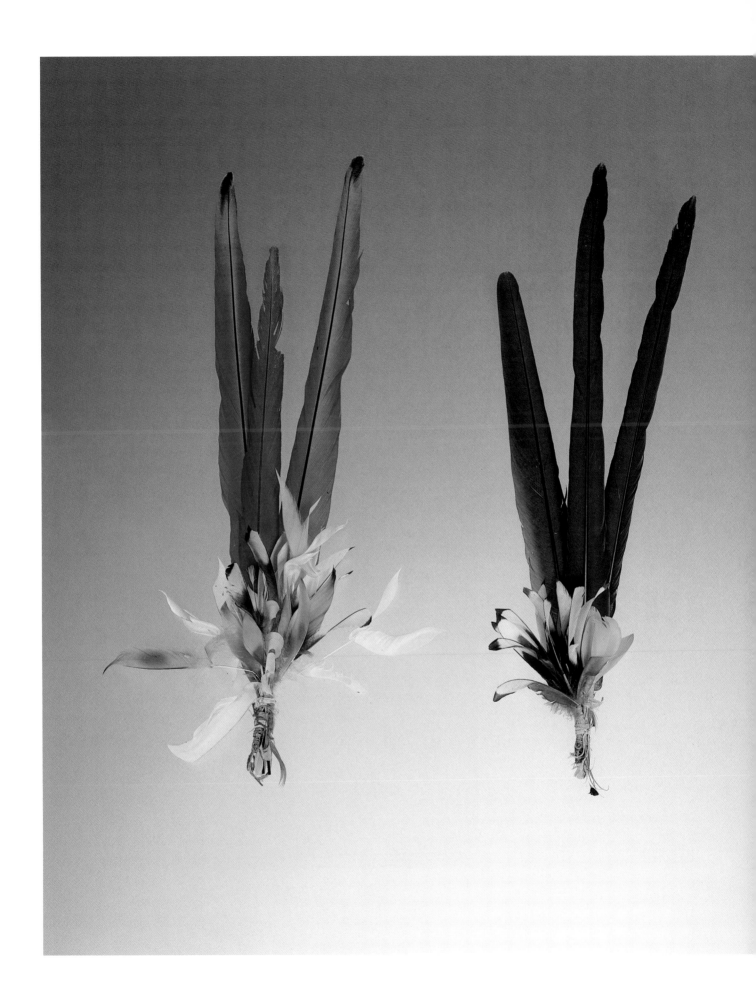

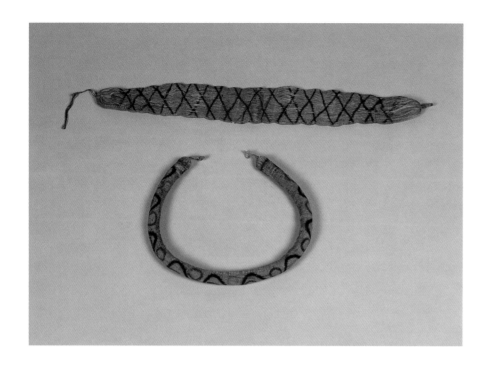

Women's hip belt—*wāō*
YANOMAMI
Cotton thread, plant pigment

The belt, which closes at the front, is nowadays only worn after completion of the puberty ritual.

Men's hip cord—*wāō*
YANOMAMI
Cotton thread, plant pigment

Women's carrying baskets—*wīī*—with and without ornamental decoration and tumpline
YANOMAMI
Mamure *Heteropsis spruceana*
bark cloth, plant pigment

On gathering expeditions through the forest which last several weeks, the women carry all the family possessions in their basket. The tumpline is put across the head.

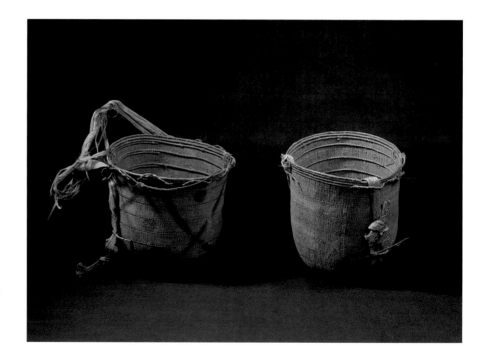

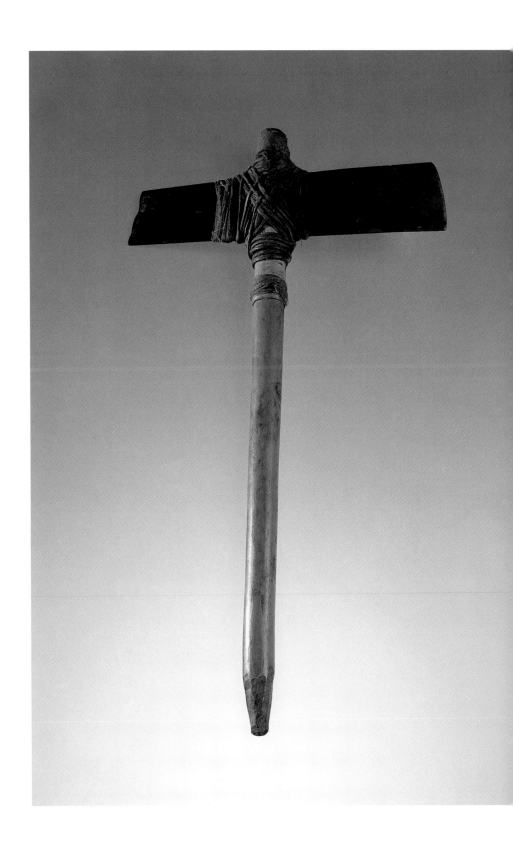

Axe made out of a shafted machete
blade— *acha*
YANOMAMI
Wood, iron, fibers of *Ananas lucidus,*
fibers of *Antiaris sacciadora*

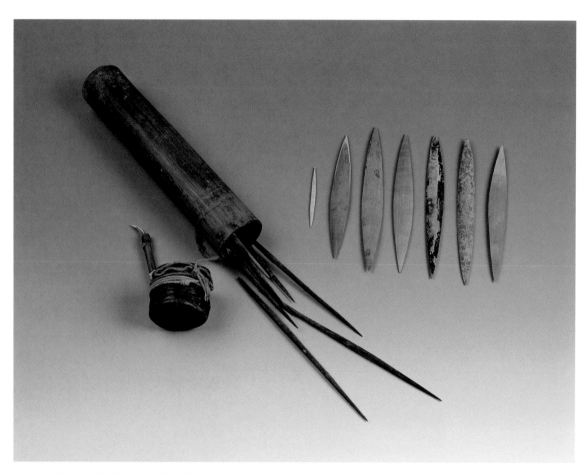

Quiver—*thora*—with fur cap and attached
knives made of teeth
The contents consist of bamboo arrow-
heads, bone arrowheads and hardwood
arrowheads coated with curare.
YANOMAMI
Bamboo cane, deer hide, bone points,
fibers of *Ananas lucidus*, plant pigment,
cotton thread, hardwood, shafted tooth of
an *Aguti picure*

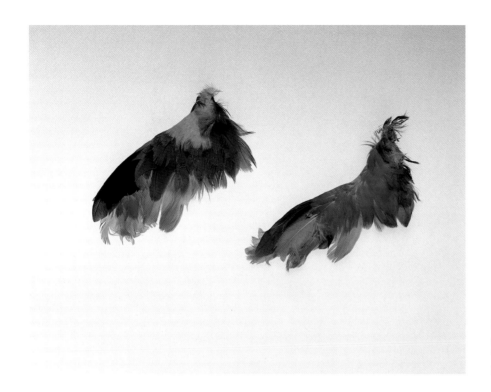

Bird wings to be made into body
decorations
YANOMAMI
Bird wings of a species of kotinga

Shoulder- or belt-bag
YANOMAMI
Ocelot fur, fibers of *Ananas lucidus*
cotton thread

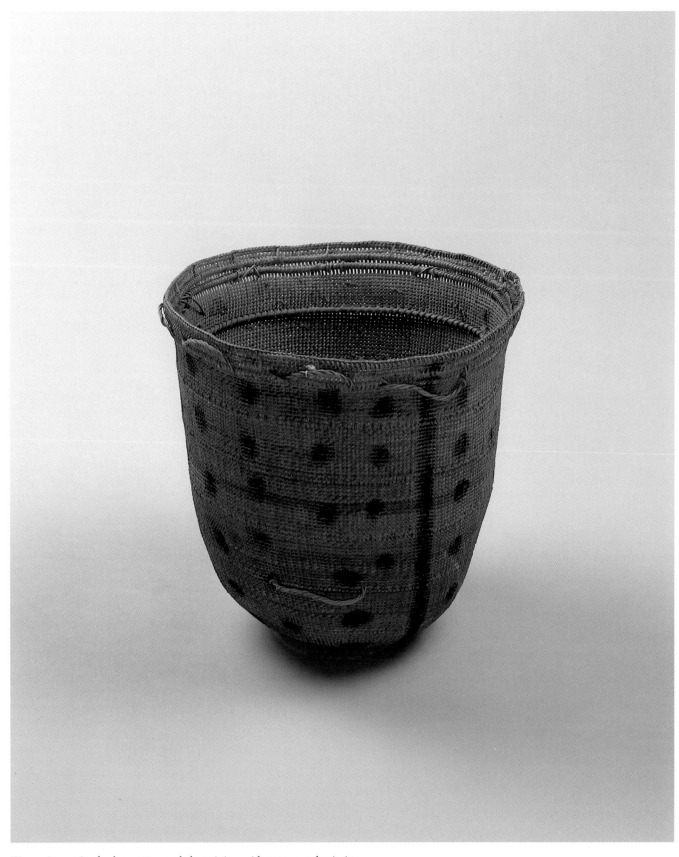

Women's carrying basket—*wïï*—made by twining, with ornamental painting
YANOMAMI
Mamure *Heteropsis spruceana*
plant pigment

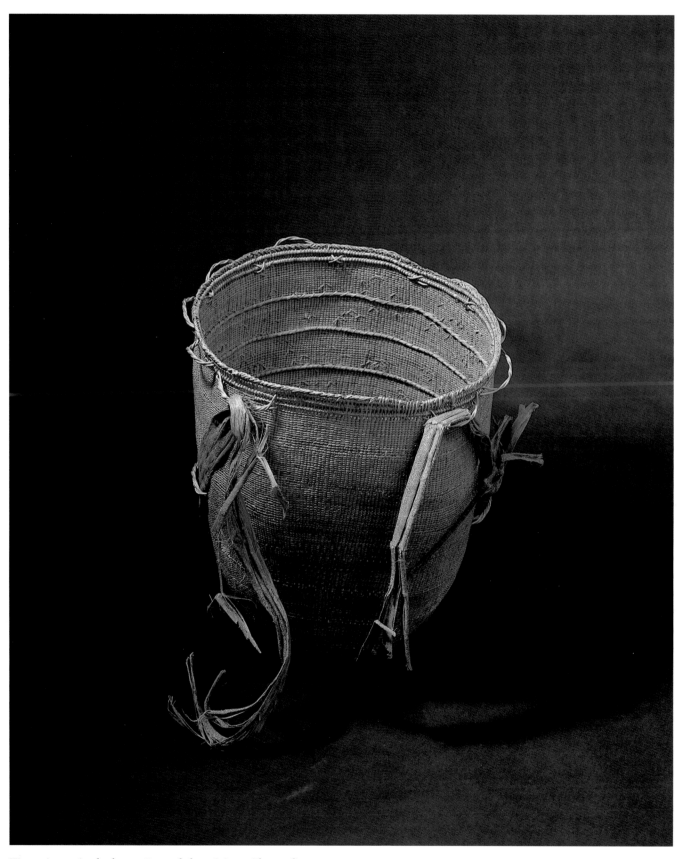

Women's carrying basket—*wïï*—made by twining, with tumpline
YANOMAMI

Mamure *Heteropsis spruceana*
bark bast

The basket is carried on the back by placing
the strap across the forehead.

Women's apron—*pīrīsī*—with small decorative rattles
YANOMAMI
Cotton thread, glass beads, seed capsules

During the dance, the small rattles attached to this laterally fastened belt jingle.

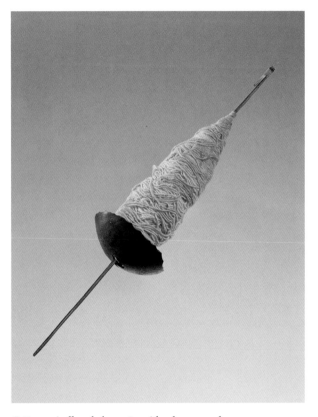

Cotton spindle—*hokoremī*—with wharve made from a piece of calabash
YANOMAMI
Wood of the seje palm *Oenocarpus bacaba*, calabash fruit, bone, cotton thread

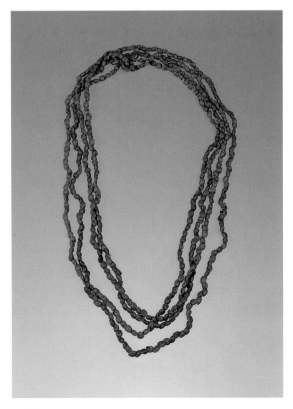

Necklace
YANOMAMI
Seed capsules

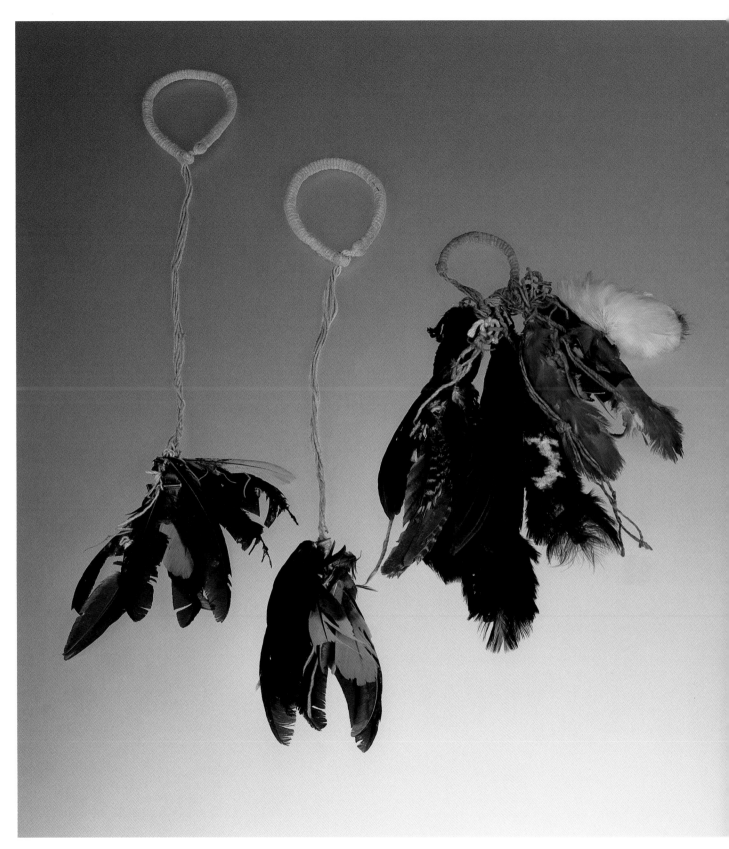

Upper arm bands—*paushi*—with attached
feather bushels and bird skins
YANOMAMI
Cotton thread, skin and feathers of toucan,
curassow and sparrow hawk

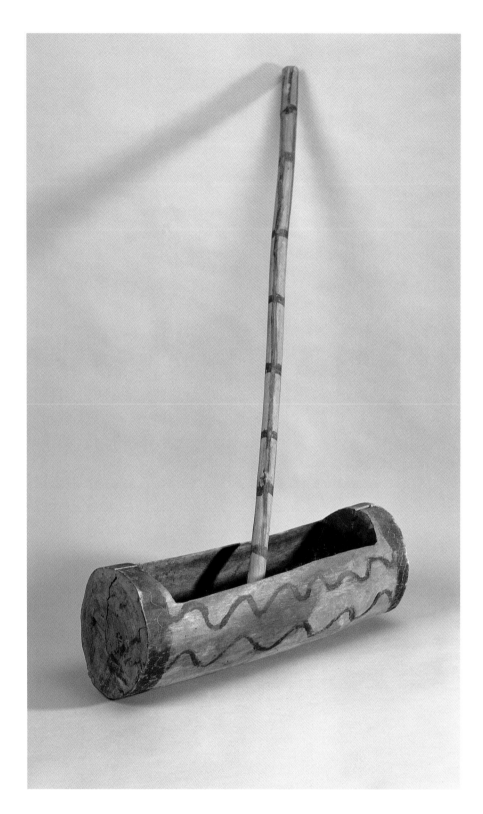

Painted wooden mortar in the shape of a
canoe—*hii hi ka*—and wooden mortar—
hii hikī tīka- motima—for grinding bones
YANOMAMI
Hardwood, plant pigment

In the course of the funeral feast,
the remains of the bones left after
burning the corpse are solemnly
ground.

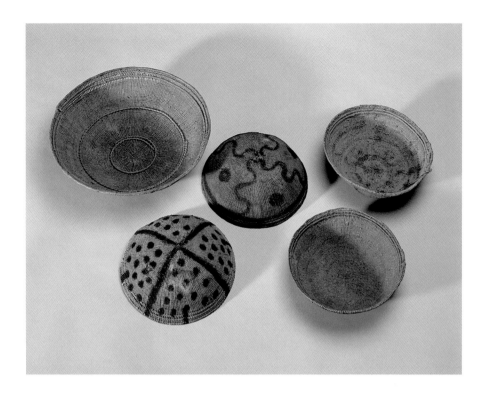

Basketwork bowls—*shoto*—with
ornamental painting
YANOMAMI
Mamure *Heteropsis spruceana,*
plant pigment

Like the large carrying baskets, the
basket bowls are also made by twining.
They serve to store smaller objects;
cotton flakes are dried in them and,
on expeditions, they are used as lids for
the women's baskets, *wïï.*

Mandible of a peccary and small knives
made from teeth
YANOMAMI
Peccary mandible, teeth of the *Aguti picure,*
wood, fibers of *Ananas lucidus,* resin

The peccary mandible and the knives made
of teeth are important tools for making
weapons. Bows are planed down with the
mandible. The knives made of teeth are
used to carve the arrowheads.

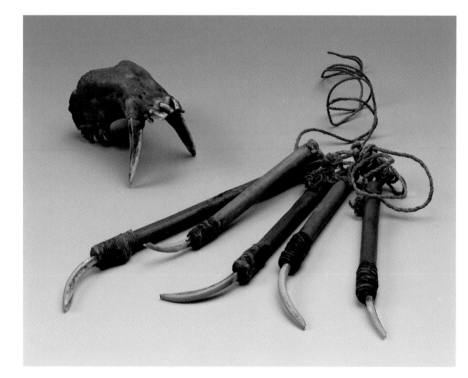

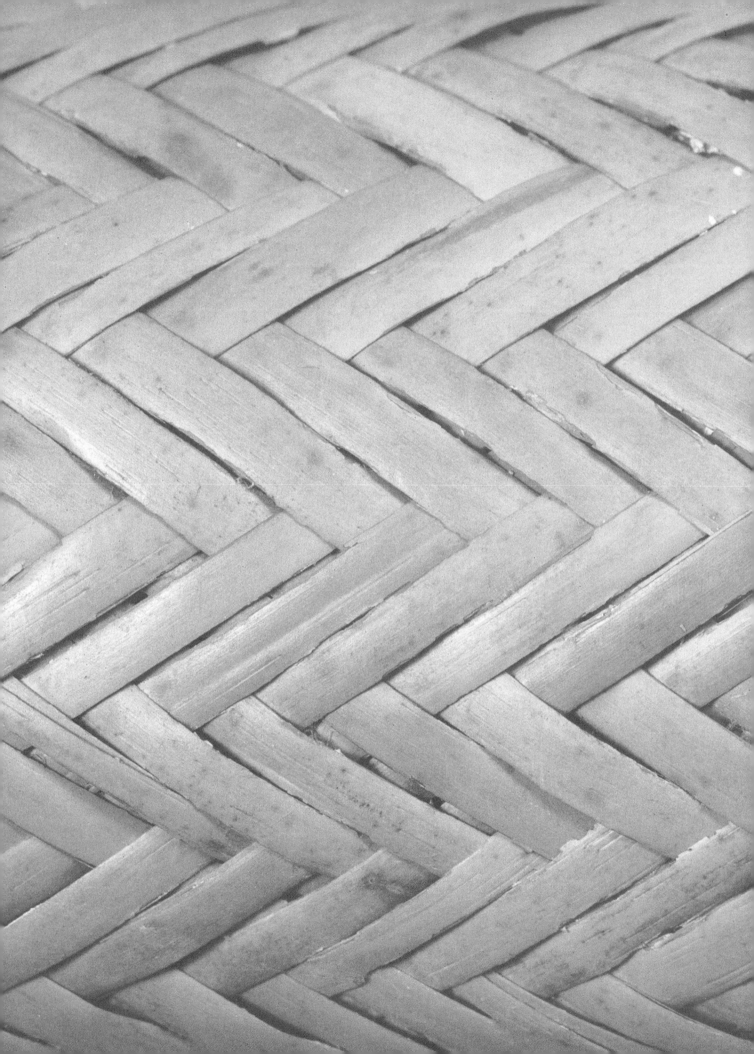

YE'KUANA

Lelia Delgado

YE'KUANA

The People of the Dugout

The myths of the Ye'kuana, passed down in songs and stories of the elders, tell of things belonging to an invisible universe. They contain ancient magical formulas, incantations by which the Ye'kuana attempt to influence reality. People transform themselves into jaguars or birds, they rise up to the stars to meet Wanadi—Wanadi the creator of the world and the lord of the heavens—or they plummet down into the horrible depths where the sinister *mawari* spirits dwell. Myth and magic weave a matrix which allows the Ye'kuana to confront their natural environment—an environment which both sustains and threatens them. The boundaries between reality and fantasy are fluid.

In their language, "Ye'kuana" means approximately "boat people," or "people of the dugout." The term comes from *ye* (wood), *cu* (water) and *ana* (people).[1] The language of the Ye'kuana belongs to the Carib-language family. In ethnological literature the Ye'kuana are also referred to as Dekuana and Makiritare.

Because of their exceptional ability as boat builders and prowess as boatsmen, the Ye'kuana have been able to defend their traditional territory—even expand it. Today they live along the banks of the rivers Padamo, Ventuari, Paragua, Caura,

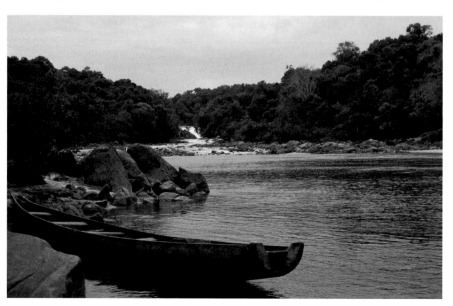

The Ye'kuana are renowned for their boat-building and paddling skills.

Uraricuera, Uesete, Cunucunuma, Yatiti, Cuntinamo, and Erebato. This territory, comprising some 30,000 square kilometers, ranges across the Venezuelan states of Amazonas and Bolivar.[2] The Ye'kuana had no contact with the so-called Conquista until the second half of the eighteenth century. The first historical mention of the Ye'kuana living on the upper Orinoco reached us from the boundary charting expedition of José Solano undertaken between 1756 and 1761, when, near the Rio Padamo, two expedition officers, Apolina Diez de la Fuente in 1760, and Francisco Fernandez de Bobadilla in 1764, struck up contact with the Ye'kuana.

From the eighteenth to the beginning of the nineteenth century, the Ye'kuna were under the influence of the Catholic Observantes Mission.[3] Originally received on friendly terms by the Indians, the Mission, together with the military, erected a string of Spanish settlements along a stretch of land reaching from La Esmeraldo to the Rio Erebato. The indigenous Indians, however, were severely repressed by the Spaniards—were severely that the Ye'kuana revenged themselves for the wrongs they had experienced by destroying the settlements in 1776.[4]

MANIOC, MAINSTAY OF THE TRADITIONAL ECONOMY

Every Ye'kuana village lies in the vicinity of a river port; paths cut through the rain forest branch out from the settlements—some lead to cultivated plots of land, others to hunting grounds, and still others follow the course of river beds. The regard the Ye'kuana feel towards nature and the plots of ground they cultivate is strongly marked by symbolic aspects.

For the Ye'kuana, things occur everywhere in the forest in connection with the existence of nature spirits. Some of these spirits are peaceable and good-natured; others, extremely dangerous and menacing.

The Ye'kuana plant corn, plantains, bananas, pineapples, and, most importantly, manioc. Manioc, yielding a large harvest, is the Ye'kuana's nutritional mainstay. It is processed into such diverse meals as *casabe*, a large baked tortilla, or into *mañoco*, a roasted stringy semolina sprinkled into soups and brews. *Yucata* is made when *casabe* is dissolved in water, and *yaraque* is a strong alcoholic drink which uses manioc as its main ingredient. *Yare* is processed from the poisonous liquid of the bitter manioc squeezed out by a press. It is detoxified by bringing it to a boil. The resulting *yare* can be used as either a sauce or beverage.[5]

Besides the cultivation of manioc, hunting and fishing are the Ye'kuana's most significant subsistence activities. Special rites emphasize the communal importance of these three activities. For instance, the elders alone decide which new plot of land should be cleared for agriculture, or when the time is right to form a hunting or fishing party. The elders take special care to avoid dangerous locales, and to leave the dreadful *kanaima* spirits undisturbed—for, as punishment, the malevolent *kanaima* could bring deadly sickness upon the entire village.

Over the course of the last few decades, blowguns, the traditional hunting instrument of the Ye'kuana, have been almost entirely replaced by firearms. Still,

The tube press is the largest and most complicated basketry utensil. It is used to detoxify manioc pulp.

The Ye'kuana traditionally hunted with blowguns.

even today it is not uncommon to meet Ye'kuana who can skillfully manufacture blowguns from tall stalks of bamboo. Their marksmanship with the blowgun darts is equally accomplished. The darts they use are constructed from either bacaba palm fibers or from strips of bamboo. The quiver which carries the blowgun darts is approximately 65 centimeters long and is fashioned by installing at one end of a bamboo stalk a folded piece of pachuba palm leaf, which is sewn together with a thread made from plant fibers.

The blowgun was used to hunt curassows, toucans, egrets, grouse, sparrowhawks, and other birds. Such game is still eaten today, and bird feathers continue to be used for purposes of ornamentation. Tapirs are also hunted, as are peccaries, howler and capuchin monkeys, and large rodents. Hunted as well are a variety of reptiles such as caimans, iguanas, and small alligators, as well as an assortment of turtles. The firearms which the Ye'kuana today employ are purchased from the criollos. It is also from the criollos that the Ye'kuana have taken over the practice of keeping a domestic pet—the dog.

As opposed to the hunt, which traditionally is practiced by one man alone or by a small hunting party, fishing is carried out by the entire community. Fishing techniques range from employing *barbasco*, a fish poison, to using bows and arrows or blowguns and darts. Catches are also landed using fish traps, nets, harpoons, and hooks.

In the forest and along the stretches of savanna, the Ye'kuana gather fruits and shoots, as well as collect the fibers of various palm trees to use them in the manufacture of everyday utensils. Wild honey and some types of insects are also collected, by which the insect larvae, eaten raw or cooked, serves as a source of nutrition.

Work is divided up among the group members according to sex. The men are largely responsible for the ritual and sacral activities; they hunt, fish, clear land for agriculture, and fashion dugout canoes and ceremonial objects. Men also build the dwellings.

Women—symbolically closely associated with fertility—are in charge of sowing the seeds as well as performing most tasks of cultivation. They are also responsible for the processing of manioc.

THE MILKY WAY OF THE COMMUNAL HOUSE

Although the culture of the Ye'kuana in some aspects resembles that of other regional ethnic groups, a closer examination reveals several differences with regard to language, material culture, magical-religious ideas, symbol usage, and craft artisanship.

The Ye'kuana live in small, clearly defined village communities made up of a few large families. Often, the local group lives together in a single *ëttë*, a conical dome building. Here, between 20 and 70 people might dwell. Each family has its own living area. The *ëttë*'s conical roof rests atop three central poles. These poles, standing between 16 and 18 meters in height, protrude from the roof's conical gable.[6] Observed from a distance, the ëttë has the appearance of a giant basket. The buildings are erected in forest clearings surrounded by the sort of large, leafy trees that lend cooling shade. The conical roof is thatched with artfully interwoven moriche or cucurito palm fronds which are anchored in place by creepers.

The erection of a *ëttë* is not merely a technical-architectural undertaking, but also an important social event—one seldom practiced today. During the communal building process the Ye'kuana sing their traditional songs to the accompaniment of flutes, snail shell trumpets, clarinets, whistles and drums. They consume generous quantities of food and fermented beverages.

Building is a sacral activity. The central poles symbolize the "tree of life". To raise the central poles into place is to reenact and celebrate creation. The pole at the very center, analogous to the mythic cosmic tree known from other cultures, symbolizes the universe and is settled into a deep "omphalos" where the shaman has first put pieces of sacred bitter manioc. According to myth, the tree of life, which once connected heaven and earth, grew from this plant. As the central pole

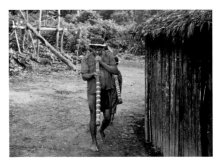

The sacred clarinet is played at ritual festivals, such as the one that marks the building of a hut.

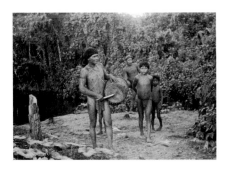

With a percussion instrument, a man spurs on his companions carrying out communal work duties.

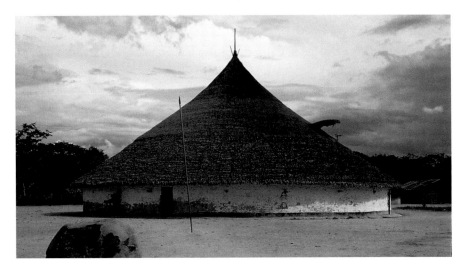

The *ëttë*, the large, dome-shaped community house, can accommodate up to seventy members as the local group's dwelling.

In the tropical climate the beautifully woven hammocks make ideal resting places.

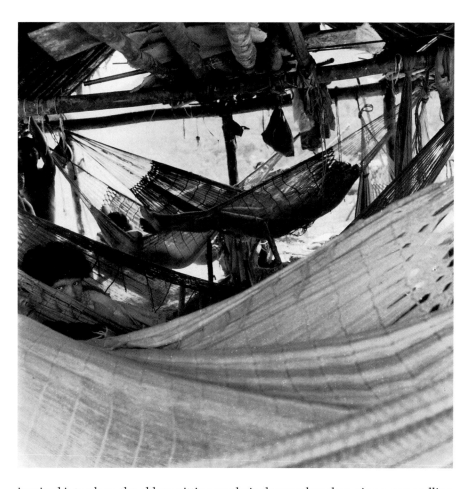

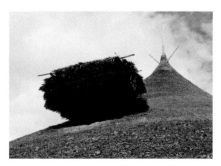

The flap opening on the roof is closed on rainy nights to keep out evil spirits.

is raised into place, the elders, sitting on their shaman benches, sing a song telling about the monkey who stole the first bitter manioc. For this ritual the women paint their bodies with broken lines. These lines symbolize the steps the monkey descended to bring the stolen bitter manioc down from heaven to earth.

The roof's construction and the names of the construction elements find analogous correlation with how the Ye'kuana conceive of heaven's architecture.[7]

The outer walls of the building form a great circle which supports the roof's construction. The roof is called "heaven of stars," and delineates the boundaries to the central area which, for the most part, is reserved for the men. The horizontal joists of the roof, running in a north-south direction, are called "the milky way."

The manner in which the inner space of the *ëttë* is divided up reflects the prerequisites of communal living within a confined area. The individual family living spaces and attendant cooking fireplaces are arranged along the outer wall. These areas are connected by a type of corridor which leads around the center. The central area is where the ceremonies take place. Here, too, the men gather to take their meals. The central area is also where the bachelors and visiting special guests overnight. The area receives its light through an open hinged flap in the roof. On rainy nights the flap is closed so that no evil spirits can penetrate the room.[8]

In the cozy atmosphere of the *ëttë* the smell of cooking spreads out from the family fireplaces. Dogs bark, children cry out, a shaman sings his nightly songs, and one of the elders rises to bring a fire back to life, its smoke rising to coat and blacken the roof's palm leaf underside.

In addition to the circular *ëttë*, the Ye'kuana also build rectangular houses, which are called *homakari*.[9] The roof of a *homakari* is made up of two angled sides which slope down and end at either side in conical jutting overhangs—a design that creates the impression of length. The *homakari* can replace the *ëttë* as the communal dwelling, be used as the assembly room, as a workplace, or as a resting area for the men. Occasionally the baking ovens are brought into the building so that the women can make *casabe* and *mañoco*.[10]

GLASS BEADS AND RED-PAINTED BODIES

The traditional artistic taste of Ye'kuana culture influences the individual's relationship with his or her body. Seldom today, but not long ago men and women cut the hair of their heads in an identical fashion. Plucked out or shaved with a bamboo knife were the eyebrows, eyelashes, hair of the armpits and genitals, as well as facial hair. The earlobes, pierced, were adorned either with colorful feathers and pieces of bamboo, or earrings made from glass beads and metal. The lips, also pierced, were decorated with feathers, and plant fibers. Men as well as women wove white glass beads into their cotton armbands. They also braided belts out of human hair or the fiber from plants to wear around their wrists and ankles, their calves and upper arms. Thick necklaces made of red, dark-brown, and black glass beads hung down to adorn their breasts.

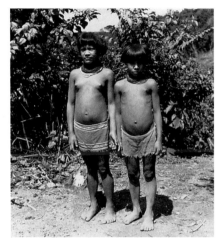

Young women traditionally wore cotton aprons which were woven with lovely glass bead designs.

Parallel lines and geometric designs contribute to the formal splendor of the Ye'kuana's body painting culture—an activity which today has all but disappeared. Wooden stamps and brushes made of thin reed tubes applied in meticulous detail *onoto (Bixa orellana)* and other dyes to the body.[11]

Among the numerous amulets, talismans, and jewelry made from glass beads, one unusual ornament deserves especial mention: it is carved from wood in the shape of a bat (*ansa*) with outstretched wings, a toucan skin hanging from it. At rituals, this ceremonial ornament is worn across the top of the back and across the shoulders in combination with cotton string necklaces decorated with feathers and peccary teeth.

Before manufactured fabrics arrived, before Western clothing became the fashion, the Ye'kuana wove the *muáho*, a cotton loincloth for men, and the women wore glass bead aprons primarily in the colors red, blue and white.[12] The wooden weaving frame used to fashion the apron was shaped like an bow. With the help of such simple wooden constructions, the Ye'kuana wove hammocks, as well as the slings in which women carried their young children.

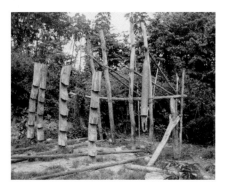

The tube presses are hung from a tall stand. When the tube is stretched the pressure exerted squeezes the poisonous fluid from the manioc pulp.

BASKETRY AND OTHER CRAFTS

It is the duty of the women to spin, to weave, and to braid the *wïwa,* the tall, slightly bulging carrying basket. On the other hand, traditionally, the weaving of the flat baskets, the *wana,* was exclusively a responsibility of the men. The *wana* basket is woven according to a special design, and many of the geometric ornaments woven into its surface carry special significance.[13] Boys first learn the art of weaving from their fathers through observation. Later they are taught how to find the suitable material and how to mix the dyes. Finally, under the watchful eyes of their fathers, they weave in a playful manner their first baskets. Technique, varieties of baskets and designs, which demand a certain practical knowledge, they learn as they become more experienced.

Many of the baskets which the men produce are needed at various stages in the processing of the bitter manioc. The processing of the bitter manioc itself, however, is exclusively women's responsibility. Large basketry trays, tubular squeezing presses, and sieves are utilized to detoxify bitter manioc of its prussic acid ingredient.

An important everyday utensil is the manioc grater. It is made of a small, flat piece of wood into which tiny sharp pebbles are inserted, then covered with a black tree resin, *peramán,* which serves as an adhesive. The stones are set by the women in clearly defined geometric patterns, which are again repeated and embellished in black and red drawings along the rim of the board.

Throughout the region, the manioc grater of the Ye'kuana was a much valued item of trade. Today, ridges of tin have almost entirely replaced the board's traditional tiny sharp stones.

A variety of calabashes, used as drinking vessels or to store beverages, are found among the household objects. The inner surfaces of the calabashes are impregnated with *peramán* or some other suitable plant substance. This not only makes the vessels waterproof, but also lends them an attractive sheen.

The technique of pottery, whereby the clay is coiled by hand, has a long tradition among the Ye'kuana and was a man's job. Today, due to the introduction of aluminum pots, the craft of pottery has all but been forgotten.

As can be discerned from the group's self-designation, the Ye'kuana—"People of the Dugout"—this is a clan of boat-building boatsmen. The *curiara,* the large dugout which they use to travel the rivers, is fashioned from the trunks of various huge trees found, for the most part, in the forests girding the banks of the Padamo and Paragua rivers.

After a tree is felled and placed on a stand to work, it is, beginning at the top and working down its length first coarsely marked with metal tools, then hollowed out by fire. This process demands much care and only advances quite slowly. The fire gradually widens the inside of the dugout, which is horizontally reinforced with sticks to keep the wood as it cools from contracting and splitting. The outer surfaces of the dugout are worked with axes and machetes until its walls have the right thickness and are quite smooth. Finally, wooden seats are secured in place, and the *curiara* is ready for its maiden voyage. The hardwood rudder, which steers

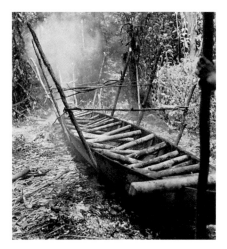

The building of *curiara,* dugouts, used to be a sacral act. In the course of the last decades, it became increasingly profane, often with a commercial interest.

the dugout down rivers and creeks, is ornamented with red and black designs. Recently, the building of *curiaras* has become more and more of an economic undertaking, for the neighboring ethnic groups as well as the criollos pay well for the Ye'kuana's prized boat-building artisanship. This economic lure, however, has lead to the deforestation along the rivers of those trees suited for dugouts.

PRESTIGE AND SPIRITUAL POWER

Formerly among the Ye'kuana, the finest dugout canoe builders, the most expert *wana* basket makers, and the best hunters of a group enjoyed high prestige. Today as well, the social cohesion is guaranteed by a few influential, highly regarded group members. The general characteristic of the chief, who in today's communities occupies an office not unlike a mayor, is a charismatic personality. It is his duty to encourage the group's feelings of solidarity. The decisions of this political leader take into account the recommendations of a council of elders in which every family of the group is represented.[14] Each member of the council has the right to voice his opinion without censorship. Meetings of the council of elders can last through the entire night; for the most part, the discussions proceed in a friendly fashion.[15]

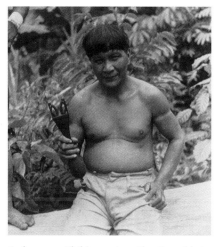

A shaman with his magic rattle. Carved into its handle are two stylized figures. For the Ye'kuana these adornments represent the magic medicine man Arauadekumo and his wife, Kahuana.

The shaman, named *huuway*, is the group's religious authority. As the "chosen-one" he has access to the sacral realms. The *huuway* is a highly sensitive man, and his calling proscribes for him a different lifestyle than that lived by other male group members. Usually, he lives apart from the community. While carrying out his duty of safeguarding the life and soul energies of the Ye'kuana, the *huuway's* kindness and compassion are constantly called upon.

The *huuway* receive their power from Medaatya, the first shaman, who learned the secret Ye'kuana wisdom from Wanadi, the creator. The succession of shamans which followed Medaatya were without exception admirable. A counterpart to the *huuway* shamans are the much feared, pseudo-human *kanaima* shamans, who can transform themselves into jaguars and attack Ye'kuana when, alone at night, they travel through the forest.

According to legend, the evil *kanaima* did not exist before the Ye'kuana first made contact with white Europeans. At fault were the weak *huuway* living at that time. The Ye'kuana, whose tools until then were primarily fashioned from stone, were greatly interested in the goods belonging to the "people of iron". The newly introduced firearms made the *huuway* smug and complacent—so much so that they ignored their traditional duties. The result of such hubris: the blood-hungry *kanaima* spirits came into the world to threaten the lives of all Ye'kuana.[16]

Each experienced *huuway* selects a young candidate to become his successor as shaman. The *huuway* initiates the young into the secret Ye'kuana wisdom passed down from Medaatya, and instructs him in the usage of arcane ritual recitations. In order to successfully complete his initiation, the chosen youth must possess special features of character: he must be a creative singer, must have prophetic

A Ye'kuana chief together with his family before the *ëttë* communal dwelling.

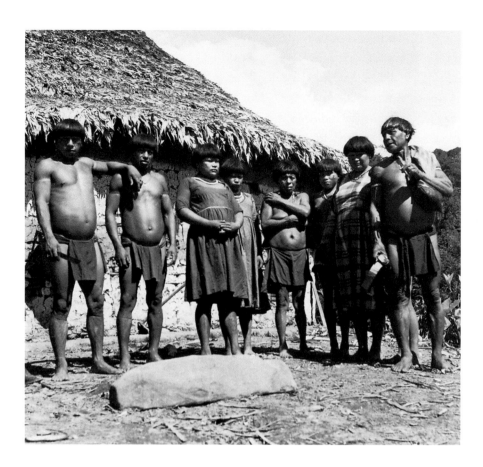

dreams, and he can only enjoy the company of the other group males for short periods of time.

The young man does not inherit the role of *huuway* until, after mastering the shamanistic songs in the old language, he successfully undertakes an ecstatic journey through the underworld. The secret ritual speech itself activates ancient knowledge. In this speech can be identified onomatopoetic imitations of the shaman birds as well as elements of an old form of the Carib language.

The celebration at which the *huuway* initiate displays his knowledge of the secret language, has been referred to as a "holy orgy."[17] The celebration culminates in the symbolic death of the new shaman. The ceremony takes place at night in the central, sacral area of the *ëttë*, where the shamans sit on wooden benches carved to resemble animals.

In preparation for his ecstatic flight, the shaman candidate paints his body with patterns using *onoto* pigment and vegetable fat. The white feathers of sacred birds are arranged and fastened along these geometric lines. During the initiation ceremony's stage of symbolic death, the new shaman sets out on his first journey through the eight levels of heaven which comprise the universe of the Ye'kuana. When he regains consciousness, returns from his death, he tells of his experiences during the journey. From this point on he possesses the sacred power.

The symbolic death is enacted by drinking the juice of the sacred plants *ayuuky* (red) and *kaahi* (blue), plants that cause intensive, prophetic visions.[18] A culture myth relates that during Medaatya's era, the shamans physically rode off

on their benches through the hinge opening in the cone roof to ascend to the heavens. The Ye'kuana, however, suffered very much in the abscence of their shamans. Since that time Wanadi, the compassionate creator, allowed the shamans to make the journey to him only with their souls, *akaato*, which at journey's end would then return to their bodies.

For the unprepared, the ecstatic flight is highly dangerous. There are tales of heavenly realms where huge scissors suddenly open, then close again, leaving in their wake the mutilated bodies of ecstatic travelers who either know too little, or are simply too slow. In another region of heaven a magnificently beautiful, naked woman emerges—Mareenawa, the eternal virgin.[19] If the shaman candidate cannot resist her seductive wiles, he is doomed to die in her embrace. The candidate, however, who can successfully avoid these impediments returns to his body as a *huuway*, and is blessed with the gifts of great concentration and of breath that can heal. He also acquires the ability to treat the sick through the nightly shaking of the sacred shaman rattles, the *maracas*. He expands his botanical knowledge, and becomes familiar with the songs of sacred birds.

The new *huuway* personally handcrafts his ceremonial objects, as for instance his jaguar-shaped wooden bench, or the rattle-scepter which he uses to direct ceremonies and ritual dances. The scepter is wrapped with plant fibers and adorned with rattles which lightly clap when shaken. But the *huuway's* most important instrument is a magic rattle which is filled with *widiiki*—crystals infused with the sacred presence of Wanadi.[20] The handle of this *maraca* is composed of two figures crouching with their backs towards one another, their heads resting on the palms of their hands, and their knees supporting their elbows. According to Meinhard Schuster, one of these two figures represents a great magic healer from the past; and the other figure represents his wife, who was an equally gifted shaman. The rattling of the *maraca* calls these two mythic healers down from the heavens to help treat someone who is sick.[21] Representing the crest of a woodpecker, the topmost portion of the *maraca* has to be adorned with red and white feathers. The woodpecker is the Sun Bird, the most potent symbol of Wanadi, and, in terms of myth, is associated with the death and resurrection of Wanadi's only son. The woodpecker is also identified with "Dios", the God of the Christians, who, as the Ye'kuana believe, was at work among their people on the upper Cuntinamo before he appeared to the white people as Jesus.[22]

Sickness is for the Ye'kuana either a result of magic, a breach or infringement of the group's moral code or hierarchical order, or it is caused by stealing the soul. Each cause of sickness requires its own kind of treatment to correct the negative balance. The *huuway* must first divine the cause of the sickness and then fight it like a warrior into withdrawal. When a sickness is caused by a breach of social rules, then the shaman forces the patient into making a confession. In order to reinstate a healthy balance within the community, as well as restore the patient's health, the patient must bring the shaman an expiatory sacrifice. If a sickness is the result of the soul being stolen, first the shaman must find the place where the soul is being held captive, and then he must exert his powers to try and free it.[23]

The pillars of myth which support the entire architecture of heaven are only visible to the shamans. The pillars rise from the peak of Kushma-Kari, a mountain located in the Duida-Marawaka Range of the Venezuelan state of Amazonas. This sacred mountain marks for the Ye'kuana the center of the world, here the eight zones of heaven touch the earth.[24]

The eight heavens are chiefly populated by mighty shamans, whose sacred duty is either to sing their secret songs, or to heedfully listen to the rattle sound their *maracas* emit without being shaken. The fourth zone of heaven is the dwelling place of the immortal souls. This is a special zone of heaven, actually a reflection of earth, with mountains, plains, forests. Despite such similarity, there is no such thing in this heavenly zone as clouds or storms. The Lake of Immortality is located here, its waters possessing the magic to keep the body from aging. Sacred animals such as the freshwater dolphin and the electric ray also dwell here. This heaven's most beautiful creature, however, is a giant, fabulous butterfly, which guards the shores of the sacred lake to keep unwelcome intruders away from the blue water.

In the seventh zone of heaven, the level abutting the highest, the souls of all the earlier shamans watch over their people. If, looking up into the night sky, one spies a shooting star, that means that somewhere in the world, a shaman has just passed away to arrive in heaven.

From the eighth zone of heaven Wanadi, together with his father, the sun, rules over the earth. Here, during an eternal feast, are found in eternal union all those beings that have achieved immortality. Most of these souls are Ye'kuana. But souls from members of other peoples are not chased away unless, in their lifetime, they have committed the worst sin of all—to kill another human being.

1 According to Daniel de Barandiarán (1961, p. 23), this name the people give themselves means, "the people with a tree-trunk in the water." Other authors refer to these Indians as "Dekuana" or "De'cuana," as well as "Maiongkong" or "Mayongong." Marshall Durbin and Hayée Seijas have found more than 53 individual names.

2 Wilbert (1966, p. 162)

3 Civrieux (1970, p. 12)

4 In 1838 Robert Schomburgk crossed this region from the Merewari to the upper Orinoko. Jean Chaffanjon and Eugène André visited the area of the upper Caura at the end of the nineteenth century.

5 With regard to the subsistence economy of the Ye'kuana, see: Barandiarán (1962[a], pp. 1–29)

6 As to the dwellings of the Ye'kuana, see: Barandiarán (1966, pp. 3–95).

7 Barandiarán (1962[a], p. 23)

8 Civrieux (1959, p. 123) describes this window, which can be opened from inside. Barandiarán (1962[a], p. 18) mentions that, by means of this roof opening, each new day is celebrated as a triumph of the Sun God, the father of Wanadi. Schuster (1976, p. 57–58) sees in this flap opening, for which there is no indigenous name, an assimilation of European architecture.

9 The *homakari* huts are described by Barandiarán (1966, p. 15), and Civrieux (1959, p. 123).

10 Important notes on the traditional material culture of the Ye'kuana can be found in Walter Roth (1924), Theodor Koch-Grünberg (1923/III), Civrieux (1959 and 1970) and David M. Guss (1989).

11 Civrieux (1959, p. 136) mentions that the facial designs are made up of straight lines that cross each other at various points. Some are slightly curved, but spirals, crosses or dots are never used. According to Guss (1994, p. 83), the body painting and the design of the *wana* baskets are closely related; they are associated with Odosha, a devil figure.

12 The *muajo, muaho or muwaaju* is an example for the use and adaptation of non-traditional materials as for instance the glass beads in indigenous clothing.

13 Compare the basketry article, "Basketry. Signs and Changes of cultural Identities" by Marie-Claude Mattéi-Müller in this catalog.

14 Fernández, Rafael, Mireya and Hernán González and the society of the Ye'kuana of Karuri, Alto Ventuari Ye'kuana. Nos Cuentan Los Makiritares. *Boletín Indigenista Venezolano.* Vol. XX, No. 17, 1981, pp. 23–41

15 Barandiarán (1962[b], p. 73) observes that today there is a lack of new young shamans, but that their position instead is occupied by experienced men and from elder healers as well as famous chiefs.

16 Barandiarán (1962[b], p. 73); also Schuster (1976, pp. 109–110)

17 Barandiarán (1962[b], p. 76)

18 Barandiarán (1962[b], p. 77)

19 Barandiarán (1962[b], p. 88)

20 Barandiarán (1962[b], p. 80f)

21 Schuster (1976, p. 92f)

22 Schuster (1976, p. 96)

23 Barandiarán (1962[b], p. 84f)

24 As to the structure of the universe of the Ye'kuana, see Barandiarán (1962[b], pp. 60–65); also Schuster (1976, p. 87–90)

ULRIKE PRINZ

DECKED OUT
IN BORROWED PLUMES

MYTH AND ART OF THE
AMAZON LOWLAND INDIANS

Cultural possessions and cultural knowledge in the Amazon Lowlands have their own origin. The myths tell how the people gain the cultural knowledge which identifies them as "true people". Several models exist describing this process of gaining knowledge while, at the same time, also explaining the Indians' relationship to their objects.

As will be shown, this knowledge not only helps them to recognize the division between themselves and their environment but simultaneously reminds them of their origin.

In the world of the myths of the Amazon Lowland Indians, it is often from the animals that the people have inherited their most important cultural acquisitions. Tricks and cunning frequently play a role: the animals are robbed, killed and betrayed as in the following tale of the Sanema, a northern Yanomami group in Venezuela:

"A *sipina*, a mythical monkey, was carrying an enormous bag. 'Come here! Come here!', the ancestors called to the monkey in a friendly way. 'All right', said the monkey. The ancestors killed the *sipina*. They shot at it with numerous arrows made of palm leaf ribs: *sek*! *sek*! *sek*! The *sipina* dropped down; it was dead: *tili*! It had with it an enormous bag. Inside it were many baskets. There were also many manioc squeezers and other baskets. The Sanema did not know how to use these. The Ye'kuana took many baskets and a manioc squeezer. In the end, the Sanema also took a basket."[1]

A myth of the carib-speaking Wayana-Apalai of Northern Brazil tells how he people kill the Big Snake Tulupere and adopt its pattern:

"Down there, they saw the Apalai, in the middle of the trail, and they saw the dead Tulupere somewhat below the mouth of the Axiki. It had caught on a branch. They saw it painted all over with beautiful patterns and of an enormous length. The Apalai pulled out a cotton cord to tie it up. They tied up the jaguar, the tree

squirrel, all the animals we make: those Tulupere had painted. [...] That is why we make *arumã*, that is the painting of the Big Snake, of Tulupere."[2]

From this mythical killing, the Wayana-Apalai derive a whole category of basketry and ornaments, the so-called "patterns of the *arumã*".[3]

The Amazon Indians frequently capture cultural knowledge, such as how to make manioc squeezers, baskets, but also how to apply decorative patterns on objects and bodies. However, a widespread alternative way of acquiring knowledge is also the "gift from the culture hero". Thus, for instance, Wanadi gave the Ye'kuana the body painting pigments to ward off diseases and evil spirits. These pigments are also used to paint canoes, oars, baskets, bows, arrows, stools, baby carriers and musical instruments.[4] But it often remains a mystery where the culture hero himself gained the knowledge he passes on to the people.

Quite frequently, cultural acquisitions also originate in a love relationship between an animal and a mythical ancestor. The Taulipan of Venezuela, a subgroup of the Ye'kuana, tell the story of the beautiful daughter of the king vulture whose jewelry becomes exemplary for all the women. The man Maichaule lies in wait for the bird woman to see her in her human form. "She was a very beautiful girl with many strings of beads on the breast, the arms and the legs. She wore a beautiful beaded apron."[5] Maichaule welcomes the girl into his house and takes her as his wife. Later on, he is transformed into a king vulture as well.

Whether stolen or given, cultural knowledge becomes a paradigm for being human. The way Wanadi, the Ye'kuana culture hero, decorated himself when

The shaman's seat shaped like a jaguar is the connecting link between the world of man and the world of the spirits.

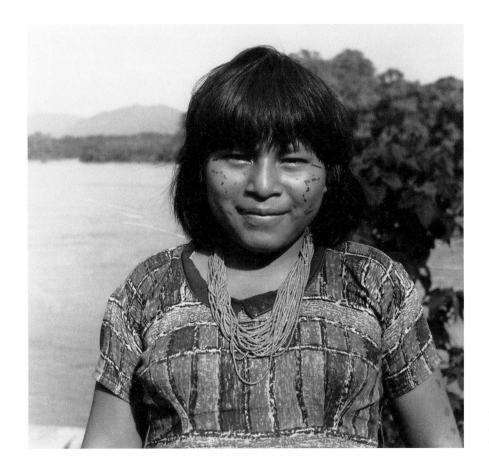

The myth tells about the beautiful daughter of the king vulture whose jewelry is an example for all women.

appearing at the first garden feast, is the way the people to this day decorate themselves in his memory.[6]

According to the Amazon Indians, culture and esthetic sense develop through processes strongly resembling each other: the culture heros bring the manioc, the fire and also the patterns for the art objects. This is why discussing Indian art always also means discussing culture.[7] Among the Indians of the Brazilian Xingu region, the idea of beauty is always closely linked with the concept of propriety: whatever is beautiful corresponds to the traditional order while the myths mostly show what is inappropriate and ugly.[8]

THE ROLE OF THE ANIMALS

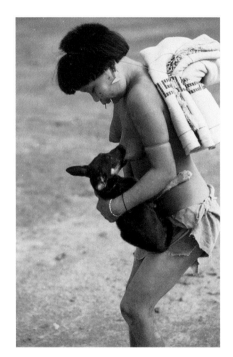

The people extend the network of their kin and social relationships to cover the animal kingdom.

Most of the time, animals are the heros in the myths of the origin of cultural acquisitions. Even if they fell victim to people, like the monkey with the baskets or the anaconda, abstract signs are a reminder of the culture-bearing act. Their symbols are repeated on the bodies as well as on the artefacts.

The relationship of the Indians with the visible animals of the forest and the savannas is very close. They are similar to the people. The Ye'kuana feel so close to the animals that they assign six different kinds of soul to them – just as to humans.[9] In former times, animals and people were of the same nature, and thus the Taulipang culture hero was able to marry the beautiful daughter of the king vulture. Today, there are differences: in the eyes of the Indians, the animals seen today have been transformed due to inappropriate behavior.

On the one hand, the animals serve as an example to the people, on the other hand, they are socialized by people spreading the network of their kinship and their social relationships over the animal kingdom.[10] In so doing, a closer kinship is felt with some of the animals since they follow comparable social rules, while others recede to the sidelines of the community because their way of life differs more strongly from the patterns of the human way of life and their moral concepts. For the Achuar of the Ecuadorian Lowlands, for instance, the toucan is a model as regards partnership. The Indians not only admire the sexual potency of the animals but, above all, acknowledge their close relationship. If one partner dies, the other toucan screams for several days but then hastens to find a new partner. The hummingbird is seen as less of an example as it does not remain faithful to any conquest and its promiscuous behavior contrasts sharply with the fidelity of the toucan.[11] In the Achuars' system, a special position is occupied by the dangerous large loners like the jaguar and the anaconda. As solitary hunters, they are excluded from social life. However, they are able to make contact with the shamans and enter into agreements with them.[12] On the one hand, this facilitates the shamans' access to the magical world and, on the other hand, it emphasizes their special position in the community.

For the Achuar (Ecuador), the toucan is a model for partner relationships.

Animals and cultivated plants are "anthropomorphized" according to the rules of social conduct. In the Amazonian world of ideas, nature does not conflict with culture, all living beings form a continuum where every animal and

plant species has its place.[13] A very similar relationship exists with the spirits with whom the people keep up a kind of social relationship. The ideational world of dreams is not really separated from the material world of the immediate natural environment. Those animals people talk to in their dreams have not really disappeared when they wake up, their language merely ceases to be comprehensible.[14]

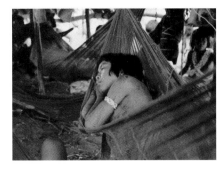

To those who dream, the world of the animals and the spirits is open.

LORDS OF THE ANIMALS

In the myths, the animals appear as culture heros, as ancestors, as "civilized" animals or lovers—but also as dangerous enemies. The patterns decorating the human body as well as the artefacts, represent a special category of living beings: these animals and plants are in reality spirits capable of changing their form and appearing to the people as human. They are the "guardian spirits" of the animals, plants and other "natural" phenomena.

This is how a myth of the Panare describes the "Lord of the rivers": "Tënawayin lives in the water. He is not an animal. He looks like a Panare of small build. When the rain comes, many small rivers come into being. When the day draws to an end, Tënawayin comes out. He appears in the new riverbeds where he precedes the water as if showing it the way. [...] Although he has the body of a man, he walks like a nutria. This is how the shamans see him. [...] He is simply the Lord of the river water."[15]

Even if most of the time the people talk of the "lords"—hence of male beings—the guardian spirits almost always represent a man and a woman or a being with male and female traits. This, above all, becomes manifest in the performance of mask spirits where in most of the cultures of the Amazon Lowlands the spirits appear in pairs, in a male and a female form, side by side.

On objects such as baskets, stools or manioc graters, the spirits or "guardian-lords" and "-mothers" are tangible mostly through abstract patterns and symbols.These can be understood as a kind of tribute to the original owners of the

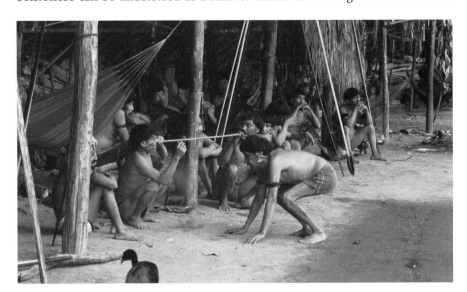

Spirits often appear in the form of animals. The shaman mimes their behavior.

food resources and the basic materials of Indian art. True to the law of reciprocity, the Indians of the Amazon Lowlands try to create a balance for the exploitation of the plant and animal materials.

Culture can be seen as the conscious expression of the closeness to the spirits and the lords of the animals but, at the same time, also the expression of the "guilty conscience" and the fear of revenge from those betrayed and robbed. The ambivalence—joy at the victory along with scruples at the same time – is shown in the respectful behavior towards the "spoils", the resources. Just as when, prior to consuming certain animals, precautions have to be taken, specific rules also have to be obeyed when gathering raw material.[16] From our point of view at least, the people's violent act against the mythical monkey which brought them the baskets and calabashes would already be a good reason for compensation, whether in rituals or in the daily manual work.

MYTHICAL ORDER

The sign-like patterns on the bodies and objects indicate social structures and social relationships. Feather decorations and body painting, hairstyle, arm- and leg- bands made of cotton, provide information on status, age groups, sex and the wearers' affiliation with specific ancestors. External changes, wearing certain patterns, but also learning specific songs, identify their owners as belonging to a specific social category.

In phases of transition, body painting clarifies and marks a person's transitory status. If, for instance, the boys among the Karajá of Central Brazil are painted with black *genipa* pigment, they are transformed into *diuré*, into otters. With the help of the painting, they become similar to real otters,[17] with which they are now symbolically equated for a phase of their life. With the application of the pigment to the body, the order of the universe is internalized and made visible on the outside. Thus every individual is meaningful within a larger context.

In most societies of the Amazon Lowlands, initiation includes a period of seclusion when the boys and girls are isolated in a special place away from the social life of the village. During this time, the young people occupy themselves with sex-specific activities. While the girls are mainly spinning cotton and processing the threads, the boys are carving arrows. In seclusion, the adolescent initiates not only learn the skills of making thread or arrows but become creators themselves: "[...] carving the arrow means two things: to experience the mythically transmitted idea of the arrow *and* to create the idea itself."[18]

The phases of transition and social maturing which the initiates experience as creators, also become outwardly manifest through the paintings on their bodies.

Indian art adapts itself to an order while at the same time serving its continuation. "In former times, the painting on the masks, the basketry patterns came into being along with the world order and, since the founders wanted it like that, to this day the painting and the basketry have to be done in the same way. Art is a cult to preserve the world."[19]

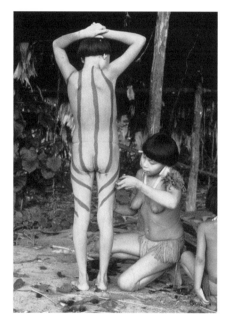

Body painting has not only esthetic qualities but also serves as a marker of social categories.

Dogs are also decorated for the feasts.

APPEASING THE SPIRITS

Thus, on the one hand, signs and patterns make the social order and the relations among the individual groups of people visible, on the other hand, they may also be read as a mis-representation of social phenomena,[20] as a failed example since they appear in animal form and the animals' behavior always corresponds only in part with the human order. For it is only in its partnership behavior that the toucan is similar to humans. The artistic representations refer back to their "natural" or mythical origin. They recall the mythical stage while at the same time overcoming it.

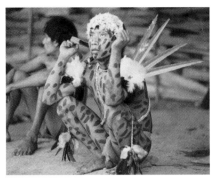

For the initiation, the Yanomami shaman is decorated with vulture down in his hair and bushels of macaw feathers. His body is painted all over with dots.

This ambiguity is characteristic of Indian art and its function of mediating between the worlds. In some techniques, it even becomes a stylistic device, since often the signs on the baskets or the decorations on clay pots can be read in two ways; they are kinetic, depending on whether one looks at the fore- or the background of the geometrical patterns, the images "change". If one looks at them for a longer time, the background comes to the fore and vice versa, while, at the same time, the significance of the signs changes.[21]

The patterns and signs on the bodies, musical instruments and weapons are not just ornamentation. They call to mind the relationship with the animal kingdom and—similar to an incantation—give it new life. During the rituals, the process of transformation into spirits is not seen to be completely without danger. At the *yamarikumá* feast of the Trumai Indians of Central Brazil, the women are transformed into spirits. They reach this state by applying *achiote* (*Bixa orellana*) pigment and by using male motifs—by rubbing their body with magical plants and by the appropriate songs. However, Aurore Monod-Becquelin reports that the patterns described in the myths do not correspond to those actually used.[22] This intentional deviation possibly serves to prevent the danger of an actual transformation. For the water spirits are "big, wild, deceitful and deadly."[23]

The painting makes it possible for the body and the cosmos to communicate. The signs activate the "state" where they originated. The symbols derive their power from this return to the origins. By conjuring up the world of the spirits, Indian handicraft goes beyond its mere utilitarian character. The signs form a bridge from the animals, the spirits, the deities and the inhabitants of other cosmic realms, to the people and symbolize the process of exchange between them. They signify at the same time repression and the staging of that mythical reality where the gifts from the deities originate. In this process of fluctuating between the realms of existence of the animals and the spirits, man experiences on a deeper level what it means to be human.[24] But to be human means to be neither animal nor spirit and includes a boundary between these realms which are nevertheless an integral part of human life.

RENDERING THE WORLD "HABITABLE"

A tale from the Sanema Indians makes it clear how directly the Indian concept of culture is linked with the manufacturing process of the artefacts. Omao, the culture hero, wants to give their ancestors modern goods to bring them up to the standard of their neighbors, the Ye'kuana, who are materially wealthier.

"[...] When Omao had created the Sanema, he thought to himself: 'Now I have created these Sanema people, these incomplete Sanema, I have to introduce airplanes, pencils and paper so they can be like the *sedenabi* strangers.' For Omao knew everything about planes and guns.

Thus Omao offered books to the Sanema. 'Here! Take this book! With this book, you can be like a stranger, really, exactly like him. You can learn how to say 'A', 'E', 'U', like the strangers, you can become like the missionaries.' But they did not accept the gift. '*Wii*! But what should we do with a book! *How do you make this pencil?* We cannot even write!' This was the answer of the ancestors [...]."[25]

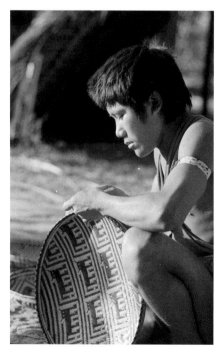

A Ye'kuana man carving a Wanadi figure.

Like the pencil, they also refuse the gun and again the missing technical know-how is the cause of the rejection. The reason is that the manufacturing processes of any objects also comprise specific esoteric knowledge. This quality of the objects is also discernible in other tales about the acquisition of the various goods. The Ye'kuana, for instance, distinguish between the "made" objects, *tidi'uma*, and the acquired or bartered objects, *mesoma*. The *mesoma* lack the magic power inherent in the "made" objects. "*Tidi*"—"to make"—denotes all the artefacts of the culture, the total sum of what one has to learn in order to become a true Ye'kuana. Becoming a mature Ye'kuana is tantamount to becoming an artist.[26]

Not only the ritual process, the performance of a primeval event, serves to confirm and renew the system but also precisely that supposedly casual process of manufacturing objects which enrich the world. Thus the making of such superficially profane objects as bows and arrows is also linked with mythical events: "Whoever carves the wood, joins the materials for the bow, in an individual, inspired act, so to speak, re-creates the social order in a visible and tangible way."[27]

The ritual and the artistic creative processes are similar in their endeavor to re-actualize the cosmic order and to produce it anew over and over again. Both are central to the understanding of Indian art—which is often created just for the moment. After the performance, the masks are carelessly tossed into the forest, the body painting has to be washed off after a certain time.[28] It is the daily Sisyphean task which creates the world and renders it "habitable" after the model of the "deities" who themselves are not inaccessible beings but neighboring, observable "family members". The works of art which are created are the cause and the aim of this activity at the same time.

In this context, "creating art" means to cover a distance on the way from an original, undifferentiated state to an esthetic order which is visible and tangible, like the bow or the manioc grater.[29] In the process of making baskets, weaving, making pottery or carving, while the hands are busy, a dialog develops between

In the process of plaiting baskets, weaving, making pots or carving, a dialog develops between the objects and the deities.

the object and the cosmos. In his work, the artist joins the material and the idealistic world.

SEX-SPECIFIC TECHNIQUES

Corresponding to the division of labor according to sex, in the Amazon Lowlands the sectors of artistic creation are also sex-specific. Men and women master different techniques relating to their respective areas of life. The men make mainly feather ornaments, musical instruments, bows, arrows, stools, canoes, oars and most of the baskets as well. The women above all specialize in pottery, they turn cotton and various strings into fringes, bobbles or tassels, they make bead jewelry and household utensils. The artistic fields are not divided identically in all the regions of the Lowlands, thus among the De'áruwa the manufacture of ceramics is a man's job, and nowadays the Ye'kuana women are skillful basket weavers. Both sexes paint their bodies but are differentiated by the exclusive use of certain patterns. However, body art not only lends itself to the demonstration of social hierarchies and the differentiation of persons according to age and sex, from it the artistic abilities, the individual taste and the peculiarities of the individual can be emphasized. With their craft, women and men not only make their contribution to the continuation of the world, they also recreate the signs anew and fill them with their own reality.

A look at the process of creating artefacts and at its prerequisites makes us aware of a further aspect of Indian art. If we want to see artists not merely as the performers of a mythical task, their individual style, closely linked with the knowledge of the spiritual and the material world, also has to be considered.

In the Amazon Lowlands, artistic creation cannot solely be seen as moving between primeval times and today, between the ideational and the material world, and it is not content with imitating and reviving mythical models. It is also able to add something new to the cosmos.

In this context, Mark Münzel drew attention to the creative component of the dream and the hallucinations: "The visionary freedom is the missing counterpart to the order in Amazonian art. With his creation, the artist [...] submits himself to the commands from primeval times, he fits into the world order. But the visionary escape is also part of this same order."[30]

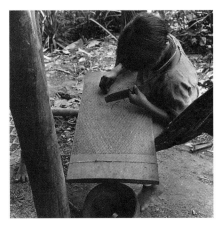

Making a manioc grater: a woman inserts small sharp stones in geometrical patterns into a wooden board.

DREAM KNOWLEDGE

The shamanistic techniques of the spiritual voyage but also the individual vision of every single person characterize the concept of the next world which is closely connected to this life. As an esthetic transformation of dream knowledge, Indian art receives its inspiration from dreams and hallucinations, caused by the consumption of drugs, where mythical acts are dreamed-up reality. Body painting and decoration are also part of the voyage into mythical time. The animal costume of

With the help of the drug *epena*, the Yano-mami work themselves into a trance. The men blow the powder into each other's nose.

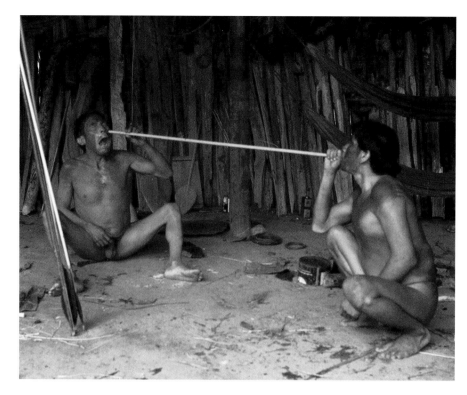

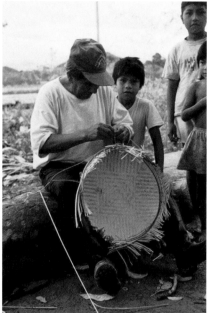

Artistic creation forms a bridge between primeval time and today.

the shaman becomes a device by which to roam the cosmos.[31] The jaguar pattern on a shaman's stool suggests the connection between the two realms and can catapult its owner into the world of the jaguar. Bird representations on snuff pipes and boards are a reminder of the feathered spirit-helpers of the shaman on his voyage into other cosmic spheres. And the Taulipang man is only able to visit the beautiful daughter of the king vulture in the sky because tobacco smoke is blown onto him and he thus becomes weightless; now he can attach his feather wings, jump up and down a few times and rise into the skies.

The knowledge of how it looks in the sky among the king vultures, at the bottom of the rapids with the Big Snake or in the house of the jaguar, is dream knowledge – assembled from the real experiences, fears and longings of the travellers into the next world as well as from the needs of man's social life. The prerequisites for the construction of an Amazonian identity are found here: whoever decks himself out in borrowed plumes is able to penetrate into the mythical world and, at the same time, to perfect himself as a human being.

THE FEAST AS A TOTAL WORK OF ART

Indian art becomes comprehensible through contemplation of its creative process. But it only comes alive in the colorful and varied ceremonies characterizing the major transitions during the life cycle and the specific social events over the course of the year. Dancers in all their splendor, painted and decorated with attributes from the world of the spirits, enter the scene and mark the start of a festive transformation connecting the world of the people to that of the animal and the spirits. Thus the different aspects of artistic and social creation merge into a whole.

When, prior to big feasts, the Panare women paint themselves with lizard patterns by means of the carved color stamps, this probably arouses associations suggested in the myth of the ceiba tree. According to Panare tradition, this tree from which kapok, or silk-cotton[32], is obtained, used to be a pregnant woman, "[...] already plump when she was transformed. Mareoka showed the Panare how to hollow her out to make a *kanowa*, the canoe we fill with *cachiri*, the drink for the feast. The child remained attached to her. It is *saranapoi'në*, the lizard which always lives in the *ceiba*. Did you not see that the Panare sometimes paint it onto the outer side walls of the festive *kanowa*? It only appears at big feasts. Nowadays, our women hide the placenta and the umbilical cords of the newborn in the *ceiba*. They do not simply throw them onto the ground [...]".[33]

The myth sketches the ideational connection between pregnancy, *kapok* and the lizard, the "guardian spirit" of this plant which, through the painting, is in turn closely associated with the female body. Since, among the Panare, a child who dies early is also buried wrapped in *kapok*[34], here the cycle of life and death is closed.

The painting with mythical patterns may initiate a process of mental and physical transformation which, although it leads back to the mythical past, also successfully leads out of it again. In the big metamorphosis of the feast, "supernatural" beings, the "lords" or "mothers" of the plants and animals, are evoked, personified by masks or by signs on the skin. The decorated and disguised body shows not only "social skin" but, at the same time, represents the "cosmic skin".[35]

The mighty ceiba tree plays an important role in the mythology of numerous Indian groups. Among the Panare, it is closely associated with female fertility.

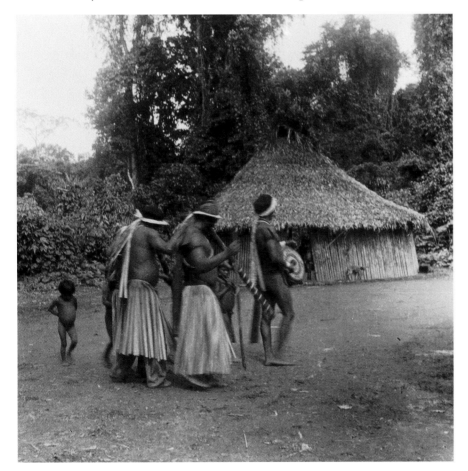

In the rituals, with the help of masks, festive dress, music and songs, the relationship with the world of the animals, plants and spirits is evoked.

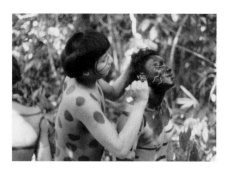

The painting with mythical patterns initiates a process of mental and physical transformation.

The ritual event causes the most widely differing realms to merge. The erecting of the central post in the traditional circular house of the Ye'kuana, at the same time seen as the "cosmic tree", is linked with the acquisition of the manioc. When a new house is built, the post is "planted" into a deep "omphalos" where parts of the bitter manioc, the sacred plant, are also buried.[36] When erecting the central post which alludes to the mythical conception, the old people sing of the theft of this plant, of the mother of the manioc. For this feast, the women paint their bodies with broken lines and thus themselves become the steps on which the mythical monkey climbed into heaven from where he stole the bitter manioc.

During the "garden feast", these mythical events are called to life again and celebrated. In the ceremony, the body, the house, the garden and the cosmos form the different levels of one and the same plan. They are united by the myth which "narratively links and leads back to a common denominator, the primeval event and its re-enactment."[37]

In the interaction of the various possibilities of artistic and cultural expression, the social order with its connection to the natural and the supernatural world emerges as an "overall work of art in motion". For the way of art, the way of culture, is an open-ended process of transformations where man has to determine his position again and again.

1 Wilbert (1990, p. 212). Translation by the author
2 Van Velthem (1988, p. 324). Van Velthem explains this process as the copying of the motifs of the snake's body painting with the help of a cotton thread the Indians lay down on the patterns and thus reproduce their shapes.
3 Cf. Van Velthem (1988, p. 311)
4 Guss (1989, pp. 57/58 and 63/64)
5 Koch-Grünberg (1927, p. 112)
6 Guss (1989, p. 419)
7 Cf. Clifford Geertz: "[…] a theory of art is at the same time a theory of culture, not an autonomous enterprise." In: Geertz (1976, p. 1488).
8 Monod-Becquelin (1988, p. 536)
9 Cf. Guss (1989, p. 52)
10 Descola (1994, p. 96)
11 Cf. Descola (1994, p. 96)
12 Descola (1994, p. 325)
13 Descola (1994, pp. 98/99)
14 Descola (1994, p. 100)
15 Mattéi-Müller (1992, p. 141)
16 Cf. article by Mattéi-Müller
17 Filho (1987, p. 81ff.)
18 Suhrbier (1998, p. 167)
19 Münzel (1988, p. 41)
20 Turner (1985, p. 51), Roe (1998, p. 175)
21 Guss (1989, p. 121), Roe (1990b, p. 137), Roe (1995, p. 102)
22 Monod-Becquelin (1988, p. 557)
23 Monod-Becquelin (1982, p. 141)
24 Cf. Turner (1969, p. 59)
25 Wilbert (1990, p. 226), Italics by the author
26 Guss (1989, p. 69)
27 Suhrbier (1998, p. 120)
28 Cf. Münzel (1989, p. 31)
29 Cf. the article by Luís Bóglar in this catalog where this idea is explained with the example of the preparation of the Warime ritual.
30 Münzel (1988, p.49)
31 Viveiros de Castro (1998, p. 482)
32 The Panare men make the small stoppers at the ends of their curare arrows from *kapok*.
33 Mattéi-Müller (1992, p. 41)
34 Personal communication M.C. Mattéi-Müller.
35 Roe (1990a, p. 106, cf. also article L. Bóglar
36 Cf. article "Ye'kuara–ThePeople of the Dugout" by Lelia Delgado in this catalog.
37 Münzel (1988, p. 41)

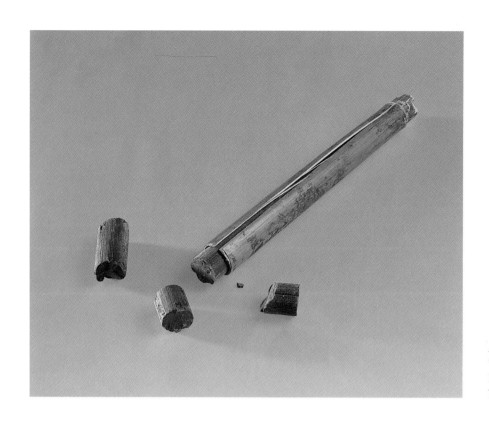

Adhesive – *peraman*
YE'KUANA
Bamboo pipe with hardened resin,
beeswax and coal dust

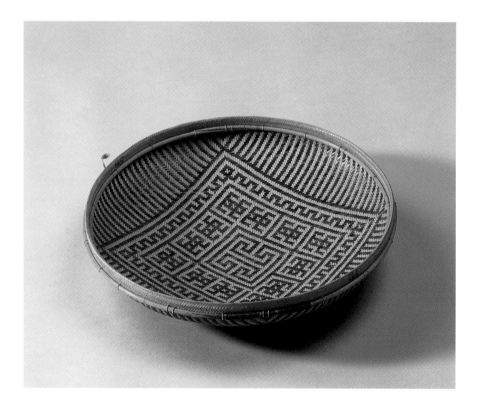

Basketry tray—*waja*—with representation of
a sleeping frog
YE'KUANA
Wickerwork made of *Ischnosiphon aruma*,
mamure *Heteropsis spruceana*,
fibers of *Ananas lucidus*, plant pigment

Next to the monkey, the sleeping and
the leaping frog rank among the most
popular patterns on the Ye'kuana baskets.

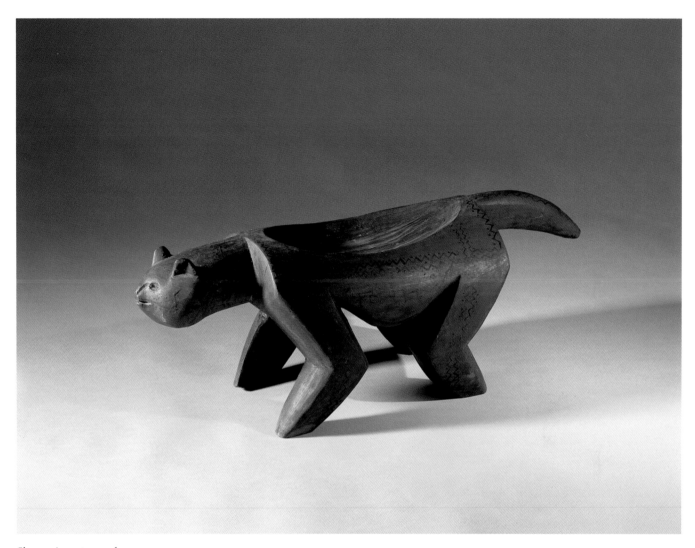

Shaman's seat—*mude*
YE'KUANA
Wood of the *Couma caatingae*

Among the Ye'kuana, the seats of the medicine
men are always carved in the shape of animals.

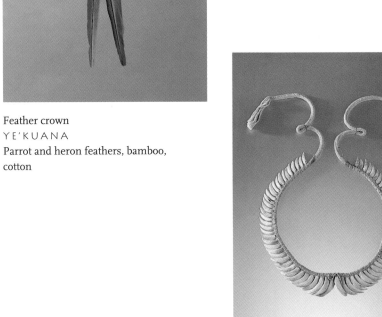

Feather crown
YE'KUANA
Parrot and heron feathers, bamboo,
cotton

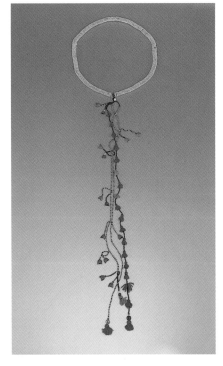

Necklace—*womo*
YE'KUANA
Glass beads, cotton, seed capsules

Necklace made of peccary teeth
YE'KUANA
Peccary teeth, cotton

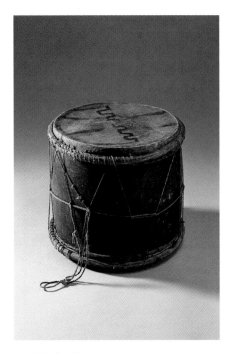

Double skin drum—*sammuda*
YE'KUANA
Wood, deer hide and monkey skin, fibers of
Ananas lucidus

On the occasion of feasts or communal
work, it was the tradition to beat drums.
Sound was produced with a wooden
drumstick or a rattle.

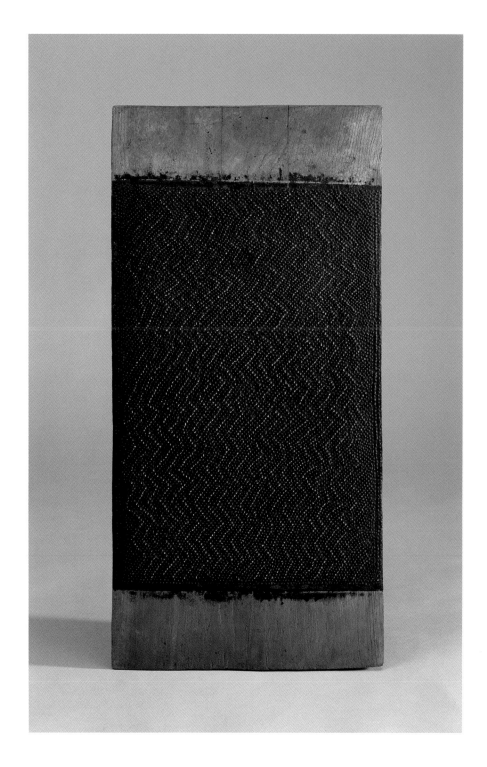

Grating board for manioc tubers—*tadaade*
YE'KUANA
Wood, stone chips, metal, resin with
beeswax, resin of *Couma caatingae*

Into the middle part of the grater, iron
pins are inserted and fixed with a black
resin. Making and using the graters is
exclusively women's work.

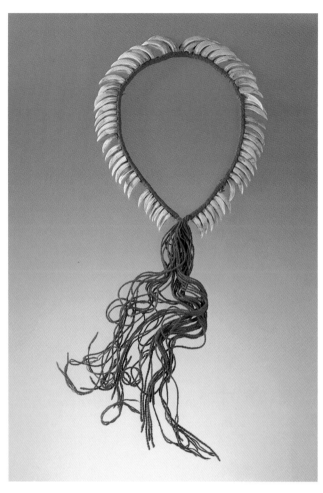

Necklace made of peccary teeth
YE'KUANA
Peccary teeth, cotton, plant pigment

The sharp fangs of the peccary are used
for necklaces and amulets. The number of
fangs gives information on the wearer's
success in hunting.

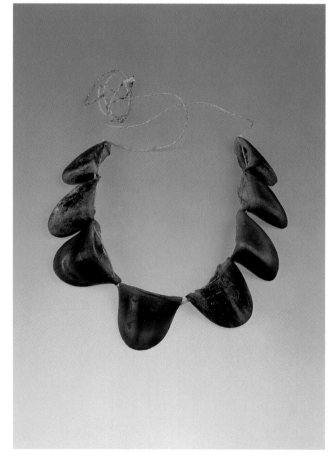

Amulet made of tapir hooves
YE'KUANA
Tapir hooves, fibers of *Ananas lucidus*

The tapir is thought to be the representative of the
lord of the animals. Sick people or pregnant women
are forbidden to eat tapir meat.

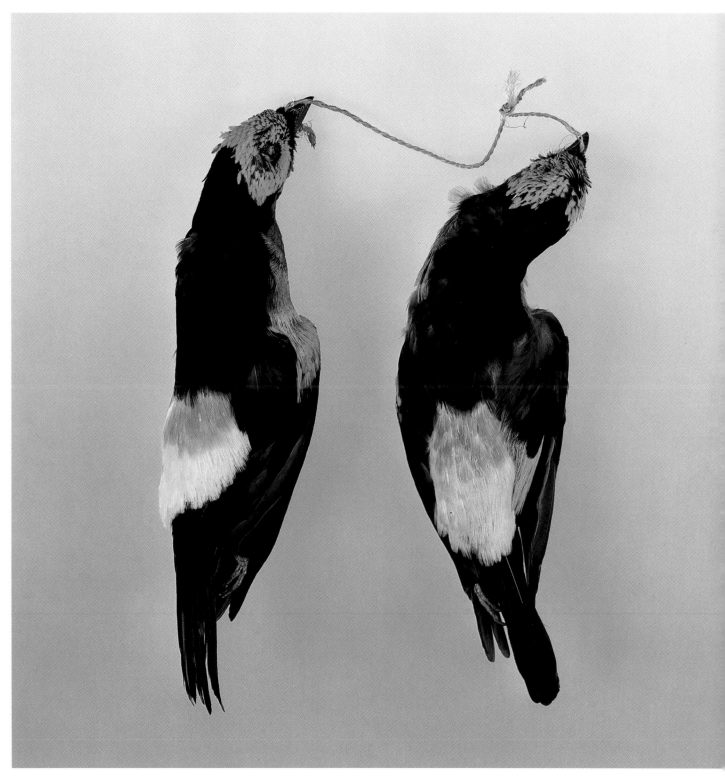

Paradise tanagers
YE'KUANA
Skin of the paradise tanagers *Tangara chilensis*

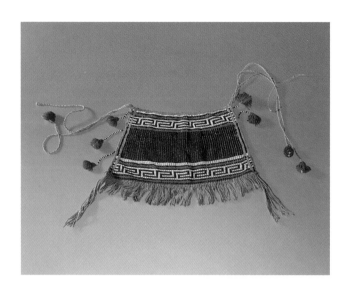

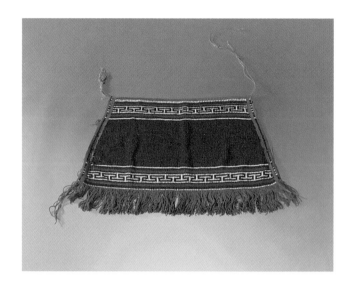

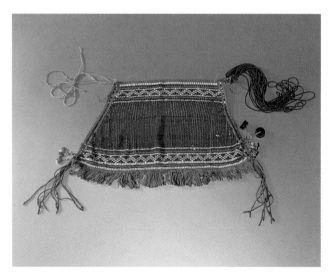

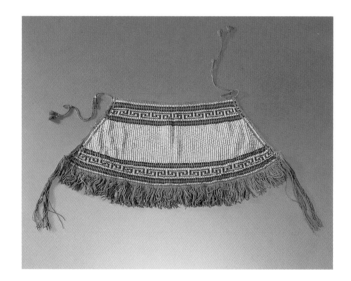

Women's beaded aprons—*muwaaju*
YE´KUANA
Cotton thread, glass beads, screw tops
and snap fasteners as little bells

These traditional trapezoid *muwaaju* are
woven on a simple frame shaped like a bow.
When making the beaded aprons, the Ye'kuana
use mainly red, blue and white beads and
diverse pendants.

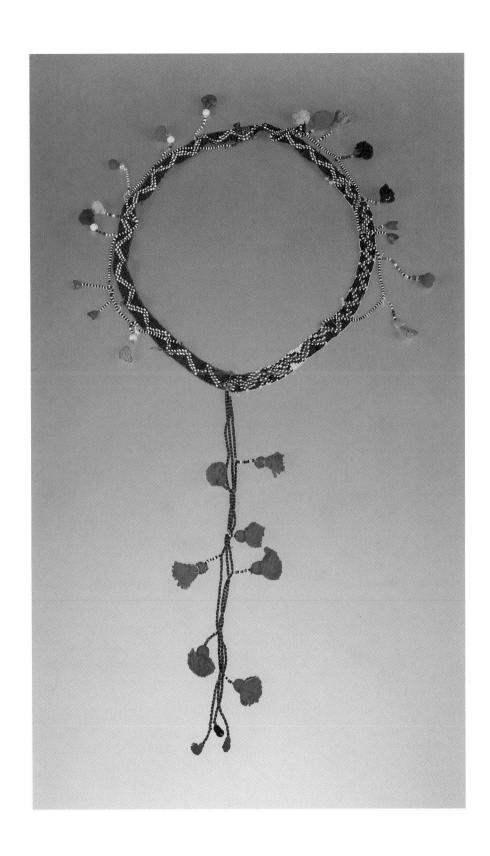

Beaded necklace—*womo*
YE'KUANA
Glass beads, cotton, seed capsules,
plant pigment

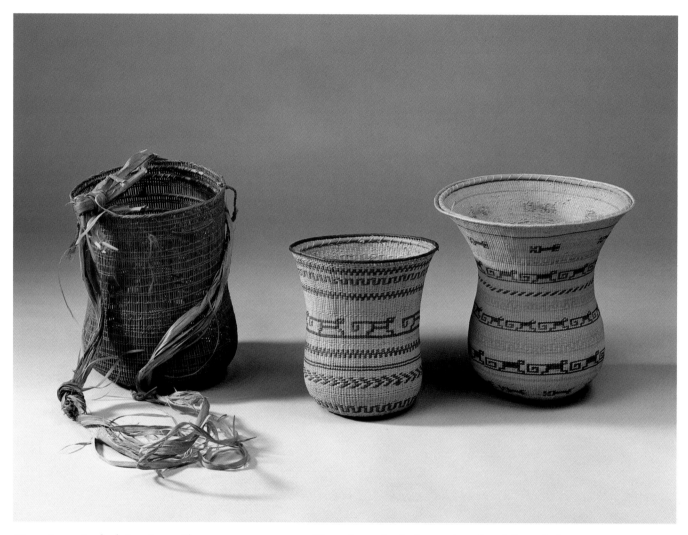

Women's carrying basket—*wĭwa*—with
tumpline
YE'KUANA
Mamure *Heteropsis spruceana*,
bark bast of *Inga spp.*

Basket used to carry loads on the back

Women's carrying baskets—*wĭwa*—in twining technique
YE'KUANA
Mamure *Heteropsis spruceana*,
plant pigment

Not until the 70s of the 20th century did the women begin to modify their
carrying baskets and to add patterns. The modern *wĭwa* baskets have become
articles in great demand on the Indian art market.

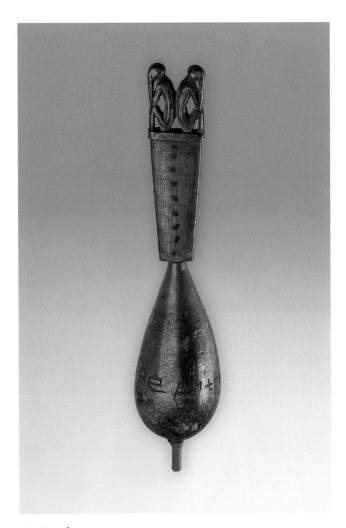

Magic rattle—*maraca*
YE'KUANA
Calabash, wood, cotton thread, stones,
plant pigment

Having passed all the tests in the course of
the initiation, the shaman gains the ability for
contemplation, the healing breath and the gift
of healing by means of the *maraca*. He learns
how to use magical plants and the sacred chants.
He is granted life force in the form of magical
crystals. The *maraca* is also filled with such
crystals. The handle of the rattle consists of a
stem and two figurines sitting back to back.
They represent a great mythical medicine man
and his wife who also had shamanistic power.

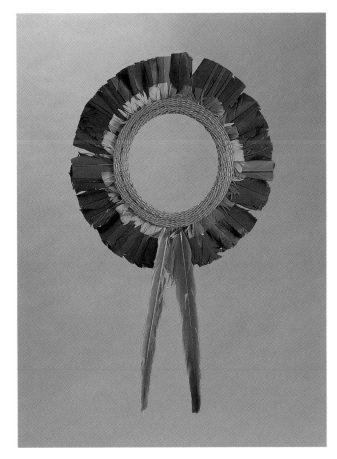

Feather crown
YE'KUANA
Parrot and heron feathers, bamboo,
cotton

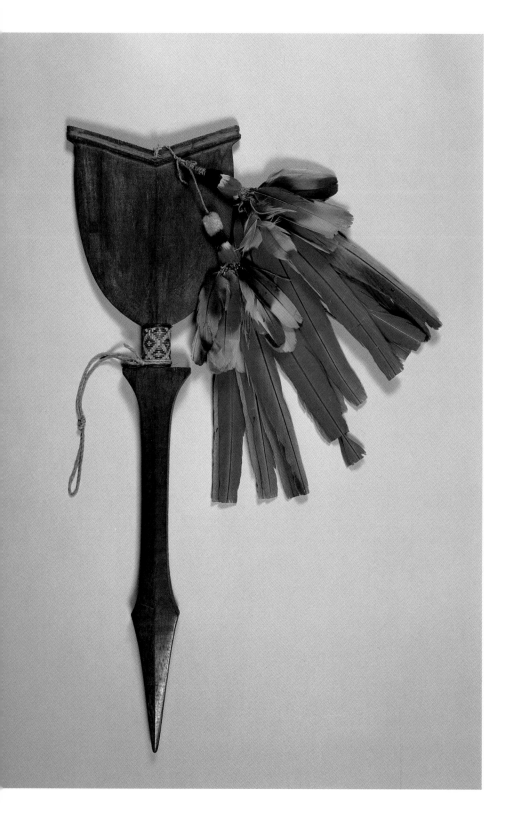

Club for ritual use
YE'KUANA
Wood of the *Ocotea cymbarum*, bamboo bark,
parrot and toucan feathers, fibers of
Ananas lucidus

This shape represents one of the most
widespread types of Guyanese ritual clubs.
During dance ceremonies, men carry these
miniature copies of the former large battle
clubs made of hard palm wood.

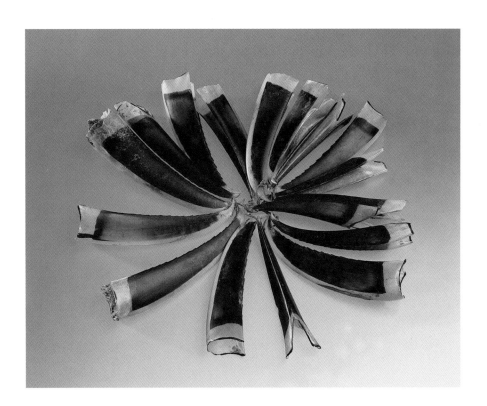

Rattle made of toucan beaks, used by
women in rituals
YE'KUANA
Toucan beaks, cotton thread

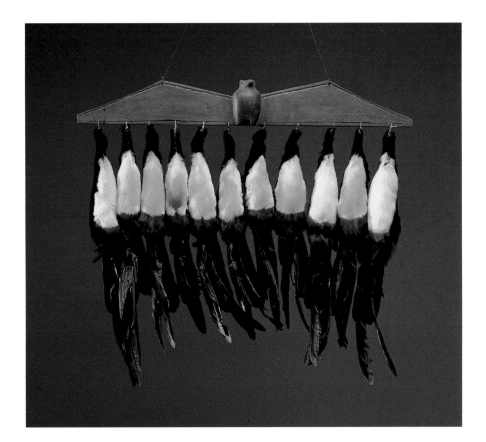

Ceremonial decoration—*ansa*
YE'KUANA
Wood, toucan skins, fibers of the moriche
palm *Mauritia flexuosa*

Ritual ornament in the shape of a bat
carved of wood to which several dried
toucan skins are attached. The shaman
places this decoration, together with a
string of boar's teeth, across his shoulder
for dance rituals.

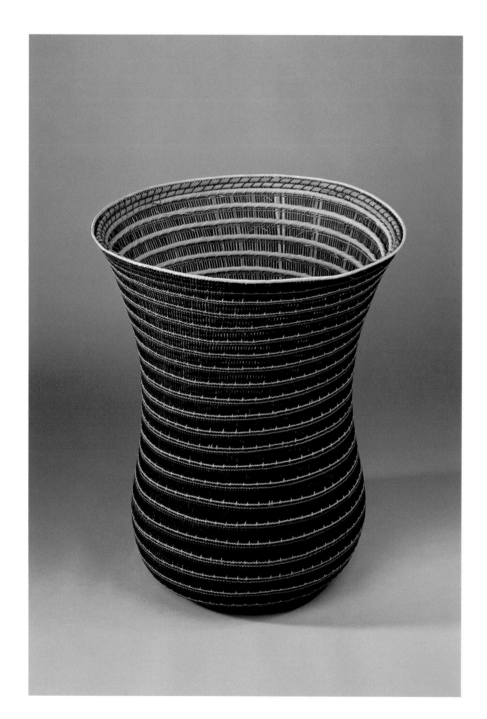

Basket—*wɨwa*—twining technique
YE'KUANA
Mamure *Heteropsis spruceana*,
plant pigment

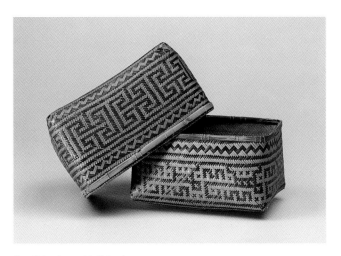

Small basket with lid—*kanwa*
Y E ' K U A N A
Wickerwork of *Ischnosiphon aruma*, fibers of *Ananas lucidus*,
plant pigment

The monkey seen with its tail coiled upwards represents the
mythical Warashiri who had hidden patterned baskets in his
carrying frame. The people did not like Warashiri since he was
in league with Odosha, the demon of death and evil. They took
Warashiri captive and discovered the secret of the carrying frame.
Then they began to weave and to imitate Warashiri's baskets
and patterns.

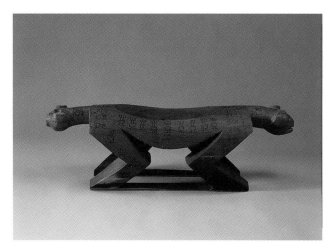

Shaman's seat—*mude*
Y E ' K U A N A
Wood, resin

The seat in the shape of a Janus-faced jaguar
is painted with anthropomorphic patterns.
The jaguar is regarded as the most powerful
of all the animals.

Grating board for manioc tubers—*tadaade*
in the making
Y E ' K U A N A
Wood, stones, resin of the *Couma caatingae*,
resin mixed with beeswax

Before the stone splinters are inserted, geometrical
guidelines are incised in the wooden board.

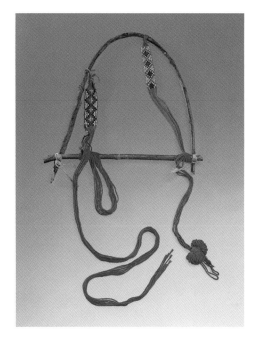

Frrame for making beaded bands
Y E ' K U A N A
Mamure *Heteropsis spruceana*, cotton thread,
glass beads, plant pigment

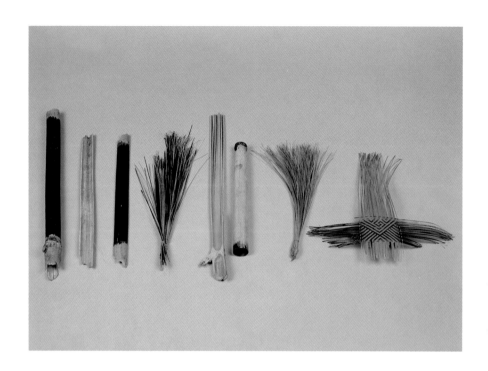

Raw material for weaving basketry trays and wickerwork sample woven in twill "weave"
YE′KUANA
Pieces of bamboo cane, bamboo bark, wickerwork of
Ischnosiphon aruma

Basketry tray—*waja*—(in the making) with representation of a monkey
YE′KUANA
Ischnosiphon aruma, mamure *Heteropsis spruceana*, fibers of *Ananas lucidus*, plant pigment

Traditionally, such basketry trays were only made by men. The flat *casabe* loaves are served on them. According to mythical tradition, the monkey brought the manioc to the people.

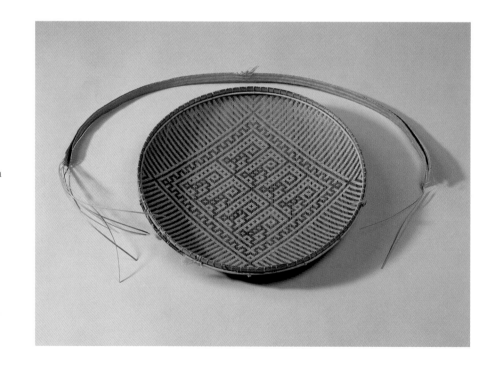

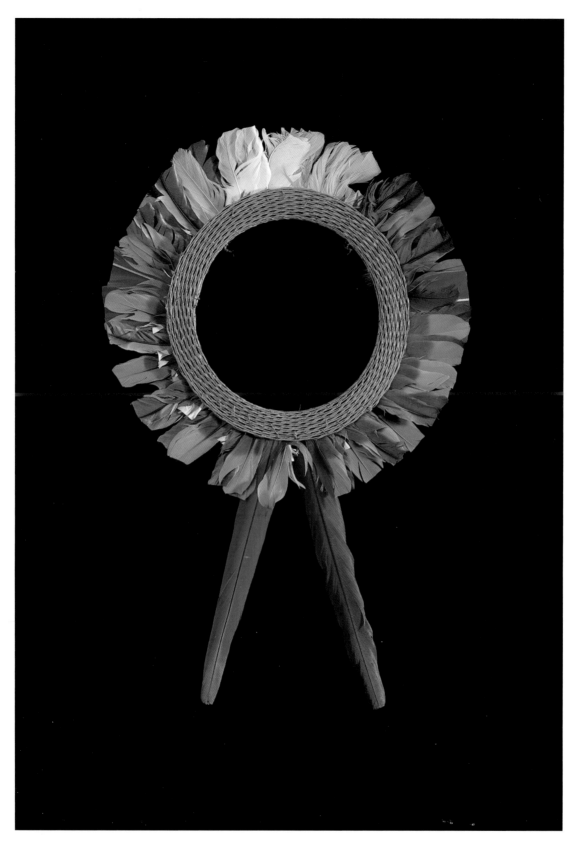

Feather crown
YE'KUANA
Parrot, starling and heron feathers, bamboo,
fibers of *Ananas lucidus*

E'ÑEPA

E'ÑEPA

The Masters of the Ceremonies[1]

Just before the sun goes down behind the mountains near the Rio Cuchivero, the E'ñepa village catches the golden light once more. The men are sitting together and talking about the events of the day, about their adventures while hunting or fishing. All the while, they are weaving the artistic round *guapa* baskets and joking and laughing.[2]

E'ñepa means "indigenous people"; this term is used by the E'ñepa for themselves as well as for their Indian neighbors. The contrasting term is *tato*, the name for all non-Indian persons. In the ethnographic literature, for a long time the E'ñepa were referred to as "Panare"; since the 70s, the name E'ñepa[3] has become increasingly common.

The E'ñepa belong to the Carib language family.[4] Their language has numerous nasal sounds and is characterized by so-called glottal stops. In the written language, the latter are represented by an apostrophe.

The E'ñepa have settled in the region of the left tributaries of the Middle

Before the sun goes down, the men sit together and weave artistic basketry trays.

The E'ñepa inhabit a barren strip of savanna south of the Orinoco.

Orinoco, in the Cedeño district of the state of Bolivar. Their territory covers approximately 20,000 square kilometers which, however, in a large number of regions they share with criollos. The so-called Southern E'ñepa, two isolated groups of villages, are found about 150 to 200 kilometers south of this area on the border of the state of Amazonas: Caño Culebra near the city of San Juan de Manapiare and Caño Iguana on the Rio Asita. In Caño Iguana as well as on the Rio Cuchivero, the E'ñepa live very close to Hodï communities.[5] At the beginning of the 80s, the E'ñepa were estimated to number close on 2,400 people, which suggests a considerable increase in population compared with earlier censuses.

Their settlement area extends over two very distinct vegetation zones. One of the regions lies parallel to the Southern Orinoco. It is an almost treeless strip of savanna about 30 kilometers long. Swampy palm groves, the so-called morichales, line the numerous rivers and streams which overflow their banks during the rainy season. The appearance of the wide llanos is characterized by enormous boulders, the geological formations typical of the Guyana Shield. The northwest of the territory consists largely of barren boulders with no vegetation. Only the higher regions in the southwest are more densely wooded and here we also find game. This is the direction the E'ñepa take on their expeditions when hunting and gathering wild fruits.

ORDER WITHOUT LEADERS

The individual settlements accommodate betwen 20 and 40 inhabitants; only rarely does the number of inhabitants rise to 90 people or more. During the past 15 to 20 years, however, under the influence of fundamentalist-evangelical missionaries, more than 400 people have come together in one "village community", a development both ecologically and economically problematic.[6]

In many of the smaller groups, the E'ñepa live more and more in houses with industrially produced sheet metal roofs and solid walls, in the manner of the criollos. In some remote areas, they still live in the big communal houses which used to be typical. Around these *churuata*, a circular house with a conical roof, smaller houses are often built where the cooking is done, or which are offered to visitors as guest houses and which also serve as storage rooms or workshops for the manufacture of handicraft. But, in former times, the E'ñepa also had smaller dwelling houses with a rectangular or oblong ground plan, and roofs thatched with palm fronds reaching down to the ground.

The roof of the *churuata* rests on several posts. The central pillar of the construction is a strong pole about eight meters long. The inside of the house is reached through a tunnel, approximately four meters in length and leading to the entrance.

Inside, everything has its fixed place, every hearth unit occupies its own living quarters where the personal possessions, hammocks, baskets and other household utensils are stored round the fireplace. A hearth unit always consists of a woman and a man. Mostly, the two are married and have children. However, this

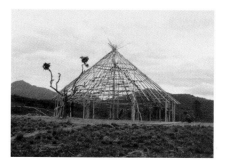

The central post of the *churuata* is a pole about eight meters high. The roof, thatched with palm fronds, rests on a grid-like construction.

smallest social unit may for instance also consist of a widow and her grown-up son.

The E'ñepa have no term even roughly corresponding to our family or nuclear family. Neither do they have a name for the extended family. When defining their own descent, the people refer to the ancestors on the father's as well as on the mother's side, although the ancestral line does not go back very far in their memory.

Older people with much insight and experience of life enjoy a certain prestige without, however, being in any way privileged because of this. The opinion of these people is respected and requested. Yet there is no political authority demanding obedience. Only the men appear to establish their position vis-à-vis the women in some matters. The lack of hierarchical power structures also shows in the fact that the E'ñepa language has no term for "chief" or "leader".

Interhuman conflicts are rare. There appears to be litte cause for arguments. Since, by tradition, everybody has free access to the natural resources and since any surplus is always jointly consumed, it is difficult to accumulate goods and gain prestige via this wealth. If tensions arise all the same, the lax residence rules allow a family group to leave the village for a while until the situation has relaxed.

Normally, the local groups form cooperative units acting in solidarity. In every-day practice, the hearth unit is the smallest organizational unit, but numerous activities are undertaken in larger groups. The division according to sex is respected in many of the tasks but also when eating: the women have their meals among themselves and the men also eat together, irrespective of the amount of food each has contributed. Surplus amounts are enjoyed by the whole group at a boisterous feast.

The men hunt and gather and cultivate the contact to the criollos with whom they trade. In addition, they prepare the gardens (*conuco*) which are then cultivated, maintained and harvested by the women. In many tasks, sisters as well as mothers and daughters work closely together. The women attend to the children, they fetch water and collect firewood. They spin cotton and on simple looms weave the men's loincloths and dye them red or paint them with ornaments. They themselves wear scanty pubic aprons.

Before the criollos settled in larger numbers in the region of the Middle Orinoco and before the E'ñepa moved to be near them because of trading opportunities, they, the E'ñepa, had lived less sedentary lives. At that time, competing for natural resources was unknown. No area, riverbed or mountain was claimed exclusively by a group or an individual. It was possible for each family to clear a plot and lay out a garden. The people were allowed to gather, hunt and fish wherever they wanted. The yield belonged to them and when they left their field because the soil had become exhausted, they also gave up their claim to this particular piece of land. This situation has changed drastically due to the influx of white people, and the attested right to property has become important. In 1976, for the first time in the history of this indigenous group, the Colorado E'ñepa community, situated near the "Los Pijiguao" bauxite mines, was granted property rights to approximately 14,000 hectares of land.[7]

At the *pajpĕto* ritual, the people bid farewell to the death spirits by loudly banging on pots and ask them to return no more.

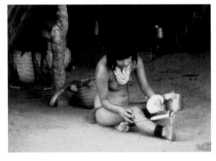

An E'ñepa woman spinning cotton.

The E'ñepa are an endogamous society which means that marriage alliances are preferably formed between close relatives.[8] As is typical for this region, the cross-cousin marriage is the preferred form of marriage.[9] The marriage takes place gradually, which means that the courtship period develops smoothly into married life. Marriage is not ceremonially emphasized by wedding rites. The groom hangs up his hammock in the living section or the house of his family-in-law and starts providing them with food. Over time and through children, the partnership among the bridal or married couple intensifies. Divorces are rare but not complicated. Sometimes, a man marries a second wife but then he mostly leaves his first wife.

The E'ñepa have adopted some of the luxury goods of the criollos; many have, however, kept their own tradition.

Contrary to other ethnic groups of the region who willingly, even eagerly, adopted European garments, the E'ñepa proudly wear their traditional *guayucos* even when visiting the settlements of the criollos.

The *guayuco* is a pubic apron woven from cotton and dyed red with *onoto*. Large tassels for decoration are attached to the four corners of the strip of fabric which makes up this loincloth. The apron is tied round the waist with a belt made of human hair. The bands wrapped round the calves are also made of hand-spun human hair. The young people decorate the upper part of the body with red woven cotton bands with tassles crossed over the chest. Strings of colored glass beads are a great luxury for them. In addition to decorating their bodies with cotton and glass beads, they also paint their skin. For this, stamps in a variety of patterns, shapes and sizes and carved out of soft, light wood, are used.

The geometrical patterns of the body painting hide magical aspects. One of the most important emblems denoting potential powers—also wielded by the shaman—is the anaconda snake inhabiting the spiritual worlds of many Amazon societies together with the toad, the tiger, the monkey, the lizard and other animal spirits.[10]

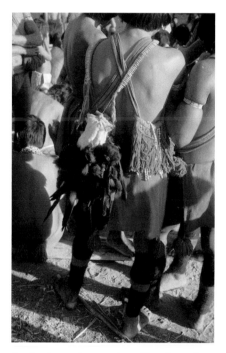

Festive decoration consists of bands made of cotton and hair and of colorful bird skins.

Many of these motifs are also found in the various artistic patterns the men weave into the shallow basketry trays, the *wapa*.[11] Apart from the basketry, the men also make festive ornaments and musical instruments such as rattles, pan pipes, clapping sticks, the two clarinet-like flutes and the two *karamatoimë* always played as a duo. [12] The two clarinets are one to two meters long and refer to the two sexes, with the male *karamatoimë* producing a lower sound than its female counterpart.[13] The nose pipe, *maijkooya*, the only instrument formerly allowed to be played outside the ritual context, is no longer used today.

The women avoid touching the flutes and the clarinets of the men. They play their own musical instruments such as the *chirijko*, a rattle stick with bundles of toucan beaks and/or peccary hooves attached. They produce clattering sounds as the women rhythmically beat them on the ground while singing and dancing at feasts.[14]

The rattles (*maraca*) of the E'ñepa are plainer than those of their neighbors, the Ye'kuana. They consist of an undecorated calabash attached to a stick. It is filled with small black fruit seeds that with every movement produce the characteristic sound. "With the *maraca*, we start the dances and the songs. There is only one *maraca*. We never play two *maracas*, like the criollos. When we move it back and

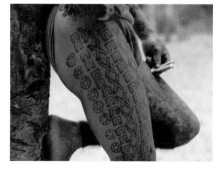

The geometrical patterns of the body painting hold magical power, the banknotes economic power.

The long *karamatoimë* clarinets are always played in duo. The "male" produces a lower sound than the somewhat smaller "female" clarinet.

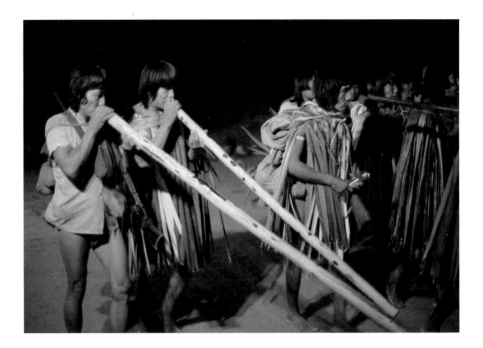

forth, we are calling the *ko'cham* spirits, the death spirits, to make them come and to make them go. During the big feasts—the feast of the loincloth or the funeral feast—not everyone is allowed to play the rattle. This is the task of O'chi'chen, the master of the *cachiri* feast." This is what an old shaman has to say on the significance of the *maraca*.[15]

SHAMANS, HEALERS AND THE FIRST LOINCLOTH

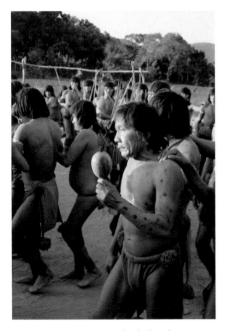

The rattle, *maraca*, is only shaken by shamans accompanying the dances and songs of the E'ñepa. With the rattles, they call the *kocham* death spirits to make them come and again to make them go.

The religious leader and shaman of the E'ñepa is the I'yan. He fullfils various functions within his group: he is a healer, he performs all the rituals related to the life cycle of an individual, and he knows the songs and ritual acts to protect his people from evil supernatural beings and from diseases. Often, he also has a certain political prestige.

Training to be an I'yan takes several years and is supervised by an older and more experienced shaman. Women rarely take on this position but are not excluded on principle.[16] The candidate isolates himself for some time from all group activities; he follows a strict diet without greasy, sweet, spicy or fermented food. He practices the consumption of strong psychoactive drugs made from tobacco and other substances whose power—so he believes—accumulates in a mass in the lower part of his chest. From this matter, the shaman candidate summons up his spiritual power.

A close relationship exists between the I'yan and certain animals whose form he is able to take on. They are his spirit-helpers and he shares his destiny with them.

"The shaman learns to fly like the birds. To be able to do this, he has to have among his intimate friends some birds that accompany him all his life. He has to

catch them one by one, never together [...]."[17] The most important magical objects—material as well as non-material—are called *i'nankën*. They are quartz stones or also invisible jaguars, snakes, birds and other animals. With the help of the quartz stones, harm can be done to enemies at long range. The jaguars are the symbolic expression of ambiguity: they personify both healing and destructive powers. In a state of trance, they are employed for the extermination of enemies.

If an E'ñepa falls ill, the people see this as a problem involving the *inyoto*, the soul or better: the vital principle. If the latter separates from the body and, during sleep, goes on a journey, it is highly susceptible to sorcery. Black magic is caused by evil spirits in the form of animals shooting invisible arrows at the soul. This is how people fall ill. The I'yan treats the disease by sucking the painful body parts of the person affected to draw out these arrows.

In former times, it was also one of the I'yan's tasks to conduct the ritual cycle for the initiation of the boys. These feasts take part during the dry period. Since only very few I'yan are left today, a relative of the initiate often takes his place.

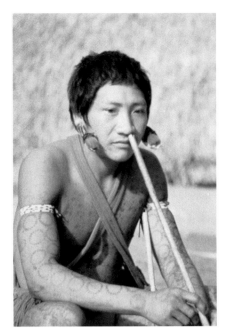

Majkooya, the nose flute, is hardly played at all nowadays.

The festive cycle which is held every three to four years and lasts for two to three months, includes a series of dances and festive acts. The initiation of the boys, aged between 10 and 13, plays an essential role in it. A first important stage is the piercing of the nasal septum of the initiates. They are now allowed to wear a special headdress with parrot feathers. Subsequently, the *kaimo* feast is celebrated for which smoked meat from game—*kaimo*—is stored in large baskets on top of the beams in the communal house. During this time, the men perform the tasks typical for women in everyday life: they bring back the bitter manioc to make *casabe* which is eaten with the smoked *kaimo*. This ceremony is accompanied by songs and the peculiar sounds of the *karamatoimë* clarinets. In the course of the feast, the women ritually attempt to steal the *kaimo*. Such rituals, while superficially calling the gender roles into question, basically serve to make the core principles of social life manifest—the division of labor according to sex and the respective areas of responsibility of man and woman. The culmination and close of the festive cycle is a dance where their first loincloth is given to the initiates.[18]

The E'ñepa shaman Yoroko describes the *katyayïnto* feast as follows: "When the moon catches up to Venus, the 'Star of the big Eyes', the night has already progressed. Then the festive procession moves slowly to the rhythm of the *karamatoimë* clarinets. [...] Men and women paint themselves with *onoto* and decorate their bodies with patterns and long strings. Some are wearing a new loincloth. The dance pole has been erected near the *churuata*. The 'Lord of the *cachiri*', the leader of the feast, starts moving the *maraca* back and forth and begins the song: *Ah ...eh...oh...* Then the dance around the pole starts. Only the men and those boys already initiated are dancing, decorated with their capes of palm fronds and the crowns of parrot feathers. *Che...che...che...*, that is the sound of the *chirijko*, the clapping stick made from toucan beaks. The wife of the festival leader knocks it rhythmically on the ground. Now the women enter the circular dancing ground and drag their feet across the ground in the same rhythm. The dances continue, inside and around the *churuata*. [...] The men utter shrill cries. In between times,

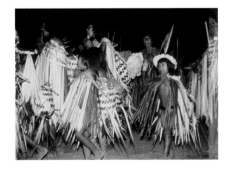

Ritual dance of the young initiates at the feast of the loincloth.

The initiates are festively decorated and for the first time allowed to wear the headdress with the macaw tail-feathers.

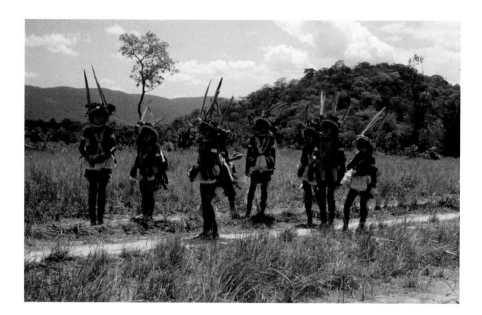

At the initiation, the godfather puts the first woven and painted loincloth on the little boy.

there are intervals for drinking *cachiri*, playing the *karamatoimë* and resting. They sing in honor of the morning, in honor of the *maipijpë*, the painted bands made of tree bark, the *tarekoe*, the capes made of palm fronds, the *amsiriyën*, the strings of monkey teeth, the *chipukopijpe*, the decoration made of toucan skin, of the *akatya*, a boy's first loincloth, and in honor of the *wuariputesa*, the boys being celebrated. These latter keep to themselves. For the duration of the feast, they are not allowed to play with the other children. After having met with their godfathers before the feast, they are not allowed to look at anybody else anymore. They have to direct their eyes to the ground and support themselves on their sticks. After every dance, they remain standing still; some of them have the strain written all over their face. The feast lasts the whole night. The next day, the baskets are opened. *Kaimo* and *casabe* are distributed while *cachiri* is still being drunk. [...] At the beginning of the afternoon, the culmination of this long feast finally arrives. Every boy has his first loincloth tied around him by his godfather who also puts all his decorations on him. Then they dance in the *churuata* for a last time. The boys sit down in the *kanowa*, the large trough shaped like a canoe, while a woman beats the sides of the *kanowa* as is customary for chasing away the *ko'cham*, the death spirits [...].[19]

MYTHS AND THE EXPULSION OF THE DEATH SPIRITS

The elaborate feast liturgies of the E'ñepa contrast sharply with the relatively seldom observed custom of reciting mythical events and making religious contents the central theme in conversations.[20]

In the concept of the E'ñepa, Mareoka created everything: fire, water, sun, day and night, plants and animals, in order that the people should have food. Like all culture heros, Mareoka revealed to the E'ñepa the secrets of their culture: he showed them how to use their cultural possessions and which plants could be

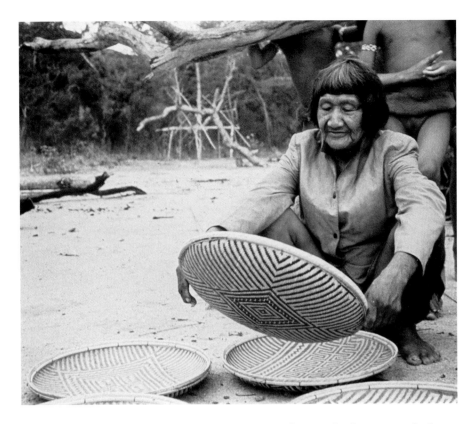

Ideally, all the rituals are conducted by an I'yan, an old, experienced shaman.

eaten and which could be used for healing. He also taught them to make hammocks and blow-pipes, basketry, flute playing and festive songs.

In mythical times, the E'ñepa lived in *arewa*. One day, they were visited by Mareoka: "Mareoka asked every one of them: what would you like to become? Would you like to become a red deer or a caiman, an armadillo, a turtle or a monkey? He gave everyone a name and thus we came to know all the animals. Some E'ñepa did not want to be transformed and so remained human beings."[21] This was how the E'ñepa ancestors' metamorphosis into tapirs, armadillos, monkeys, birds, crocodiles took place and they are still "people in the bodies of animals; this is why they must not be eaten". In addition, he created the snakes which originally were the little blow-pipe arrows of a shaman. Those containing *curare* became poisonous snakes.

The E'ñepa believe the soul or the ideational principle of a person to be the direct life force manifesting itself in the chest and in other parts of the body where the pulse can be felt. A person dies when this soul principle leaves the body for good; it is then transformed into the *ko'cham*, the death spirits. Leave is then taken of the soul with funeral dances and special songs so it may enter the realm of the dead—*arewa*. This place in the next world lies in the sacred mountain at the Upper Cuchivero where, according to mythological tradition, the E'ñepa came from.

Like the boys' initiation, this ceremony, the *pajpeto*, ideally is conducted by a shaman. He begins to sing the mourning songs which vary depending on the prestige, age and sex of the deceased. While the songs and dances for the deceased continue, the ancestral spirits return, since they feel the longing of their living relatives, and try to take these with them to *arewa*, the land of the dead. Then the

I'yan has to induce the *ko'cham* spirits to withdraw again so that the members of the community are able to leave their houses without fear once again.[22]

They dance for many hours in the closed house. Then the men as well set out on the trail that leads in the direction of *arewa*, making a lot of noise by banging on pots. The noise chases away the evil spirits and enables the living to live.

1 This contribution is based primarily on the article on the E'ñepa by Paul Henley (1988). In the following, only in connection with additional information will this source be referred to. Further secondary literature will be listed separately.

2 On the art of basketry among the E'ñepa and other ethnic groups, cf. the article "Basketry—signs and changes of cultural identities" by Marie-Claude Mattéi-Müller in this catalog.

3 Maria Eugenia Villalón calls them E'ñapa.

4 On the language of the Panare-E'ñepa, see: Mattéi-Müller (1994).

5 Henley (1994, pp. 264–267)

6 These data are derived from Paul Henley (1994, p. 265). As early as 1988 when the E'ñepa group of Colorado already numbered 226, Henley raised the critical question whether this community—although comprising a considerable portion of the whole ethnic group— could be seen as representative of their traditional culture.
In the following six years, up to his publication in 1994, the influx into this Colorado group had even increased considerably.

7 Henley (1988, p. 294)

8 On the kinship system of the E'ñepa, see Wilbert (1966, pp. 36–42), Villalón (1978) and Henley (1988, pp. 257–263).

9 For a representation of these kinship relations cf. the article "Sharing and exchanging— reciprocity in the life of the Yanomami" by Gabriele Herzog-Schröder in this catalog.

10 Cf. also the contribution "Decked out in borrowed plumes" by Ulrike Prinz in this catalog.

11 Cf. the article "Basketry—signs and changes of cultural identities" by Marie-Claude Mattéi-Müller in this catalog.

12 *aramatoimë* is a term synonymously used in certain regions for *karamatoimë* (Mattéi-Müller, 1994, p. 20).

13 Mattéi-Müller (1994, p. 108)

14 Mattéi-Müller (1994, p. 75)

15 Mattéi-Müller (1992, p. 47 ff.). Translation from the Spanish original by Gabriele Herzog-Schröder.

16 Personal communication from Marie-Claude Mattéi-Müller to Gabriele Herzog-Schröder.

17 Mattéi-Müller, Marie-Claude: *Yoroko—Intimate reports of a Panare shaman* (1992, p. 96). All the passages taken from this publication have been revised by Gabriele Herzog-Schröder on the basis of the Spanish original.

18 Henley (1988, p. 282)

19 Mattéi-Müller (1992, pp. 65–66)

20 Against this background, the collection of myths by Mattéi-Müller (1992) is particularly valuable.

21 Mattéi-Müller (1992, p. 24)

22 Henley (1988, pp. 279/281)

MARIE-CLAUDE MATTÉI-MÜLLER[I]

BASKETRY

SIGNS AND CHANGES OF CULTURAL IDENTITIES

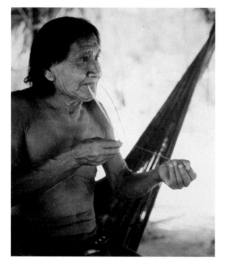

The *itiriti* cane has to be peeled first. Apart from the knife, the only tools necessary for weaving are the fingers and the teeth …

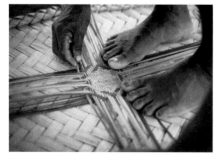

… and sometimes the feet.

Without doubt, basketry is one of mankind's most widespread handicraft activities. It is practiced on all the continents, in almost every culture, independent of their technological stage of development, thus in the industrial countries as well as among the so-called "primitive peoples". It is one of the most ancient technologies and possibly one of the simplest since, in general, only one single tool, a knife, is needed in addition to the basket-maker's fingers and teeth. But this does not mean that there is no wickerwork made in an extremely complex way. One example is the woven tubular squeezer needed to prepare bitter manioc. It is a fact that the history of basketry reaches back to the very early epochs of mankind. Thus traces of woven fibers have been found on ceramics as far back as the Neolithic period. However, indications allowing us to date precisely the origin of basketry are quite scarce since, due to its rapidly decaying plant material, this technique carries the seed of its own "death" inside it. The plant fiber which dominates in basketry does not stand up to time as do, for instance, flintstone, metal or fired clay.

The whole tropical belt—above all the wooded part, less so the savannas—anywhere in the world, in Asia, Africa or America, all year round offers an almost unlimited variety of different plants, above all palms, lianas or other vines, reeds, rushes and roots to be used in basketry. It is therefore not surprising that the most magnificent works of basketry—from the technical as well as from the esthetic point of view—are still today produced in these particular regions of the world.

The basketry of the Orinoco cultures of South America also has all these characteristics. The population groups producing by far the most varied and most artistic works of basketry in this area belong to two of the large Amerindian[2] language families and live on Venezuelan territory: the Caribs and the Arawak groups. Others, such as for instance the Yanomami and the Hodï, produce considerably plainer basketry.[3]

In his research of the basketry of the Desana living in the Columbian Amazon region, Gerardo Reichel-Dolmatoff shows that the indigenous languages of

Columbia have no comprehensive term for the whole range of objects made from plant fibers.[4] This also goes for the languages of Venezuela. Neither does "basketry" appear to correspond to a classificatory category in the Amazon cultures. The decisive factor in naming the woven objects is in principle their form and even more so their function, regardless of the material used. By the way, the (German) term "Korbflechterei"—and the same may also be said for the English "basketry", the French "vannerie" or the Spanish "cestería"—expresses neither the range nor the variety of the products of this artistic handiwork. The basket itself is only one of them. In addition, there is a whole series of objects, varying in shape, size and use, which do not fit into the category of "basket": fans, sieves, strainers, presses, mats, hats, headdresses, weapons, fish traps, cages, quivers, musical instruments, partitions, bags, boxes, plates, ornaments and various coasters.

Indeed one of the most important features distinguishing basketry from other handiwork—such as pottery, sculpture or carving—is precisely the multiplicity of its functions. Otis Mason[5], probably the best expert on Amerindian basketry, documented 116 different possible uses, from kitchen utensils to garments and decorations. However, anthropologists agree that basketry has special significance in connection with a further essential cultural activity, namely eating. The preparation of food is the axis around which all these activities turn: basketry objects are produced with the most varied techniques and materials for gathering, carrying, storing, drying, grinding, pressing, sifting, straining, forming, mixing and even cooking and serving, and boats for fishing and hunting are also woven. Apart from that in the kitchen, basketry plays an important role in the most varied aspects of domestic life, in the context of social relationships, in trade and also in ceremonies.

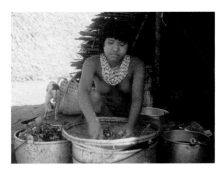

Basketry is used in various ways in the preparation of food. A Panare woman kneads pumpkin pulp on a basketry tray.

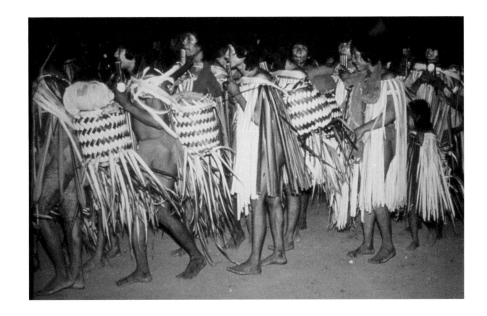

At festive rituals, the dancers wear capes made from palm leaves and carry two-colored baskets especially made for this event.

NATURE'S GENEROSITY: THE VARIETY OF RAW MATERIALS

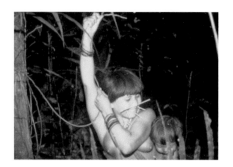

In the forest, a Yanomami woman collects *mamure* vine from which the large carrying baskets and basketry trays are woven.

There is a series of basic materials known to almost all Amazon groups. However, not every ethnic group uses these plants in the same way. Thus, for example, vines or aerial roots[6], known in Venezuela by the name *mamure*, are used extensively by the Yanomami who weave nearly all their baskets from these lianas which are up to 30 meters long and approximately four to nine millimeters in diameter. On the other hand, their neighbors, the Ye'kuana, until 20 years ago used *mamure* sparingly and exclusively for the baskets woven by women, while the majority of the other baskets, traditionally made by men, were mainly woven from various species of bamboo, canes and palms. A further group, the Panare-E'ñepa, living close to the Ye'kuana, never weave baskets from *mamure* but only use it for fastening, especially in house building. They prefer rushes and the leaves of various palms. As we are this year celebrating the anniversary of Alexander von Humboldt's journeys to the equinoctial regions, it is well worth pointing out that it was he who first mentioned the *mamure* aerial roots: "The Indians assured us that masses of vejuco de maimure were growing in the forests on the Sipapo. This vine is very important to the Indians since they produce baskets and mats from it."[7] Of all the plants playing a significant role in basket-making in the whole Orinoco region, the palms have to be emphasized, above all the moriche palm (*Mauritia flexuosa*), the chiqui-chiqui palm (*Leopoldina piassaba*) and the large and small seje palm (*Oenocarpus bataua, Oenocarpus bacaba*), the coroba palm (*Oenocarpus polycarpa*) and the cucurito palm (*Maximiliana regia*). The E'ñepa use the leaves of the coroba or the cucurito palm for their carrying baskets while the Warekena prefer the leaves of the seje or the chiqui-chiqui palm depending on the geographical distribution of the respective palm species that grow in different ecosystems. Thus, for example, the coroba palm grows mainly in the state of Bolívar, more rarely in the state of Amazonas, and the distribution of the chiqui-chiqui palm is limited to the blackwater areas, which is why today the Arawak groups of the Rio Negro use this material exclusively. Weaving from material of the moriche palm, as is customary among the Híwi and above all among the Warao in the Orinoco delta, has only been practiced for about 30 years. All the other groups use these leaves to thatch the roofs of their houses but not for weaving.

THE CULTURE OF THE BITTER MANIOC: THE SACRED ITIRITI

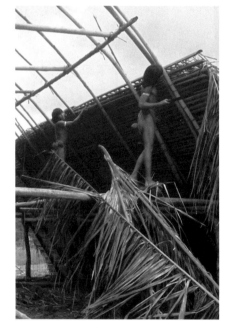

Mamure vine is also used in building the *shapono* to tie the beams and posts together. The palm fronds or leaves to thatch the roof are also secured with *mamure*.

There is no doubt that the plants of the *Ischnosiphon* species, the maranta family, called *itiriti, itirite* or *tirite* in Venezuela, play an extremely important role. Because of its stability and flexibility, *itiriti* with its long, smooth stalks offers a variety of possible uses. The local Indians themselves repeatedly stressed the significance of these plants. In some societies, a heavenly, magical origin is ascribed to them,

others see them as powerful, even as dangerous if a weaver were to break certain rules. For the Ye'kuana, *itiriti*—*ka'na* in their language—was brought from heaven to earth by Edodicha, an ally of the creator Wanadi, while bamboo—*wana* or *eduduuwa*—came from Warishiri, the spider monkey, an ally of the demon Odosha: "Unlike the *waja tomennato*[8] which consist of either *wana* or *eduduuwa*, the loosely woven baskets can only be made from *ka'na (itiriti)*, the sacred cane brought to earth by Edodicha. This shows that the originally mythical opposition between Wanadi and Odosha has been transferred onto the choice of the materials necessary to make the baskets. Due to its heavenly origin, the *ka'na* of the *kutto shidiyu* guarantees that all food is consumed on pure material and touches neither anything unclean nor profane."[9]

Among the E'ñepa, the *itiriti*—in their language *mananke*—belongs to Amana, the Snake Spirit, boa and coral snake at the same time, whose breath turns into a rainbow—*amana tachi*, literally "the breath of Amana". Amana is an evil being killing people with its arrows. The basket-maker has to know where and when he may cut his or her stalks without provoking Amana's anger. Many groups know this fear of the owner-spirit of the *itiriti*. It is why scraps of bark from the stalks are not simply treated as garbage.

The Warekena, one of the Arawak groups of the Rio Negro,[10] represent the leaf of the *itiriti* itself on their large sieves. This is always a motif in two colors where a black and a red square are superimposed. An old Warekena explains: "[...] you do this to show the *tirite*, so the *tirite* and its leaf become very clear to the people for this plant has been sent to us by Napiruli [the highest creator of the Warekena]."[11] Although this is obviously an abstract representation, a kind of optical game, this design, called *chújwa-kakami*—"leaf of the *itiriti*"—in the Warekena language, could actually be the result of empirical observations because of the asymmetrical composition of the leaf.[12] The use of the *itiriti* is closely connected with the preparation of the manioc tuber, especially the bitter manioc. From the various species of bitter manioc, *mañoko* is produced. The grated mass is turned into *casabe* loaves and the boiled juice serves as the basis for *catara*, an excellent sauce seasoned with peppers and large ants. The sieves for the manioc flour, the strainers for the manioc dough and the most indispensable utensil for the preparation of bitter manioc, the tubular squeezer tube, *sebucán*, consist of woven *itiriti*. The *sebucán* may be up to two meters long and is the most complex product of Amazon basketry. It is used to squeeze the toxic, prussic-acid-containing juice from the manioc pulp. In their study on the basketry of the Ye'kuana, Hames and Hames write that 10 out of 18 baskets are partly or totally intended for the preparation of manioc.[13] This basic food of many Amazon groups appears to have been of prime importance for their basketry and particularly in the use of the *itiriti*.

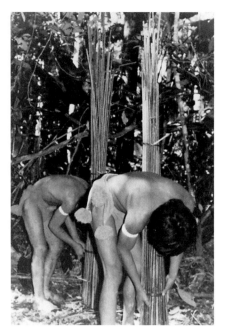

Handling the raw materials calls for an attitude of respect. The cut *itiriti* is carefully tied into bundles.

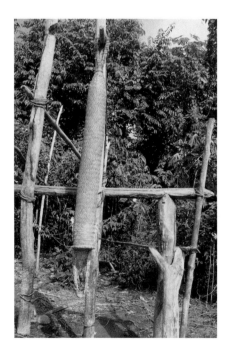

The *sebucán* is the most important basketry product of the Carib manioc cultures. It is used to squeeze out the toxic manioc pulp.

A woman turning *casabe*, the large manioc loaf which is baked on a griddle.

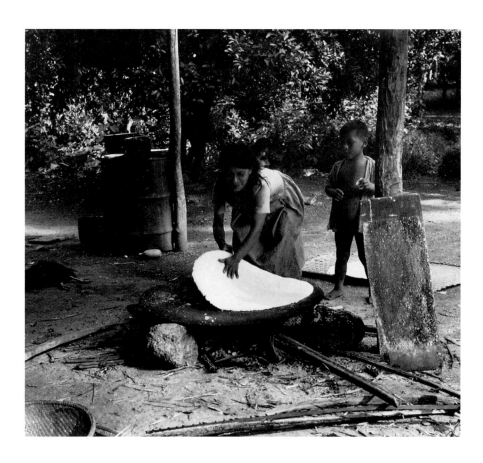

THE YE'KUANA:
MASTER BASKET-MAKERS OF VENEZUELA

Of all the Carib groups of Venezuela, the Ye'kuana have best succeeded in keeping their basketry alive, varied and—in many respects—innovative despite the increasing distribution of plastic and metal. Koch-Grünberg who, between 1911 and 1913, had the opportunity to visit various Ye'kuana communities of the Caura, Ventuari and Alto Padamo, wrote: "The small, round basketry trays, woven in black-and-yellow patterns, in which the manioc loaves are served, are of outstanding beauty. They are true works of art, in the refinement of the weaving strips and the overall finish far surpassing similar products from their eastern neighbors and the tribes of the Upper Rio Negro."[14] To this day, the Ye'kuana are the most artistic basket-makers of the Orinoco region.

Allegedly, the Ye'kuana are the only people who, in addition to *itiriti*, in making their round decorated basketry trays also work with bamboo cane (*wa'na*) customarily used only to make spears. However, this material mainly serves the Ye'kuana for making robust basketry bowls. Whatever the material, cutting and preparing first of all requires training, including knowing the plants, their life cycle, the cutting method and, not to forget, the consent of the owner-spirit.

"First, we learn how to cut the cane properly for if the cut is not done right, the cane does not grow again; and it is also important to have the consent of the spirit of the canes before we cut them. The *achaadi*, the wise men and ritual specialists, take on the task of speaking with the spirit and asking it for its consent by

telling it the use for which the cane is being cut. Only after they have obtained its consent do we cut the strong and smooth stalks. There are many similar kinds of cane, one has to know how to distinguish them. The quality and the beauty of the baskets depend on it. Then we learn to prepare the different materials, to dry them, to dye them and to cut the canes and the lianas until each piece is the right size, shape and strength for the respective type of basket."[15] A further characteristic of Ye'kuana basketry is the use of clay to dye the *mamure* strips black, a technique which, although found in other South American ethnic groups as well, such as the Embera-Chamí of Columbia, has not been established for any other group from the region between the Upper Orinoco and the Parima range. The black coloring is achieved by immersing the boiled fiber strips in black clay. "Where there are earthworms, the black is often darker", according to a woman basket-maker in Boca del Ninchare. Depending on the composition of the soil and on the hue of black or grey the woman basket-maker wants to achieve, the *mamure* strips remain in the clay for one to two weeks. Then the strips are taken out, boiled together with the dried leaves of chica (*Bignonia chica* HBK) and dried in the sun. Black coloring may also be achieved with other substances such as *caruto* (*Genipa americana*) or with certain techniques, mainly by mixing specific resins with charcoal.

If the chica leaves are boiled together with the liana fibers, a number of pretty colorings from pink to dark red to purple result. The chica plant, frequently mentioned by the first historians (Gumilla, Gilij, Humboldt) since it was not only used in basketry but also in pottery, is not in use at all today among the Indians of Venezuela apart from the Ye'kuana. All other societies obtain red from *onoto* (*Bixa orellana*) by smearing the paste on the already woven baskets, or by means of a liquid color used to dye the strips. To fix the color and achieve more shine, the Ye'kuana mostly use the sticky sap of a tree they call *arukuni*.

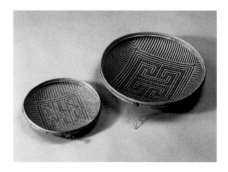

Two Ye'kuana basketry trays woven in twill "weave".

ICONOGRAPHY:
THE FIGHT BETWEEN WANADI AND ODO'SHA

In his informative analysis of the basketry of the Ye'kuana, David Guss discovered the close connection between shamanistic power, mythical thinking and basketry.[16] As has already been mentioned, gathering the fibers is subject to specific rules the basket-maker has to follow unless he wants to bring serious harm on himself or his family. But the baskets themselves as well may be powerful, even dangerous, and turn into man-eating monsters if a shaman wishes it. When old Maha'noma wanted to take revenge on the Shiricheña—a group calling itself the "star people"—he "loaded a stack of carrying baskets into the dugout canoe and threw them into the water. He threw in one which turned into a water snake, another one which turned into a caiman, the next into an alligator, the next into a piranha, the next into a ray. The lagoon filled up with creatures and *mawari* demons. Maha'noma was weaving and weaving and throwing in his carrying baskets."[17]

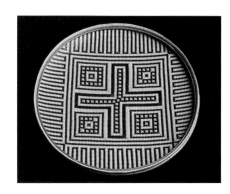

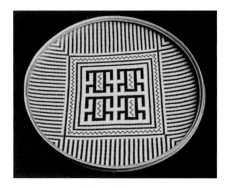

The patterns of the basketry trays are fascinating with their severe geometry. Many designs refer to figures from the mythical past. The cross motif is called *Wanadi motai*, "Wanadi's shoulder". The frog motif, here the sleeping frog, recalls the wife of the culture hero.

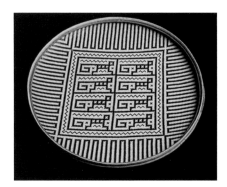

The figure with the tail curled downwards is Yarákaru, the white monkey. This nephew of Wanadi was in league with Odo'sha. He brought the night into the world.

The patterns on the basketry trays are for the majority graphical representations of the culture heros from the mythical past: Wanadi and Odo'sha. Wanadi is the creator, a heavenly being, symbol of life and of goodness.[18] Odo'sha is a demon, an earthling born from a rotten placenta, symbol of death and of evil. Since he wanted to be the ruler of the world, he fought against Wanadi. The allusion to Wanadi is deduced from the name of two typical patterns: *wanadi motai*, literally "Wanadi's shoulder", represented by two x-shaped crossed lines. It is also called *wanadi tonoro*, "Wanadi's bird" and refers to the woodpecker on whose black back some small white feathers form a V. The other, more pictorial pattern represents a frog. This is *wanadi hiñamohïdï*, literally "Wanadi's wife", or the frog *ke'kwe*.

According to myth, Wanadi had to take on various forms to free his wife Kaweshawa from maltreatment by the curassow-man Kurunkumo. As the sloth-man, Wa'de, he appeared at a feast and then "he turned into a cockroach. He turned her (Kaweshawa) into a cockroach as well. Thus they both crawled like spirits towards the mountain of meat. They ate and ate [...] jumped onto the main pole in the middle of the house. They jumped. When like spirits they arrived on top, Wanadi turned into a woodpecker but she turned into a frog [...]. He flew far away carrying his wife, the frog, in his beak, upwards and downwards. They came to a high tree called *faru hidi*. It was the sky. When they arrived there, the bird climbed down the trunk and they turned again into the man and the woman they were in reality."[19]

Allusions to Odo'sha are even more frequent on the decorated baskets. He is represented by *woroto sakidï*, literally "the image of Woroto", according to Guss a different name for Odo'sha himself: the pattern is said to resemble more closely the "face painting of the devil" or a "death mask".[20] Very similar to this design is the so-called *mado fedï*, literally the "face of the jaguar", apparently in connection with fear, death, finally with Odo'sha himself. Odo'sha's allies, the *mawari*, evil mountain goblins, are represented on the *mawari e'sadï*, literally the "inside" or the "house of the *mawari*", whose graphical expression is also a variant on the "patterns of the Woroto". According to legend, these patterns were indeed copied by Warashiri, the monkey man who had hidden baskets with woven ornaments in his big pannier.[21] Warashiri was a cannibal; he was in league with Odo'sha. But the people took him captive and discovered the secrets of his pannier. They saw the baskets. Thereupon they started to weave and to copy the baskets of Warashiri. This is why the figure of the monkey man Warashiri appears on the baskets. The other monkey, the one with the tail curled downwards, is Yarákaru, the white monkey. As a human being, Yarákaru used to be a nephew of Wanadi, but, prompted by Odo'sha, he opened the shrine where Wanadi kept his power, his tobacco and also the night. When he opened it "night fell. [...] Thus darkness came into our world, it was Yarákaru's fault [...]. He became blind. He could never see the sky or the earth again. He became frightened, ran away in the semi-darkness, not like a human being but like a white monkey."[22]

A further figure associated with Odo'sha is the snake whose graphical representation may appear on all the objects of Carib basketry. Roth also discovered it

on the baskets of the Waiwai of Northern Brazil.[23] It is also found on the baskets of the E'ñepa. The Ye'kuana call it *awiiri*, coral snake, and it appears on the baskets beautifully outlined like a kind of right-angled spiral. Guss brilliantly sums up this juxtaposition of basketry and myth: "By adopting the baskets of the *warashidi* cannibals, the Ye'kuana re-enacted Wanadi's epic fight against Odo'sha."[24]

It should be mentioned that the choice of pattern made by the basket-maker is not accidental. In former times, a young man was only allowed to choose the pattern for his first basket with his father's consent. This basket, intended as a gift to his wife, in a certain sense had to be the sign of this union, especially since these patterns had to be repeated on all the following baskets. However, this tradition reported by Guss does not appear to be valid anymore today.

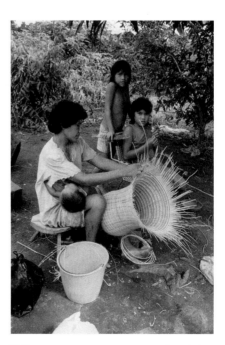

The "face of the jaguar" in the *mado fedï* pattern frightens the beholder. It is associated with the death-bearing demon Odo'sha.

WOMEN: PROTAGONISTS OF THE NEW YE'KUANA BASKETRY

In the Carib cultures, as also among the Arawak, basketry is traditionally a man's job. It is a privilege and the duty of a man to weave the majority of the baskets required in the family. The women are allowed to help gathering and preparing the raw material but they do not partake of the status granted to the men through basketry. But, in actual fact, the Ye'kuana women also weave. Their technique, the material and their products differ from those of the men: they make exclusively deep, highly robust carrying baskets (*wïwa*) for wood and manioc tubers and those with a narrow opening (*setu*) for storing cotton, pepper or other small things. They only use *mamure* vines whose fibers they twine in a spiral while the men use *itiriti* and palm fronds which, depending on the material, they turn into serge-like[25] or hexagonal wickerwork. Nowadays, the proportion between men and women in the production of basketry has drastically changed. For more than ten years now, the men have woven increasingly fewer and fewer of the decorated baskets intended to be sold. They pursue different, better-paid activities such as building dugout canoes or cultivating and selling coffee, they work as guides or motorcyclists transporting people or goods, or serve in a government office—in health care or in schools. Some of the men have no skill in the art of basketry anymore and buy their manioc squeezers and sieves from other Ye'kuana. On the other hand, more and more some of the women have started to make baskets for sale, and in a community on the Upper Caura, women basket-makers tried to copy a few patterns from the *wajas* to make them more attractive. This development started 25 years ago. In the beginning, they imitated geometrical patterns such as zigzags or the concentric rhombs *wayamu kadï*, meaning literally "similar to the morrocoy" because of the similarity with the markings on the shell of this turtle. Then they started depicting the monkey and the frog. They showed it to the women of the neighboring community of Santa Maria de Erebato and thus a new generation of women basket-makers originated along the Caura and its tributaries and who today offer magnificent colorful pieces decorated with a wide vari-

Ye'kuana women weave *mamure* vines into their *wïwa* carrying baskets which traditionally had no patterns.

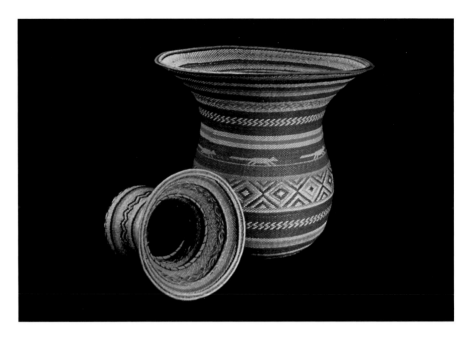

Over the last 25 years, some Ye'kuana women have started developing their *wïwa* carrying baskets into artistic decorative baskets by weaving into them colored patterns known from the basketry tray tradition. These new baskets fetch considerable prices on the art market.

ety of figures like the armadillo, curassow, duck, deer, fish, dog and even the *churuata*, the communal house. Since these new baskets are intended exclusively for sale, some of the women—free from the constraints of tradition—invented their own designs and bravely introduced new colors, new shapes, new sizes. Until now, this new basketry made by the women has only further developed on the Caura where missionaries assist in the transport and the sale of the baskets. In the meantime, some of the men are trying to take up the manufacture of the decorated *waja* basketry trays again and to modernize them. Recently, *wajas* from some Ye'kuana communities of the Ventuari are to be found with innnovative elements in the distribution of colors and in the patterns. Little by little, the marketing conditions for these new handicraft products are also being improved.

INNOVATION IN BASKETRY: THE PANARE-E'ÑEPA[26]

Basketry among the E'ñepa who, like the Ye'kuana, belong to the Carib people, is also by tradition closely connected with the preparation of manioc. The E'ñepa live dispersed over a large territory and, depending on the geographical location—in the vicinity of a mine, a mission or a large city—they are exposed to various influences and impressions. Their encounter with some Ye'kuana basket-makers at the end of the 60s resulted in fundamental innovations in their basket production.[27] At the time, the E'ñepa had been making exclusively undecorated baskets intended for their own use. Impressed by the beauty of the Ye'kuana baskets, some E'ñepa started to copy them and soon reached a high degree of skill in the weaving of round, decorated basketry trays called *wapa* in their language. When applying patterns to their baskets, the E'ñepa take the same artistic liberties as the women basket-makers among the Ye'kuana. The E'ñepa wickerwork, called modern Panare style[28], offers a surprising variety of markedly original figurative and

geometrical patterns unique in Carib basketry. In addition to countless animal figures (tapir, centipede, spider, cat, dog, bird, deer), the most peculiar things are represented on the *wapa*: cars, trucks, airplanes or helicopters. Since these basketry trays serve mainly a decorative purpose and are intended exclusively for commercial use, durability is no longer an indispensable quality. This allows the creators to discontinue the traditional weaving mode, i.e. the alternately crossing strips, the colors and the shapes of these basketry trays, and the round shape has sometimes become an oval. The traditional square boxlike baskets (*petaca*) have grown larger and occasionally taken on a cylindrical shape. For twenty years, in the 70s and 80s, E'ñepa basketry experienced a fantastic boom. However, this phenomenon only affected the communities situated on the road, built in the mid-70s from Caicara to Puerto Ayacucho, that is those with contacts to the Ye'kuana and able to profit from the opening of this major link road which facilitated the sale of their products. But for the last ten years, this process has, due to various internal and external factors, been in a decline. The increasing sedentariness of these communities has resulted in a shortage of raw materials in the vicinity of the settlements so that, in the meantime, longer and longer distances have to be covered to find *itiriti*. Since the *itiriti* stalks are heavy in themselves, this makes procuring the basic material for basketry considerably more difficult. Demand for agricultural products among their criollo neighbors, particularly from the mining village of Los Pijiguaos, have caused the E'ñepa to cultivate larger garden areas and to sell their harvest surplus to them. Then the national economic crisis forced them to sell their baskets for a higher price in order to be able to continue to buy their own cooking pots, axes and other tools. This in turn caused sales to drop. Although the E'ñepa are still weaving today, they do not pursue it with the same drive they showed in past years. Many of the young Panare no longer learn the art of basketry and most of them have long forgotten that, in former times, the shamans caught their most powerful allies, the jaguars, while weaving baskets...

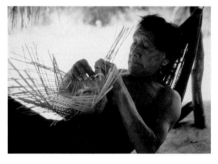

The modern basketry style of the Panare-E'ñepa has been influenced by the works of their neighbors, the Ye'kuana.

"How do you catch the jaguar which, so people say, pleases the shaman so much?"

"Why are you asking?"

"Because I would like to have it among my animals. I have been looking for it for a long time. I have got the liana to tie it up and I have not found it."

"The one that bites, that mountain jaguar, it is not the right one. The jaguar of the shamans does not have to be tied up. [...] You only catch it by means of complicated magic, in an invisible way. The shaman makes two baskets, not just any baskets but those with the big eyes [wide stitches in the weaving. Author's comment]. These are the *ëweï*, woven traps like those used in fishing. The baskets have to be very attractive. Their openings are loosely woven. The shaman dyes them black. Then he puts them one after the other on a trail he himself has swept clean. He leaves them there for a while. When the shaman comes back, they are no longer there. All that is left are the scratched tracks of animal paws.

Tih...tih...tih, there comes a jaguar. It reaches the shaman, looks at him. *Sih...sih...sih*, the scream of a second jaguar can be heard.

They are approaching on separate trails. There are two of them, a male and a female. Then the shaman, already a bit weakened, swallows the potion. The jaguars recognize their master at once. One or the other sniffs at him, they lick his body all over. He has to remain still. They pass their tongues over his eyes, his mouth, his nose, his ears, his testicles, his rectum, this is how they learn to feel him, to recognize him.

Maara...they leave him alone. *Sa...sa...sa...sa*, the master cleans his jaguars, not with water but with straw from the same plant which was used for his potion. Then he cleans himself with the same fiber. And so he now has his jaguars that will accompany him everywhere."[29]

THE WAREKENA: ARAWAK ART OF BASKETRY ON THE RIO NEGRO

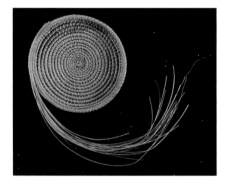

The Warekena and other Arawak groups weave in spiral technique using the fibers of the chiqui-chiqui palm.

Much of what has been said about the Carib groups may also be applied to the Arawak, particularly to the Warekena, a small Arawak group on the Rio Negro.[30] Here as well, basketry is traditionally men's work. The raw materials used are also *itiriti* (*puwá-puwá* or *tulipe*, depending on the species of *Ischnosiphon*), *mamure* (*tápe*) and various palms. The techniques are the same as described above, meaning straight or diagonal twill "weave" or hexagonal wickerwork. The Warekena use *onoto* as a red dye and obtain black with a mixture of soot and a resin from the bark of the *tumé-tumé* tree that serves as a fixing agent. Here as well, basketry traditionally is closely connected with the preparation of manioc.

The Warekena never showed the same innovative imagination as the Ye'kuana or the E'ñepa. However, as a new element in Arawak basketry, the use of the chiqui-chiqui palm fibers must be mentioned. Chiqui-chiqui is used to make numerous commercial objects such as shallow and deep baskets, coasters, chests, brooms, fans or various containers. Like all the other palms as well, the chiqui-chiqui palm which only grows in blackwater areas, was formerly used in the weaving of various panniers. Today, the Warekena, and, incidentally, also the other Arawak groups of the Rio Negro region, the Baré, Baniwa and Kurripako, use chiqui-chiqui mainly to produce handicraft objects for the trade. Here as well, the women are nowadays in the lead as regards production. Many members of this Arawak group have migrated from the Rio Negro to the suburbs of Puerto Ayacucho where a larger clientele for their products exists. Yet the chiqui-chiqui palm does not grow in the vicinity of Puerto Ayacucho so that the raw material has to be "imported" from the Rio Negro which makes production more difficult and, of course, more expensive. Characteristic of these new products is an unconventional weaving technique hardly used elsewhere in this region: the spiral technique or the so-called coiled semi-weaving where "one element of a warp is coiled like a horizontal spiral and then sewn on with another, very flexible, element".[31] These baskets are of more recent origin and intended exclusively for the trade.

Warekena basketry differs from that of the Caribs primarily with regard to the mythological backgrounds and the legendary origin of basketry as well as the

interpretation of the woven patterns. For the Warekena, it was the culture hero Napiruli who brought them everything: "The days of Napiruli's arrival were drawing near … the people were very pleased and, coming from the sky and from Napiruli's troops, all kinds of instruments could be heard. The troops had instruments and Napiruli brought with him many *kabána kuali* (petroglyphs) with drawings on them explaing the making of houses, baskets, the handicrafts, and drawings of dugout canoes, benches, *imakuánasi* or family names of the people."[32] He also brought them the colors. "Napiruli said to one person: 'You shall become the master of handicraft'. The person replied: 'How can I do that?' Napiruli said: 'With this!' And he gave him a sharp stick (probably instead of a knife). 'And what else?', he asked. Then he gave him three colors: white, black and red."[33]

The Warekena use the colors for their carrying baskets and basketry trays but apply them in a much plainer way than the Ye'kuana or the E'ñepa since they use exclusively geometrical designs. Many of the names of their patterns refer to animals, but none of the graphic representations in fact show an animal. In her study on the esthetic aspects of the Warekena baskets, Natalia Díaz identified four basic patterns: the trail of the ants (*dasiyapumi*), the leaf of the *tirite* or *itiriti* (*chújwa-kakami*), the cheek of the piranha (*ume kakomi*) and the back of the woodpecker (*wanáli sepami*). The latter is reminiscent of the *wanadi tonoro* pattern of the Ye'kuana. All these patterns were also introduced by Napiruli and are related to other artistic forms of expression in the Warekena culture such as the rock and stone paintings frequently found in this region.

THE LEGACY OF THE PARTRIDGE-SPIRIT: THE ART OF BASKETRY AMONG THE YANOMAMI

As has already been mentioned briefly, of all the societies between the Orinoco and the Parima range, the Yanomami are the only group which, by tradition, does not cultivate bitter manioc.[34] This correlates with the comparatively plain basketry as well as with the almost exclusive use of the arum vine *mamure*, called *masimasi* in their language. *Itiriti* (*mokoroma*) plays a subordinate role among the Yanomami. There are only five types of Yanomami basket: the carrying basket (*wii*) and the round, more or less bulging basketry tray (*shoto*) —these two types of basket are made by twining[35], the medium-sized (*yorehi*) and the large carrying basket (*sharapï*) woven in open hexagonal wickerwork, and finally the small basket (*mora*) made in simple twill "weave" and serving to store shaman's utensils. Men produce only the loosely woven carrying baskets and the small *mora* basket. The more elaborate baskets woven from *mamure* and made by twining are manufactured exclusively by the women and their production is considerably more important than that of the men. Thus in the Yanomami group basketry is mainly the domain of the women. Over the past years, since the foundation of a cooperative[36], these activities have even been intensified. The cooperative gave the population in the vicinity of mission stations the opportunity to turn baskets into a business. Here, the women are able to exchange their baskets for machetes, cook-

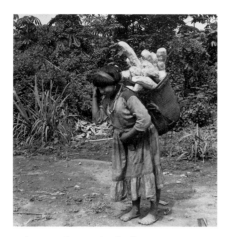

In her sturdy carrying basket, a Sanema woman from the Ventuari takes home the manioc tubers she has peeled and washed at the watering hole.

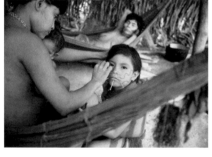

The Yanomami paint the baskets with the same patterns as those on their bodies and faces.

ing pots, soap, shorts or other products on offer at the cooperative. Afterwards, the baskets are resold to various trading firms.

In addition to their function as commodities and trade goods, these baskets are also used in rituals, for instance in connection with funerals[37]. The loosely woven carrying basket *yorehi* is the only one where the bones of the deceased may be stored before the *paushimou*, prior to their being pulverized and mixed with the banana soup.

Wïï and *shoto* are in principle dyed with *onoto* while the loosely woven carrying baskets have neither color nor decorations. But the kind of pattern and color among the Yanomami is basically different from that among the Carib and Arawak groups. The Yanomami do not dye the strips individually, they paint the whole surface of the basket with *onoto* after the wickerwork is finished. With a small stick and black dye, decorations are then added, though this is not obligatory. In contrast to the ornamentation among the Carib and Arawak groups, among the Yanomami they appear to serve an exclusively decorative purpose. In an analysis of the patterns, it has been possible to identify ten different ones none of which, however, seems to have a specific mythological significance. The names of the ornaments in the Yanomami language are merely descriptions:

The circle (*kahorarawë*), with small dots (*tipikiwë*), with dots (*titikiwë*), with broad wavy lines (*ëyëkëwë*), with sinus curves (*torerewë*), with crossed lines (*yahiriwë*), with broken lines (*mï parahiwë*), with parallel lines (*yahetiwë* or *tirputuwë*), with curved x-shaped signs (*haotowë*), with crosses (*pakirawë*).

The Yanomami keep emphasizing that the patterns on the baskets are not different from those of the body painting, as if they considered the basket surface to be skin. After all, most of the body paintings also have a purely esthetic function, and the few with a symbolic character—such as the black face-painting of men setting out to war—, are not used in basketry. In addition, the myth of the origin of basketry also appears to confirm the esthetic function of the designs more than to contradict it. In Mahekototheri in 1996, two shamans told the legend of the first woman basket-maker: Pokorayoma, the partridge-spirit[38]:

"It was Pokorayoma[39] who wove the first carrying basket. In a place where many lianas and vines (*nano ka*) grew, that was where Pokorayoma lived with her husband. She wanted to try to weave. 'Try it with this vine, cut it up', her husband said to her ...'Make *wïï* (carrying basket), make *shoto* (basketry tray)'. And so she did it. She split the lianas into very thin strips which she put all on top of one another and then left them lying there whilst she broke up more. She started with the base, deftly crossing the strips and weaving them together. She built up the elements, on and on, breaking off the strips no longer needed. She reached the rim, finished the main part well, and then finished off the rim carefully. She put the small basket down and immediately started making a new one, a basketry tray. When she was finished, she put both baskets down on the ground and walked around them. She put the baskets down on the ground and both Pokorayoma and her husband turned into colored partridges. Later on, the women copied her baskets. It was Pokorayoma and her husband who taught the women. That is why today it is also the women who weave the baskets."

A short survey of the four ethnic groups of the Venezuelan Amazon region points to the significance of the art of basketry in all aspects of the respective cultures. The everyday use is only the visible side of basketry. Although in some cases today, their esthetic value comes second to the commercial interest, the art of basketry still carries hidden dimensions, spiritual, symbolic, and magical, and it has been the aim to emphasize these. This insight corresponds to the view of Peter Rivière who, in his study of Amazon baskets and basketry, came to the conclusion: "In the whole region of the South American Amazon Lowlands [...] [baskets] are at one and the same time an essential part of the technology as well as an artistic expression reaching beyond the basic needs of everyday life [...]. To a varying degree, the products of basketry, their construction, their design and their use are not only an esssential part of the technology and the economy of the Amazon Indians but at the same time embody their concepts of the world in which they live and for whose protection and conservation they fight."[40]

1 The author's special thanks go to the Management for Cultural Affairs of the State of Bolívar, the Foundation for Ethnomusicology and Folklore (FUNDEF), the International Foundation for Ethnomusicology and Folklore (FINIDEF) as well as to the Research Unit for Human Ethology of the Max Planck Society (Andechs/Erling) who have supported the various periods of research on traditional basketry in Venezuela.

2 I.e. referring to the Indians of the Americas.

3 The difference between the various types of basket becomes easily comprehensible when looking at the Cisneros Collection where all these groups are extensively represented.

4 "What we call 'basketry' is not an original category of the phenomena, the indigenous languages have no general term for it, and the Indians do not think in the inventory-like order of concepts of a museum [...]. Our category of 'basketry' is an intellectual fiction having little or nothing to do with the 'own point of view' of the Indians." (Reichel-Dolmatoff 1985, p. 1)

5 Mason (1970)

6 Aerial roots or vines of various species of *Heteropsis* of the *Aracea* family; these are climbing arum plants. George Bunting (1979, pp. 139–190) calls them *Heteropsis flexuosa*.

7 Humboldt uses "Maimure" instead of "*mamure*" (Humboldt 1980, p. 279).

8 *Waja tomennato*, literally "painted baskets", are round trays with delicately applied patterns while *kutto shidiyu*, literally "the rear end of the frog *kutto*" are also basketry trays but without patterns.

9 Guss (1989, p. 141)

10 Cf. the article "Arawak—Northwest Amazon Peoples between two Worlds" by Ulrike Prinz in this catalog.

11 Día Peña (1993, p. 135)

12 Día Peña (1993, p. 165) mentions this information that she received from the director of the Herbarium Ovalles of the Universidad Central de Venezuela, Dr. S. Tillet, according to whose observations the *itiriti* leaves have an irregular oblique shape in contrast to those of the majority of the Amazon flora which are symmetrical.

13 Hames/Hames (1976, p. 4)

14 Koch-Grünberg (1923, III, p. 345)

15 Bermúdez (in preparation, p. 53)

16 Guss (1989)

17 Civrieux (1970, p. 208)

18 Cf. the article "Ye'kuana—the People of the Dugout" by Lelia Delgado in this catalog.

19 Civrieux (1970, p. 68)

20 Guss (1989, pp. 106–107)

21 Cf. the Sanema myth in the article "Decked out in borrowed plumes..." by Ulrike Prinz in this catalog.

22 Civrieux (1979, p. 45)

23 Roth (1924, pp. 355–356)

24 Guss (1989, p. 119)

25 Serge technique is wickerwork where the the weft elements skip two or more warp elements; the ornamental patterns are produced by deviations from the basic pattern.

26 Panare is the term by which this group is known in the ethnographic literature. E'ñepa is the name in their own language. Cf. also the article "E'ñepa—the Masters of the Ceremonies" by Lelia Delgado in this catalog.

27 The encounters leading to the innovation process in basketry took place at Caicara, a small town on the Orinoco where the E'ñepa come to buy household utensils such as cooking pots, knives and machetes. The innovation process is described in detail by the author in cooperation with Paul Henley (in: Henley/Mattéi-Müller 1978).

28 Henley/Mattéi-Müller (1978, footnote 14)

29 Mattéi-Müller (1992, pp. 101–102, 105)

30 Cf. also the article "Arawak—Northwest Amazon Peoples between two Worlds" by Ulrike Prinz in this catalog.

31 Definition according to Reichel-Dolmatoff (in: Vasco Uribe 1987, p. 105)

32 González Ñañez (1980, p. 118)

33 González Ñañez (1980, p. 12)

34 Cf. also the article "Yanomami—those born-from-the-calf" by Gabriele Herzog-Schröder in this catalog.

35 More precisely, this is twining in twos over a passive system (Seiler-Baldinger 1991, p. 39)

36 Regarding the cooperative, cf. also the article "Exchanging and sharing…" by Gabriele Herzog-Schröder in this catalog.

37 A detailed analysis of the significance of the basket in connection with funerals is found in Gabriele Herzog-Schröder: *Okoyoma, die Krebsjägerinnen des Oberen Orinoko* (in preparation).

38 One of the two shamans came from Makehoto itself, the other from the upper Manaviche river. Recording, transcription and translation by the author of this article.

39 Pokorayoma is the name of the female spirit of the colored partridge *pokaramï (Odontophorus gujanensis)*. This bird lives mostly on the ground. Its nest is said to be very beautifully woven.

40 Mowat et al. (1992, p. 158)

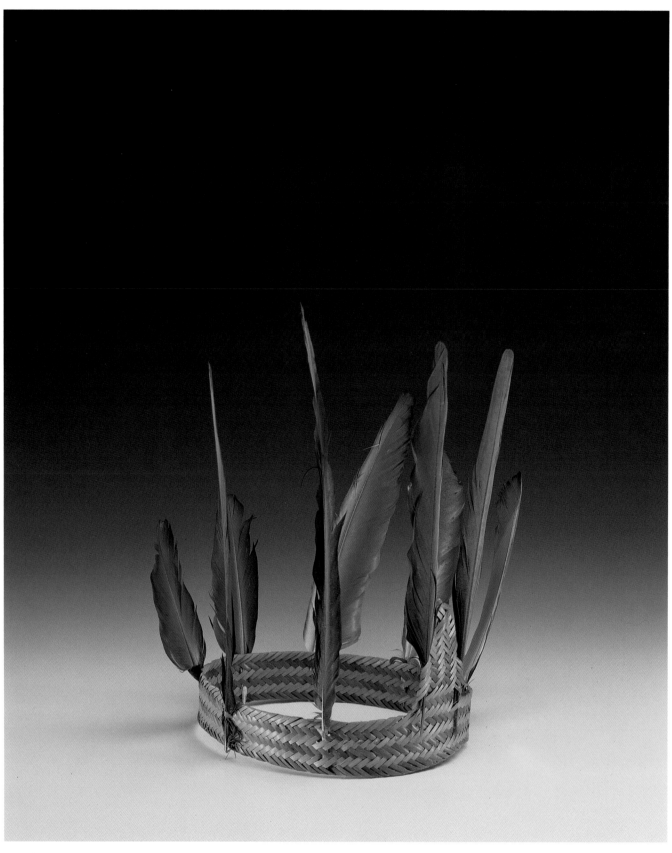

Headdress—*arako*
E´ÑEPA
Strips of *Ischnosiphon aruma*,
macaw tail-feathers

At the feast for the boys' initiation,
katyayīnto, the initiates wear feather crowns
with macaw tail-feathers.

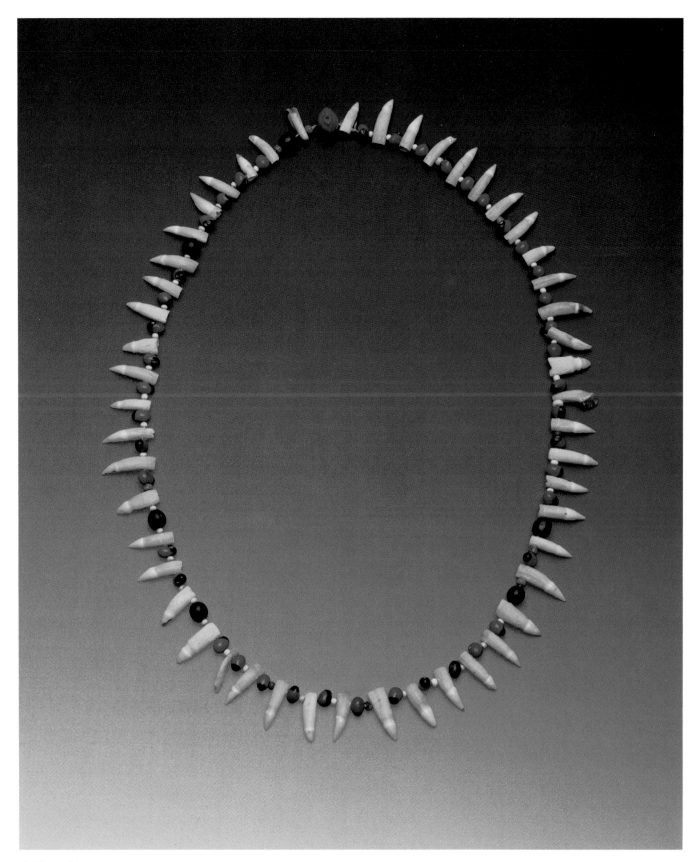

Child's necklace
E'ÑEPA
Crocodile teeth, seed capsules of *Hormosia sp.*,
glass beads, cotton thread

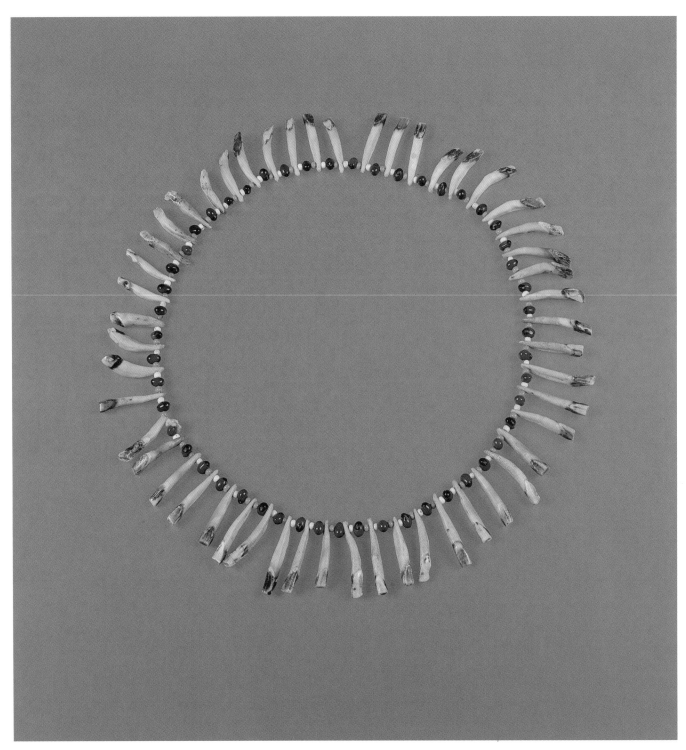

Necklace made of dolphin teeth
E'ÑEPA
Dolphin teeth, seed capsules of
Hormosia sp., glass beads, cotton thread

For the E'ñepa, the dolphin is the guardian
of the Orinoco. They also regard it as the
mother of the fish. In the Carib language,
the term for dolphin is "orinoko". Thus the
river is called after its master, the dolphin
gave it its name.

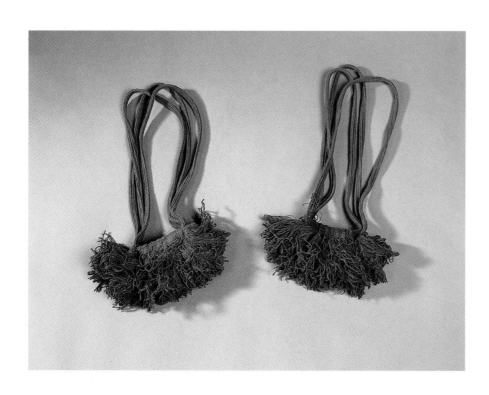

Breast ornament with tassels—*aapojto*
E´ÑEPA
Woven cotton bands, cotton tassels, plant
pigment *Bixa orellana*

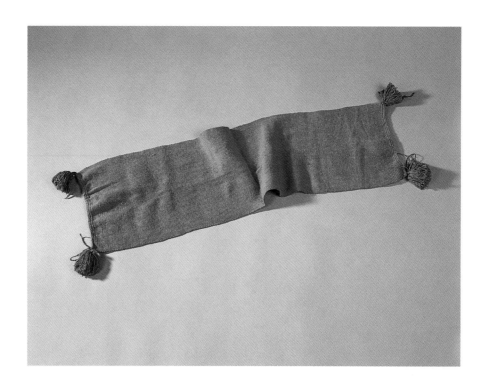

Pubic apron of an E'ñepa man—*katya*
E´ÑEPA
Woven cotton, cotton tassels,
red plant pigment *Bixa orellana*

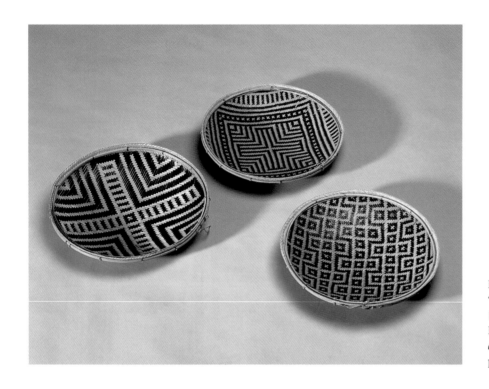

Basketry trays—*wapa*—woven in twill
"weave"
E´ÑEPA
Bamboo, wickerwork made of *Ischnosiphon
aruma*, fibers of *Ananas lucidus*, plant
pigment

Basketry trays—*wapa*—woven in twill
"weave"
E´ÑEPA
Bamboo, wickerwork made of *Ischnosiphon
aruma*, fibers of *Ananas lucidus*, plant
pigment

The basket in the middle shows the represen-
tation of a turtle shell.

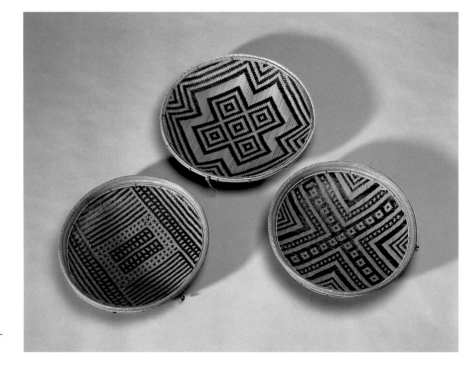

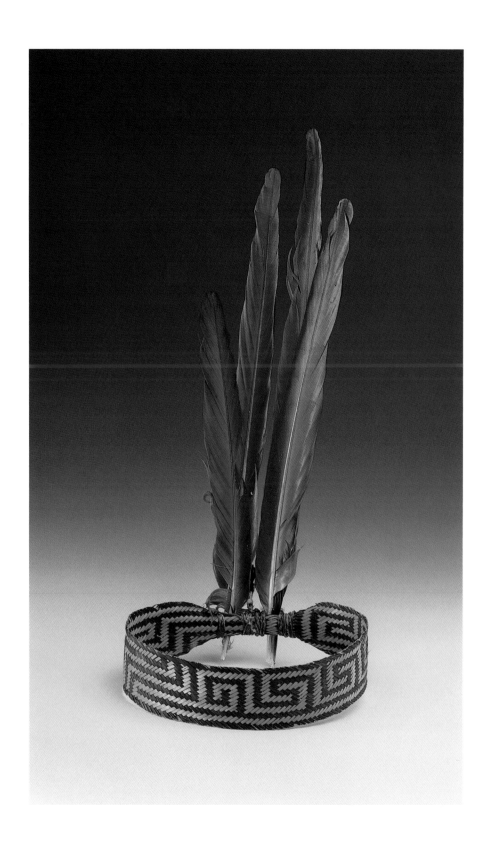

Headdress—*arako*
EʹÑEPA
Macaw and curassow tail-feathers, fibers
of *Ischnosiphon aruma*, fibers of *Ananas
lucidus*, cotton thread, plant pigment

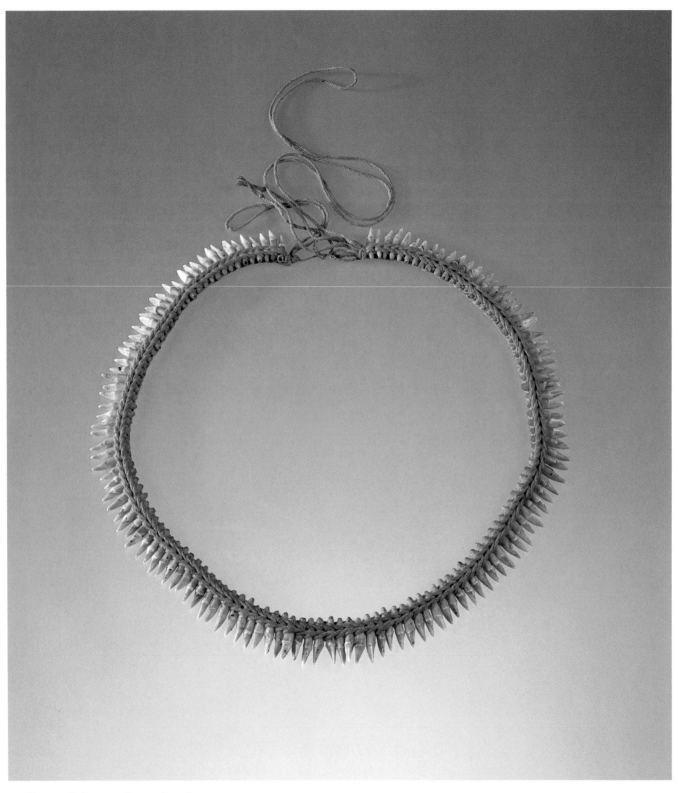

Necklace made from monkey teeth—*arkonyën*
E'ÑEPA
Monkey teeth, cotton thread

Necklaces made from monkey teeth are worn by boys and, in rare rituals, by adult men. The tamarin is regarded as the guardian spirit of the little boys, and the tooth necklaces as well as ornaments or body painting are a reminder of this.

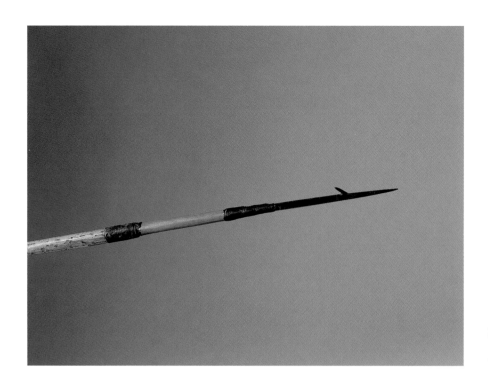

Harpoon
E'ÑEPA
Wood, metal, resin

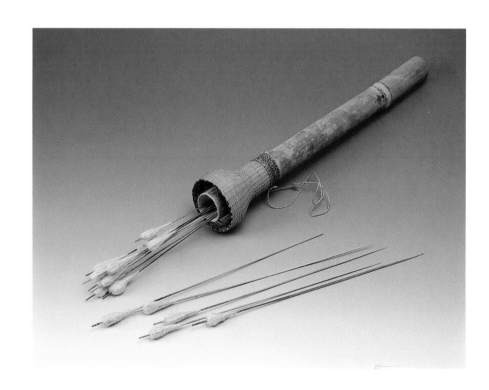

Quiver—*parana*—with blowpipe arrows
E'ÑEPA
Bamboo, bamboo points, fibers of
Ananas lucidus, kapok, plant pigment

Quiver for storing blowpipe arrows.
The kapok stopper at the end of an arrow
stabilizes its position in the pipe.

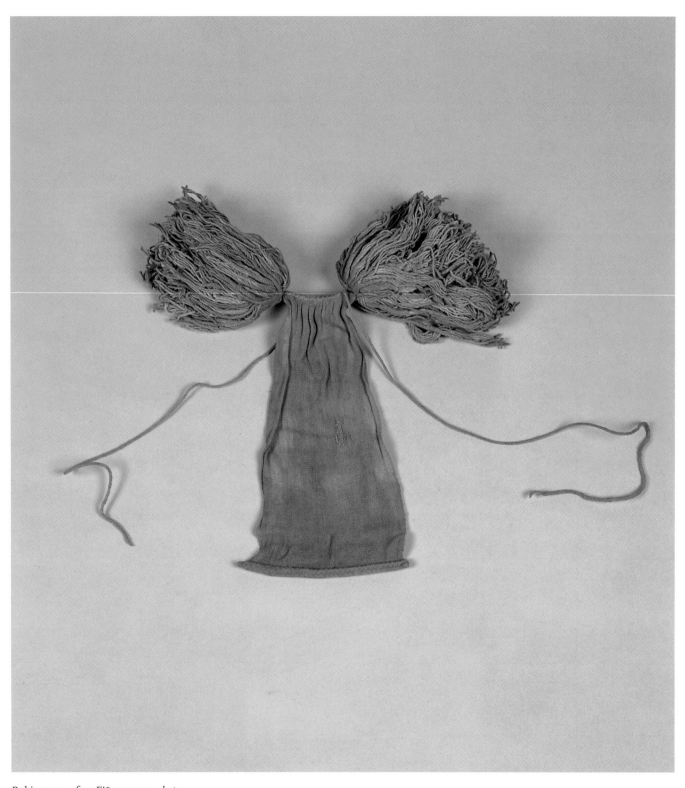

Pubic apron of an E'ñepa man—*katya*
E´ÑEPA
Cotton, red plant pigment *Bixa orellana*

The women spin, weave and dye the men's *katya*
loincloths. Before the onset of puberty, the boys are
solemnly presented with their first *katya* in a ritual
lasting several days, the *katyayĩnto*.

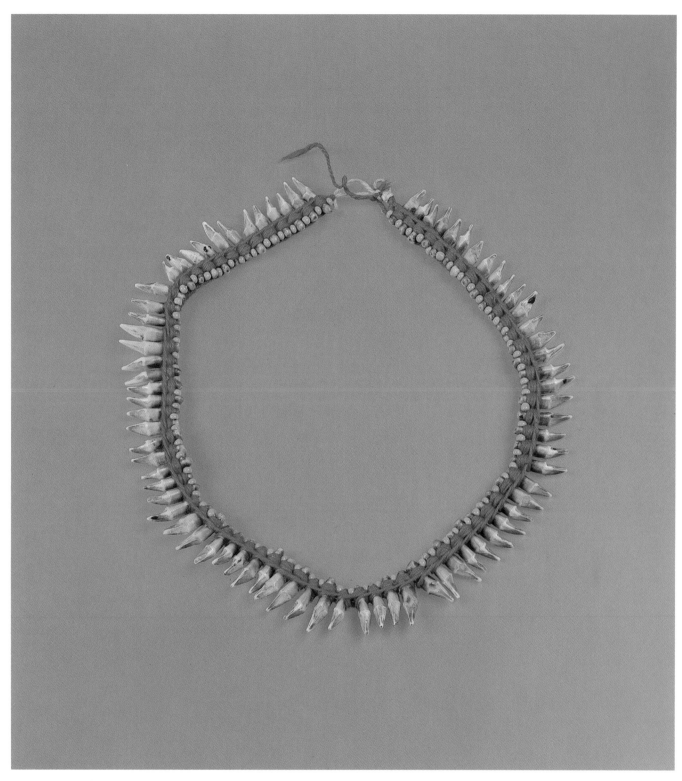

Necklace made of monkey teeth—*arkonyën*
E'ÑEPA
Monkey teeth, glass beads, cotton thread
dyed with plant pigment *Bixa orellana*

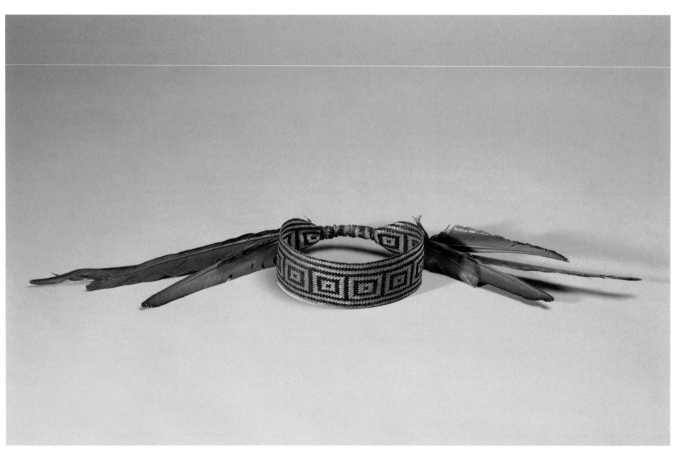

Headdress—*arako*
E'ÑEPA
Macaw tail-feathers, fibers of *Ischnosiphon
aruma*, fibers of *Ananas lucidus*, plant
pigment

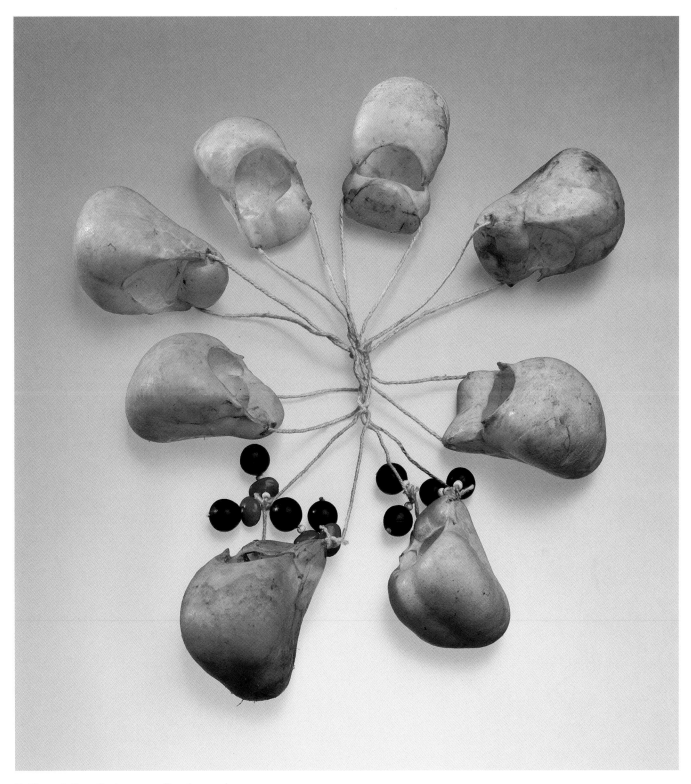

Rattle made from the larynges of howler monkeys
E'ÑEPA
Larynges of howler monkeys, various fruit skins, glass beads,
cotton thread

Women clatter at ritual dances by rhythmically pounding
the ground with a stick to which rattles are attached. In most
cases, the rattle consists of toucan beaks; the illustration
shows a rare kind of rattle.

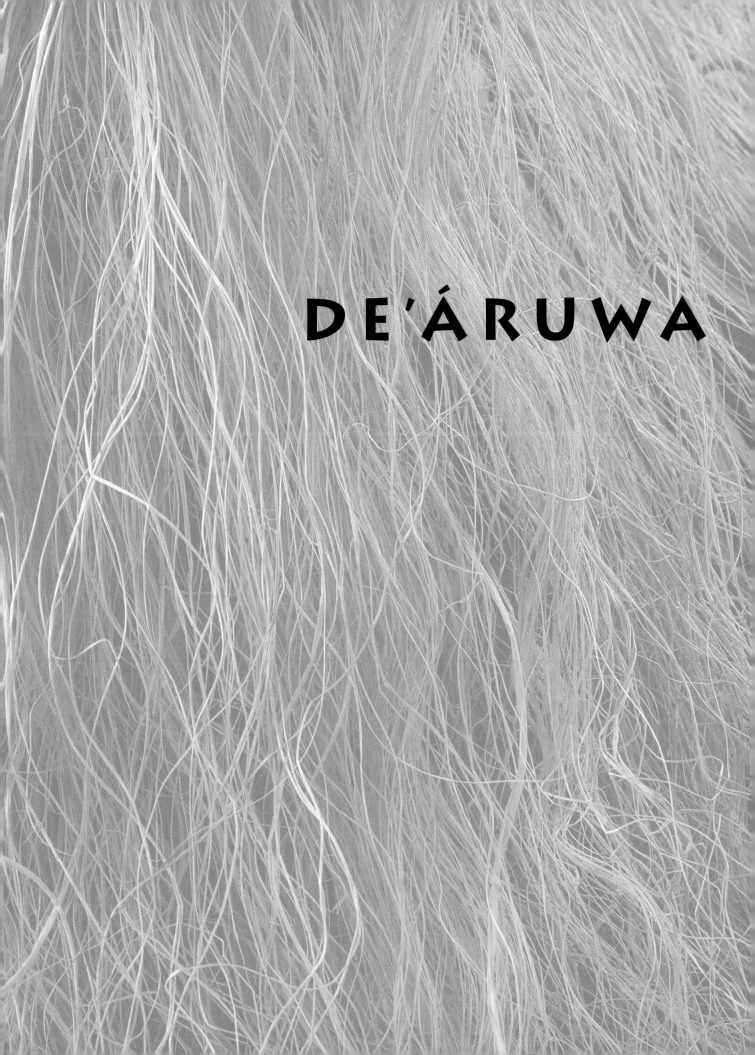

DE'ÁRUWA

DE'ÁRUWA

The Lords of the Forest

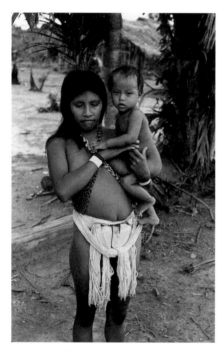

A traditionally garbed De'áruwa mother together with her child.

The De'áruwa are known within ethnological literature as the Piaroa or also as Wóthuha—"the Knowing Ones." They most usually refer to themselves as the De'áruwa, which can either mean the "People of the Forest," or "Owners of the Forest."[1]

The De'áruwa's traditional territory ranges along the right bank of the Orinoco, in what is today the state of Amazonas in Venezeula. The Mako, a subgroup of the De'áruwa which evidently split off long ago, live in the Rio Ventuari region.

The traditional territory of the De'áruwa is covered with tropical rain forest, from which occasionally rise up prominent, bare sandstone formations. Owing to the area's near impenetrability, it was neither colonized nor missionized until relatively late. The De'áruwa had their first sporadic contacts with Jesuits towards the end of the seventeenth century. More regular contact, however—with the Venezuelan government and with missionaries of the Salesian Order—did not come about until the fifties of the twentieth century. Early on, the Catholic mission on the middle Orinoco at Isla Ratón was a favorite stopping place for the De'áruwa. There, several De'áruwa acquired the Spanish language and became acquainted with the lifestyle of the white people. Also, from North America, the New Tribe Mission (NTM) energetically attempted to convert the De'áruwa to the Christian faith. Because of such frequent contacts, diseases broke out among the De'áruwa, epidemics which greatly decimated the population. In the aftermath of the epidemics many De'áruwa moved to live in the vicinity of criollo settlements, because only there could they receive medical treatment. This time of reorientation resulted in their moving to new small enclave settlements in the state of Bolivar, as well as in Colombia. Since the seventies, the frequency of contact with the white population has continued to grow. Today, some eighty percent of the De'áruwa are Christian; they live in single houses with electricity, running water, and medical supervision. Their population numbers some 11,000 people.[2]

Linguistically, the De'áruwa belong to the small Saliva family; their language is divided into several dialects.[3]

The traditional circular hut of the De'áruwa, the *iso'de*.

LIFE AND WORK

Into the nineties, cut-off in the mountainous region of the upper Cuao, a small group of De'áruwa still live the traditional lifestyle.[4] Their traditional communal house in the form of the *churuata* is, somewhat set back from the nearest river, built near a brook. The De'áruwa call their communal house *iso'de*. Here all the members of the group, from between 5 and 60 people, take up residence. Scattered around the house lie tended garden plots where manioc, corn, sweet potatoes, bananas, and pineapples are grown. Young family members, as well as in-laws who have married into the group, perform the work for the community elders. Men and women cooperate as much as possible. The men clear and prepare the garden plots; the women sow and harvest.

The De'áruwa's main source of nutrition are manioc "tortillas" *(casabe),* which they revere as a sacred food. It is made in a complicated process: first the manioc tubers are peeled and grated; the pulp which results is then fitted into a press where the juice is extracted by stretching the squeezer. By this means the manioc pulp is separated from the prussic acid. The detoxified manioc meal is then baked on flat stones or metal sheets into tortillas. The fluid which was squeezed out by the press is later brought to a boil to be mixed with pepper juice and ants to be used as *yare*, a spicy sauce.

Because of the significance of manioc, the manioc grater is a very important household utensil. It is fashioned from a wooden board cut to the proper shape by

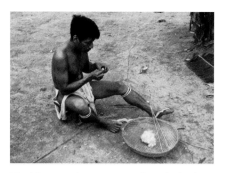

The blowgun darts are coated on the back end with kapok, the tree silk of the ceiba.

the men. The shaman then performs a ritual of purification. Finally, the women hammer into the board's surface tiny sharp stones in geometrical patterns.

Besides the slash-and-burn agriculture which the De'áruwa practice, hunting, fishing and gathering—in keeping with all indigenous Amazonian cultures—play important subsistence roles. The dry season is the period of hunting parties. Traditionally, the De'áruwa hunted game with a blowgun outfitted with a mouthpiece. A tooth from the peccary or the agouti was used as aiming bead. The renown of the De'áruwa for their production of curare, a blowgun poison, traveled far out beyond their territorial borders. In the past, curare—in addition to manioc grates, blowguns, canoes, medicinal herbs, *peraman*-wax, feathered headdresses, and dogs—was one of the De'áruwa's most important trading items. In the meantime criollo goods, first and foremost fishing hooks and various metal utensils, have found their way to the De'áruwa through the trading system. Here too, firearms have largely replaced the blowgun.

Despite a long list of food enjoinders, the De'áruwa hunt howler monkeys, armadillos, weasels, capybaras, anteaters, sloths, and agoutis, as well as such reptiles as the caiman. Favorite wild game also include a variety of birds and fish. The De'áruwa neither hunt nor eat deer or tapirs; many of the groups also protect the peccary, for they believe that the spirits of ancestors reside inside them. Fundamentally, the eating of wild game is considered a dangerous risk because the meat can cause disease. Only the use of medicinal herbs and, more importantly, the ritual songs of the shaman, can purify the meat and make it edible.[6]

THE COMMUNAL HOUSE—"WE ARE ONE"

The round house—*iso'de*—is constructed by a simple technique. The form varies in accordance to the number and needs of the dwellers. The roof of the communal house, which has a circumference of roughly 17 meters and an apex of roughly 12 meters, is crowned by a conical dome. Four posts connected by horizontal joists rise up at the center to support the roof. The roof is thatched with palm leaves.[7]

The individual family compartments are not separated physically. Each dweller knows the boundaries demarcating the area in which his or her hammock hangs and the family cooking fire burns. Torches only occasionally illuminate the gloom of the house interior. The central area is reserved for guests. Here, too, can be found enough room for practicing artisanship activities and for holding celebrations.[8]

Those living within the *iso'de* are closely related.[9] The marriage between cross-cousins (father's sisters' or mother's brothers' children) from the same residential unit is preferred. Endogamous marriages reinforce the group's solidarity and the individual's willingness to perform altruistic tasks. The members of a local group say: "We are one, we are for each other *tikí cawaruwae.*" This roughly means: "We are a group of relatives who have married among themselves."[11]

THE WAY OF THE LEGENDS

The De'áruwa adorn their bodies with a large variety of ornamentation. Typical are triangular, metal earrings attached to the earlobes by bands of blue and white glass beads. The long, wide peccary teeth necklaces ornamented with colorful feathers are worn solely by the shamans. The feathered headdress is also reserved for the shaman, since he derives his power through this ritual object. Over the course of the last few years, however, headdresses and other ornamentation have been produced for trade with the criollos. Infused in these hand-crafted objects is a delight in color inspired by the splendor of the bird world.

Men and women paint their faces with a black vegetable dye mixed with resins, and with red *onoto (Bixa orellana)*. The paint is applied to the body with a wooden stamp. The designs and forms of the variously sized stamps are used in combination, whereby women employ a different set of stamps than men. The women paint themselves with *iwa meruwae*, which can be translated as meaning, "menstruation designs." According to the De'áruwa, such designs, manifesting the source of fertility, originate inside a woman's body.[12]

The men paint their faces with designs signifying the male inner body. They are intimately connected to the hunt and shamanistic song. These geometric forms—patterns which can also be found woven into basketry—bear a special allegiance to the animal and spirit world, and are metaphorically called, "The Way of the Legends."[13] *K'eraeu paeraetaemi*, which are found inside the men's bodies, contains all the words of sacred songs. Through ornamentation—as well as through sacred songs—*k'eraeu paeraetaemi* appear in the outer world. By painting his face, a De'áruwa makes visible all the knowledge he has gathered over the long course of his participation in initiation ceremonies.[14] When a shaman enters a state of trance after inhaling *yopo* powder (or some other drug), he encounters the truth of these male designs.[15]

The De'áruwa possess botanical knowledge so sophisticated that they are able to create a wide variety of hallucinogens. Although *yopo* is by and large always produced by the same method, some shamans attempt to improve upon it by adding their own ingredients. To the *yopo* utensils belong a wooden mortar and pestle for the production of the drug powder, the inhalation tube, a brush used to apportion the powder, a snail shell for storage, and a curassow feather to sweep the powder together. All of these utensils are kept in small, covered, rectangular baskets called *petaca* or *yopera*.

RUW'A—MEDIATOR BETWEEN THE WORLDS

In each community there are one or two respected males—called "Ruw'a"[16]—who retain the local spiritual as well as political power. The Ruw'a is a religious leader who implements his visions and inspirations to preserve the well-being of the community.[17] The Ruw'a must be considerate, emotionally stable, and of a

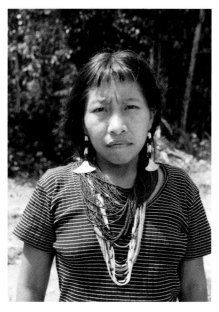

De'áruwa woman with glass bead jewelry and the typical triangular earrings.

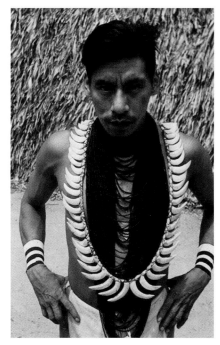

Only the shamans wear necklaces of peccary fangs.

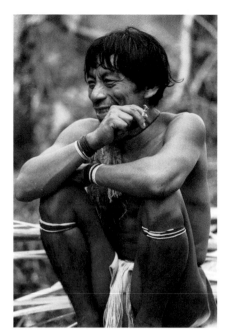

The smoking of tobacco inspires the shaman to tell stories of mythical events.

peaceable nature—in other words, possess those very character traits which fulfill the De'áruwa's male ideal.[18]

The knowledge of the Ruw'a is by no means limited to worldly matters. As the spiritual leader it his duty to protect the community from supernatural danger. Above all, he controls the invisible powers. No one has more knowledge than a wise Ruw'a about the De'áruwa's gods, culture heroes, and mythic past. While in trance, he finds entrance into the spirit world, the supernatural sphere from which his powers stem. The shaman travels across various realms, enters a mountain—which to him is transparent—and arrives at the site where humans and animals first came into the world.

Like a warrior, the Ruw'a is constantly confronted with death. The De'áruwa believe that most diseases result by the breaking of food taboos. When a man kills an animal, the spirit of the animal father,[19] the animal's protector, enters the hunter's body to cause sickness. The words sung by the Ruw'a—the *meñe*—possess the power to heal. For this reason the shaman is also called *meñeruw'a*, "Man of Song."[20] In this connection he is associated with the *tianawa*, the helpful spirits who vouchsafe the shaman his healing words of song. The *tianawa* are the ultimate source of the shaman's healing power. With their aid, the shaman confronts the earth spirits who visit sickness and disease upon human beings and animals.[21]

Among the numerous spirits that inhabit the space are also mythical beings like Wahari, the culture hero who created the world, and his sister C`ehuru (also known as Tscherú). Other spiritual beings take on the forms of animals to wander the world. They appear as jaguars, coatis, wasps, or eagles. "Each animal signifies a different sickness. When people sing the words of Wahari, the sickness cannot take hold."[22]

Formerly, the oldest and wisest member carried the highest status within the group and was the political leader. Today that status, due to the increasing acculturation of the De'áruwa, is more and more often conferred upon those who, for instance as teacher, nurse, or government administrator, are in a position offering better strategies for dealing with the criollo society.

SACRED FEASTS AND DEATH

The Warime is the most important feast of the De'áruwa.[23] In order to assure good harvests and to secure advantageous marriage alliances, it is celebrated at intervals of approximately three years. This festive rite, in which the creation of the world is reenacted, gathers together the members of a number of local groups.[24]

During the mythic age, animals and human beings were not outwardly distinguishable from one another—only later did they take on the forms they possess today. That is when the first Warime feast was celebrated.

Wahari, who appeared in the shape of a tapir, was the first seer and is recognized as the benevolent creator of the De'áruwa. His dangerous opponent is Keu-

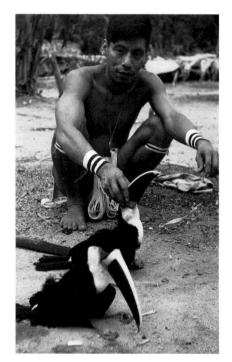

Each animal species is associated with a type of disease, which the shaman can heal with songs.

moie, the anaconda who plagues humankind with sickness and death. Both spiritual beings are called upon during the ritual.[25]

Each being of the universe has its place of origin, to which, upon death, its soul returns. When a Ruw'a dies his soul returns to the place of the winds, high over the mountains. His breath generates a jaguar, his hands spawn small tigers, and from his eyes pour wasps. These spirits remain behind in the burial cave to watch over the mortal remains of the Ruw'a. His windpipe, however, leaves his corpse, rises up to transform into a flute to preserve the music of the Ruw'a's songs.[26]

1 The information gathered in this article is based largely on the work of J.O. Kaplan (1988).
2 OCEI (1993)
3 Zent (1944, p. 275)
4 Zent (1994, p 275)
5 Kaplan (1988, p. 378)
6 Monod (1975, p. 206)
7 Grellier (1953, pp. 253–263)
8 Kaplan (1988, p. 335)
9 The kinship system is connected to the concept of consanguinity (blood relatives). The De'áruwa themselves talk in this connecton about "blood, flesh and bones" (Kaplan 1988, p. 350).
10 Compare to this marriage rule the text, "Exchange and Sharing—The Meaning of Giving Among the Yanomami," by Gabriele Herzog-Schröder in this catalog.
11 Kaplan (1988, p. 351)
12 Kaplan (1988, p. 339)
13 Kaplan (1988, p. 339)(compare also the text, "Decked out in borrowed Plumes—Myth and Art of the Indians of the Amazonian Lowlands," by Ulrike Prinz in this catalog.
14 Kaplan (1988, p. 339)
15 Kaplan (1988, p. 344)
16 The term "Ruw'a" actually refers to all beings that possess power and knowledge.
17 Regarding the shamanism of the De'áruwa, see Kaplan (1988, p. 389).
18 Kaplan (1988, p. 388)
19 Kaplan (1988, p. 392)
20 According to Boglár (1982) *"menjeruwa"*
21 Kaplan (1988, p. 393)
22 Monod (1975, p. 206)
23 Compare the article, "Warime—The Power of the Masks," by Luiz Boglár in this catalog; compare also Agerkop (1983).
24 Kaplan (1988, p. 384)
25 Zent (1994), p. 278)
26 Kaplan (1988, p. 403)

LUIZ BOGLÁR

WARIME

THE POWER OF THE MASKS

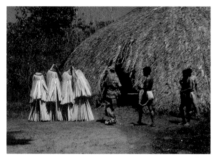

The row of masked dancers moves forward in rigidly formalized dancing steps.

"Mara-redyo ihtine, dyahowej ihtine penerua puhkuru..."—"Child of Mara-redyo, Child of the toucans, I am a stranger among you..."* The Song of the Peccary-Mask

From the palm huts emanate songs and strong rhythms. A hand pushes a reed curtain aside and masked figures emerge in single file, clapping sticks and shaking rattles, to accompany the rhythmic steps and nasal-voiced song of the dancers.

The masked dancers move past the female audience: first, the peccary boar spirit dancers, then the monkey spirit dancers, then, bringing up the rear, the wild bee spirit dancers.

"Hina-itsoma mariwekane pejenne Kuaomine... Njemeh[1] had said. We have come from below, from the below beneath the Mariweka. Where we were born, where Wahari created us. Where he gave us our name." An "orchestra" of flutes, pipes, and wooden bullroarers accompanies the dancers' rhythmic movements. It is a wall of spirit-conjuring sound alternatively complementing and drowning out the vocal lines of melody. Smouldering resin is placed at the feet of the dancers—smoke to chase away the evil demons. The feverish, excited atmosphere lasts several hours before the dancers again return to their huts. A De'áruwa utters the word *"Tahkü!"*—it is over—and with that the spectacular-visible part of the singers-dancers-drama comes to an end. Memories of this colorful frenzy are unlikely to pale until they are replaced by fresh scenes from the next Warime ceremony.

Warime is a synthesis of art! An Indian opera in the jungle! It is exceedingly complex. In order to understand its details, one must comprehend its whole! It reveals an exceptionally wide range of distinctive values. In order to take in the forest, one must see the individual trees. Everything at once—everything together!

The Warime ceremony, like every collective cult ritual, conjoins several functions. These transcend its ritual significance as a magical entreaty to the animal world to prosper and be fertile. For the initiated De'áruwa men, the rite more importantly—from the beginning of preparations to the ceremony's close—contributes to the further endowment of their own powers as well as the consolidation of their societal standing. For the young De'áruwa, those who have yet to be

initiated, this custom affords the opportunity to grow familiar with the rite's culture. This culture is not limited to the rite's performance, the staged action that takes place before the audience, but incorporates all the knowledge and ideas necessary to ensure the authentic transmittal of De'áruwa tradition.

The Warime is one of the most important events in the life of the De'áruwa. The stories told during the course of the ritual reveal the tribal wisdom passed down from generation to generation. Myths, religious ideas, and ritual objects meld together via movement and sound to form complex symbols—the essence of the group's knowledge. The ritual is the cradle of culture! The uninitiated boys not only receive an abstract instruction in religious ceremony through watching and listening, but they can also contribute to the creation of the symbols, as well as, through active participation, learn and understand the course and meaning of the rites. The expressive culture of the De'áruwa is revealed in all of its glorious complexity by the ritual process—a process that calls on all group members.

What do the myths reveal about the preparation for the ritual? "Wahari, Buoka, Iminja Enemej, and Uhorio Ruadyei sat and snorted *yopo* while they prepared for their celebration. By working together they helped Wahari devise the festival."

Where does this all take place? *Ruwode,* in the language of the De'áruwa means, "House of the Masks." It is erected solely for the Warime event as the "workshop" where the ritual objects are made. If for any reason no *ruwode* can be built, a deserted hut can be used in its stead.

Women and girls are not allowed—this is of great importance!—to gain an insight into the preparations. "So Wahari began to devise the form of the festival. And he said to Tschecheru, his sister, that if she would also like to have a ceremony for herself, then she must plant large amounts of manioc and brew plenty of manioc beer. And Wahari began to build the little hut, in which he wanted to make the ceremonial masks together with Buoka. The women loved the music of the dance of masks. They were working very hard sowing the crops, and then they

Making Warime masks is a collective ritual process.

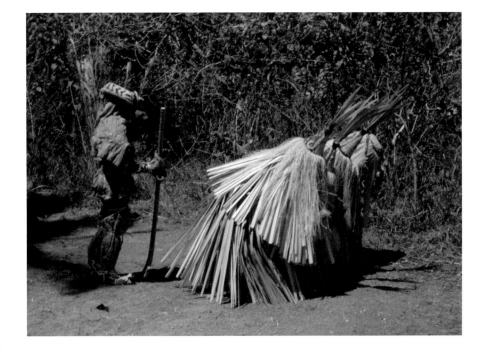

During the Warime ritual the mythic origins come to life.

came closer to hear the music. The preparations for the ceremony were almost completed. Tschecheru was proud of her brother. She said, 'Yes, my brother is truly a great thinker.' She asked her brother how he was able to make all these things. But Wahari told her: 'Women can never be allowed to see the preparations.'"

In the morning, the men enter the hut, they chat, roll a cigaret, light it and pass it around. At the same time, they pass around the materials for the objects to be made, carefully selecting them.

If more reed, creeper, bast, resin, or some other raw material is needed, the shaman leading the festival seeks out a few young men to send them out in the late afternoon or evening along a stream into the nearby forest. They return in the evening, because then the women rarely dare leave their huts. By this means the young men are able to gather the raw material and bring it back without hazarding any "misfortune".

The men with more experience are responsible for obtaining the materials which require more complicated gathering skills. This includes such activities as the tapping of latex, as well as the stripping of bast, and the chopping of palm leaves—raw materials that are needed to make the dancers' costumes. The men also dive to the bottom of streams to collect the white clay used as dye. The white clay is a sacred element, and here too, no woman may learn of its origins.

The process through which the materials acquire their symbolic values takes place before the eyes of the participants: the reed, the bast, the palm leaves and many other materials, as long as they are in their natural settings in the woods, are nothing more than profane raw materials. However, the moment they are gathered or cut down as raw materials, they begin to be infused with symbolic content, a process which continues from the finding place to the village, where, in the "workshop," the metamorphosis of these raw materials into sacred objects in the sense of the De'áruwa symbol system is consummated.

"Beneath the center of the world there was a forest in which the drug plants lived: *dada, tuminja, tuipa, kareru*. First, of course, a person must find the trees! Wahari commanded: 'Find the trees, take a piece of them for yourselves, crush it, pour water over it, drink it.' When they found the trees, Wahari truly drank the juice of the *kareru*, and as with the magicians, so also within him were born ideas. The *kareru* drink created the ideas!"

The De'áruwa live on one hand according to rites of everyday life, and on the other hand according to those rites which are connected to the seasons—the religious ceremonies which take place annually, or even less frequently. The ritual acts are performed by the shaman; in the language of the De'áruwa the shaman is called *menjeruwa*. Because the magical-mythical song—called *menje*—is thought to be a remedy by the De'áruwa, the word *menjeruwa* actually carries the meaning, "the man of the healing songs." *Menjeruwa* essentially means "medicine man."

Magical ritual songs sound from the huts evening after evening. Most of the songs are De'áruwa myths of the animal world. When the animals were created, sickness was introduced into the world. Each animal species is associated with a

type of sickness. The *menjeruwa* must cleanse the animals and the bagged game of their sicknesses with song, in order to make their meat edible—for if he did not the people would grow ill. In preparation for his song, the *menjeruwa*, together with some other male group members, sniffs *yopo* powder, a hallucinogenic. The powder is inhaled through a tube in the shape of a Y. Those wanting to become familiar with the De'áruwa world of spirits and demons have either consumed *yopo* powder, drunk *kareru,* or chewed *tuipa* a number of times. They will then sing:

"Buoka drank of the juice of the tree. In his vision he saw his future. He asked himself: 'Where are my thoughts going? What future do my visions prophesy for me?' His visions took him to the underground sacred sites of the peccary and other animals. He saw all the animals under the earth, and he heard the sound of the peccary instruments. After one single swallow of the juice of the *kareru,* he received his first vision: before him appeared the picture of the peccary instruments."

During the preparations for the Warime, the older, more experienced male members pass on their ritual knowledge to the uninitiated youths. From one of their number a shaman might well arise. The youths first learn how to construct the ceremonial musical instruments. They later learn how to fashion the masks.

First the *tschuwo,* a nose-flute, is made. Reed, gourd, and wax—nothing more than these simples materials is required. The tuning of the *tschuwo* and its mythical significance is, on the other hand, much more complicated:

"Wahari played outside of the huts on the *tschuwo*. But Tschecheru lay in a hammock in one of the huts. She heard the sound and became curious. That could well be something interesting! 'What is it, what speaks out there?' she asked herself. The sound of the nose-flute pleased her. 'Who is playing it?' she thought to herself, and became afraid. Wahari walked carefully back and forth as he played the instrument. He was directly outside of the hut in which his sister lay. As the sun came up, he carefully hid the instrument, burying it in the ground. His sister came out, looked around for the nose-flute, and would have loved to have known where the sound had been coming from. The *tschuwo* is dangerous, just as dangerous as the *worrah* or the *da-a,* the *ayaho* or the *muotsa*. They hold dangers in them. The musicians who play these instruments are not costumed like the dancers wearing masks."

The De'áruwa orchestra is made up of many other instruments besides the nose-flute. Some of the instruments are played already during the making of the masks—but the complete orchestra is not heard until the Dance of the Masks. Because the ability to create and the ability to play an instrument naturally go hand in hand, each ritual musician is necessarily a ritual musical instrument maker.

Another secret instrument is the *muotsa*[2], a simple leaf-pipe. The *muotsa* can also "speak"—but no one may witness from whom it is borrowing its voice.

The *reninju,* plaited in the form of a cage, is a reed rattle. The *reninju* may only be played during the dance by the men wearing masks. The musical instruments are charged with the symbolic presence of the animal world. *Dyaho* is the De'áru-

wa word for toucan; on the *dyaho*-flute can be played the names of the fruits and palm nuts which the toucan loves. The mythical water snake is represented by the *da-a*, a twin flute: each of the flute's wind-chambers, at semi-tone intervals, must be played at the same time. One wind-chamber embodies the male principle, the other wind-chamber embodies the female principle.

Experienced De'áruwa, those who have taken part in a number of Warime festivals, make the masks, while the younger men play the continually growing number of ceremonial musical instruments.

The *worrah* establishes the fundamental rhythm of the orchestra. The *worrah* is played by two musicians, each with a tubular pipe. In alternation, they blow short tones into a hollowed calabash. Earlier, in place of the calabash, which works as a resonator, a clay pot was used. "We call them *worrah*, because Wahari gave them this name. We say the 'old woman', 'woman *muotsas*,'—that's how we know that these flutes are the woman *muotsas*. That means, 'a woman with two ears', *thaha raabe hahkwa*, 'where the two ears go in!' The pipes are played into the resonating body to give the sound more depth. Two voices sound inside and two voices sound outside."

What ethnologists refers to as dance masks, are for the De'áruwa representations of animal spirits. The protagonists of the ritual are the *ime*, which means the white-lipped peccary. Their ritual partners are the spirits of *histschu*, the monkey, and *redyo*, the wild bee. The dance masks bearing their representations are objects of bizzare beauty. All the same, it is not the finished masks which impart the symbolic power, but the process by which the masks are crafted. To make a white-lipped peccary mask, *ime*, ten materials are required. The complex construction of the mask evidences a knowledge of nature gathered over centuries. Also a necessity—and bespeaking a similar tradition—is how the work process is organized.

The nose of the peccary-mask is fashioned from rushes bound into a circle. The part which forms the head starts directly above the nose. Finally, the wicker-work receives a coating of bast and other materials. Everything is done in a manner rigidly determined by long tradition.

Each of the men involved in the production process, perhaps now and then trying on a mask to see how it will fit during the dance, takes to hand the half-finished masks or musical instruments to make some addition or alteration. No mask is the creation of any one group member, but the result of the communal effort. The myths tell of two types of peccary masks, just as two types of peccary exist in nature. The one from Wahari was the larger, it was an *ime*, which represents the white-lipped peccary. The peccary of his brother, Buoka, was the smaller *mekira*, the collared peccary. In keeping with the myths, the two masks have different designs.

The myths tell of the creation of the peccaries and about the ritual itself. These myths are often repeated during the period of festival preparations. "We often sing of *ime*, the white-lipped peccary, before we eat of his meat, and also during the Dance of the Masks. The *ime* has several songs. One story tells about the *ime*'s creation. It is sung during the Dance of the Masks in a straight forward

The twin flute which uses a clay pot as a resonating chamber is called the *worrah*, "old woman." It is played by two musicians.

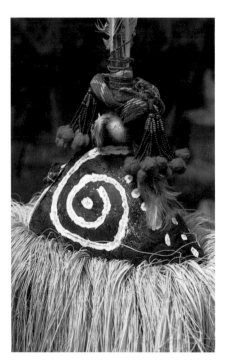

The peccary-mask is constructed over a plaited fundament, then richly decorated.

manner. The song that repels the peccary sickness, though, swerves around like a brook. I like the Warime Song, and I also like the other songs, because they are interesting. [...] Pureydo is the name of the place where the peccaries came into being. This was the work of Wahari. The people wear masks when they go into first one hut, and then the other, and then another. Before the De'áruwa were created there was nothing, only the forest and many mountains of rock. One mountain of rock was a deserted hut. The huts of the De'áruwa are like mountain peaks. And Wahari knew of the deserted huts when he was fleeing from his murderers. Because Kwojmoj, the poisonous snake, wished for his death. Wahari, though, so that he wouldn't be recognized, put on a mask and always changed his form. He traveled from hut to hut and gave the people many gifts, until he finally arrived at the deserted hut. That's why we sing of this place. Pureydo is not near here, it lies very far away."

The material fundament of the *histschu*, the monkey mask, is likewise plaited reeds. The face is modeled from wax. Exactly as with the *ime*, it is painted with white earth and cinnabar plant pigment. For eyes it receives pieces of glass, a reference to the creation myth: "Buoka tore out the right eye of his brother Wahari. [...] But Wahari was born blind. He couldn't see anything. [...] When Wahari opened his eyes, it was dark. [...] And so he went off to search for all the sacred places near the mountain, in order to find the sun."

After the animal masks are given shape, meaning after the layers of the various materials are attached, follows the most important part of the ritual production process: the painting. Here, *Bixa orellana*, a dye which is called *onoto* in Venezuela, and *urucu* in Brazil, plays a vital role. The mixing and painting of the dyes is done in a most simple way. The leaders of the ritual allow only very few men to carry out this part of the process. The painting is the last step of the work

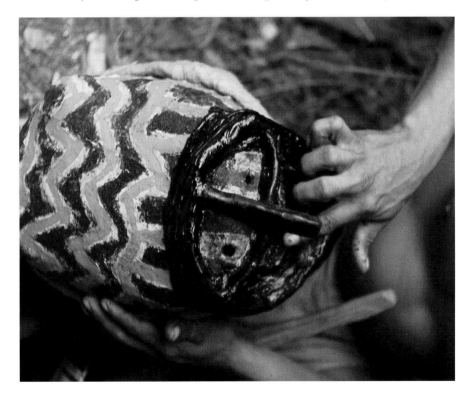

The *redyo*-mask, the Spirit of the Woods, is modeled from beeswax.

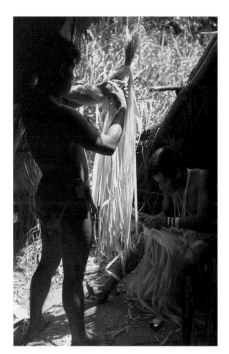

Mask making takes place in a special hut. The process is kept from the eyes of women.

in the production of the masks. Here, the inanimate object, the mask, is given a soul, and therewith it takes up residence on a level identical with the animal spirit it represents. The red plant pigment employed also plays an important role as a coloring for everyday utensils. The red designs on the manioc graters which stand for womanhood are one example.

Since mythic times, cinnabar in its De'áruwa ritual usage has been closely associated with the supernatural. *Onoto* is ascribed the power of being able to transport the masks crafted by human hands to the sphere of animal spirits. The red feathers of the macaw, placed in the nostrils of the finished *ime*-masks, are thought to possess a similar magic. According to the De'áruwa, the macaw, unlike most other animals, neither carries a disease, nor is it able to spread it. Thus, the macaw's pure nature predestines the bird as a mediator between the human, animal, and spirit worlds. The De'aruwa use not only the sacred *onoto* dye and macaw feathers for colorful effects, but also such secular mediums as the blue and white glass beads woven into armbands and necklaces, and the juice of the genipa fruit used to paint the skin.

Of special complexity is the significance of the wild bee mask, *redyo*. Here one can learn much about how the De'aruwa conceive of their natural surroundings, the manner in which they, proceeding from their mythical teachings and religious ideas, turn raw materials into symbols of culture.

The mask's intricate production process mirrors the multi-layered meanings synthesized in and signified by the finished *redyo*. As with each of the other masks, the basis of the *redyo* is formed by a basket-like plaiting. The "face" is modeled from a combination of resin and wax. The "face" presents a variety of aspects at once: when the viewer regards the object from the top, the red and white stripes give the impression of an insect's back—the back of a wild bee. But this impression is complicated by the representation of a human-like face at the bottom. This segment of the mask also visually intimates a wild bee nest hidden in a tree trunk. The mask is lastly seen as the synthesis of these alternating impressions: at the same time a wild bee nest in a tree and an individual wild bee, the *redyo* transcends these visual meanings to become and embody the Spirit of the Forest. The costume that goes with this mask is made from bast—during the Warime, it is almost as if the *redyo*-dancer is himself a tree set into motion.

The De'áruwa condense the whole of nature in the Warime ritual to express all aspects of change, from coming into being to departing. The name by which this ethnic group refers to itself gives a clue as to the importance of this festival. The presence of nature which is made accessible and symbolically celebrated during the Warime allows these people to become what De'áruwa, literally translated, means: "Lords of the Forest".

1 Njemeh, a shaman and political leader, is the informant of Boglár. The name Njemeh roughly means deer.

2 *Muotsa*, the simple leaf-pipe, "is made from the wood of the holly. A piece is cut off, divided into two thin strips, and planed with a knife. Between these strips a ribbon of uru palm leaf is inserted. It is a secret instrument, and therefore dangerous. [...] The word *muotsa* means as much as old!" (Boglár, 1982, pp. 57–58). They are also called "the old speaking woman" (Boglár 1982, p. 215). *Tschuwo* is a simple bamboo flute, which is played by exhaling breath through the nose. *Da-a* refers to two reed pipes played at once by two people. They are held crosswise. They are associated with the anaconda and represent the male and the female principles. Both flutes differ in sound by a semi-tone (Kaplan 1988, p. 345). In former times the *da-a* were made from tree bark. *Dyaho* is the name of a toucan (Boglár 1982, p. 58). The *worrah* is made up of two reed pipes, which are alternately held into the hollow of a calabash bowl to produce short tones.

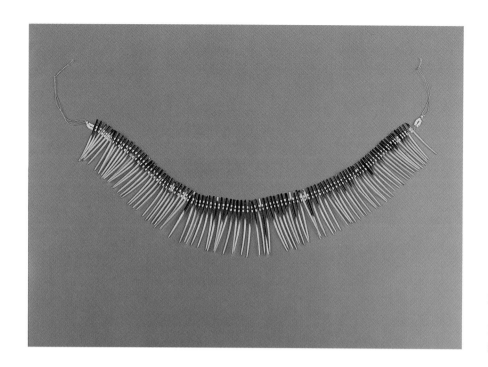

Necklace of porcupine quills
DE'ÁRUWA
Porcupine quills, cotton thread,
glass beads

Shaman's rattle—*rädiyu*
DE'ÁRUWA-MAKO
Calabash, wood, *Ananas lucidus* fibers,
seed capsules

During healing ceremonies the shaman
accompanies his songs with this rhythm
instrument.

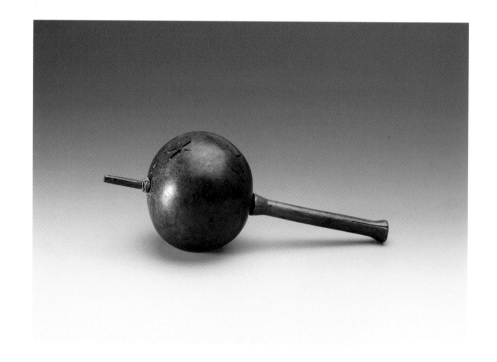

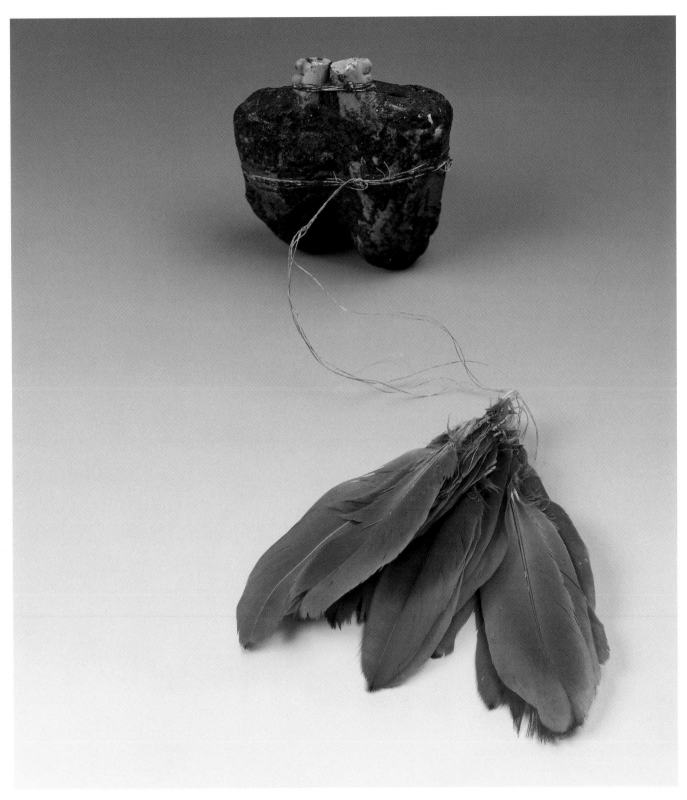

Pipe made of crayfish pincers
DE'ÁRUWA
Crayfish pincers, parrot feathers,
Sittace macao, beeswax, fibers of
Ananas lucidus

Such pipes are played above all
by children.

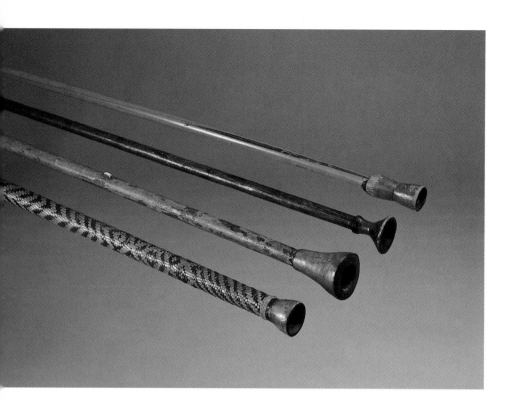

Blowguns—*yuwana*
HODÏ
DE'ÁRUWA
DE'ÁRUWA
E' ÑEPA
Reed, wood

A blowgun is composed of two tubes fitted into each other. The diameter of the outer tube measures about two centimeters. The inner tube is most often bartered for by the Ye'kuana. On the blowgun's stout end a mouthpiece carved from wood is attached with a generous layer of resin. Such blowguns were traditionally used to hunt birds and small game, above all such tree-climbing animals as monkeys or sloths.

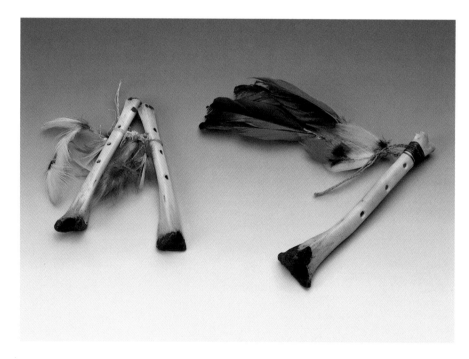

Bone flutes
DE'ÁRUWA
Deer bones, beeswax, parrot and toucan feathers, fibers of *Ananas lucidus,* resin with bee aggregate, cotton thread

Bone flutes are secular instruments for the De'áruwa. They are played for amusement, but never in the context of a sacred ritual.

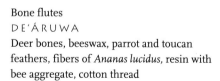

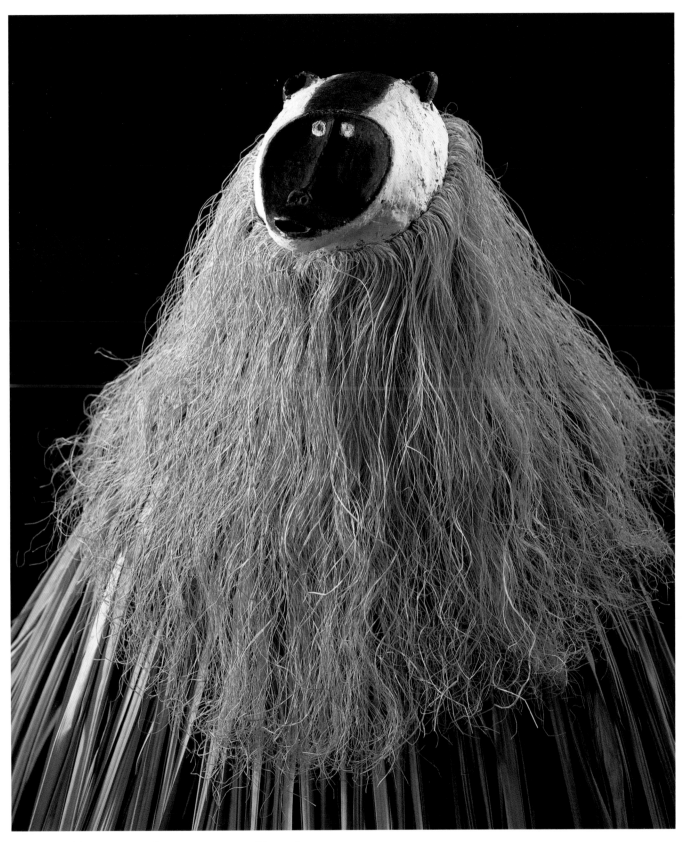

Jichu mask of the Warime ritual representing a capuchin monkey
DE'ÁRUWA
Bark from *Antiaris sacciadora*, mamure *(Heteropsis spruceana)*;
fibers from moriche palm *(Mauritia flexuosa)*, beeswax, plant pigment,
white clay

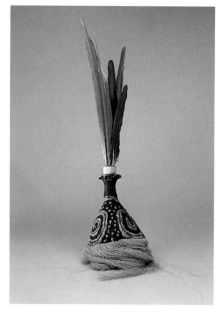

Ime-mask of the Warime ritual, representing a peccary
DE'ÁRUWA
Bark material from *Antiaris sacciadora,*
mamure *Heteropsis spruceana;* moriche palm
fibers *Mauritia flexuosa,* macaw tail feathers,
earth pigment, fibers from *Ananas lucidus,*
resin mixed with bee aggregate, plant pig-
ment

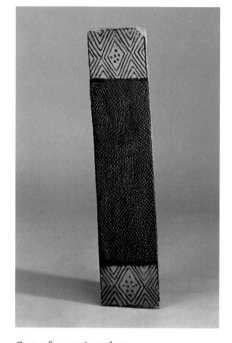

Grater for manioc tubers
DE'ÁRUWA
Wood, stones, resin of the couma tree
Couma caatingae

The bitter manioc *(Manihot esculenta)* must
be grated in order to remove its prussic acid
component. The women grate the tubers,
detoxify the pulp, and bake *casabe* tortillas.
This process of transformation finds analo-
gy when a shaman sings a song of purifica-
tion to the carcass of hunted game. Only
after receiving such special treatments do
manioc and animal meat become edible.

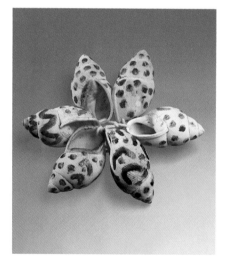

Sound-producing body decoration—
ʼkänäriyubä
DE'ÁRUWA
Shell of river snail, cotton thread,
plant pigment

This decoration is worn by men when they
visit other communities.

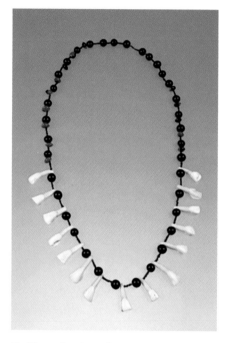

Necklace of tapir teeth
DE'ÁRUWA
Tapir teeth, seeds of *Hormonsia sp.,*
glass beads, cotton thread

Wahari, the culture hero of the De'áruwa,
often appears in stories of myth as a tapir.
Such necklaces are considered protective
amulets.

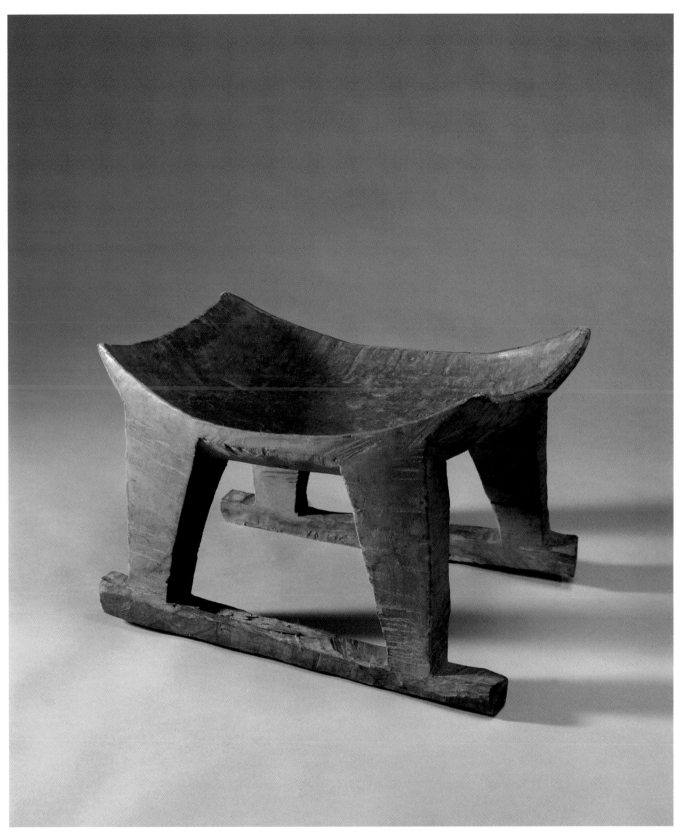

Shaman's seat—*deyä'ka*
DE'ÁRUWA
Wood of *Couma caatingae*

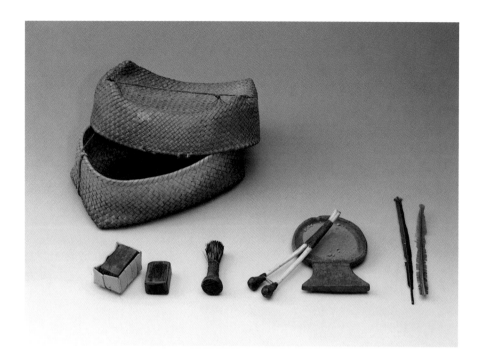

Small basket with lid for *yopo* utensils—
daruwäpja
DE'ÁRUWA
Palm leaf, wood, feathers, seeds of the seje
palm *Oenocarpus bacaba*, peccary bristles,
heron bones, cotton thread, beeswax, resin
mixed with bee aggregate

The lidded basket serves for storing the *yopo*
utensils. Prior to healing ceremonies, the
shaman goes into trance by means of the
yopo drug after inhaling the powder from
the snuff tray into his nose via the Y-shaped
snuff utensil. the trimmed feathers are used
to clean the hollowed bones.

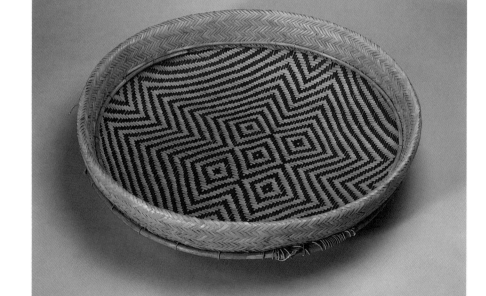

Basketry tray—*manarë*
DE'ÁRUWA
Fiber from *Ischnosiphon aruma*, mamure
Heteropsis spruceana; cotton thread, plant
pigment

The design imitates a tortoise shell.

Ladle
DE'ÁRUWA
Halved calabash, plant pigment

Pair of pipe flutes with feather adornments
DE'ÁRUWA
Reed, parrot and toucan feathers, cotton
thread, fiber from *Ananas lucidus*

Music has a magic effect: only through
song and flute melody does game become
edible.

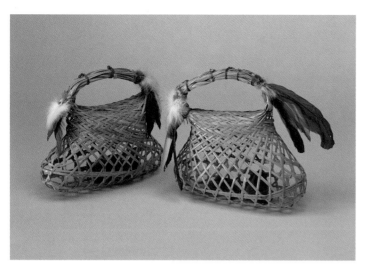

Plaited hand rattles
DE'ÁRUWA
Plaited from *Ischnosiphon aruma,* fibers from *Ananas lucidus,* parrot
feathers, tapir hooves, seed capsules

The typical instrument of the *ime*-mask wearer during the Warime ritual.
The nut shells in the cage-like wickerwork are called *morocoto,* which is the
word for large fish. It is of significance how the rattles are held during the
dance. When the dancer imitates the sound of the peccary, the rattles are
held horizontally. They are held vertically during song. Either a nut or an
animal hoof pounds against the plaiting like a fish thrashing inside a fish
trap.

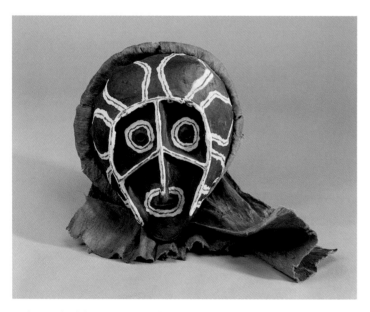

Redyo-mask of the Warime ritual, representing the Spirit of the Woods
DE'ÁRUWA
Bark from *Antiaris sacciadora,* mamure *Heteropsis spruceana,* beeswax, plant
pigment, resin mixed with bee aggregate, white clay

Redyo is the Spirit of the Woods. Associated with wild bees, he is consid-
ered a benevolent figure.

Masks with body costumes of the Warime
ritual, representing a capuchin monkey and
a peccary
DE'ÁRUWA

The costumes of the dancers are made up of
a skirt and a cape-like covering over which
dangle the frills from the mask. According to
legend, Wahari, the first shaman of the
De'áruwa, held the original Warime ritual.
He constructed a mask covering his entire
body so that Tschecheru, his sister, would
not recognize him. The De'áruwa honor the
peccary as an ancestor. Respective to the two
peccary species found in southern Venezue-
la, the white-lipped peccary *(Tayassu pecari)*
and the collared peccary *(Tayassu tjacu),*
there are two types of peccary-masks: the
ime-mask, and the smaller *mekira*-mask.
The masks are placed on the head looking
towards the sky. The palm-fiber curtain hides
the face of the dancer. The wearers of the
ime-masks accompany their dance with the
shaking of plaited rattles. The palm covering
also rustles loudly with each movement.

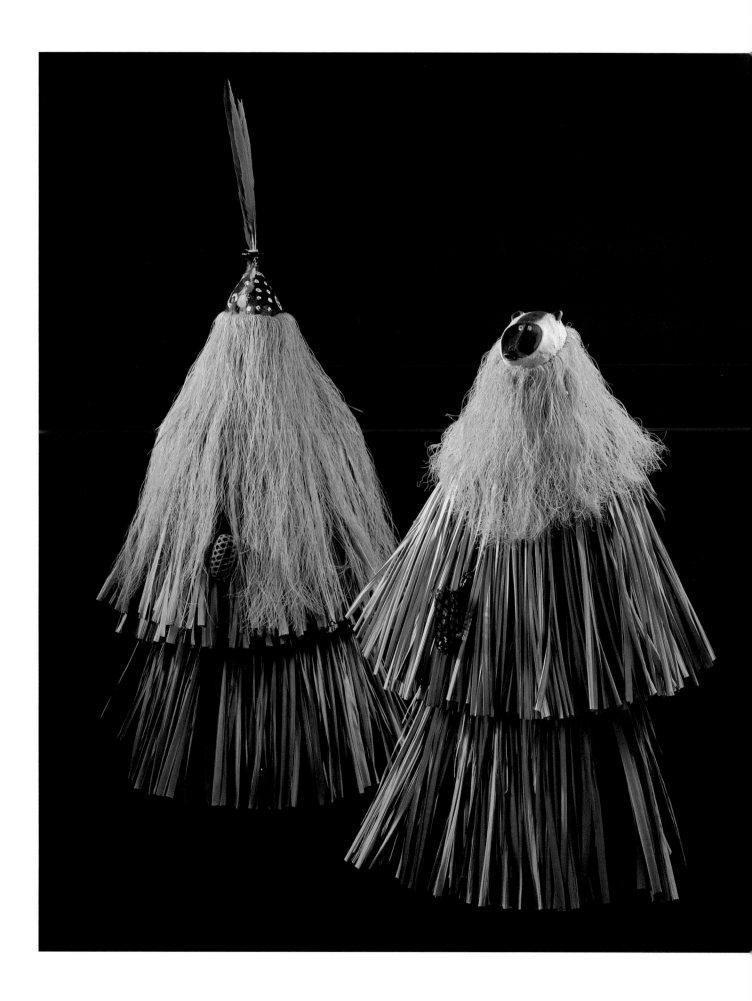

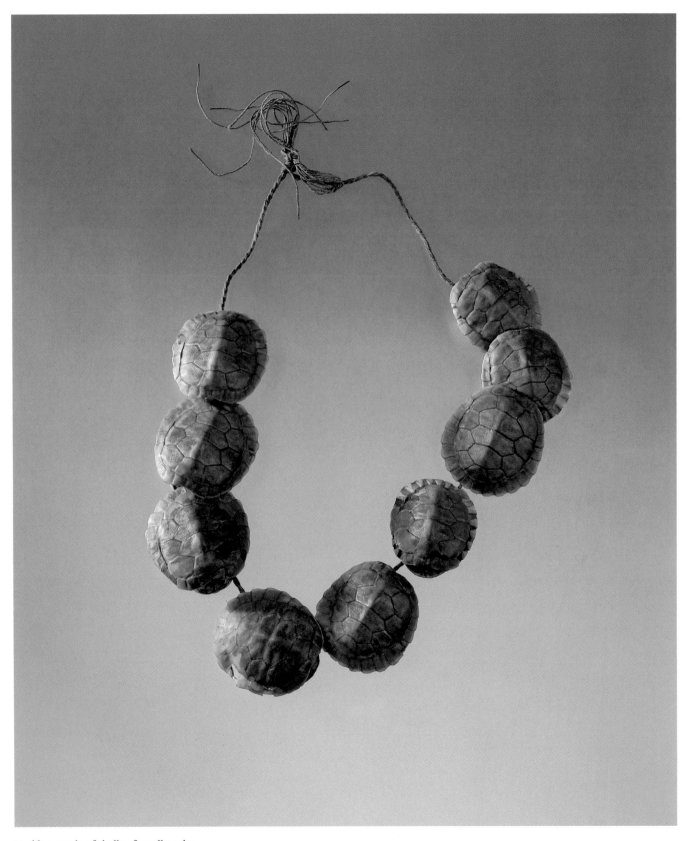

Necklace made of shells of small turtles
DE'ÁRUWA
Turtle shells, cotton thread

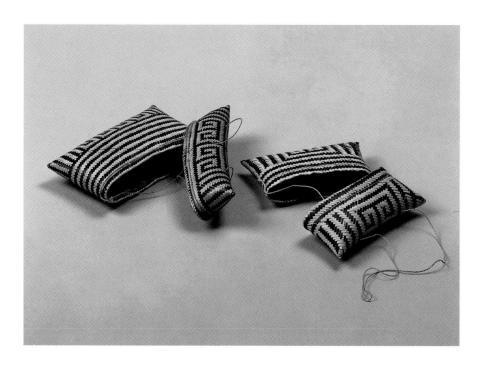

Two small woven bags with lids and tumplines
DE'ÁRUWA
Fibers of *Ischnosiphon aruma*, fibers of *Ananas lucidus*, plant pigment

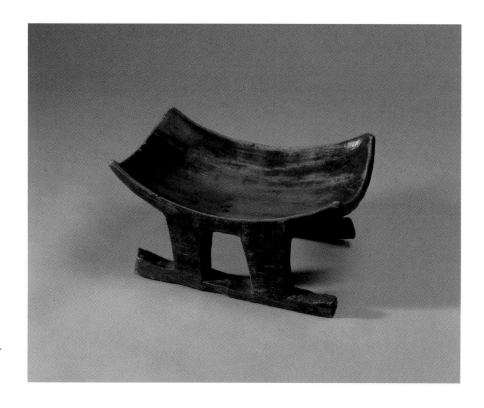

Shaman's seat—*deyä'ka*
DE'ÁRUWA
Wood from the couma tree *Couma caatingae*

In former times, the seats were reserved for the shamans who used them when perform-ing healing ceremonies. Nowadays they are used for sitting in everyday life as well.

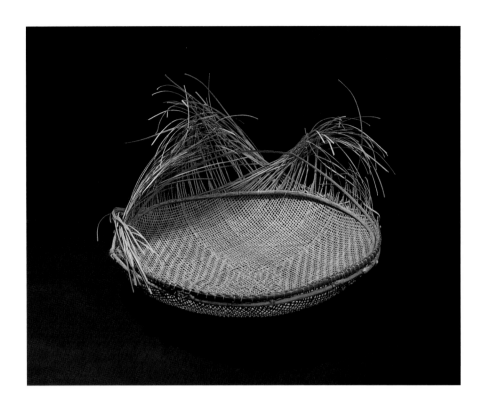

Sieve—*rútu'ka* (in progress)
D E ' Á R U W A
Wickerwork of *Ischnosiphon aruma*, mamure
Heteropsis spruceana, fiber from *Ananas
lucidus*

Sieves are used during the processing of
bitter manioc. The grated manioc is placed
in a tube press and squeezed of its poison-
ous fluid. Then the dry, stringy pulp is
removed from the press and separated from
its woody component by sifting it through
the basket-like sieve. The flour is then baked
into *casabe* tortillas. This same type of sieve
is used to lift from the water fish anaesthe-
tized with fish poison.

Cage to transport tamed birds
D E ' Á R U W A
Fiber from *Ischnosiphon aruma*, mamure
Heteropsis spruceana

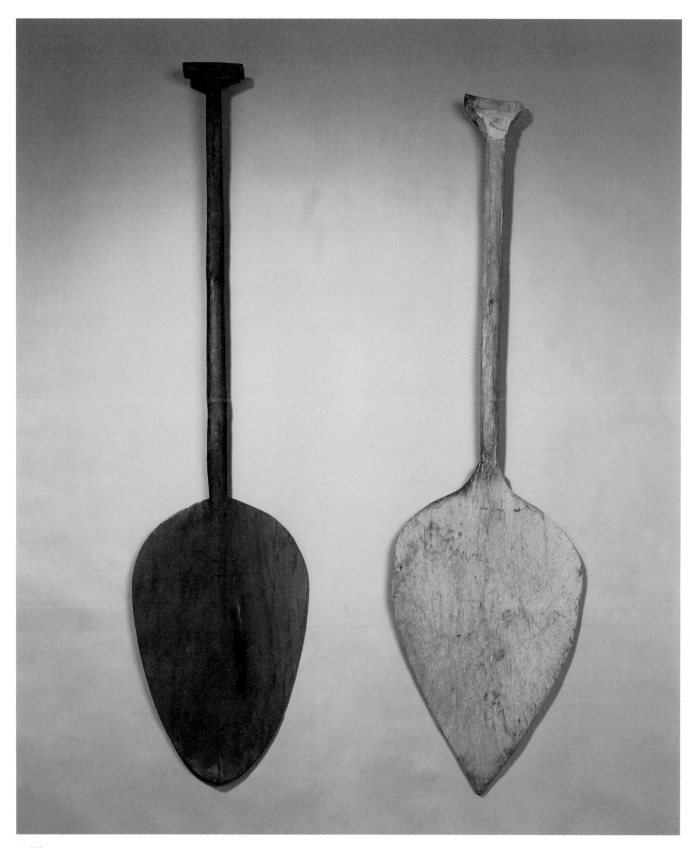

Paddles
DE´ÁRUWA
BARÉ
Wood of *Ocotea cymbarum,*
fustic tree *Lafoensia punicifolia*

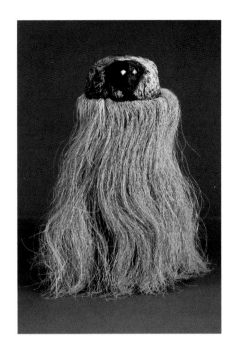

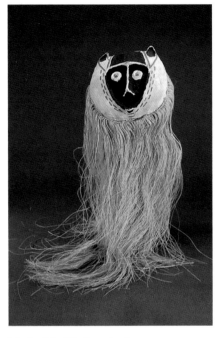

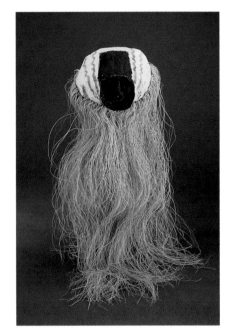

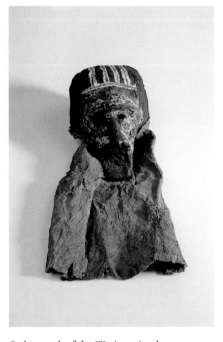

Mask of the Warime ritual
DE'ÁRUWA
Bark of *Antiaris sacciadora,* mamure
Heteropsis spruceana, moriche palm fiber
Mauritia flexuosa, beeswax, plant pigment,
resin mixed with bee aggregate, white clay,
fiber from *Ananas lucidus*

In preparation for the festival rite the men
of the local group construct the masks
under the supervision of the ritual leader.
While they create the figures, the myths are
recited and the traditional songs are sung.
During the Warime ritual the creation of the
world is reenacted.

Jichu-masks of the Warime ritual,
representing a capuchin monkey
DE'ÁRUWA
Fiber from *Antiaris sacciadora,* mamure
Heteropsis spruceana, moriche palm fiber
Mauritia flexuosa, beeswax, plant pigment,
resin mixed with bee aggregate, clay, fiber
from *Ananas lucidus*

The head of the masks is modeled from bees-
wax and resin. Constructed atop a basket-like
plaiting, the heads are painted with clay and
plant pigment. The eyes of the mask at the
top are inset with pieces of mirrors.

Redyo-mask of the Warime ritual,
representing the Wild Bee Spirit
DE'ÁRUWA
Bark bast fom *Antiaris sacciadora,* mamure
Heteropsis spruceana, beeswax, plant pig-
ment, resin mixed with bee aggregate, white
clay

The mask embodies at once the individual
bee and the beehive. It symbolizes the
power of the forest, or the power of nature,
and is regarded as the most important fig-
ure of the Warime ritual. The wearer of the
redyo-mask does not sing, but instead utters
loud cries and accompanies his steps with
the pounding of his scepter upon the
ground.

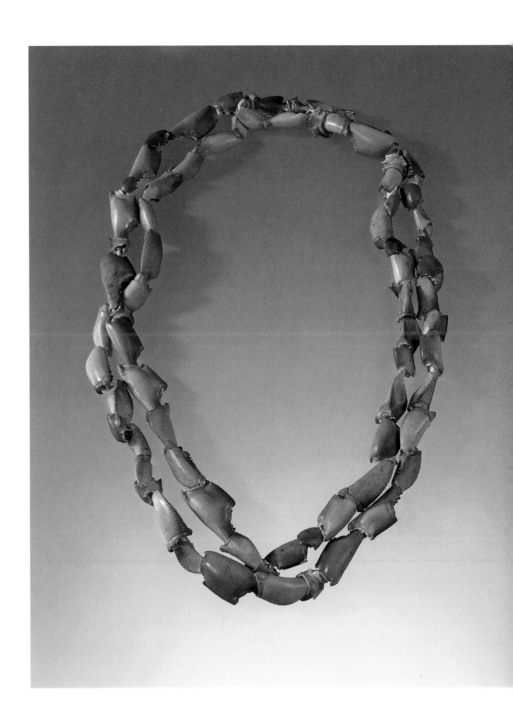

Necklace made of crayfish pincers
DE'ÁRUWA
Crayfish pincers, cotton thread

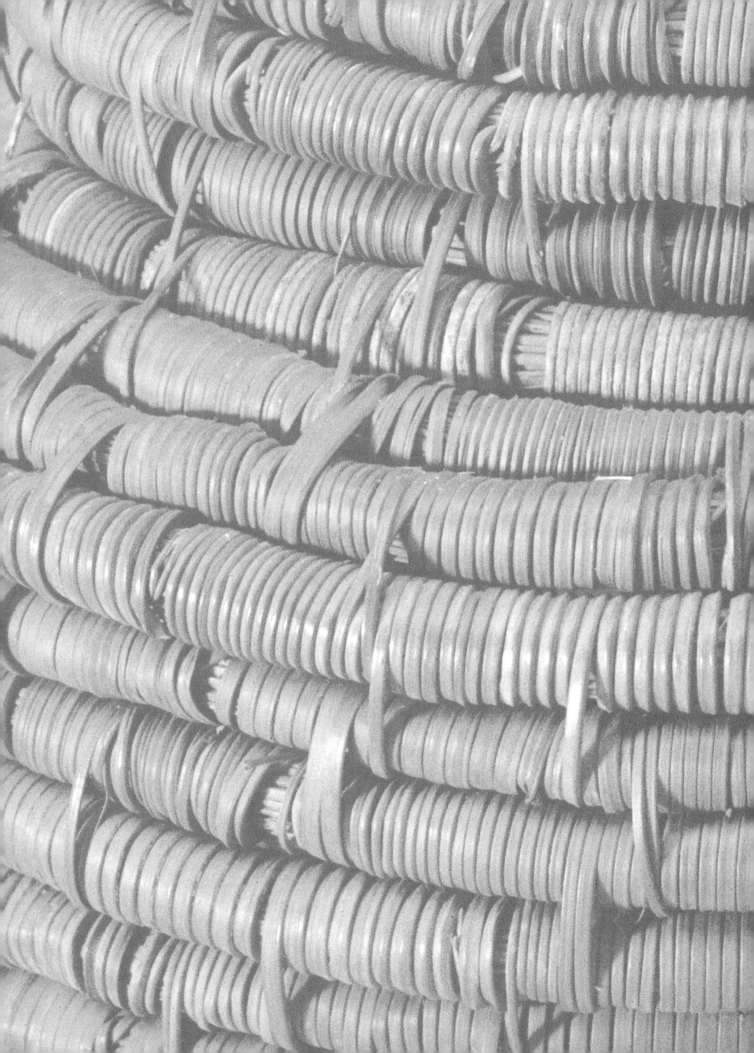

HÍWI

HODÏ

ARAWAK

PUINAVE

LELIA DELGADO AND GABRIELE HERZOG-SCHRÖDER

HÍWI

THE PEOPLE OF THE SAVANNA[1]

Under the scorching sun, the Híwi wander towards the golden savannas of the Apure River. The wide, splendid panorama teaming with lively reflections allows them to momentarily forget the centuries of persecution they have endured in the name of faith and progress. The Híwi realize that they can find no respite in the society of "civilized" big landowners. The landowners consider it a game to hunt the Indians, which they call "guajibear." Derived from this word is "Guahibo", the name given to them by the criollos.

The Híwi miss their traditional lands. No longer can they refresh their senses on the birdsong, changing shadows, dust clouds, or earthy scents carried by the wind. No longer are the Híwi heirs of a kingdom of fire and smoke. Taken from

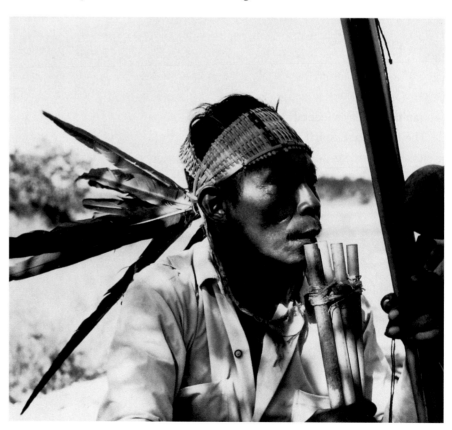

The Híwi play various wind and percussion instruments at festive occasions.

them are the rivers with the giant water snakes in which they envisioned the lords of wind, thunder and lightening.

Torn from their roots, they seek the lost paradise of the vital elements. They fight for survival using that same stamina of spirit which traditionally allowed them to experience the mystery of the world and to understand its meaning. Death could come at any moment.

Rituals and oral traditions offer no defense against the brutal and arrogant nature of the *racionales*, "the rational ones", as the white settlers refer to themselves as opposed to the Indians. The traditional sacred sites are mined with unexpected dangers. Loneliness and the fear of being hunted characterize Híwi life today. Robbed of their traditional lands, the Híwi wander like strangers in the world. Still, they are trying to make peace with their fate.

HUNTED HUNTERS

Híwi literally translated means, "people." The Híwi also refer to themselves as Wayapopihíwi, "the People of the Savanna." In ethnological literature they are mostly referred to as the Guahibo, or Guajibo.[2] As opposed to the Híwi who are culturally assimilated, those groups which are traditional, meaning still leading lifestyles maintained by the hunting of wild game, are called by the non-Indian population Cuiva. The Híwi have largely managed to hold on to their language, which is one of the Indian idioms of Venezuela yet to be definitively classified.[3]

The Híwi population is estimated to be between 15,000 and 20,000 people. Most live on the llanos, the wide, savanna grasslands of the Orinoco basin. The Híwi are one of the region's most populous ethnic groups, the major portion living in Colombia. An estimated 5000 to 6000 Híwi live in Venezuela, by and large along a narrow strip of land bordering Colombia. As of the middle of the seventies, some 4000 Híwi were counted living in and around Puerto Ayacucho, the capital of today's federal state of Amazonas.

The Híwi's traditional territory was formerly populated by a variety of ethnic groups. In the meantime they have disappeared or were absorbed by the Híwi. The subgroups of today are possibly of mixed or different ethnic descent.[4] The exact development does not allow itself to be traced back. The history of the Híwi lies for the most part in the dark—reports are rare and amount to little more than a few statements by travelers and missionaries.

The first mention of the Híwi reached us from Nicolaus Federmann in the year 1538. Underway with one of the first great expeditions, Federmann traveled across the llanos and in the region of the Rio Meta he encountered the Híwi. He describes them as hostile nomads. Many reports dating from this era testify already to the disintegration of the llanos groups as a consequence of subjugation and colonialization. At the time entire peoples were exterminated or taken as slaves. This process affected those Indian groups who lived in permanent communities more than those who were nomadic or semi-nomadic. The Achagua and the Saliva, who had also settled the llanos, withstood the force of the rapid

change for only a short while. The Híwi were somewhat more clever in terms of resistance strategies, many managing to elude the Europeans by retreating into rough terrain. The chroniclers of the seventeenth and eighteenth centuries repeatedly describe the Híwi as nomadic, warring hunters and gatherers. They were notorious for their raids on settlements and missionary outposts. The Jesuits called them too "temperamental" to be settled at the mission station.

The rapid evolution of Híwi society from one of nomadic hunters to one of settled farmers took place over the past 100 to 150 years. Several Colombian groups and even a few of the communities of the Venezuelan state of Apure managed to maintain their traditional lifestyle as hunter-gatherers. In addition they supplemented their hunting with some farming. With relative ease they could survive in the rugged regions between rivers difficult for white people to access. There, again, their numbers could grow.

One of the strategies the Híwi used to secure their survival is barter. Exchange between the nomadic hunter-gatherers and the settled groups was an important economic mainstay even during the pre-colonial period. However, over the last couple of centuries, due to conflicting demands on the land, intertribal strife has often arisen. Rivalries over women is another source of animosity between groups. Although these conflicts seldom escalate into bloodshed, the Híwi have the reputation of being aggressive. This reputation has often served as a pretext for discrimination. Even over the past 40 years the Híwi have suffered greatly from persecution, often having to fear for their lives. In these remote regions the racist idea still survives that Indians have more in common with animals than with people, and that to "wipe them out" is nothing other than an "hygienic act."[5]

Today, the Híwi of Venezuela live between the mouths of the Meta and the Vichada, western tributaries of the Orinoco. A few smaller groups can be found living on the north bank of the Meta, as well as along the right bank of the Orinoco. Further downriver, in the vicinity of La Urbana, as well as just north of the mouth of the Apure, small Híwi settlements exist. A further community, which separated in 1945 from the groups living along the Orinoco, has in the meantime grown to number some 200 people. They live in the richly forested region near Manapiare, a tributary of the Rio Ventuari.

Most Híwi live on the huge plains of the llanos. Here seasons of copious rain alternate with periods of lasting drought. Soil, flora and fauna—even the moods of people—change depending on the season. Before the rainfalls begin in May, it is hot, windless. Soon after the rains arrive, the land is flooded. For amphibians and fish this is the season to flourish, but for the cows, jaguars, chiguire, deer, snakes, and birds, the torrential downpours signal the retreat to the higher ground where they seek refuge.

FROM HUNTER-GATHERERS TO HIRED HANDS

Most of the Híwi live today as farmers or as agricultural workers. Many secure their livelihoods looking after animals on the large estates of the fertile savanas. Some find work as rubber tappers in the forest. Others eke out an existence in one of the few small towns, leading the melancholy life of day laborers.[6] Many have left their traditional settlement areas and communities to find neither friends nor means of steady employment in the criollo world. Indian families wait on the outskirts of Puerto Ayacucho for months in the hopes of finding odd jobs. One of their few chances to receive a bit of income arrives when a freighter drops anchor: perhaps dock workers are needed. It comes as no surprise to learn that rates of criminality and prostitution are growing.[7]

The settled Híwi who practice slash-and-burn agriculture grow mainly bitter manioc. They also plant sweet manioc, sweet potatoes, yams, pepper, plantains, beans, sugar cane, and occasionally pineapple. Such inedible crops as cotton, fish poison, tobacco, and plants that contain hallucinogenic substances are also cultivated. The agrarian lifestyle also permits the keeping of chickens, for which a separate chicken coop is erected.[8]

The penchant for hunting and the high regard granted expert hunters plainly evidence the Híwi's traditional past—especially when one considers how little relevance hunting as a technique of subsistence holds for the Híwi farmers. Because game is rare in the more densely settled areas, where one must travel great distances to encounter larger game, a shift of preference can be observed: more and more Híwi have turned to fishing. Hunting still plays an important role among the smaller groups who practice seasonal farming, and even a larger role among the nomadic groups. But, as the criollos claim more and more land for themselves, here too, the activity of hunting will decrease in rank as a survival strategy.

The men are the hunters—although women occasionally also pull an agouti or an armadillo from its den. The preferred hunting technique is to ambush animals at their gathering places or at their watering holes. When tracking larger game like tapir or deer, trained hunting dogs are sometimes employed.

In former times the Híwi hunted in groups of close relatives. Women and children made loud noises with *macanas*, clubs, machetes or sticks to drive the game in the direction of the hunters. The animals were surrounded and killed with bows and arrows. This communal event belongs to the past. Traditional weapons, however, are still frequently used.

Most hunting parties are made up of two or three men. The kill is divided among the party members according to strict rules. Any transgression would compromise one's hunting luck in the future. The successful hunter's parents-in-law receive particular consideration. The hunter is allowed to keep special portions of the game. He divides among his hunting partners the largest portions of meat. Hunting luck is positively influenced by magic. Numerous hunting taboos must also be respected. On the night before the hunt the hunter must fast and refrain from sexual relations. The rules of taboo, which forbid the hunting of cer-

tain animals, differ from locale to locale. The Híwi of the Orinoco, for instance, are not allowed to eat the meat of the *tonino*, the fresh water dolphin.[9]

The most important game are iguanas, armadillos, such rodents as the agouti and chiguire, deer, peccaries, anteaters, porcupines, tapirs, and monkeys, as well as various birds like doves, parrots, and toucans. Jaguars, foxes, snakes, and caimans are in wide areas neither killed nor eaten, since many of the Híwi groups associate their own creation with the mythic origins of these animals.

Fish largely satisfy the Híwi protein needs. In the meantime almost everywhere fishing has become an important subsistence technique. The Híwi are accomplished at various techniques of fishing, using bow and arrow, line and hooks, fishing-nets, and small traps. At night they use torches to lure the fish. In fishing parties consisting of at least one leader and two helpers, *barbasco* fish poison is used. A stream is dammed and bundles of chopped *barbasco* are laid on wooden slats to be lowered into the water. Once the poison takes effect the fish forced to the surface are scooped from the water.

Members of fishing parties must also respect a series of taboos in order to procure success. Menstruating or pregnant women are not allowed to take part in these enterprises because it would bring bad luck. Following a successful fishing outing a portion of the catch is smoked and another portion ground into fish flour to be used as a source of nutrition once the meat provision is exhausted.

The nomadic groups, that are turning more and more into a relic of traditional times, live by gathering such sources of food from the savanna as fruits, nuts, insects, lizards, and turtles. Turtle eggs are dried in the sun or eaten raw. They also gather ritual and medicinal plants, as well as materials to manufacture utensils. Men and women together take part in the gathering forays. An effective method of procuring food and game is to set the dry grass of the savanna aflame. Once the fire dies, the remains of turtles, insects and snakes can be collected. A few weeks later, larger game will be lured to the freshly growing grass—always a good hunting opportunity.

When their croplands can be left alone, those Híwi who have taken up farming occasionally take a little vacation from their settled lifestyles. The entire family retreats for a few days into a palm grove to camp and live off the palms and nature. Besides the seje and cucurito palms, the Híwi also have a strong preference for the moriche palm. From its fruit a great number of foods and drinks can be made.

CREATIVE ADJUSTMENT THROUGH HANDCRAFT SKILLS

The size of a settlement is a reflection of the economy practiced locally. Hunters and gatherers erect their temporary camps in the woods flanking bodies of water, or between rivers, choosing a zone suited to their preferred technique of food gathering. They stretch their hammocks between trees in the open or construct simple windbreaks of wood and palm fronds. The settlements of the seasonal farmers are usually made up of two or three huts of oval or round ground plans. Permanent settlements, however, might contain between 10 and 15 huts housing between 50 and 150 people. The compact dome huts which the Híwi erect with ground plans ranging from oval to rectangular have palm roofs reaching down to the ground. They are called *tamo* or "mosquito houses," and rest on six to eight poles. Today, however, in the manner of criollo architecture, the permanent farmers erect rectangular buildings with roofs of corrugated iron.

Two valuable survival skills which the Híwi possess are their handcraft gift and a talent for trading. The earliest accounts we have of the Híwi already attest to their cleverness when bartering with other ethnic groups of the region.

Traditionally the Híwi sell the criollos bagged game, wild fruits, and snuff-drugs. Recently, especially in the villages along the Manapiare and the Orinoco, the range of agrarian trading products has grown considerably. In addition to the criollos, the Piaroa and the Ye'kuana belong to the trading partners of the Híwi.

Many Indian societies have adopted the westerner's outside appearance.

From their Indian neighbors the Híwi receive manioc graters, wooden benches, dugout canoes, and wooden stamps for face painting.

In the material culture of the Híwi textile production occupies an important place. The Híwi have always woven attractive and at the same time sturdy hammocks from palm fibers—goods sold today in the marketplace. In the meantime the Híwi dress themselves in the manner of the white people; one rarely encounters the traditional clothing made from bark fiber. The body decoration worn by women—long necklaces composed of red and blue glass beads—is still worn today. The men, too, continue to wear long necklaces and amulets adorned with caiman teeth, jaguar claws and the seeds of the cumare or cucurito palms. Body painting is rarely practiced anymore; for ritual occasions, however, the face is ornamented with designs.

Basketry is largely a male enterprise. For the transport or storage of foods, the men plait baskets then paint them with red and black geometric designs. Recently, women have begun to produce baskets to sell. They can be found at criollo markets beside the hammocks, benches, and wooden articles so imaginatively carved.

The primary trading goods are the clay vessels which the women make in the forms of animals or humans. The vessels are made by coiling technique, smoothed with pieces of calabash, dried, then fired over open flames. Afterwards they are decorated with geometric designs. The Híwi are the only Venezuelan Indians who are able to conduct such a booming trade with the pottery goods they produce. Most likely this ability can be traced back to the influence of earlier agrarian societies such as the Achagua.[10]

MUSIC FOR THE SPIRITS

At festive gatherings the Híwi make music on various wind instruments and drums. A number of the types of flutes they produce themselves. From long deer bones they construct flutes with three apertures. The pan pipes they make consist of five or six reeds. A special type of flute fashioned from the skull of a deer, usually including the antlers, is made by closing with resin or wax all the openings except at the base. Blowing into the one remaining hole produces from the skull a whispering, almost murmuring tone.

An important instrument is the *maraca*. The body is made of a calabash with to a wooden handle. The black feather helmet of the curassow is attached at the top. The seeds filling the calabash produce a sound when shaken. The medicine men have special shaman rattles which are filled with crystals. While the secular *maraca* is solely decorated with geometrical designs, occasionally, the shaman rattle is also adorned with representations of objects. All of these designs are considered to represent the spirits of the souls of passed away medicine men.[11] Their power is brought to life by the rattling of the shaman rattle.

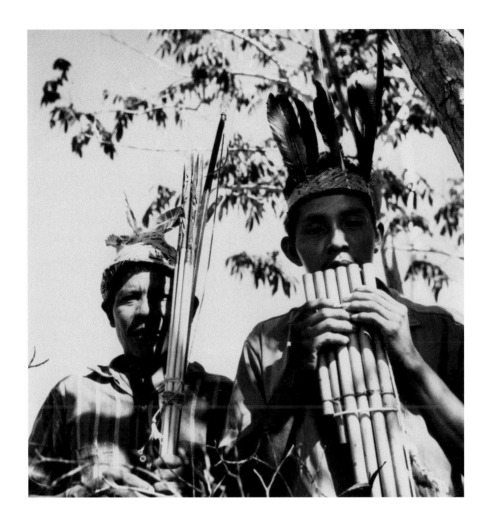

The panpipes of the Híwi are composed of five or six reeds. Today the Híwi can be divided into ten regional groups—there were certainly many more in the past. The surviving groups are the Awirimomowi or the Bólamomowi—"People of the Dog"; the Baxumomowi or Duhaimomowi—"People of the Baxu Fish"; the Hamarúamomowi or Aínawimomowi—"People of the Hamarúa-Fish"; the Húramomowi—"People of the Parakeet"; the Kabalémomowi—"People of the Kabalé-Fish"; the Káwirimomowi—the people who refer back to the mythical cannibal Káwiri; the Mahamomowi—"People of the Yellow-Headed Macaw"; the Metsáhamomowi—"People of the Tapir"; the Newïthïmomowi—"People of the Jaguar"; and the Okorómomowi—the "People of the Armadillo".

FAMILY LIFE AND KINSHIP TIES

The Híwi have no higher political organization; as a people they are relatively heterogeneous and practice numerous different types of lifestyles. A number of subgroups can be identified, groups which differ in terms of customs and of dialect. However, between these groups there is apparently no established hierarchical order. In the meantime the differences between these subgroups, due to the unrelenting settling of their traditional territory by criollos, have largely disappeared. Many of these subgroups have merged, others have left the land of their ancestors.

The smallest social and economic unit of the Híwi is the nuclear family, which is made up a man and a wife—or wives—and their children. Each of these units has their own cooking place, weapons, kitchen utensils, and garden where food crops are cultivated. The extended family group, which is made up of a number of closely related nuclear families, possesses the political power. This extended family group shares a dwelling and distinguishes itself by a collective economy. Membership in such a group is, however, never obligatory, and the constellation of such groups is constantly changing.

The kinship organization is for the most part matrilineal, which means that an individual primarily sees herself or himself as the descendant of the mother and her relatives. The preferred form of marriage is the cousin marriage; following the

wedding ceremony the married couple usually moves in with the family of the bride. It is the groom's duty to volunteer to do a number of chores for his father-in-law.

The extended family group is advised by a "local leader." His authority is not gained through any formal, political structure or a defined set of rules; the office is not institutionalized. The Híwi language has no concept for the social position of such a leader. The leader makes suggestions, which by no means must be followed. The position of leader brings with it no material advantages, although it does mean prestige and respect. The leader tries to mediate arguments in order to prevent more serious disputes. He also plans the hunting and fishing parties, as well as coordinates those occasions which call for communal labor such as sowing seeds or clearing land.

CARVED ANCESTORS—PANTHEON OF THE SPIRITS

According to the cosmology of the Híwi the world was created by supernatural beings. While it came into being in one supreme act, human beings were the final result of several failed attempts by the creator of the world, the adventurous culture hero Kuwai. First Kuwai created clay figures. They dissolved in the rain. Then he made figures out of wax. They melted under the sun. On his third attempt he carved a human couple out of hardwood. A mythical mouse fashioned the penis and the vagina, and thus it became possible for humankind to multiply.

The Híwi honor a wide pantheon of mythical beings. Kuwai, the highest creator and ruler of the culture heroes, was followed by other "culture-bearers": Iwinai, from whom the Híwi learned how to build huts; Matsúludani, who showed them how to make and use bows and arrows; Tsámini, who introduced agriculture; and Madúa, who invented the various languages, as well as taught the Híwi how to build dugout canoes.

In addition to these creators there are a number of other mythical figures, as for instance: Yamxa, the lord of thunder and creator of snakes; Dówati, an evil being who devours human souls; Kuliwakúa, who steals corpses; and finally Masiphépere, who is represented as a skeleton and who is thought of as the harbinger of death. The Híwi living along the Orinoco also associate Masiphépere with the spirits of deceased medicine men.[12] Other mythical figures, the Mánu, are the lords of the rivers and animals.

DUAL SOULS AND THE MAGIC OF THE SHAMAN'S RATTLE

The Híwi believe that all humans and animals possess two souls: *yethi* and *húm-pe*. *Yethi* is invisible and leaves the body during sleep to appear in the dreams of other people. *Húmpe* is chained to the body and doesn't leave until the time of death when it travels to a heavenly sphere filled with great bounties of provisions—the dwelling place of Kuwai. When a shaman dies his *húmpe* goes to join a great snake who lives on the bottom of a river.

The shamans or medicine men are the highest spiritual authorities. They are able to work black magic as well as white magic. Their power manifests itself during trances induced by taking the hallucinogenic *yopo*. The drug is inhaled through the nose with the help of an instrument made from bird bones. This *yopo* inhaler has two tubes which come together in the shape of a Y.

Often a candidate shaman follows his father's calling. Paying his teacher with material goods or by performing services, the youth must undergo a long period of training. Over time he achieves insight and experience. The Híwi culture has no formal ceremony to mark the end of a shaman's training. As soon as the young shaman is sure of his abilities, he begins to work and to treat the sick.

The shaman receives his powers through a magical crystal, the *wánali*. The *wánali* helps him reveal who is responsible for the bad luck or the death of a group member. It is pieces of *wánali* crystal which produce the typical sound of the shaman rattle. By shaking the crystals the shaman can call forth diseases and death in enemies. If he chooses he can project himself with invisible thought rays into the body of an enemy to cause troubles.

Diseases are traced back to various causes. Often they are interpreted as consequences of black magic. Most likely an ill-meaning medicine men had projected his black thoughts into the body of the sick person. However, a number of evil and bizarre spirits also cause sickness when they temporarily take up residence in humans, animals, or even plants.

Many ideas in this context are closely connected to the belief that spirits are attracted by the smell of fresh blood and from meat dishes. These spirits cause mild sicknesses which can be cured with medicinal plants, through rest, bathing, or by drinking large amounts of water. Sicknesses caused by the breaking of taboos are treated in much the same fashion. The "evil eye" of a shaman, on the other hand, may induce severe sickness. Here only a medicine man with the aid of his helping spirits, *málike* and *málikai,* can bring about a cure. A variety of ritual elements are employed in such cases, such as dance, song, massage, the blowing of tobacco smoke across the patient, the sucking of wounds, as well as the ingestion of plant extracts. But the shaman above all heals with the sound of his rattle.

BURIAL AND DEATH SPIRIT SPELLS

The primary burial takes place soon after a group member dies. The corpse, usually with a few personal possessions, is buried in the forest or on the savanna. All members of the local group take part in this act. The burial itself is carried out by kin, but not by the relatives most closely related. The dwelling place where the death occurred is deserted, and special rituals are undertaken to protect the living from the negative influences of the death spirit, *yethi*. The family members fast and refrain from work for a period of days. Measures are taken so that Kuliwakúa, the cannibalistic lunar spirit, does not steal the corpse. Those in grief paint their faces with a mixture of coal and tree resins charmed by a medicine man with his breath. The face paintings work to keep the newly deceased from coming back and haunting the dreams of the living. This protection shows a general fear among the Híwi of zombie-like beings. The secondary burial takes place at some favorable point in time during the following five years at a celebration that lasts for days. Friends and relatives join to dance, eat, and drink. The beverage of preference is *yaraki*, an alcoholic drink produced by complicated means. On the last day of the ceremony the exhumed bones of the deceased—usually only the long bones of the arms and legs—are painted red with *onoto* and placed in a vessel to be deposited in the hut of relatives. Those who live there leave their abode and destroy all the deceased's possessions. Now the deceased has no reason to return from the dead.

1 This text is largely based on the information by Donald J. Metzger and Robert V. Morey (1983). Additional sources are individually cited.

2 Occasionally the Híwi are also called Sikuani, a name which, as Zerries stated, the people themselves think of as derogatory. Additional names by which they are known are: Guajivo, Guayva, Guagiva, Guaiva, and Gaivo.

3 Cf. Mattéi-Müller (1992, p. 5)

4 Reichel-Dolmatoff (1944 p. 437)

5 Müller (1995, p. 220)

6 Münzel (1978, p. 160)

7 Boglár (1982)

8 Zerries (1956, p. 227)

9 Zerries (1956, p. 230)

10 Kirchhoff (1950, pp. 441, 451)

11 Zerries (1956, p. 231)

12 Zerries (1956a, p. 231)

LELIA DELGADO AND GABRIELE HERZOG-SCHRÖDER

HODÏ

THE UNKNOWN FOREST DWELLERS

The Hodï live in dense forest. Here, only scattered beams of light penetrate the thick canopy of leaves to trickle down into the green of vegetation. Dark waterways wend their way along the forest floor, sweep past boulders to cascade over rocky cliffs into even darker depths. In this remote and secluded region lived the ancestors of the Hodï; thanks to their territory's near impenetrability, they were spared the invasion of the rubber tappers.

It will take some time before we can begin to assess the knowledge and world concept of the Hodï. We have only very few testimonies about their culture, information that is difficult to unravel. We know very little about their complex language, and next to nothing about the culture myths that pervade their lives. To this day they have allowed us only a superficial glance into their everyday world in which human beings, plants and animals live in an intimacy that seems to have few boundaries.

The traditional territory of the Hodï lies along the middle Orinoko valley. It is bordered on the east and south by the Sierra de Maigualida, the homeland of the

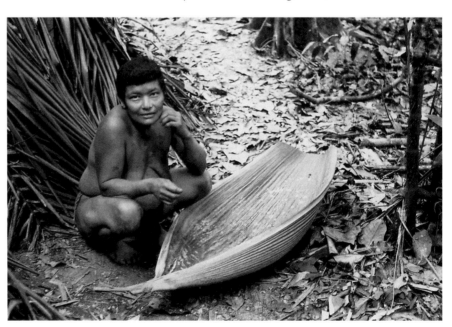

The Hodï were first identified as an individual ethnic group around the middle of the twentieth century.

Ye'kuana. To the south-southwest, Hodï territory extends to the Caño Majagua and the Rio Asita. To their southwest live the De'áruwa of the Manapiare valley, as well as the small Carib group of the Yawarana. To the west their territory reaches as far as the Parucito River, and to the north it stretches to the Rio Cuchivero and the Rio Kaima. Here the Hodï have much more intensive ties with the E'ñepa than they do with their other Indian neighbors. Throughout their territory the Hodï live exclusively as forest dwellers.[1] The Hodï have no traditional use of boats; instead, to cross wider riverbeds, they construct bridges made from poles and creeper. The little knowledge that we have of this ethnic group comes from the Hodï groups living on the Rio Kaima in the northern part of their territory, and, in the south, from those who have settled along the Iguana, a tributary of the Rio Asita. Their total population is estimated to be between 300 and 400 people.

Ho means "human, person", and *dï* is the plural suffix ending for "living being". The Hodï have appeared in print under a variety of names; not until the seventies and eighties did it became apparent that groups referred to as the Chicana or Chicano, the Yuana, or, respectively, the Yowana or Waruwaru, all belong to the same ethnic group. Theodor Koch-Grünberg was the first to point out that the Hodï have their own language. Although similarities with the Saliva language, and with the language of the Yanomami, as well as with the Maku language, have been established, to this day the language of the Hodï cannot be assigned to any of the larger Amerindian languages.[2]

Because of the Hodï's geographical isolation—their traditional land is solely reachable by traversing a complicated water system—we know very little about their history. Not until the first half of the twentieth century when the criollos, on their search for pendare, balatá, chicle, and sarapian, were lured far into the rain forest, did the first infrequent contacts with Western civilization arise. Intensive ties between the Hodï and the E'ñepa have existed for a great number of years, a fact evidenced by the material cultures of the two ethnic groups. Judging from the style of dress, a member of the Hodï and a member of the E'ñepa are nearly indistinguishable. It is because of this resemblance of material culture that, in the north, where the Hodï and E'ñepa share a living territory (occasionally actually living together in the same settlements), the Hodï were not recognized as forming an independent ethnic group.

The first known encounter between the Hodï living in the south and criollos took place in the year 1942 along the Majagua River. The criollos, from San Juan de Manapiare, reported that at the time the Hodï still used stone axes. Sporadic meetings between the Hodï and the criollos continued until 1969. Koch-Grünberg reports having received word from the Ye'kuana about the "wild Waruwádu living in the high mountain watershed area between the Rio Ventuari and the Rio Erebato."[3] The evangelist New Tribes Mission made the first outside contact with the "Yuwana", a group of Hodï previously known only from hearsay. Reportedly, the Yuwana initiated the encounter. This event was documented in 1972 by Irenäus Eibl-Eibesfeldt, a human ethologist.[4] Initially, a group of Yuwana made themselves known to a Piaro hunting party. The Piaroa reported their discovery of "uncontacted" Indians to the missionaries, who, in turn, set out to establish rela-

tions with the group numbering perhaps some 100 people. The term "Yuwana"—which these people seemed to use to refer to themselves—was almost immediately determined to be erroneous, for it means as much as "relatives," but cannot stand as the term it was understood to be. In the year following this late discovery of one of Venezuela's last isolated Indian groups, representatives of the New Tribes Mission founded a mission station at the Caño Iguana. During the eighties, a Catholic mission station was also established in Kayama on the Rio Kaima. The Hodï, together with the E'ñepa who inhabit this area, find themselves in the Church's care. This northern group of Hodï, by trading blowguns or curare with the E'ñepa of the Rio Cuchivero, had long possessed a few metal utensils such as axes, machetes, knives, and fishing hooks. From the missionaries they received Western clothing, soap, and aluminum pots; thus a profound process of cultural change was set in motion.

The many years of living together with the E'ñepa altered the material culture of the Hodï.

Traditionally the Hodï plant gardens on small plots of cleared land; hunting and food gathering in the forest are also of great subsistence importance. Unlike the Hodï's Carib neighbors, the most important plant food is not the bitter manioc, but plantains. This is also true of other forest ethnic groups, as for instance the Yanomami. The Hodï also cultivate sweet bananas, sugar cane, papaya, pineapples, and pepper, as well as various tubers such as sweet potatoes, yams and, finally, sweet manioc—which, as opposed to bitter manioc, does not require a complicated detoxification process to become edible. Also cultivated are cotton, calabash trees, and tobacco. The tobacco is dried and ground, to be mixed together with other plant substances to form a paste that is sucked. The forest offers the Hodï an assortment of wild-growing food, as for instance palm fruits, honey, and insect larvae.

During the dry season hunting is practiced intensely. The Hodï hunt tapir and peccaries from a close distance using long lances with points traditionally made from bamboo. Today, however, the points are also made from scraps of broken machetes. The hunter receives the head, breast and front legs of the game he kills. The remainder of the animal is divided up among relatives within the local group.

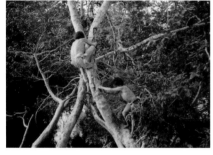

The Hodï know how to make use of the forest's natural resources, be it palm fruits, honey or insect larvae.

Different techniques are used to hunt small game. For instance, birds are lured by bird calls to be killed by blowguns, or baited by fruit laid out in the open, or a bird trap is employed. The hunters build blinds out of leaves and branches to kill small animals with their blowguns and curare-treated darts. Fishing, contributing little to the total subsistence, is practiced in the afternoons. The keeping of such domesticated animals as monkeys, agouti, chiguire, turkeys, parrots, toucans, owls, pheasants, cranes, and wood-peckers, is not to improve the daily menu, but rather because these animals serve as mascots. The practice of keeping dogs, introduced to the Hodï by other indigenous groups, arrived very late. The dogs are used in hunting.[5]

Women are for the most part, if not exclusively, responsible for preparing the daily meals. Pieces of meat are wrapped in leaves to be grilled over an open fire. The women prepare soups out of grated, unripe plantains. Peccary meat is consumed at once; what is left over is either dried or smoked. The storage of provisions is difficult and cannot exceed a span of two to three days. This explains why

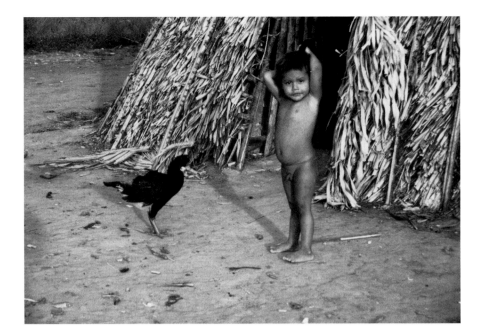

food is eaten immediately, the surpluses being distributed to other members of the group. When a guest arrives, even a stranger, the Hodï extend their hospitality by offering food and drink—whereby the host himself demonstratively helps himself to the repast before bidding the guest to join in.[6] Especially cherished is a lightly fermented maize beverage. In groups it is consumed in large quantities.[7]

The Hodï live in communities of one or more nuclear or extended families. The local groups are small and connected by blood relationship. If a number of families share the same hut, each family group is autonomously responsible for the gathering and cooking of its own food. Internal relationships are stabilized by exchanging and giving.

Marriages are usually monogamous. Polygamous relationships, however, also occur. If a married couple no longer gets along, separation is uncomplicated. Marriage is equally simple: a couple simply build their own campfire and set up house next to the living area of either the parents of the bride or of the groom.[8]

The Hodï erect permanent settlements made up of individual rectangular houses. Additionally—most frequently during the dry season—they leave their permanent settlements to wander across their territory, settling down for short periods of time in temporary camps. The camp dwellings are made up of simple windbreaks or roof-like branch grids leaning against each other to be covered with interwoven palm leaves. The Hodï hang their hammocks from the vertical joists which support these constructions.

In former times, clothing was seldom worn by the Hodï. At some point in the past, the northern Hodï adopted the dress of the E'ñepa and began wearing loincloths. The loincloth worn by the men is a rectangular strip of woven cotton. It runs between the legs to cover the genital area and is secured in place by a string that wraps the waist, or by a belt braided from human hair. The apron worn by the women covers only the public area. It is usually made of cotton, though it can also be made of leaves or bast. It is secured in place by a set of thin strings.[9]

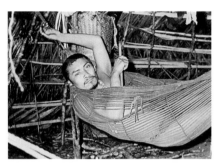

A Hodï man relaxes in his hammock.

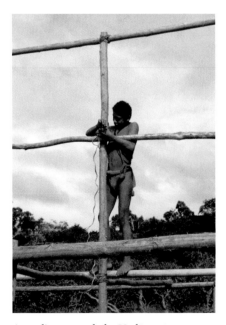

According to need, the Hodï erect permanent settlements or camps with simple windbreaks.

The garments of the Hodï are quite similar to those of the E'ñepa. The two groups live together in the northern part of the Hodï territory.

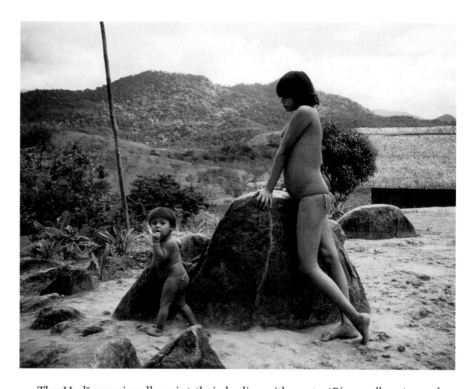

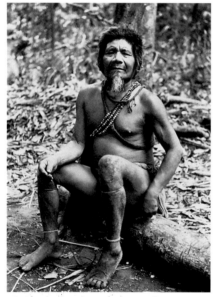

Men as well as women adorn themselves with Job's-tears bead necklaces. Feather decoration is unknown among them.

The Hodï occasionally paint their bodies with *onoto (Bixa orellana)* or other plant pigments. Men and women, young and old, adorn themselves with long necklaces made of dried seeds, most frequently Job's-tears *(Coix lacryma-jobi)*. They also decorate their bodies with fragile macaw wing bones or with the beaks of various types of birds, and with peccary hoovers. The Hodï pierce their earlobes to wear reed strips and splinters from monkey or peccary bones. Feather adornment, prized by all their indigenous neighbors, has never been observed as worn by a Hodï. The adults wear on their wrists, legs, and ankles bands made of cotton or human hair. These bands seem to have a deep magic-religious significance, for every attempt to trade for these bands has failed.[10]

With the exception of house building and the clearing of garden plots, work is hardly divided according to sex. The spinning of cotton is an activity performed by both men and women. Both sexes cook, weave, and fashion simple pottery objects.

The Hodï produce diverse basketry items such as mats, bird cages and carrying baskets. From palm fibers they also produce plaited sitting mats and containers for carrying fire-drills. The so-called *guayares* are rectangular baskets made from palm leaves roughly woven together, after use, they are simply tossed away. Calabashes are used as drinking vessels, as cooking utensils, and as containers for storing or distributing beverages and food.

Like everywhere in this region, the *maraca* rattle is an important musical instrument among the Hodï as well. Eibl-Eibesfeldt reports having observed a rattle that was fashioned from the top of a monkey's skull. It had been filled with either pebbles or seeds. It is plausible that this object arises from the same idea which gave impulse to the *maraca*—the idea of generating noise by shaking a head-shaped form.[11]

Among the northern Hodï, in the area near the Kaima, a unique string instrument was found with a wooden resonating chamber measuring some 80 centimeters. Two movable bridges varied the tone of the strings. The Hodï manufacture flutes from bamboo and the bones of deer.

Little is known about the magical-religious world of the Hodï. The E'ñepa, however, fear the mighty shamans of the Hodï, believing they have at their disposal magical substances which they blow at their enemies. At the same time the Hodï shamans can protect themselves from enemies by using a powder derived from roots and called *madúa*.

A Hodï elder—the same man who occupies the local group's highest political position—undertakes the healing of the sick. He removes the "bad blood" of his patient by either sucking it from an open cut or by blood-letting. Should a patient be experiencing pain in a part of the body, the elder treats it with massage, thereby removing the pain by gripping it from the body with his hands. Another healing technique the elder might employ is to breathe on the painful body part. Unlike the medicine men of his Indian neighbors, he does not use tobacco smoke. Nor does he use *maraca* rattles or songs—instead, the Hodï elder performs his healing ritual in strict silence.

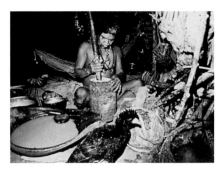

In the Hodï kitchen a lightly fermented drink is prepared.

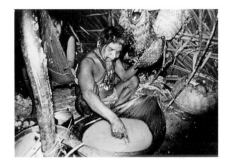

The old man tastes the drink before he offers it to his guest.

1 This article is largely based on the contribution by Walter Coppens (1983). Additional important authors are individually listed.
2 Koch-Grünberg (1923/IV) Guarisma and Coppens (1978); Henley, Mattéi-Müller and Reid (1994–96)
3 Koch-Grünberg (1922, p. 235)
4 Eibl-Eibesfeldt (1973, p. 68)
5 Eibl-Eibesfeldt (1973, p. 266)
6 Eibl-Eibesfeldt (1973, p. 141f.)
7 Eibl-Eibesfeldt (1973, p. 142)
8 Eibl-Eibesfeldt (1973, pp. 283–286)
9 Cruxent (n.d.)
10 Bou (1970), quoted by Eibl-Eibesfeldt (1973, p. 140)
11 Zerries (1953)

ULRIKE PRINZ[1]

ARAWAK

NORDWEST AMAZON PEOPLES
BETWEEN TWO WORLDS

When, in the middle of July, thick, cold fog shrouds the ghostly caatinga trees, the Áparo, the toad people, come out of hiding. Furtively they row in tiny boats on the wild, dark waters. It is said that the toad people cause the dug-out canoes of the Indians to capsize and that they are able to turn into little men carrying thunder and lightning on their shoulders.

The Indians of the Rio Guainía, Rio Negro, Rio Casiquiare and their tributaries tell the story of the mysterious Áparo, the toad people, living in the remote regions at the bottom of the lagoons. When the water level drops, innumerable of these "toad Áparo" or "Wáapu" come ashore. In mythical times, the Áparo attacked the people living in this region by approaching their settlements unnoticed—wrapped in the thick fog they themselves had created. They killed all the people there and vanished without trace.

Sometimes, when the fog has lifted, people find one of their oars whose lancet shape is reminiscent more of a sacred weapon than a paddle. People living close to the course of the rivers insist on having heard the stroke of the Áparo yet the toad people themselves remain invisible.[2]

This phenomenon—the sudden onset of cold fog—which prompts the Indians to embellish the nights of July with their tales, lasts about four to six days and is called *áparo*. The same name is also given to that particular frog which differs from all the others because of its remarkable mouth; when open, the inside can be looked into like into a bag or a sack.[3]

It is often only the little stories which point to the common cultural substratum of the Arawak groups who today are scattered. Their cultures are to be found in many areas of tropical South America. In former times, they were among the most influential groups in the north of the subcontinent. Between the Amazon and the Orinoco delta, they spread themselves along the waterways over the whole Guyanese coast. In the process, they in turn drove out groups who did not know how to make use of the canoe so intensively. On the Upper Rio Negro, they occupied the strategically important position between the two largest river

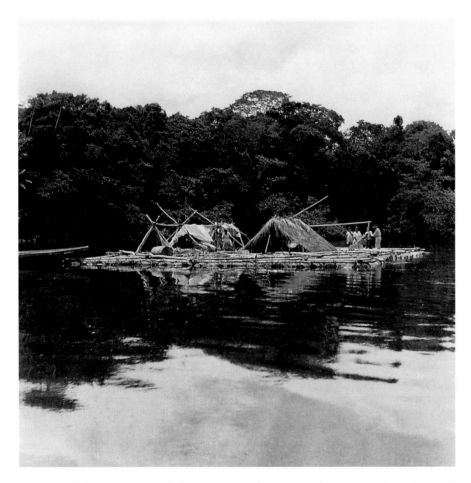

systems of the Orinoco and the Amazon, thus controlling the trade in lowland products and goods from the Andes region.

In comparison, only small groups of Arawak-speaking Indians today inhabit the border region between Venezuela, Columbia and Brazil: the Baniwa, Kurripako, Baré, Piapoco and Warekena.

LINGUISTIC DIVISION

Based on the more or less pronounced linguistic relationship between the various ethnic groups, it is possible to trace approximately the historical division of the different groups that, at one time, had advanced as far as the Rio Negro and its tributaries.

Their languages are still very similar.[4] The settlement and enslavement policy of the Portuguese decimated the ethnic groups and resulted in a Tupi dialect with a Portuguese influence. The so-called lingua geral which was introduced as a lingua franca, further contributed to their linguistic assimilation. This caused the almost total loss of some of the Arawak languages of Northwest Amazonia.

The name Baniwa comes from the lingua geral and has been used for the Arawak-speaking groups of the Rio Içana and its tributaries in the Brazilian region of Northwest Amazonia since early colonial times. Yet, at the same time, it serves as the name for a group known in Columbia and Venezuela under the name of Kur-

ripako. But Kurripako would also not be correct as a generic term since it in fact denotes just one of five subgroups which includes the Baniwa of Brazil.[5] To avoid confusion, the name Baniwa is used here only for the northern Arawak group in Venezuela. To simplify matters, the term Wakuénai should be used for the five dialect groups of the Kurripako on the Guainía. It means "people who speak our language"[6] and serves to distinguish the Arawak speakers from the neighboring Tukano groups of the Vaupés region.

The Wakuénai have settled in small groups on the main rivers Içana and Guainía as well as on their tributaries in the region where the three countries meet. The majority, about 6,000 people, live on Columbian, a small group, the Baniwa-Kurripako, on Brazilian territory. Approximately 3,000 people live on Venezuelan soil.[7]

Although the regions of the phratries[8] have changed, since the 18th century the Wakuénai have remained in their traditional region which they regard as sacred territory. The oldest songs define this region whose center is located at the Hipana rapids on the Rio Aiary. Many of the important mythical places are decorated with petroglyphs and give evidence of their property rights.[9]

The Baniwa live scattered in small groups on the banks of the Rio Casiquiare, on the Guainía and on the Upper Orinoco near Santa Barbara. Some live in Maroa, the main town in the district of Casiquiare in the Federal Venezuelan State of Amazonas. They number fewer than 1,000 people.[10] Not only for the Baniwa but also for other Arawak-speaking groups like the Wakuénai, Baré and Warekena, Maroa is the center for trade and the exchange of goods in this region. To this day, the inhabitants of Maroa still go hunting, fishing and gathering wild fruits for their own needs. Depending on the season, these activities are pursued with varying intensity. Today, many Baniwa are employed by the government administration as paid workers or policemen, almost all their children attend the government schools.

In dispersed settlements in the Cauabóri-Baria river system and on the Rio Negro, there are still approximately 1,300 Baré, most of them in the towns of Puerto Ayacucho, San Fernando de Atabapo and Santa Rosa de Amanadona. Some of the Baré also speak the language of the Baniwa which is very similar to their own, but due to the progressing adaptation to Western culture, their language is threatened with extinction.

The Warekena are to be found today on the Rio Xié in Brazil as well as on the Casiquiare and Rio Negro in Venezuela. They only reached the Venezuelan Amazon region in 1927. In both countries, their groups each number about 320 people, with only 40 percent of them still speaking their own language.

Most of the Warekena live in the settlement of Guzman Blanco.[11] On Venezuelan territory, they maintain important contacts not only with the criollos but also with the Baré Indians of the Rio Negro as well as with the Baniwa from Maroa and from the Caño Aquio.[12]

The Piapoco, the "people of the toucan", trace their origin back to a phratry of the Wakuénai known by the name of Hohodene.[13] They originally lived on the middle reaches of the Rio Guaviare. In the 18th century, they fled from the mis-

sionaries, and in the years between 1913 and 1948, they evaded the clutches of the colonial power by retreating into impassable areas. After the decline of the rubber boom, they came back to occupy at least a part of their land again.[14] Today, their main group, about 5,000 people, reside in the eastern highlands of Columbia. In Venezuela, some groups—a total of approximately 1,800 people—have settled in the Department of Atures in the State of Amazonas.[15]

Despite the common cultural substratum, close social relationships between the Arawak-speaking groups in Northwest Amazonia have only been formed in the more recent past. However, the social distance is rapidly decreasing through marriage connections, through joint participation in feasts and through daily contact.[16] In many respects, the mythical stories of the cultures of the common ancient Arawak culture complex are similar and their culture heroes at times only differ in name.[17]

HIERARCHICAL SYSTEMS

A common characteristic of the Arawak-speaking groups in the Northwest of Amazonia is their division into exogamous patrilineal clans[18] or local groups. A strict system of descent traces the ancestors of every clan back to their mythical-historical origins. The clans, on the other hand, belong to various phratries or alliances exchanging marriage partners with other phratries of the same area.[19]

The whole social system is founded on the basic unit of the nuclear family. Several families form the local groups which are represented, on the next higher level of the clans, by a leader in the council of the elders. The so-called "capitán" may be the founder of a settlement or the oldest man of a community, a grand-father, father or uncle, but, in any case, a person with high prestige and excellent reputation. It is he who decides whether to change or move a settlement to other parts of the group's territory and concerns himself with the temporary or permanent fission or fusion of individual groups. He settles litigations between two factions or in conflicts that often arise when criollos invade Indian territory.[20]

The Piapoco are divided into five large patrilineal clans whose members all descend from one mythical ancestor. They consider themselves descendants from five mythical brothers whose birth order determines the position of the individual descent group.[21]

Each group controls a specific territory and its natural resources. The borders are precisely established and the nuclear families have exclusive right of use. Relatives may obtain special permission to use the fields. However, if they help themselves without explicit permission, conflicts may arise.

As is the case with their Arawak neighbors, Warekena society is also divided into exogamous patrilineal clans. The various lines of descent are represented by animals, the *imákanasi*. Today, only the animals are a reminder of the old clan orders of the Warekena since they are still closely connected with the people they are assigned to. Thus people believe that the spirit of a person can be called by drawing his or her *imákanasi* figure on the ground.[22]

ARAWAK WAY OF LIFE

In addition to the similar language, the Arawak groups of the region also share numerous cultural characteristics. They are known as successful gardeners cultivating mainly the bitter manioc brought to them by the culture hero Kuwai. Before the arrival of the Europeans, the larger river valleys had been occupied by agrarian groups with large populations. The groups between the larger rivers and the headwaters, on the other hand, depended more on hunting and fishing. It was a region with active trading between the two ecological zones but with long-range trade relationships as well.

To this day, their highly developed techniques enable many groups to produce beyond their own needs and to supply the local markets with the surplus. Trade is carried out as bartering as well as on a monetary basis.

The mythical calendar of Káali determines the cultivation of the Wakuénai gardens. From the end of March to the middle of April, when the Pleiades are in the sky at night, the yields in agriculture as well as in fishing reach their peak; families in all the villages are then busy planting the bitter manioc. It is also the time when many species of fish, after a long journey upriver, come together at the same spot in the flooded savanna as if for a rendezvous, and spawn.

Next to their fishing and the intensive cultivation of their fields, the Arawak-speaking groups have always also been known for their skill in building canoes. To this day, for instance, the Warekena enjoy a good reputation as boatmen and boatbuilders. Their method of boatbuilding is similar to the Ye'kuana and they also make heart-shaped oars. Today, however, the dugout canoes are mostly powered by an outboard motor.

A further characteristic of the traditional culture of the Arawak Indians was their architectural art and their attractive pottery. In former times, the *budares* of the Wakuénai, ceramic griddles to roast *casabe* and *mañoco* on, were the trade goods most in demand in the region.[23] The knowledge of pottery, practiced only by the women, its technique, designs and colors, came originally from the culture hero Napiruli. After being fired, the vessels were treated with a glaze made of resin and made waterproof. Under Western influence, both arts have given way to the pragmatism of aluminum pots and the simple house construction in the criollo style.

The main activity of a majority of the assimilated Arawak population, especially the Wakuénai, the Warekena and the Piapoco, consists of collecting chiqui-chiqui palm fibers which they trade in large amounts for industrial goods or sell to the Columbian and Venezuelan settlers.

The Wakuénai women make baskets, brooms, tubular manioc squeezers, mats and hats from chiqui-chiqui and the *mamure* fiber they call *puwá-puwá*. In the course of commercialization, new ornamental styles and techniques have been developed.[24]

To gather the fibers of the palms growing on the banks of the rivers Inírida and Guainía, the Indians organize expeditions lasting several months and put up camps by the river. Gathering the fibers is tedious work; to make a profit, many

tons of chiqui-chiqui have to be collected. Large boats with outboard motors are essential for the transport.[25]

BETWEEN ADAPTATION AND RESISTANCE

For over two centuries, the Arawak groups of Northwest Amazonia have been in close contact with the non-Indian population and have thus been exposed to enormous pressure to adapt and integrate.[26]

In the years between 1740 and 1755, numerous cultures of the Upper Rio Negro were almost exterminated due to the slave trade; an estimated 20,000 Indians were abducted and forced into slavery. The slave traders were followed by missionaries, soldiers and settlers.

In early colonial times, just a few years after the official abolishment of slavery, the northern Arawak people found themselves caught between the colonial powers of Spain and Portugal who fought over the Upper Rio Negro and its inhabitants. The aggressive displacement in this area of conflict affected not only the ethnic groups with high populations living on the courses of rivers but also the smaller ethnic groups of the interfluvial regions, resulting in an increase in the number of warlike clashes. In the process, some of the Indians living in the remoter areas were absorbed by the larger groups.

In 1840 the National State of Brazil was established which depended on Indian labor, and on the production of manioc and other Indian products of the Upper Rio Negro. To win the independent Indians as well as a work force in Manaos, in 1850 the government of the Province of Amazonas, bordering on Venezuela, started a "civilization program".

At the time, a distinction was made between the "indios gentíos", the Indians still living in the forest and without contact with the national society, the "indios aldeados", those Indians already living in colonial settlements and maintaining trade relationships, and the "civilized" Indians working for the criollos and supplying the market with agricultural products. In the course of this program which authorized the settlers to recruit Indians to work for them and secure their supplies, attempts were made to settle the indigenous population in the colonial towns and to force them to be christened. Children were often taken from their parents by force. For many groups, the difficult and lengthy process of adaptation was now beginning which resulted in high losses in population due to diseases which were brought in.

Only few ethnic groups succeeded in eluding this "civilization program". Thus, for instance, a phratry of the Wakuénai, the Hohodene, collectively resisted the government program. Their oral tradition recalls how a white trader tried to persuade them to settle on the Rio Negro. They fought by force of arms and withdrew into more remote areas. The authorities reacted with a punitive expedition causing a massacre and abducting the leaders to Barra, today's Manaos. After several years of imprisonment, the headman succeeded in escaping. His sons, however, were integrated into the national army. A myth relates how the headman

of the Hohodene came back to the Rio Içana where the members of another phratry, the Oalipere-da-kenai, formed a peaceful alliance with him.

As a result of these events and also because of the progressive impoverishment of the Indians torn from their traditional environment, the region was thrown into extreme unrest. This paved the way for millenarian liberation movements where Indian shamans appeared as preachers and raised the hope of salvation and a better world among the oppressed Indian population. Indians and criollos together developed a kind of "popular Catholicism" where traditional belief concepts mixed with the Catholic cult of the saints and which was very well received by the people. San Juan Day, 24 June, became a day when the faithful were able to express their hopes of change, and tensions experienced by the impoverished and exploited social classes were vented in big feasts.

One of the best-known and most influential preachers of Venezuela was Venancio Aniseto Camico, a powerful shaman of the Baniwa Wakuénai who promised freedom from the rule of the white people.[27] He found his followers among many different Indian groups living on the rivers Vaupés, Xié and Rio Negro in the border region between Venezuela and Brazil. Venancio brought tidings of political and religious liberation. He promised independence from the criollos and preached the end of economic suppression.

A further important leader of the Tucano Indians, Alexandre Christu from the Upper Rio Negro in Brazil, promised a revolutionary reversal of social conditions: the Indians would rise as rulers over the white people, with the same power, the same riches and for the same length of time that the white people had dominated. Hundreds of Alexandre's followers held ritual dances on the Lower Rio Vaupés. The government of the State of Amazonas felt forced to send in a commission supported by armed forces to regain control of the situation. With some of their followers, Venancio and Alexandre withdrew into the more remote regions of the jungle and the movement dispersed. All that remained was the message of the imminent end of the world which had merged with hope of a better life in another world.

After the tremendous political and religious turmoil between 1857 and 1869, the Brazilian government at least discontinued its aggressive "civilization" and christening program and instead sent more missionaries into the areas. Temporarily, the situation eased.

However, the peace did not last: in 1870 already, the rubber boom reached the Upper Rio Negro. The Indians had always used caoutchouc to caulk their vessels and boats. While searching for the "white gold", local patrons, the so-called "rubber barons", gained control over the latex production simply by occupying those parts of the rainforest where the rubber trees *Hevea Brasiliensis* were growing. Thus the whole region of the Rio Negro, Içana and its tributaries fell into the hands of a single man: Don Germano Garrido y Otero, known as the "King of the Issana". He and his family ruled over the region for more than 50 years. With an army of about 100 workers, the *seringeiros*, he had the rubber tapped which, due to the invention of galvanization, had become an article in great demand in Europe. A system of prepayments and loans kept his workers in debt and thus con-

stantly dependent on their patron. The yoke of the rubber tappers caused mil-lenarian expectations of salvation to flare up again. Indian leaders of the Arawak and the Tucano together organized cleansing ceremonies and promised the coming of a better era. Again, the army intervened and sent the leaders to jail. Relations between the white people and the Indians were at breaking point.

Although, during colonial times, the majority of the Arawak had been able to withdraw from the center of the territorial litigations between the two colonial powers of Spain and Portugal, living in the border zone now almost proved to be their undoing. The national borders which had been drawn up not only restricted their mobility but, in addition, the closing of the national borders severed the tra-ditional alliances between the various groups. These groups now had to decide which of the three countries they formally wanted to belong to, even if their terri-tory was situated on one of the islands in the river, as it were, between the natio-nal borders.

Around 1943, a North American protestant, Sophie Müller of the New Tribe Mission NTM, arrived in the region where the three countries meet at the Upper Rio Negro. Under her influence, numerous groups converted to Protestantism. She turned vehemently against shamanism and proclaimed that she had been sent by God to prepare the people for the second coming of Christ and the end of the world. With her apocalyptic preachings, Sophie Müller addressed topics familiar to the Indians and caused a new wave of millenarian movements. During impressive dance feasts, the Indians awaited the big transformation of the world.

To obtain latex, the trunks of the rubber trees *Hevea Brasiliensis* are tapped.

One of the most noticeable consequences of Sophie Müller's work was the undermining of the Indians' self-esteem. In contrast to the Catholic mission, the New Tribe Mission insisted on an assimilation to the culture of the white people and on the abandonment of indigenous identity. In addition, there was the disso-lution of the extended families and clans as well as the fragmentation of the Indi-an population caused by both churches encouraging primarily inter-ethnic mar-riages as long as the partner was only Protestant or Catholic. In many places, this strategy resulted in a division of the Indian population into believers and non-believers, it divided the Wakuénai but also affected the Tucano- and lingua geral-speaking groups. Their identity was now more strongly defined by their religious orientation than by their belonging to a particular ethnic or kinship group.

Thus today the "Wakuénai of the South" support the popular Catholicism which is characterized by syncretistic elements and in which "Fiestas del Patrón" blend with native myths and ceremonies. On the other hand, the "Wakuénai of the North" are mostly professing Protestants who, as far as possible, eliminate the cultural features; they also represent the major part of the rural proletariat.

A third group with its own identity are the "Wakuénai of the East". It consists of alliances of Wakuénai, Warekena but also of Baniwa and of the lingua geral- but originally Arawak-speaking population. On the basis of Indian religious hierar-chies and ceremonial exchange between the various groups, the "Wakuénai of the East" form an increasingly strong pan-Arawak movement striving for social change.

The latex sap is melted into large balls for transporting and selling.

INDIAN LIFE
BEHIND THE OUTWARD ASSIMILATION

In view of this checkered and, for the Indians, fateful history, it is surprising that at least some of them have succeeded in preserving their cultural identity or, in more recent times, reviving it.

In various aspects, a multitude of the Arawak groups have outwardly adapted to the style of dress, the type of building and the settlement structure of the criollos. On the other hand, they have not lost the recollection of numerous ancient myths explaining the origin of the world. These are now given new meaning in the creation of a pan-Arawak movement.

The sacred stories are a reminder of the ancestors and their rules on which the origin and the development of religious hierarchies is based. Thus the Wakuénai myth of origin relates how the culture hero Iñápirríkuli talks "in his powerful way", how he names the origin of all the groups and lists their "tobacco-spirit names". In the first place, he mentions the birth of the *yárinárinai*, the "white people", and only afterwards the various Wakuénai groups are created. Iñápirríkuli assigns different sib names to them. Although the white people, as the "first-born", are given the status of the more powerful, in contrast to the Wakuénai they do not receive any sib names but only one single tobacco-spirit name. The more sib names a group receives, the more differentiated and the more human-like it is thought to be.[28] In the *malikáli* songs, the historical memory of the origin of the world and the distribution of land is also stored. Napiriruli, the Baniwa creator god, lives in the highest cosmic realm. His son Kuwai passes his sacred knowledge on to mankind. His songs gave the world its present form.

Myths and rites of the Arawak culture complex play an important part in the cultural reorganization and the construction of a new Indian identity. With the revival of the traditional feasts, old and new alliances are confirmed and strengthened.[29] For those communities sharing a similar cultural and historical background, celebrating the traditional *pudáli* exchange feast[30] together plays a special role.

The course of the *pudáli* feast is based on the original tripartite *pudáli* which, these days, gains new significance in connection with Christian rituals like Holy Communion and the sermons. The exchange feast is no longer celebrated in the same elaborate way.

The ideal time to hold a *pudáli* feast is the start of the rainy season when the Leporinus fish reach the flooded forest areas. Then the deep bass of the sacred *kulírrima* trumpets sounds, intended to recall the rolling of the stones in the riverbed and heralding the arrival of the fish.

Every family or local group used to be able to initiate a *pudáli* feast. It consisted of three different stages:

In the opening stage, the "master of the *pudáli*", followed by his relatives and accompanied by musicians, singers and dancers, visited the village of the hosts. The visitors' first dance was accompanied by a flute duet. The "master of the *pudáli*" brought smoked fish and meat as a gift. After a festive and formal speech,

he handed the gift to the hostess, the wife of the group leader, whom he addressed as "little sister".

The acceptance of the present opened the second stage of the ceremony where the realms of the visiting and the hosting group merged. With the distribution of food, the feast lost its formal character and large amounts of the lightly fermented manioc beer were served. Men and women alternately sang drinking songs. For up to four days and nights, the people danced a ritual pair dance to the sound of the *kulírrima* trumpets. At the end, as a way of saying thank you, the visitors presented the hosts with the trumpets decorated with symbolic designs of their family group.

In the third stage, the *pudáli* changed from a mundane exchange feast—whose aim and object had been above all the maintenance of the good relationships between the groups and the initiation of marriages—into a feast of the spirits. The mythical past was evoked and the borders between men and women, as well as between people and animals, were abolished.

The first ceremony, dominated by the men, was followed by the women's feast.[31] It started about a week later and was organized by the "mistress of the *pudáli*". She fed the guests with large amounts of manioc. The dances and the distribution of food and drink were repeated, as were the musical performances on the sacred instruments. However, this time the women gave the speeches and distributed manioc mush to the women initiators of the feast. Instead of the *kulírrima* trumpets, the *wáana* stamping tubes sounded the invitation to dance. Then followed the so-called *druzuapani* dances, the "dances of the fishnet".[32] In the same way as the *kulírrima* trumpets had completed the male cycle, the fishnet songs and dances ended the feast held by the women.

The collective dance and music feast *madzéru* which is held today in the villages of the lower Guainía, appears to be a revitalized form of the old *pudáli* festival cycles. Other ethnic groups like the Baré, Baniwa and Warekena also take part as well as lingua geral-speaking Indians with whom the Wakuéni work when collecting the chiqui-chiqui fibers. In dances and songs, memories of the mythical times are evoked when the world was still undifferentiated and chaotic. The feasts help the cultural integration of other Arawak- and lingua geral-speaking groups by including them, during the ritual, in the creation of the symbolic order and letting them take part in the ritual exchange. Even today, the principle of giving and taking, the most important function of the *pudáli* feast, is still able to create a wide network and become a powerful instrument of pan-Arawak identity.

1 Manuscripts written by L. Delgado have been a valuable addition to this text.

2 Carlos A. Rodriguez (1922, pp. 15–22)

3 González Niño (1984, p. 107, 108)l

4 González Ñañez (1970, p. 46)

5 Hill (1986, p. 69)

6 Wright (1994, p. 76), Cf. also Wright (1983, p. 538)

7 Mattéi-Müller, Marie-Claude: "The Situation of the Indigenous Languages of Venezuela.— Languages in danger of disappearing". In: *Atlas of Endangered languages for* UNESCO (in preparation)

8 Phratries: mergers of several family groups or clans tracing their descent from a common ancestor.

9 Wright (1983, p. 538)

10 Wright (1981, p. 8) *The Baniwa Peoples of the Upper Rio Negro Valley*

11 González Ñañez (1972, p. 7)

12 González Ñañez (1970, p. 112)

13 Vidal (1989, p. 35)

14 Vidal (1983, p. 227)

15 The most important settlements are Primavera, Laja Lisa, Morichal, Agua Blanca, Siquita-Ibucubáwa and Kataniapo. Other families settled in larger towns, in Manoa, San Fernando de Atabapo and Puerto Ayacucho. Cf. Vidal (1983, p. 220).

16 Hill (1993, pp. 34–38)

17 González Ñañez (1968, p. 88)

18 Patrilineal clan: kinship group belonging to the patrilineage and finding partners outside this group.

19 In former times, in contrast to their neighbors, the Tucano, the Arawak-speaking groups always took care to marry partners from the same social rank within the linguistic group. Over time, the exogamous marriage practices between the phratries were responsible for the development of enclaves of affinale kin groups among the Wakuénai. Hill (1996, p. 144)

20 Cf. Wilbert (1966, p. 91)

21 On the political and social organization of the Piapoco see Vidal (1983, p. 183).

22 On the culture and mythology of the Warekena see González Ñañez (1968; 1980).

23 González Ñañez (1973, p. 156)

24 Journet (1980/81, p. 143)

25 Journet (1980/81, pp. 171–173)

26 Unless otherwise noted, this chapter follows mainly the descriptions by Robin Wright (1983) and Jonathan Hill (1984).

27 Wright (1983, p. 545), Hill (1996, p.151 ff.)

28 Hill (1996, pp. 35–37)

29 Wright (1983, p. 552)

30 For a description of the *pudáli* feast see Jonathan Hill (1987; 1993).

31 Hill (1993, pp. 12–13)

32 Hill (1986, p. 83)

LELIA DELGADO AND GABRIELE HERZOG-SCHRÖDER

PUINAVE

THE COMMON
AND THE EXCEPTIONAL[1]

Where the rain falls in great sheets that pour down from the trees to form tiny rivulets flowing like a sparkling crystal labyrinth across the forest to empty into the Rio Inírida, there, for the Puinave, is the center of the world. From here a great flood once issued, rushing up from the bowels of the earth to sweep away the first generation of living creatures. It is the site where mankind was created; here the Gods first taught the people culture; and here the world became what it is today. Sacred trumpets and flutes originated in those distant times, instruments that were made from the bones of a terrifying demon who had forced the people to live under the relentless yoke of a matriarchy. During the *yurupary* rite, when the Puinave celebrate their strong connection with their ancestors, the unusual melodies produced by these sacred instruments travel far out into the surrounding woods.

It is for the most part unknown how and when the Puinave came to the Inírida River (Colombia). A subgroup today lives on the Orinoco in the vicinity of Castillito, a cliff island.

Myths passed down orally from generation to generation have preserved the Puinave's traditional knowledge. Shrouded in secrecy, on the other hand, is how and when the Puinave first settled near the Inírida River, which lies in today's Columbia, flowing to join the Orinoco near San Fernando de Atabapo on the border with Venezuela. However, one of the first maps of this region, drawn by a Jesuit in 1741, already mentions the existence of the Puinave.[2] At the beginning of the twentieth century the Puinave, referred to under a variety of names, were observed as living at various locales in the region surrounding the Inírida River and one of its tributaries, the Nooquéne. A few groups later wandered eastwards from Columbia to the Orinoco district of Venezuela, where even today they are considered as outsiders. Although the Puinave living in Venezuela have in the meantime grown in numbers, they are still considered an ethnic minority.[3] They have taken up residence in locales where the forest gives way to savanna. Estimates of the total Puinave population range from between 1800 to 3500 people, whereby only a small portion lives on Venezuelan territory. The Puinave language is related to the Makú.[4] During the last decades, marriages between Puinave and the other Indian societies of the region, foremost with the Kurripaco (Wakuénai), have become more frequent. The Puinave of the Rio Mirida have for the most part given up their own language, favoring instead that of the Kurripako.[5]

SLASH-AND-BURN AGRICULTURE AND DEPENDENCE ON LABOR

Traditionally, the cultivation of manioc on cleared plots of land is the Puinave society's economic basis. The manioc is mainly processed into *casabe* and *mañoco*, food which can be stored despite the region's hot, damp climate. Agricultural crops are for the most part planted for their own subsistence. However, should the demand arise, a woman is able to produce over the course of a month some 40 baskets of *mañoco*. Only bitter manioc is farmed for commercial purposes.[6]

Fishing also plays a relevant economic role. Fishing is practiced throughout the year, whereby fishing techniques vary according to the season. During the dry season, the Puinave fish small streams using fishhooks, harpoons, and bow and arrow. During the wet season, they fish small streams and dammed ponds using fish traps and meshed fish nets.[7] Fishing with *barbasco*, a fish poison, is most usually a lively community undertaking—men, women and children all taking part.

In former times, for hunting purposes, a blowgun with a carved wooden mouthpiece was used to bag game. An animal tooth was used as a sighting bead. Today without exception hunting is practiced with firearms. Because hunting is now carried out for commercial purposes—the selling of furs—it has lead to a severe decimation of game.

Traditionally the Puinave worked together to secure communal prosperity. Hunting and fishing surpluses were shared among the members of the group; no one went without. The adoption of new economic strategies has undermined the

traditional principles of solidarity and mutual caring, the rivets which formerly held the group together. Today fewer and fewer goods are shared communally. With the new dependency on the criollo economic system, the possession of material wealth has become a factor by which social standing can be differentiated.

Traders, specializing in natural goods, use a "payment in advance" system. They pay their Indian workers by extending them credits in material goods. Many of these goods, such as outboard motors, gasoline, fabrics, radios, sewing machines, soap, salt and canned preserves, have in the meantime, for the Puinave, become necessities. By using this "payment in advance" system, the traders not only secure the labor of the Indians, but also obtain a double profit: on the one side the profit which comes from the resale of such Indian goods as plant fibers, latex, feathers, pelts and wood; and on the other side the profit from trading to the Indians products exorbitantly marked up in price.[8]

It is not surprising that this system of trade has seriously upset the Indian economy. Trade relations between the ethnic groups have become brittle as well. On top of this, the Puinave have had to accommodate a rhythm of labor entirely foreign to them. Not only has this resulted in strain on their capacity for work, but also overexploitation of their territory's natural resources.[9]

The possession of material goods has induced competition between group members. This has lead to a shift in the network of reciprocal relationships between group members and altered the traditional pattern of solidarity. This can be observed in the division of subsistence goods. One consequence of this is the increasing frequency of arguments and conflicts in the families. This happens when the personal ambitions of an individual group member opposes his or her communal duties and responsibilities.

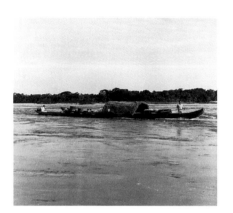

The traders use the river for transportation. The *bongos* are a typical boat construction for the upper Orinoco.

ADAPTATION AND RECOLLECTION

Judging by their outward appearance, the Puinave can hardly be distinguished from the mixed populations of the states of Apure, Bolívar, and Amazonas. The men wear trousers and shirts. The women wear colorful cotton dresses. They speak Spanish well. For the most part it is items produced industrially that find use in their households.

Formerly, the Puinave settled at any one single locale for only a short period of time. This mobile lifestyle can possibly be understood as a response to the invasion of white colonialists, as a way of protecting themselves. Only after the introduction of paid labor—and the resulting dependency on the economy of the criollos—did the Puinave become sedentary. Despite such a profound alteration of lifestyle, the Puinave have not forgotten the dynamic worldview of their ancestors.

At the beginning of time above the clouds which today cover the earth, lived people of a different species peacefully together.[10] The first human beings were resplendent and good-natured, until a monkey caused strife and dissatisfaction among them. So clever were the monkey's intrigues that they unleashed a war—

a war so terrible that, with the exception of one woman, the entire group was wiped out. After realizing that everyone was dead, the only surviving woman went around and gathered up all the bones to lay them out on the roof of her house to dry. After the course of five days, from the dried bones were born Túpana, his brother Qáitari, and his sisters Maunuddua and Amarrundua.

Túpana was so weak and small, that the woman worried he was doomed to die soon. It was only through her great patience and care—together with the help of the sun's warming rays—that Túpana survived and the woman was able to watch him grow. When Túpana was older, he killed the woman and created out of her flesh the dwarfs which live beneath the surface of the earth. The underworld was huge, and its huts, gardens, and rivers were illuminated by an unknown source. When it was night in the underworld, it was day on the surface of the earth. The dwarfs had only *casabe* and *mañoco* to eat, for no fish lived in their rivers. Occasionally they would set off on a hunting party, but the animals of the underworld were so huge, strong, and ferocious, that the dwarfs were always forced to withdraw in fear.

One day Túpana came down from his heavenly dwelling to call the dwarfs together. He blew on a trumpet which he had fashioned by rolling a platanillo leaf. The moment the dwarfs heard the call of his trumpet, they emerged from an underworld entrance. This hole in the earth, concealed by large boulders, was located near the rapids of Cupipan—a site which, for the Puinave, marks the center of the world.

Túpana saw that these humans were very small. Through a tobacco leaf he blew on them, and this made them grow. Then he built them houses, taught the men how to use bows and arrows, and how to make manioc sieves, baskets, arrowheads, canoes, and rudders. He taught the women how to produce fabric from the bark of trees, and how to spin plant fibers in order to weave hammocks. He also taught them how to make fire and how to cook food. He instructed them as to the type of clay needed to make pottery. He also taught them how to plant manioc, and how from the tubers, once the poison was removed, *casabe* and *mañoco* could be produced.

Túpana performed all these deeds for the people. But instead of thanking him, the people, being evil, wanted to kill him. Seeing this, Túpana decided to destroy them by calling forth all the waters from the underworld rivers to flood the earth. Hardly a human being survived the great flood. Túpana gathered together the few survivors and paired them as couples. To each couple he gave a different language so that no three people could understand each other. He did this in order to be certain that human beings would be unable to band together and conspire against him.

Disappointed by the people, Túpana created Yopinai, a demon whose task was to establish the rules regulating the lives of women. With Yopinai on their side, the women took over the reign. Although the women turned the men into slaves, they, at the same time, were the servants of Yopinai. The women made human sacrifices and at rituals dedicated to him, they danced and sang in his honor. Any man who observed these rituals was subject to death.

Then one day Yopinai gave the order to kill all the children who were male. For the first time the women refused to follow one of Yopinai's decrees. Then Yopinai ordered a large, month-long ceremony to take place. One of the rules of the ceremony was that for the length of its duration, the women could eat only coal and earth. Yopinai believed that this would render the women infertile.

The men were ordered to leave the settlement and reside in the woods for the length of the ceremony. When they returned they found the women sickly and emaciated. The men seized the chance to free themselves from the demon's tyranny by killing him and burning his remains on a funeral pyre. From the ashes of the demon grew seje and manaca palms as well as other trees that bear edible fruits. From that point on the men have ruled, the women being in under dominion.

Remaining behind in the ashes of the funeral pyre were only the bones of Yopinai—his spirit had departed for the underworld. Túpana saw all this and took great care that the world did not end. He made the fruit grow and woke the sun each morning, brought rain, lightening, thunder, and wind. He realized that Yopinai had been evil, and that it was justified that the men had killed him. He decided to secure the social order.

Túpana ordered the people to fashion musical instruments from the bones of Yopinai. The music that flowed from the instruments was to express their hate of Yopinai, as well as pay him, Túpana, homage. But some of the people wanted to possess these bone instruments, and this caused jealousies. To solve this problem, Túpana taught the people how to construct musical instruments from wood. The original instruments he then took to sink them into a lagoon at the center of the world. Since that time, as a sign of their loyality, the Puinave have played the sacred flutes and trumpets at rituals. As long as the flutes are played, the demon Yopinai cannot regain his ruling power.

SOCIAL ORDER IN THE RITUAL

From this myth arises the most important event in the life of a Puinave youth, the *yurupary* ritual. The celebration marks the occasion when a male youth takes leave of the domain of women and children to take on his responsibilities in the world of men.[II]

During the ceremony the initiates are taught how to handle the sacred flutes. Women and children are not allowed to see the instruments—a single glance would cause death. And so it is of importance that they leave the village for the duration of the ceremony. On the morning of the festive day the *cuhay* trumpet is blown to signal to the women and children that the time to withdraw has arrived. The unique sound of these sacred trumpets can be heard deep in the primeval forest, for they are very long and heavy. The smaller flutes which accompany the trumpets are called *majuari*; they possess by contrast a higher-pitched tone.

The *yurupary* ceremony includes a flagellation ritual. To this end, ceremonial whips are fashioned by using *peraman* to attach strings of *curagua* onto supple,

elastic sticks. The whips are used to strike the initiates—who must fast in preparation for the ceremony—hard across their shoulders, arms and breasts. By enduring the painful blows, the Puinave believe that the initiates not only strengthen their own willpower, but as well guarantee the fertility of the community, and the fertility of the surrounding plant and animal world. As the sun goes down, a dance begins which lasts until dawn. Careful plans and preparations must be made prior to the ceremony, for over its course an abundance of food and drinks—as for instance *pai*, a dish of fermented *casabe* mixed with yams, or *yaraque*, an alcoholic drink made from *casabe* and water—are consumed.

Traditionally, the social structure was anchored in the hierarchy of the ritual, and through initiation and ritual practices the young men were introduced into this ordering structure. Over the course of the last few decades, however, this order has been largely undermined by aggressive missionizing practices. In many communities, evangelist preachers of the New Tribe Mission (Misión Nuevas Tribus) have taken over the community's spiritual and, therewith, political leadership. They have replaced the traditional beliefs, which had survived the rubber boom, with a fundamentalist view of the New Testament. As with many other ethnic groups of the Amazon region, the Puinave, through this "process of civilization", have lost a great deal and, unfortunately, in return gained very little.[12]

1 This text is primarily based on the notes of Johannes Wilbert (1966). Additional sources are individually cited.
2 Triana (1983, p. 681)
3 Zerries (1964/65, p. 29)
4 Flowers (1994, p. 281)
5 Hill (1984, p. 187)
6 Zerries (1964/65, p. 31)
7 Triana (1983, p. 689)
8 Triana (1983, p. 691)
9 Triana (1983, p. 691)
10 As to the mythology this text is largely based on the notes by Wilbert (1966, pp. 101–114).
11 *Yurupary* denotes in the Lingua geral the figure of a culture hero who established the patriarchal social order. *Yuropary* myths and rituals are typical of the Indian societies of the northwestern Amazon region and the upper Rio Negro, especially in regions inhabited by Arawak societies and their neighbors. The *yurupary* ritual was described by, among others, Koch-Grünberg (1923), Waldegg (1942) and Rozo (1945).
12 Flowers (1994, p. 282)

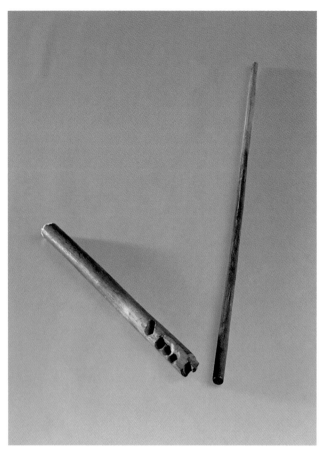

Fire-making utensils
HODÏ
Hardwood

Rattle from peccary hooves
HODÏ
Peccary hooves, cotton thread

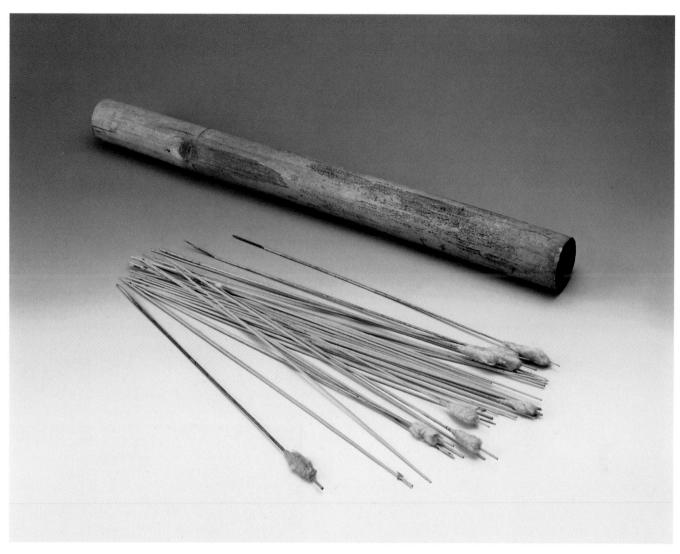

Quiver with blowgun arrows
HODÏ
Bamboo, bamboo shavings, kapok,
fibers from *Ananas lucidus*

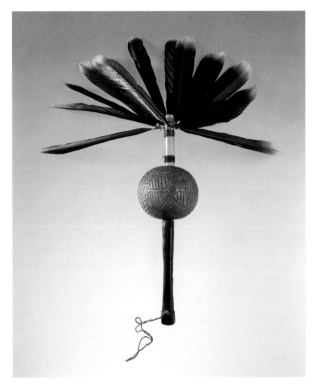

Shaman's rattle—*tsiitsiito*
HÍWI
Calabash filled with seed capsules and magical crystals, the
wánali stones, black feather helmet of the curassow, reed, plant
pigment

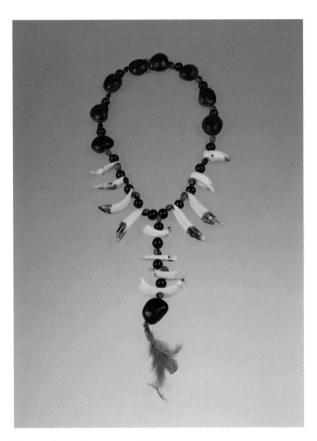

Shaman's amulet—*puwonobürü*
HÍWI
Various seeds, jaguar teeth, peccary teeth, armadillo claws,
feathers, cotton thread

Jaguars, foxes, snakes, and caimans are not eaten because
some Híwi groups connect their own mythical origins with the
origins of these animals.

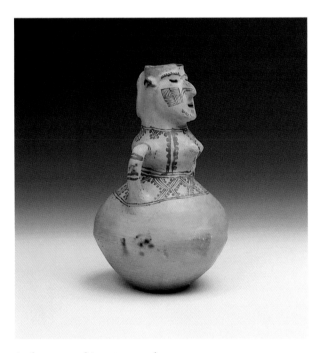

Anthropomorphic water vessel
HÍWI
Fired clay

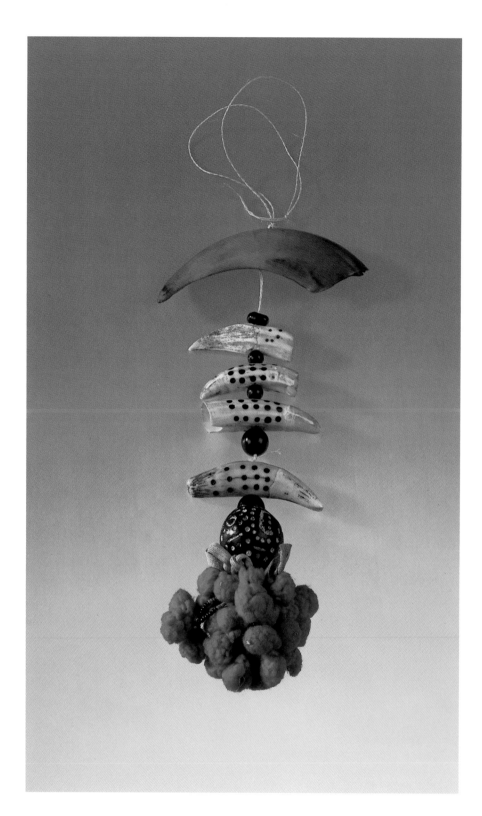

Amulet—*puwonobürü*
H Í W I
Crocodile teeth, jaguar teeth, armadillo
claws, glass beads, seeds, fruit of the
chiqui-chiqui palm *Leopoldina piassaba*,
cotton thread, plant pigment

Tapir and caiman teeth threaded between
red and blue glass beads and seed pits are a
sign of the successful hunt. The amulets
recall the hunter-gatherer past of the Híwi.
At the same time they distinguish their
wearer as a successful hunter, they bring
good luck in hunting.

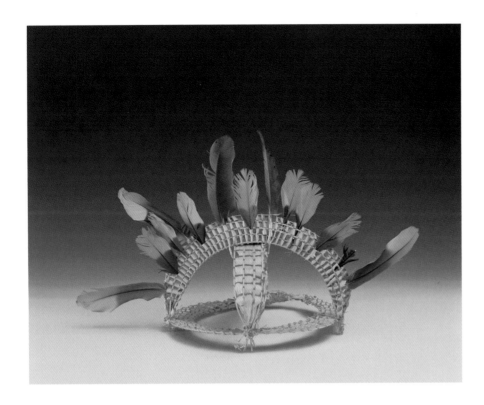

Men's headdress
H Í W I
Wickerwork of fibers of cucurito palm
Maximiliana regia and moriche palm
Mauritia flexuosa, parrot feathers

Panpipes—*jiwaburü*
H Í W I
Reed

Five hollow reeds are connected with string,
and the sixth and largest reed is held sepa-
rately. To play the typical melodies, two such
pipes are needed, one "male" and one
"female." Each of the pipes has the range of
a third in semitones. The two pipes compli-
ment each other in such a manner that a
diatonic scale is heard.

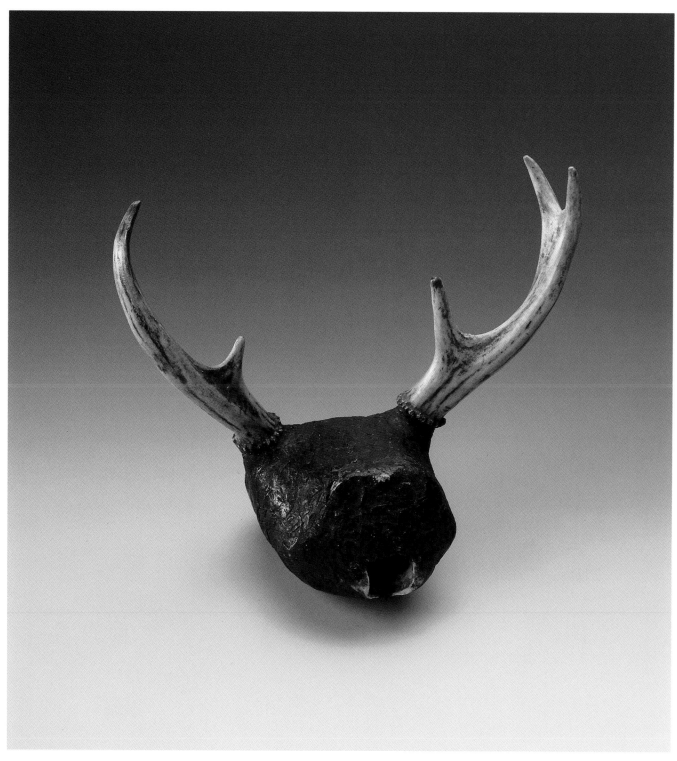

Skull pipe—*oweibi*
HÍWI
Deer skull, with beeswax and resin compound

The Híwi construct such pipes from the skulls of deer. The skull is cleaned, and then, with the exception of one opening, covered with resin and beeswax. The antlers are used by the musician as grips.
The deer was the first animal that Kuwái called into the world. He sang its name and the world opened a bit. Then he flew across all the regions and called all the animals to life by singing their names.

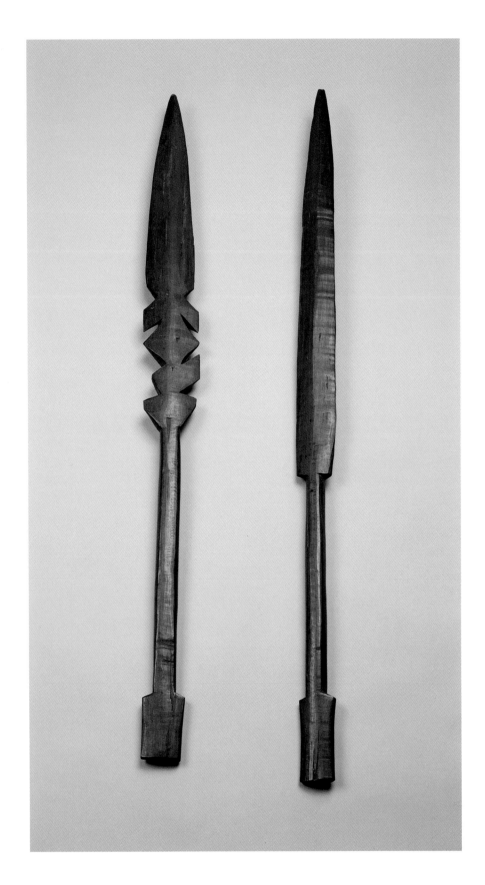

Ceremonial clubs
HÍWI
Hardwood

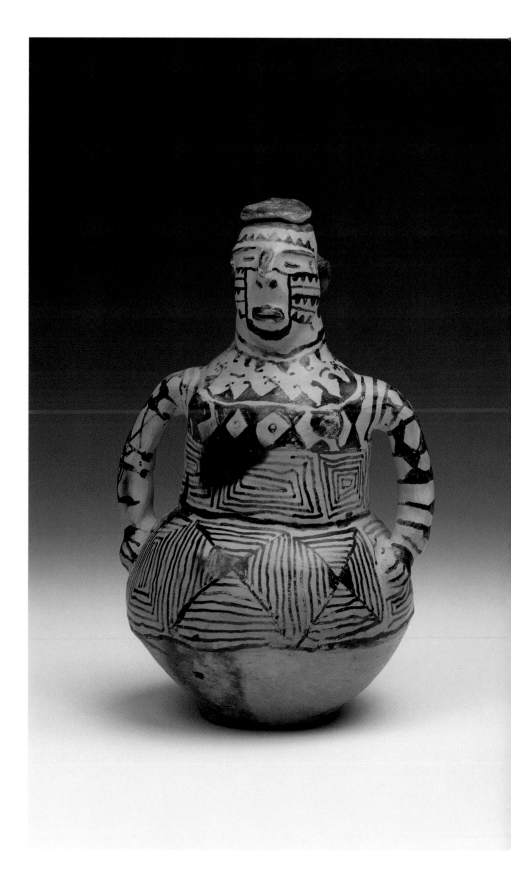

Anthropomorphic water vessel
HÍWI
Fired clay

The Híwi women make pottery goods to
sell. The dried clay vessels are fired over
open flames and then painted with plant
pigments. The water vessels in the form
of women or animals are richly decorated
with geometrical designs. The designs are
based largely on the face painting tradition-
ally practiced by the Híwi in former times.

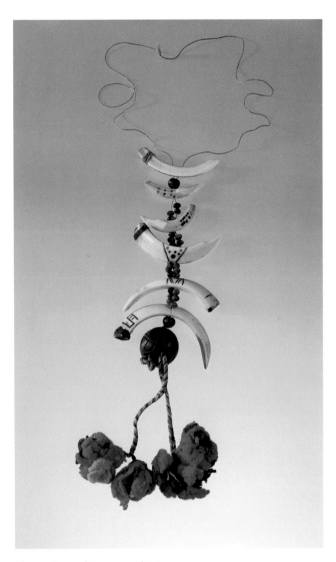

Shaman's amulet—*puwonobürü*
HÍWI
Armadillo claws, peccary teeth, chiqui-chiqui palm fruit
Leopoldina piassaba, various seeds, glass, resin, plant pigmenmt

The teeth and claws are filled with small seeds and *wánali* magic
crystals, then encased by a resin and bee putty compound. The
teeth decorated with dots show the same "pinta del tigre" design
that the shaman wears as decorations at important séances.

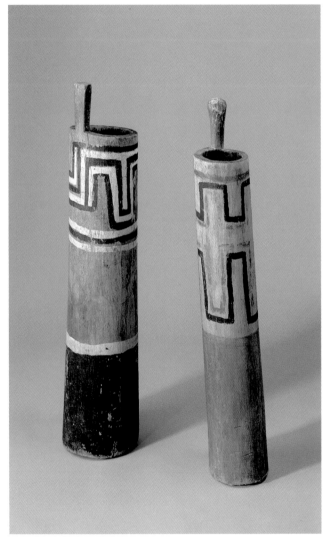

Stamping posts—*waana*
HÍWI
Wood of *Inga spp.,* plant pigment

Musical instruments with "male" and "female" painted designs.
The *waana* is a hollow cylinder made from lightweight wood. The
vertical grip is used to raise the pipe from the ground to drop it
again in rhythm. The pair, made up of the "male" *pebito*, and the
somewhat smaller "female" *pesorowato*, are always used together at
dances. The tone of the "male" *pebito* is lower and more penetrat-
ing than that of the "female" *pesorowato*.

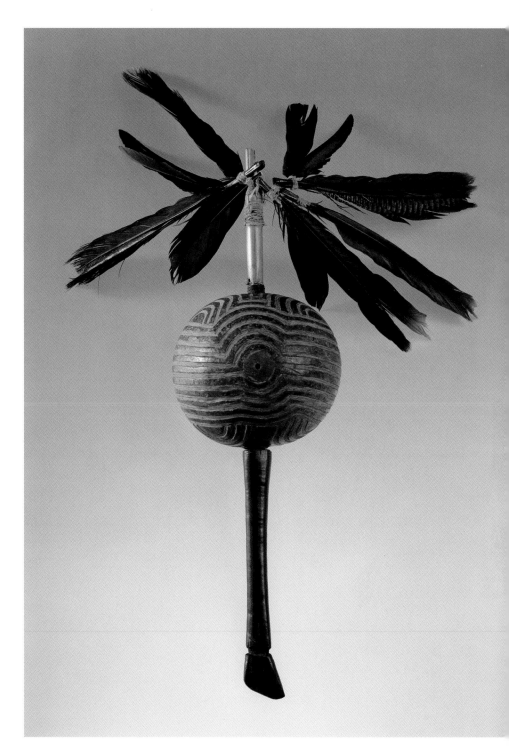

Shaman's rattle—*tsiitsiito*
HÍWI
Calabash filled with seeds and magical crystals, the *wánali* stones, black feather helmet of the curassow, reed, plant pigment

The medicine man uses the rattle to magically influence game and plants, and to heal the sick. When someone is severely sick, through dance, song, and the inhalation of *yopo* powder, the shaman enters a trance to detect the source of the sickness. He also calls on *málike* and *málikai*, two helper spirits. They were created by the culture hero Kuwái and can take on the form of birds. The light movement of air which accompanies the shaking of the rattle as it passes over the patient signifies the breath of the helper spirits, and is meant to "blow away" the sickness.

Weaving utensils
PUINAVE
Wood, cotton

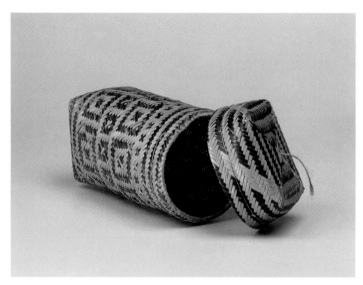

Basket with top
PUINAVE
Wickerwork of *Ischnosiphon aruma*, fiber
from *Ananas lucidus*, plant pigment

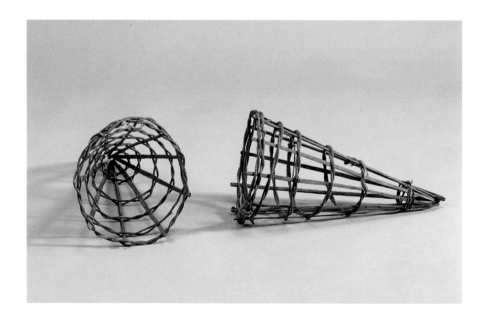

Fish traps
PUINAVE
Mamure *Heteropsis spruceana*, bamboo

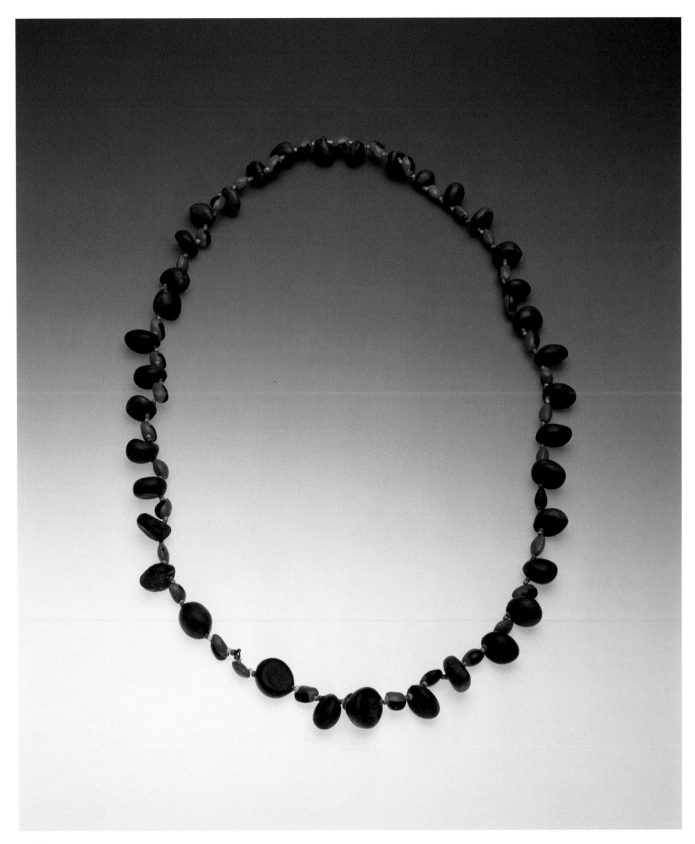

Necklace
PUINAVE
Seed capsules, glass beads, cotton thread

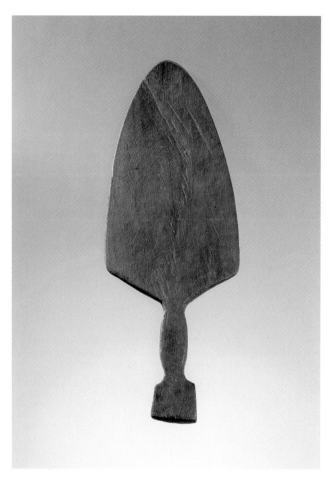

Turning spatula for *casabe* tortillas
ARAWAK—WAREKENA
Wood

Manioc is considered a sacred plant by the
Warekena. Girls as well as boys during their
initiation ceremonies are urged to take care
of and respect the manioc plant, for it is like
a second mother who nourishes everyone.

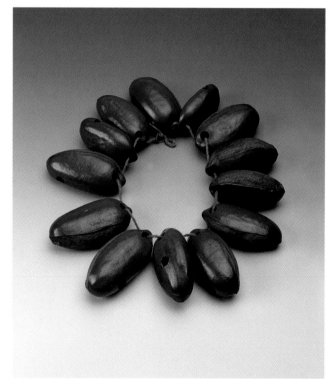

Clapper made from palm fruit pits
ARAWAK—WAREKENA
Palm fruit, cotton thread

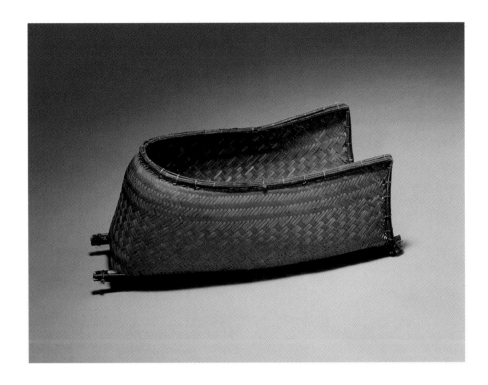

Carrying basket for children
ARAWAK—WAREKENA
Wickerwork from *Ischnosiphon aruma*,
fiber from *Ananas lucidus*, wood

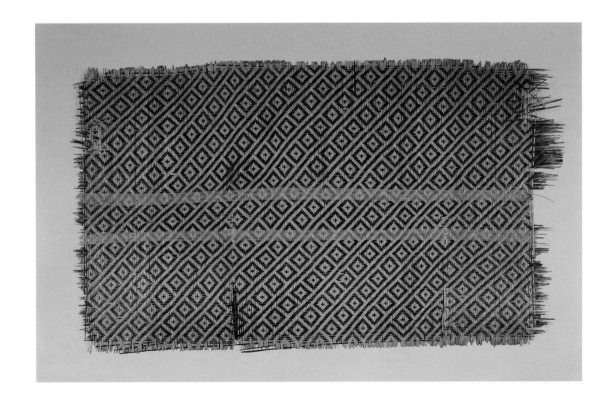

Sleeping mat
ARAWAK—
WAREKENA
*Ischnosiphon
aruma*, plant
pigment

Turning spatula for manioc tortillas
ARAWAK—BARÉ
Wood

This manioc spatula takes its form from the machete.

Brush
ARAWAK—BARÉ
Palm fruit of the jigua palm *Caryocar glabrum*

The fruit of the jigua palm is well-suited for combing the hair.

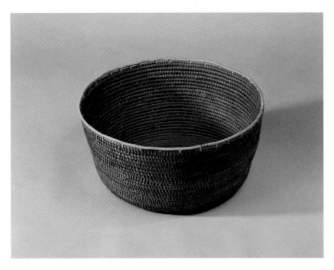

Basket
ARAWAK—BARÉ
Chiqui-chiqui fiber *Leopoldina piassaba*, mamure *Heteropsis spruceana*

Basket woven from chiqui-chiqui fiber in coiling technique. A thin bundle of palm fibers is rolled into a spiral and then sewn together with a second elastic fiber.

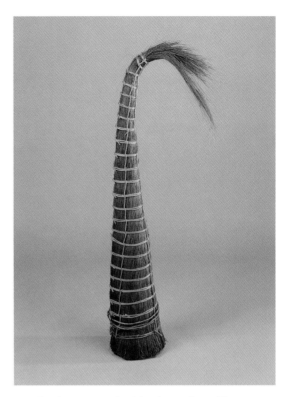

Bundle of raw material of the chiqui-chiqui fiber
Leopoldina piassaba
ARAWAK—BARÉ

The palms from which the chiqui-chiqui fiber is obtained grow along the banks of the Inírida and Guainía rivers. The gathering of the fibers is a difficult chore—in order to make any economic sense, many tons of chiqui-chiqui must be collected. Today, the fiber is used chiefly for trade with the criollos.

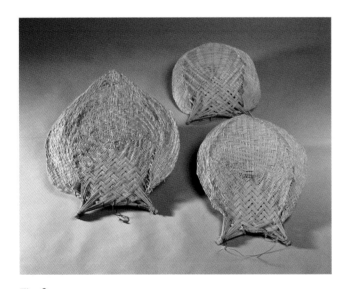

Fire fans
ARAWAK—BARÉ
Fiber from *Astrocaryum tucuma*

In the beginning human beings did not have fire. It was in the possession of the caiman. It carried the fire in its stomach, and when it spoke, flames spewed from its mouth.

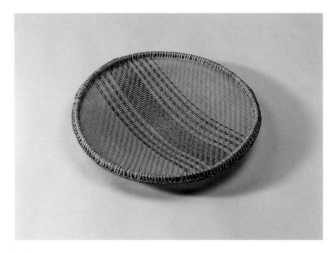

Sieve
ARAWAK—BARÉ
Plaited from *Ischnosiphon aruma*, mamure *Heteropsis spruceana*, plant pigment

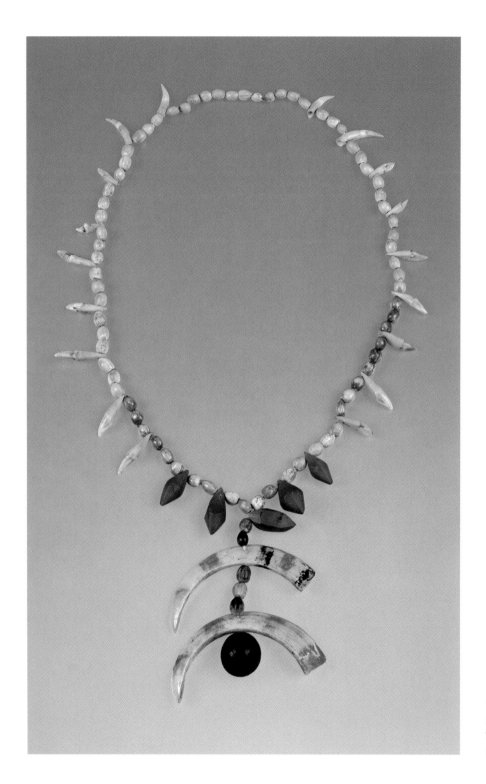

Necklace
PIAPOCO
Tapir teeth, monkey teeth, armadillo claws,
seed capsules

Handbag made from armadillo shell
TOTAPUYA
Scales from armadillo shell, copper wire,
fibers from *Ananas lucidus*

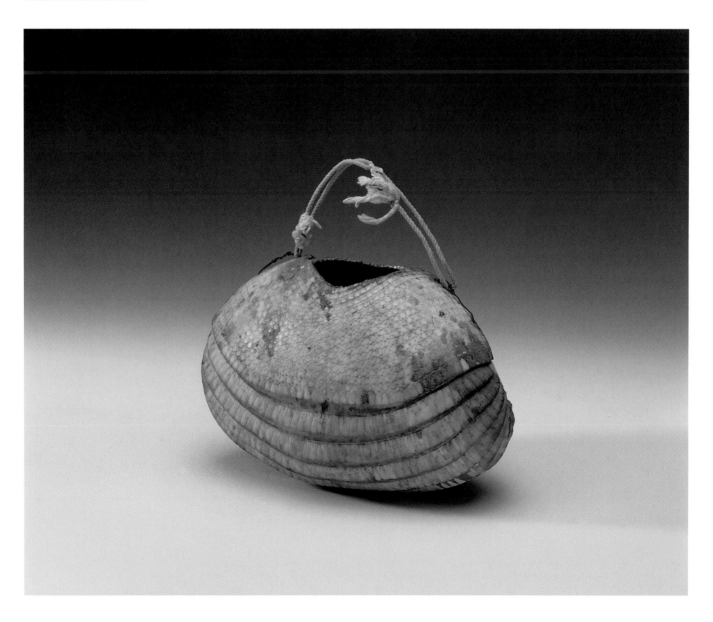

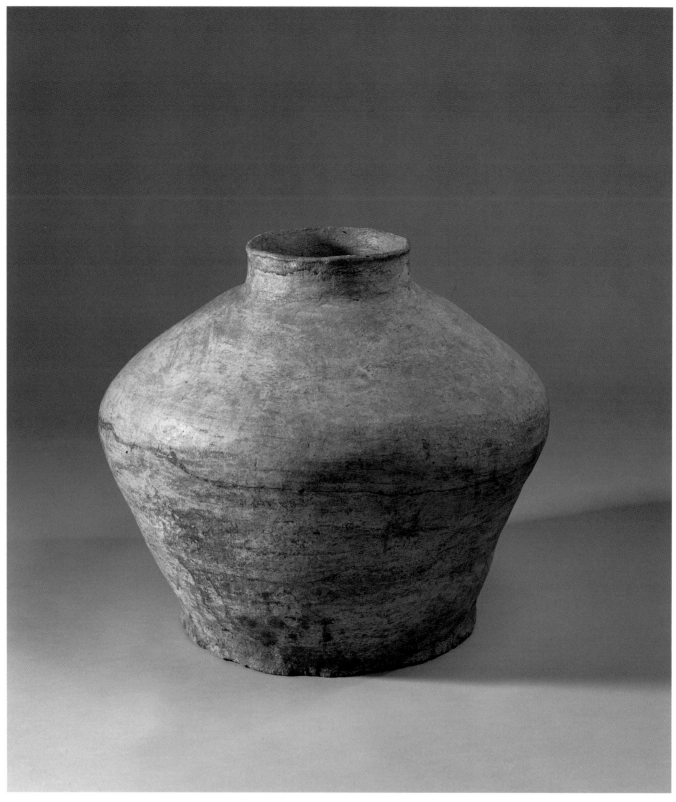

Clay jug
ARAWAK—BANIWA-WAKUÉNAI
Fired clay

Napiruli, the creator god of the Baniwa, taught women the techniques of pottery and the designs
and colors of the vessels. After firing they are coated with a glaze of plant resin.

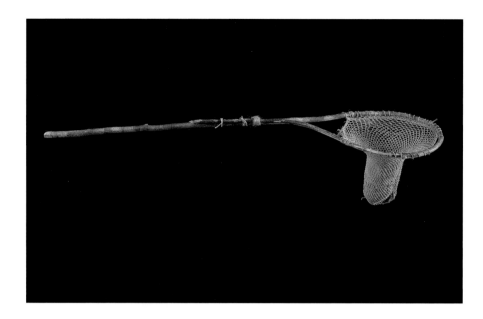

Fishing-net
A R A W A K—
B A N I W A - W A K U É N A I
Mamure *Heteropsis spruceana*, fiber
from *Ananas lucidus*

The net is used to remove the fish from fishing traps. Every year from the end of March to the middle of April, when the Pleiades are in the night sky, many fish migrate upstream to spawn on the flooded savanna. For the Indians this is the time of abundance, and they hold a great *pudali* exchange festival. Women sing their "fishing-net songs" as part of the festivities. Not only is food traded there, but new alliances between groups are established, or old alliances renewed.

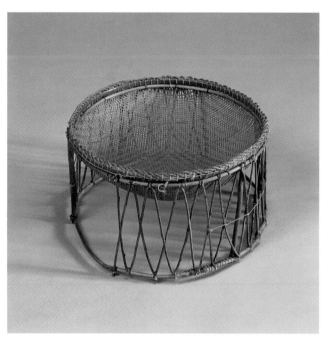

Sieve with frame
A R A W A K - B A N I W A - W A K U É N A I
Wickerwork from *Ischnosiphon aruma*, mamure
Heteropsis spruceana, fiber from *Ananas lucidus*

The manioc flour is sifted through this artfully
woven sieve made of rushes and bromelia fibers.

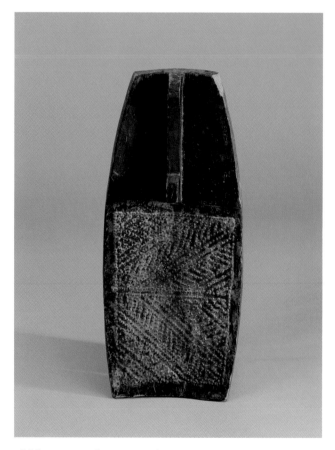

Children's grater for manioc tubers
A R A W A K - B A N I W A - W A K U É N A I
Wood, stones, resin from the couma tree *Couma Caatingae*, resin
mixed with bee aggregate

The Arawak are known as accomplished planters. They cultivate
the bitter manioc, which was brought to them by Kuwái, the culture
hero. The complicated process of detoxifying the prussic-acid-
containing tubers is a women's job learned already in childhood.

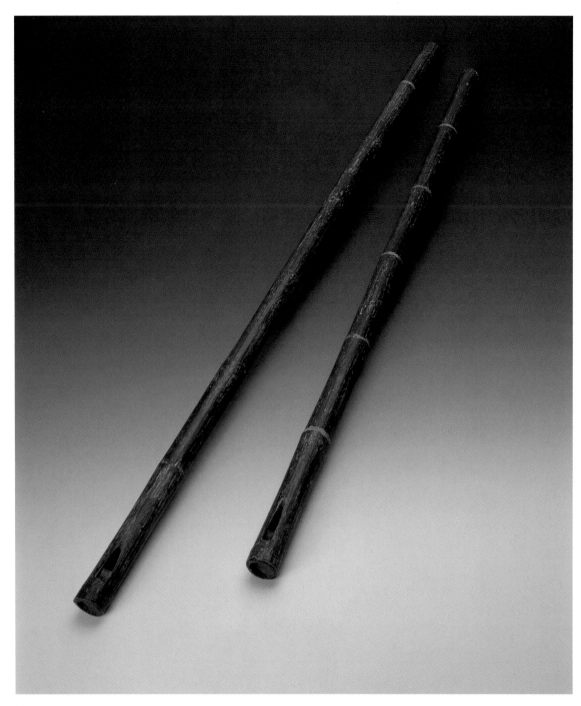

Flutes— *yupuruto*
ARAWAK—BANIWA
Wood of *Astrocaryum sp.*

Music and song are used by the Arawak ethnic groups as powerful bearers of the mythic tradition. During the boys' initiation ceremony, when the *yupuruto*-flutes are played, the "People of the Song" recall the journeys of the culture heroes Kuwái and Amáru. The myth tells the story of the creation of the sacred flutes and trumpets by Kuwái. The culture hero Iñápirríkuli told a squirrel to measure the palms. The squirrel quite expertly climbed and marked off a tree. But the squirrel wanted to kill Iñápirríkuli, and so not only did it mark the tree off, but also cut it into segments meant to topple down atop the culture hero. Iñápirríkuli, however, saw this, and from a safe distance he touched the tree with a stick. As the tree segments fell down, he noticed that they were hollow inside. He blew through the smallest segment and heard the wonderful song of a little frog. He tried out the other segments, and heard the various bird and fish voices, which Kuwái once had sung when he created the world.

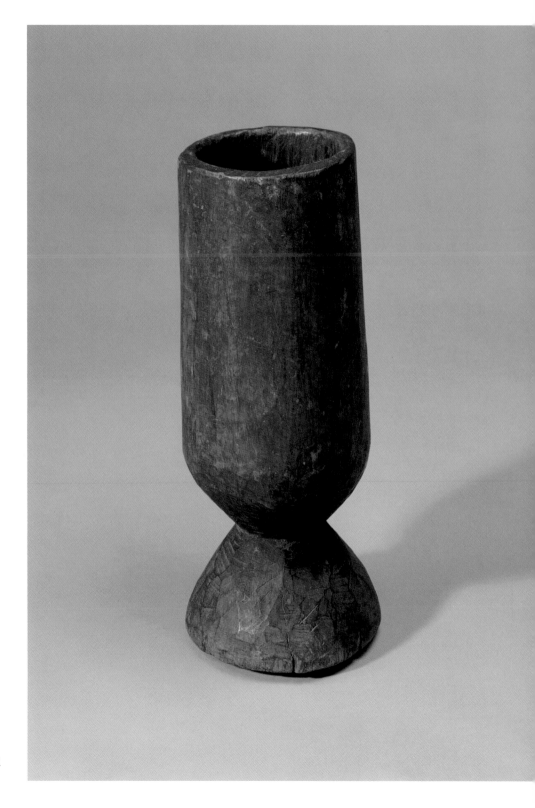

Wooden mortar
ARAWAK—
BANIWA-WAKUÉNAI
Hardwood

Women use the mortar to mash the
manioc pulp after it is removed from
the tube press. The mortar is also used
to hold meat for tenderization.

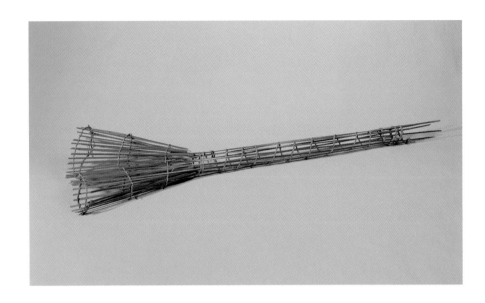

Fishing trap
ARAWAK—WAKUÉNAI
Ischnosiphon aruma, mamure *Heteropsis spruceana*

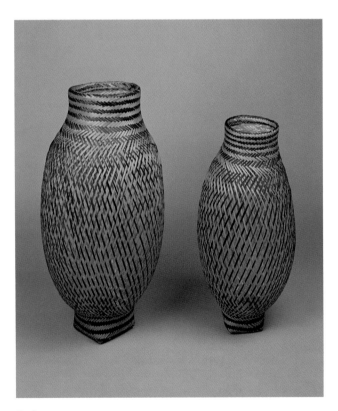

Baskets
ARAWAK—WAKUÉNAI
Ischnosiphon aruma

These loosely woven baskets can be used as bird cages
or as fishing traps.

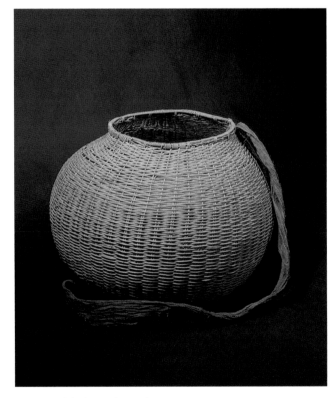

Basket with bulge and tumpline
ARAWAK—WAKUÉNAI
Mamure *Heteropsis spruceana*, fiber from
Antiaris sacciadora

Grating board for manioc tubers
ARAWAK—WAKUÉNAI
Wood, stones, resin

Three flutes
ARAWAK—WAKUÉNAI
Bamboo reeds, plant pigment, sisal

The sounds emanating from a flute are associated with animal voices. During the initiation ceremonies the youths learn to associate the sounds of the flutes with certain sacred animals.

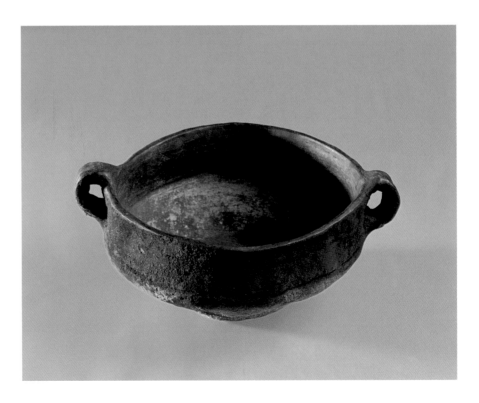

Pottery bowl with two handles
ARAWAK—WAKUÉNAI
Fired clay

Pot stand
ARAWAK—WAKUÉNAI
Bamboo, mamure *Heteropsis spruceana*

A stand of wooden slats artfully arranged in opposte directions and
secured at top and bottom with creeper.

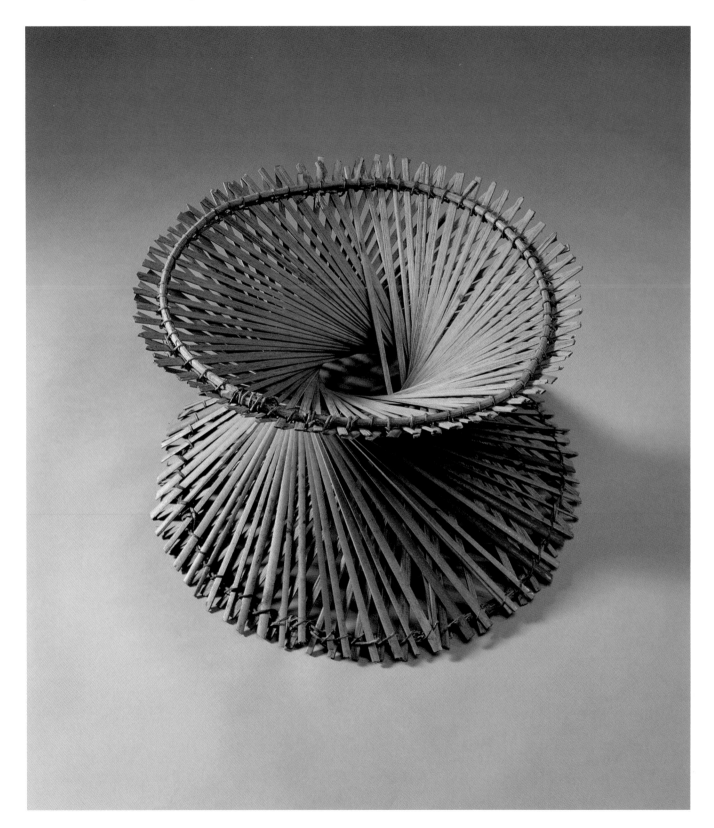

APPENDIX

Bibliography

Agerkop, Terry (1983): *Culturas aborígenes de Latinoamérica I. Piaroa*. Caracas, Consejo Nacional de la Cultura de Venezuela, Instituto Interamericano de Etnomusicología y Folklore. Caracas, 1983

Albert, Bruce (1985): *Temps du sang, temps des cendres. Représentation de la maladie, système rituel et espace politique chez les Yanomami du sud-est (Amazonie brésilienne)*. Thèse, Université de Paris X, 1985

Albert, Bruce (1993): "La massacre de los Yanomami de Haximu". *La Iglesia en Amazonas* 62/63 1993

Alès, Catherine (1990): "Chroniques des temps ordinaires. Corésidence et fission Yanomami". *L'Homme* 113 (1) 1990, 73–101

Barandiarán, Daniel de (1961): *Santa María de Erebato o la fundación de un nuevo pueblo en el Estado Bolivar*. Caracas 1961

Barandiarán, Daniel de (1962a): "Actividades vitales de subsistencia de los Indios Yekuana o Makiritare". *Antropológica* 11 1962, 1–29

Barandiarán, Daniel de (1962b): "Shamanismo Yekuana o Makiritare". *Antropológica* 11 1962, 61–90

Barandiarán, Daniel de (1966): "El Habitado entre los Indios Yekuana". → *Antropológica* 16, 1–95

Bermúdez, Beatriz: "La Cestería Ye'kuana guarda el secreto de la yuca amarga". *Revista Bigott* 43, 1997, p. 32–40, Caracas

Bermúdez, Beatriz (in preparation): *Trama, mitos y cestería Yékuana*

Boglár, Lajos (1982): *Wahari. Eine südamerikanische Urwaldkultur*. Leipzig/Weimar, 1982

Bou, Jim (1970): "Found but Lost". → *Brown Gold* 27 (10) 1970, 6–7

Bourdieu, Pierre (1979): *Entwurf einer Theorie der Praxis auf der ethnologischen Grundlage der kabylischen Gesellschaft*. Frankfurt am Main, 1979

Bunting, George (1979): "Sinopsis de las Araceae de Venezuela". → *Revista de la Facultad de Agronomía de Maracay* X (1–4) 1979

Chagnon, Napoleon A. (1968): *Yanomamö. The Fierce People*. New York, 1968

Chagnon, Napoleon A. (1977): *Yanomamö, the fierce people*. (2nd edition) New York

Civrieux, Marc de (1959): "Datos antropológicos de los Indios Kunahana". *Antropológica* 8 1959, 85–146

Civrieux, Marc de (1970): *Watuna: Mitología Makiritare*. Caracas, 1970

Cocco, Luís (1972): *Iyeweiteri: Quince Años entre los Yanomamos*. Caracas, 1972

Colchester, Marcus (ed.) (1985): *The Health and Survival of the Venezuelan Yanoama*. International Workinggroup of Indigenous Affairs (IWGIA), Document 53. Copenhagen, 1985

Coppens, Walter (ed.): *Los Aborigenes de Venezuela*, Vol. 1–3, Caracas, 1988

Coppens, Walter (1983): "Los Hoti". In: *Los Aborígenes de Venezuela*. Vol. 2. Caracas, 1983, 243–301

Cruxent, Jose Maria: *Los Shikana del Río Kaima*. (unpublished manuscript)

Delgado, Lelia: "Un etnógrafo entre dos mundos". Enrique Stanko Vráz, *A través de América Ecuatorial*, Caracas, 1992

Delgado, Lelia: "Alfred Wallace y Richard Spruce, étnografos en tierra humboldtiana". *Dos Naturalistas Britanicos en la Amazonia Venezolana*, Caracas, 1994

Delgado, Lelia: *La Colección Proyecto Orinoco* (in preparation)

Descola, Philippe (1994): *In the Society of Nature. A Native Ecology in Amazonia*. Cambridge, 1994

Díaz Peña, Natalia (1993): *Aproximación a la estética primitiva de la etnia Warekena*. Caracas, 1993

Disselhoff, Hans-Dietrich, and Otto Zerries (eds.) (1974): *Die Erben des Inkareiches und die Indianer der Wälder*. Berlin, 1974

Eden, Michael J.: "Ecological Aspects of Development among Piaroa and Guahibo Indians of the Upper Orinoco Basin". *Antropológica*, 39, 1974, pp. 25–26

Eibl-Eibesfeldt, Irenäus (1971): "Eine ethnologische Interpretation des Palmfruchtfestes der Waika (Venezuela) nebst einigen Bemerkungen über die bindende Funktion von Zwiegesprächen". *Anthropos* 66 (5–6), 767–778

Eibl-Eibesfeldt, Irenäus (1973): "Die Waruwádu (Yuwana), ein kürzlich entdeckter, noch unerforschter Indianerstamm Venezuelas". *Anthropos* 68 1973, 137–144

Fernández, Rafael, Mireya y Hernán Gonzáles y la Comunidad Yekuana de Karuri, Alto Ventuari (1981): "Nos Cuentan Los Makiritares". *Boletín Indigenista Venezolano*. Vol. XX, no. 17 1981, 23–41

Filho, João Odilon de Souza (1987): "A 'Festa da Casa Grande' dos Karajáq. → *Publicações do Museu Histórico de Paulínia*, 34 1987, 76–83

Flowers, Nancy M. (1994): "Puinave". In: *Encyclopedia of World Cultures*. Vol. VII 1994, Boston, Mass., 281–282

Geertz, Clifford (1976): "Art as a Cultural System". *Modern Language Notes* 91 1976, 1473–1499

González Ñáñez, Omar (1968): "Sexualidad y rituales de iniciación entre los Indígenas Warekena del Río Guainía—Rio Negro, TFA". *Revista Montalbán, Universidad Católica Andres Bello*, 17 1968, 103–138

González Ñáñez, Omar (1970): *Orígenes del mundo según los Baniva*. Venezuela Misionera, 1970

González Ñáñez, Omar (1972): *Los Guarequena*. Caracas, 1972

González Ñáñez, Omar (1973): "Ensayo de interpretación de la realidad artesanal y otros aspectos de la actividad económica y cultural de los Aborígenes del Territorio Federal Amazonas, Venezuela". *Boletin Bibliografico de Antropologia Amerericana* 36 (45) 1973, 137–165

González Ñáñez, Omar (1980): *Mitología Guarequena*. Caracas, 1980

González Niño, Edgardo (1984): *Historia del Territorio Federal Amazona*. Caracas, 1984

Grelier, Joseph (1953): "Los Indios Piaroa de la región de Puerto Ayacucho". *Boletín Indigenista Venezolano* I (2) 1953, 253–263

Guarisma Pinto, Virginia, and Walter Coppens (1978): "Vocabulario Hoti". *Antropológica* 49 1978, 3–28

Guss, David M. (1989): *To Weave and Sing. Art, Symbol, and Narrative in the South American Rain Forest*. Berkeley a. o. 1989

Hames, Raymond and Ilene Hames (1976): "Yekuana Basketry: Its Cultural Context". *Antropológica* 44 1976, 3–58

Harris, Marvin (1996): *Menschen, wie wir wurden, was wir sind*. München, 1996 (Amerikanisches Original: *Our Kind*, 1977)

Henley, Paul (1988): "Los E'ñepá (Panare)". In: *Los Aborigenes de Venezuela*. Vol. 3. Caracas, 1988, 215–306

Henley, Paul (1994): "Panare". In: *Encyclopedia of World Cultures*. Vol. VII 1994, Boston, Mass., 264–267

Henley, Paul, and Marie-Claude Mattéi-Müller (1978): "Panare Basketry: Means of Commercial Exchange and Artistic Expression". *Antropológica* 49 1978, 29–130

Henley, Paul, Marie-Claude Mattéi-Müller and Howard Reid (1994–1996): "Cultural and Linguistic Affinities of the Foraging People of Northern Amazonia: a New Perspective". *Antropológica* 83 1994–1996, 3–38

Herzog-Schröder, Gabriele (in preparation): *Okoyoma. Die Krebsjägerinnen vom Oberen Orinoko. Geschlecht, Ritual und Repräsentation.*

Hill, Jonathan D. (1984): "Los Misioneros y las Fronteras." *América Indígena.* Vol. 44 (1) 1984, 183–190

Hill, Jonathan D. (1986): "Los Arawacos del Río Negro". *Sistemas Ambientales Venezolanos.* Vol. 1. Caracas, 1986

Hill, Jonathan D. (1987): "Wakuénai Ceremonial Exchange in the Venezuelan Northwest Amazon". *Journal of Latin American Lore* 13 1987, 183–224

Hill, Jonathan D. (ed.) (1988): *Rethinking History and Myth. Indigenous South American Perspectives on the Past.* Urbana, 1988

Hill, Jonathan D. (1996): *History, Power, and Identity. Ethnogenesis in the Americas, 1492–1992.* Iowa City, 1996

Journet, Nicolas (1980): "Los Curripaco del Río Isana: economía y sociedad". *Revista Colombiana de Antropología* 23 1980

Kaplan, Joanna Overing (1988): "Los Wothuha (Piaroa)". In: *Los Aborígenes de Venezuela.* Vol. 3. Caracas, 1988, 307–411

Kirchhoff, Paul (1950): "Food-gathering tribes of the Venezuelan Llanos". In: Steward, Julian (ed.): *Handbook of South American Indians.* Vol. IV. Washington, 1950

Koch-Grünberg, Theodor (1922): "Die Völkergruppierung zwischen Río Branco, Orinoco, Rio Negro und Yapurá". In: *Festschrift für Eduard Seler.* Stuttgart, 1922, 205–266

Koch-Grünberg, Theodor (1923): *Vom Roraima zum Orinoko. Ergebnisse einer Reise in Nordbrasilien und Venezuela in den Jahren 1911–1913.* Vol. 1–4. Stuttgart, 1923 (resp. 1928)

Koch-Grünberg, Theodor (1927): *Indianermärchen aus Südamerika.* Jena, 1927

Lévi-Strauss, Claude (1981): *Die elementaren Strukturen der Verwandtschaft.* Frankfurt am Main, 1981

Lizot, Jacques (1980): "La Agricultura Yanomami". *Antropológica* 54 1980, 3–93

Lizot, Jacques (1982): *Im Kreis der Feuer. Aus dem Leben der Yanomami-Indianer.* Frankfurt am Main, 1982

Lizot, Jacques (1988): "Los Yanomami". In: *Los Aborígenes de Venezuela.* Vol. 3. Caracas, 1988, 479–583

Mason, Otis (1970): *Tufton Aboriginal American Basketry.* New Mexico, 1970. (1st edition, 1902)

Mattei-Mueller, Marie-Claude (1994): *Diccionario Ilustrado Panare—Español Español—Panare: Un aporte al estudio de los Panares—E'ñepa.* Caracas, 1994

Mattei-Müller, Marie-Claude (1992): *Yoroko, Confidencias de un Chamán Panare.* Caracas, 1992

Mattéi-Müller, Marie-Claude (in preparation): *The Situation of the Indigenous Languages of Venezuela. Languages in Danger of Disappearing*

Mauss, Marcel (1968): *Die Gabe.* Frankfurt am Main. (Original: *Essai sur le Don,* 1925)

Metzger, Donald J. and Robert V. Morey (1983): "Los Híwi (Guahibo)". In: *Los Aborígenes de Venezuela.* Vol. 2. Caracas, 1983, 125–216

Monod, Jean (1975): *Un rico caníbal: relación y observaciones del autor entre los Piaroa.* Mexico, 1975

Monod-Becquelin, Aurore (1982): "La Metamorphose". *Journal de la Société des Américanistes* 68 1982, 133–147

Monod-Becquelin, Aurore (1988): "Der dekorierte Mensch. Körpermalerei bei den Trumai des Alto Xingu (Zentral-Brasilien)". In: Münzel, Mark (ed.) *Die Mythen sehen.* 1988, 533–570.

Mowat, Linda, Howard Morphy and Penny Dransart (eds.) (1992): *Basketmakers, Meaning and Form in Native American Baskets.* Pitt Rivers Museum. University of Oxford. Monograph 5

Müller, Wolfgang (1995): *Die Indianer Amazoniens. Völker und Kulturen im Regenwald.* München, 1995

Münzel, Mark (1978): "Mittel- und Südamerika. Von Yucatán bis Feuerland". In: *Die Indianer. Kulturen und Geschichte.* Ed. by Wolfgang Lindig and Mark Münzel. Vol. 2. München, 1978

Münzel, Mark (1988): *Die Mythen sehen.* (Museum für Völkerkunde; Roter Faden zur Ausstellung. Vol. 14 and 15) Frankfurt am Main, 1988

Münzel, Mark (1989): "Bild und Drama in Oralkulturen". In: Scharlau, B. (ed.): *Bild Wort Schrift. (Beiträge zur Lateinamerika-Sektion des Freiburger Romanistentages).* Tübingen, 1989, 19–36

OCEI (1993): Censo Indígena de Venezuela, 1992. Tomo I. Officina Central de Estadística e Informática. Caracas, 1993

Posey, Darell A., "Indigenous Mangement of Tropical Forest Ecosystems: the Case of the Kayapó Indians of the Brazilian Amazon". *Agroforestry Systems* 3, 1985, pp. 139–158

Posey, Darell A., "Cultivating the Forest of the Amazon: Science of the Mebengokre", *Orion Nature Quaterly* 9, 1986, pp. 16–23

Prinz, Ulrike (1999): *Das Jacaré und die streitbaren Weiber. Poesie und Geschlechterkampf im östlichen Tiefland Südamerikas.* Marburg, 1999

Reichel-Dolmatoff, Gerardo (1944): "La cultura material de los indios guahibo". *Revista del Instituto Etnológico Nacional* 1. Bogotá, 1944, 437–506

Reichel-Dolmatoff, Gerardo (1985): *Basketry as metaphor. Arts and Crafts of the Desana Indians of the Nothwest Amazon.* (Occasional Papers of the Museum of Cultural History. no. 5) Los Angeles, 1985

Rodriguez, Carlos A. (1922): "La leyenda de los hombres Aparo". *La Iglesia en el Amazonas,* 1992, 15–22

Ribeiro, Berta, *A Arte do Trançado dos Indios do Brasil. Um estudo taxonômico,* Museu Paraense Emilio Goeldi, Fundação Nacional de Arte, 1985

Roe, Peter G. (1990a): "The Language of the Plumes: 'Implicit Mythology' in Shipibo, Cashinahua, and Waiwai Feather Adornments". In: Preuss, Mary (ed.): *Lail Speaks! Selected Papers from the VII International Symposium on Latin American Indian Literatures.* 1990, 105–135

Roe, Peter G. (1990b): "Impossible Marriages: Animal Seduction Tales among the Shipibo Indians of the Peruvian Jungle". *Journal of Latin American Lore* 16 (2) 1990, 131–173

Roe, Peter G. (1995): "Arts of the Amazon". In: Brown, Barbara (ed.): *Arts of the Amazon.* London, 1995

Roe, Peter G. (1998): "Paragon or Peril? The Jaguar in Amazonian Indian Society."

In: Saunders, Nicholas J. (ed.): *Icons of Power: Feline symbolism in the Americas.* London, 1988, 171–202

Roth, Walter (1924): "An Introductory Study of the Arts, Crafts, and Customs of Guiana Indians". *Annual Report, Bureau of American Ethnology 1916–17.* Washington, 1924

Rozo, J. M. (1945): "La fiesta del diablo entre los Puinave". *Boletín de Arqueología* 1(3) 1945, 241–247

Schuster, Meinhard (1976): *Dekuana: Beiträge zur Ethnologie der Makiritare.* München, 1976

Seiler-Baldinger, Anne-Marie (1991): "Systematik der Textilen Techniken". *Basler Beiträge zur Ethnologie.* Vol. 32. Basel, 1991

Simpson, George, "Los Indios Kamarakotos", *Revista de Fomento,* Vol. III, N° XXII/XXV, Caracas, 1944

Steinvorth Goetz, Inga (1970): *Uriji jami! Die Waika-Indianer in den Urwäldern des Oberen Orinoko.* Asociacion Cultural Humboldt. Caracas, 1970

Suhrbier, Birgit M. (1998): *Die Macht der Gegenstände. Menschen und ihre Objekte am oberen Xingu, Brasilien.* Marburg, 1998

Triana, Gloria (1983): "Efectos del contacto en la adaptación y patrones de subsistencia tradicionales: los Puinave del Inírida". *Boletín de Antropología.* Medellín, 1983

Turner, Terence (1969): "'Tchikrin': A Central Brasilian Tribe and it's Symbolic Language of Bodily Adornment". *Natural History* 78 (8) 1969, 50–70

Turner, Terence (1985): "Animal Symbolism, Totemism, and the Structure of Myth". In: Urton, Gary (ed.): *Animal Myths and Metaphors in South America.* Salt Lake City, 1985, 49–106

Van Velthem, Lúzia Hussak (1988): "Wama-Aruma. Mythos und Technologie der Wayana-Apalai in Pará (Brasilien)". In: Münzel, Mark (ed.) *Die Mythen sehen.* 1988, 278–330

Vasco Uribe, Luis Guillermo (1987): *Semejantes a los Dioses. Cerámica y Cestería Emberá-Chamí.* Bogotá, 1987

Vidal, Silvia (1983): "Los Piapoco". In: *Sistemas Ambientales Venezolanos.* Vol. 1. Caracas, 1983

Vidal, Silvia (1989): *El modelo del proceso migratorio pre-hispánico de los Piapoco: hipótesis y evidencias.* Caracas, 1989

Villalón, Maria Eugenia, *Aspectos de la organización social y la terminología del parentesco E'ñapa (vulg. Panare),* Caracas, 1978

Viveiros de Castro, Eduardo (1998): "Cosmological Deixis and Amerindian Perspectivism". *Journal of the Royal Anthropological Institute.* Vol. 4 (3) 1998, 469–488

Waldegg, Hermann von (1942): "Indians of the Upper Orinoco". In: *Proceedings of the 8th American Scientific Congress.* Vol. 2. Washington, 1942

Wilbert, Johannes (1966): *Indios de la región Orinoco Ventuari.* Caracas, 1966

Wilbert, Johannes (1990): *Folk Literature of the Yanomami Indians.* Los Angeles, 1990

Wilbert, Johannes: *Enclopedia of World Cultures.* Vol. VII: "South America". 1994.

Wright, Robin Michael (1981): *History and Religion of the Baniwa Peoples of the Upper Rio Negro Valley.* Michigan, 1981

Wright, Robin Michael (1983): "Lucha y sobrevivencia en el Noroeste de la Amazonia". *America Indígena.* Vol. XLIII (3) 1983, 537–553

Wright, Robin Michael (1994): "Baniwa-Curripaco-Wakuenai". In: *Encyclopedia of World Cultures.* Vol. VII 1994, Boston, Mass.

Zent, Stanford (1994): "Piaroa". In: *Encyclopedia of World Cultures.* Vol. VII 1994, Boston, Mass., 275–278

Zerries, Otto (1953): "Kürbisrassel und Kopfgeister in Südamerika". *Paideuma.* Vol. 5 (6) 1953, 323–339

Zerries, Otto (1956a): "Beiträge zur Ethnographie der Guahibo-Indianer des Territorio Amazonas" Venezuela. *Paideuma.* Vol. 6 (4) 1956, 224–234

Zerries, Otto (1964): *Waika—Die kulturgeschichtliche Stellung der Waika-Indianer des oberen Orinoco im Rahmen der Völkerkunde Südamerikas.* München, 1964

Zerries, Otto (1964/65): "Algunas Noticias Etnologicas Acera de los Indígenas Puinave". *Boletín Indigenista Venezolano.* 9 (1–4) 1964/65

Zerries, Otto (1976): "Zum Problem der Wirtschaftsform der Yanoama (Süd Amerika)". *Ethnologische Zeitschrift* 2 1976, 85–90

Zerries, Otto and Meinhard Schuster (1974): *Mahekodotedi: Monographie eines Dorfes der Waika-Indianer (Yanoama) am Oberen Orinoco (Venezuela).* München, 1974

GLOSSARY

acculturation → culture change

affines. Persons related by marriage, i.e. marriage partners or relatives-in-law. In the South American Lowlands, these are often persons in a close kinship relationship. (→ cognate, → cross-cousin marriage)

agouti (*Dasyproctidae*). South American rodent. The term *picure* is used in Venezuela.

alpargatas. Simple sandals with woven straps and rubber soles worn by the rural population of Venezuela.

Amerindian. Referring to the original population of America and the descendants still living today.

amulet. Object with alleged mysterious power, mostly worn on the body. In Amazonia, disease and misfortune are often seen as magical attacks by hostile shamans, spirits or other malevolent beings. Amulets made of plant or animal substances or of stone are supposed to protect a person from such attacks. Amulets are worn around the neck or another part of the body, they may also be attached to an object, such as the quiver for the arrowheads, so as to bring good luck in hunting.

Ananas lucidus (Venez.: *curagua*). Bromeliad. Supplies fibers for a variety of uses, for example as string, to make masks, ornaments etc.

ansa. Ritual decoration of the Ye'kuana in the shape of a bat carved in wood, with toucan skins dangling from it. At dance rituals, the shaman hangs this decoration across his shoulder together with a string of boar teeth.

áparo. Small toad spirits bringing bad luck which, according to the beliefs of the → Arawak groups of the Rio Negro region, row on the rivers in the fog.

Arawak, also Aruak. One of the most important South American language families. Arawak-speaking groups today live on the coast of British Guyana, in Columbia, in the Brazilian Mato Grosso and on the Atlantic coast of Peru. It is assumed that the geographical distribution of this language family was even much wider before its displacement by the Carib Indians before the end of the 15th century. Baniwa, Wakuénai, Baré and Wareké-na are still some of the few Arawak-speaking groups living in the regions on the Orinoco and the Casiquiare.

armadillo (*Dasypus novemcinctus*), Venez. *cachicamo*. New world, armoured, nocturnal mammal. It feeds on insects and small animals. Its scales are arranged in such a way that, in case of danger, it is able to roll itself into a protective ball. A difference is made between the kinds with three or five claws on their front legs.

autochthonous (Greek). Indigenous, originating from own tradition.

balata and chicle (Venez.). Latex sap from the bark of tropical trees (such as for instance *Sapotaceae* and *Euphorbiaceae*). In part, the quality of the various kinds of latex differs considerably. The most productive and best-known kind of latex, *Hevea brasiliensis*, is used to make the so-called caoutchouc. The rubber boom started in South America in the middle of the 19th century and only declined again in the second decade of the 20th century.
Since the invention of the vulcanization process (1832), balata has played an important role in the production of rubber products. In the last century, an American called Adams experimented with the raw material chicle. He bought large amounts of chicle with the intention of producing tires. The project failed since, in contrast to balata, chicle could not be vulcanized. However, in one series of his experiments he added flavoring agents and thus invented chewing gum. To this day, Chicle Adams is still one of the most successful brands of chewing gum in the USA.

Baniwa → Arawak

báquiro, also *váquiro* (Venez.) → peccary

barbasco (*Jacquinia armillaris; Tephorsia toxicaria; Phyllanthus piscatorum*). Name of a series of fish poisons used in group fishing. The crushed leaves or roots are dissolved in the water of a stream. Toxic substances extract oxygen from the water; the fish are anesthetized and float on the surface, or they swim close to the surface gasping for air. Most often, the women wait in a group down river and lift the fish from the water with woven sieves. By tradition, this fishing method is subject to strict taboos; it is only permitted at specific times of the year and at larger intervals of time.

Baré, also Balé → Arawak

batata (*Ipomea batata*). Sweet potato used as a vegetable or for fermented drinks.

bauxite. Conglomerate of various minerals used as source material for aluminum. Due to the rapidly increasing demand on the world market, bauxite has become one of Venezuela's important exports. The region between Caicara del Orinoco and Puerto Ayacucho, which is also the territory of the E'ñepa-Panare, is rich in bauxite. Together with the diamond fields of Guaniamo in the south of the E'ñepa-Panare territory, the bauxite mines of Los Pijiguaos are the largest mines in the Orinoco-Parima area. Although the E'ñepa-Panare received the property rights to more than 14,000 hectares of land as far back as 1976, the perpetuation of their traditional culture is threatened if mining continues.

Bixa orellana → onoto

blowpipe (Venez.: *cerbatana*). For hunting birds and smaller quadrupeds, especially tree-climbing ones. To make a blowpipe, two pipes made of wood or reed are inserted into each other. They are up to three meters long and closed at one end by a mouthpiece, such as a calabash fruit cut in half. Arrows for blowpipes are thin and short and mainly coated with → curare.

bongo → *curiara*

bride service. Part of the marriage obligation where, before or at the start of his marriage, the groom has to perform services for his parents-in-law over several months or sometimes years.

caapi, also ayahuasca or yajé (Banisteria caapi). Psychoactive substance from a tropical bush or a liana and contained in the leaves, roots or bark.

cachiri. Fermented drink made of manioc, sweet potatoes or other tubers.

calabash, (Venez. totuma). Vessel made from the dry fruit of a tree gourd. Parts of the gourds are used as dishes, bowls or also as spoons.

canoa → curiara

caoutchouc → balata

capibara → chiguire

caraña (Protum carana). Aromatic tree resin used as medicine or as a glaze.

Caribs, also Caraibs or Kariña. Term for an ethnic group which gave the name to a large South American language family. At the time of the arrival of the Spanish in Central and South America, the Caribs had settled in regions in the north of the South American continent and on the Lesser Antilles. Today, they are to be found scattered all over the northwest of South America, mainly in the so-called cultural region of Guyana which also includes parts of Brazil and southern Venezuela. The most important Carib groups on the Upper Orinoco are the → E'ñepa and the → Ye'kuana. The word 'cannibal' derives from the term 'Carib'. When the Spanish, led by Columbus, landed on the Lesser Antilles, they witnessed fights between Carib groups and the Araucanian population. At that time, the image of the "warlike Caribs" was created which no longer corresponds to reality.

casabe, also casave. Baked flat loaves made of manioc mush; staple food in numerous Indian and → criollo societies.

Casiquiare. Natural channel connecting the Amazon river system with that of the Orinoco via the Rio Negro.

ceiba (Ceiba pentandra). Kapok tree whose seed capsules are lined with silky down, so-called kapok. The Orinoco Indians use this material for their blowpipe arrows: a kapok stopper at the end of the arrows stabilizes their position in the pipe. Worldwide, kapok is also used as upholstery material.

chicle → balata

chiguire, also capibara (Braz.) (Hydrochoerus capybara). Capybara; largest rodent in South America.

chiqui-chiqui, also chique-chique. Fibers of the Leopoldina piassalba palm which grow out of the trunk below the palm fronds. Chiqui-chiqui is an important raw material in basketry; especially the → Warekena use this fiber for their coiled basketwork. These water-resistant fibers are also exported to make brushes, brooms, hawsers, ropes and many more things. The inhabitants of the Upper Orinoco area also use the leaves of the chiqui-chiqui palm to thatch their houses.

churuata (Venez.). Round communal house of the → Ye'kuana, E'ñepa and De'áruwa with conical roof.

clan. Kinship group, mostly of common descent, as a rule living together and having property in common.

cognate. Close relative on the father's or the mother's side with whom an in-law relationship or marriage is excluded. Often tantamount to blood relative. (Opposite of → affines) → cross-cousin marriage

coil technique. Method of making pottery by putting coils of clay in a spiral next to and on top of each other and then joining them by spreading the clay. In the more recent basketry of the → Arawak, an analogous technique is to be found called simple coil technique.

Conquista (Span.). Conquest, capture. Denotes the epoch of the warlike seizure of Central and South America by the Spanish in the 16th century.

coroba (Scheelea macrolepis burret). Palm without thorns native to the Venezuelan state of Bolívar. Cultivated because of its oil-containing fruits; the fronds are also suitable for thatching roofs, the trunk supplies valuable wood.

criollo. (from criar, to raise, port. crioulo, frz. créole). All people raised in America independently of their previous origin are called criollo, including Indian populations as opposed to non-Americans. Applies to things or languages as an American reality of mixed origins, like créole languages.

cross-cousin marriage. Marriage with a descendant of the mother's brother or the father's sister (→ affines). A widespread marriage rule or preference in the Amazon Lowlands with a series of social consquences that promote group solidarity. (→ cognate)

culture change. Transfer of culture through close contact with neighboring ethnic groups; voluntary or also enforced assimilation to the life style of the → criollos.

culture hero. Mythical hero and culture bearer. Often appears in primeval times as the creator who brought the cultivated plants to the people and taught them handicrafts and fundamental rituals. He often appears as an animal (→ lord of the animals). Sometimes, the figure of the culture hero appears as a pair of twins or brothers with one being good-looking and clever, the other one, however, simple-minded, evil and unattractive. The culture hero does not interfere in the events of present-day life but the stories where he plays an important role explain and legitimize current customs and social rules. The culture heroes of the individual groups are called for instance → Wahari (De'áruwa-Piaroa), → Wanadi or Wanato (Ye'kuana), → Omao (Sanema, northern Yanomami group), → Mareoka (E'ñepa-Panare), Napiruli (Arawak) and Kuwai (Híwi).

curagua → Ananas lucidus

curare, also *urari* or *ourali*. An alkaloid, deadly poison for arrows still used today in hunting by several Indian groups of the South American Lowlands. The poison affects the crossing point between nerve and muscle and, directly injected into the bloodstream, causes paralysis of the respiratory musculature. Since it is not absorbed into the gastrointestinal tract, consuming game killed with curare is safe. The poison is procured by extracting it from the roots and bark of various species of strychnos (*Longiaceae*) and chondodendron (*Menispermaceae*). Various recipes exist to make curare and it is mixed with up to 20 ingredients. The → De'áruwa and the → Ye'kuana poison the points of their small blowpipe arrows by smearing about three centimeters of them with curare. The → Yanomami use the arrow poison by impregnating arrowheads especially prepared with notches. These are attached to long arrows and shot with a bow. Curare arrows are mainly used to hunt monkeys. The wounded monkeys cling convulsively to the high tree tops; due to the muscle relaxant effect of the curare, the animals gradually loosen their grip and crash to the ground. Making curare is thought to be a fine manual art among the Indians; the poison is one of the most important commodities in the South American Lowlands.
Because of their antispasmodic effect, specific kinds of curare, above all the so-called tube curarine, are also used in modern medicine, for example in the treatment of spasms or for endotracheal anesthesia.

curassow (*Cracidae pauxi*). A type of bird the size of a turkey with black shiny plumage. In the Amazon Lowlands, mainly the helmeted curassow (*Pauxi pauxi*) is to be found. The tail feathers of the curassow are often used to feather the arrows or for decoration. The Yanomami men use the curly skin of the bird's heads as upper arm bands.

curiara, also *bongo, canoa*. Dugout canoe, the customary transport vehicle on the rivers. The *bongo* is the large one for passengers and charge.

De'áruwa, also Piaroa, Wo'tihé, Uwottixa. Venezuelan Indian group whose name for themselves means "people of the forest" or also "masters of the forest". By tradition, the approximately 8,500 De'áruwa (census 1988) inhabit the regions to the right of the Orinoco: the banks of the rivers Paruazza, Manapiare, Autano, Cuao, Sipapo and Guayapo in South Venezuela. Since the 50s, many De'áruwa have migrated from their native area and moved for instance to → Puerto Ayacucho. → Saliva

endocannibalism. Form of funeral where the bodies of the deceased members of one's own group are consumed. In most cases, the act of anthropophagy is limited to the consumption of bone powder obtained by grinding the remaining bones after burning the corpse. For the → Yanomami, the soul of the deceased can only be set free by this funeral practice.

endogamous society. Marriage alliances are ideally formed between close relatives with the → cross-cousin marriage representing the preferred kind.

E'ñepa, also Panare. Indian people of the Carib-speaking group inhabiting the region of the left tributaries of the Middle Orinoco. E'ñepa means "indigenous people". In large areas, they share their territory of 2000 square kilometers with the → criollo population and in part also with the → Hodï. Over the last decades, the exploitation of extensive mineral resources, above all → bauxite, has forced the E'ñepa to adapt considerably.

epena, also *ebena* (Yanomami). Snuff powder made from the ground seeds of *Anadenanthera peregrina* and the ash from the bark of the *Elisabetha princeps*. Further ingredients may be added to the mixture. Among the Yanomami, the drug is blown into the consumer's nose by a second person with a snuff tube. → *yopo*

ëttë. → Ye'kuana house with conical roof. There is space for twenty to seventy people with every family having its own living quarters. The construction of the roof and the individual building elements are an analogy of the Ye'kuana concept of the firmament. Thus the central post symbolizes the cosmic tree which forms the connection to heaven.

exogamous patrilineal local group. Settlement communities tracing their descent from a common ancestor. The members are bound by the rule to look for a marriage partner outside their own descent group.

feather crown. Headdress with feathers, often indicating a shaman or medicine man. The *puthewa*, the feather crown of the De'áruwa medicine man, is neither a decoration nor a symbol of the wearer's political power. It is a reminder of its wearer's connection with the mythical creator.

genipap (*Genipa spruceana Step*), Venez. also *caruto*; Braz. *genipapo*. Blueish-black plant pigment used in body painting.

Guahibo → Híwi

guayuco (Venez.) Garment of Indian men. The pubic apron consists of a long strip of woven fabric and is worn around the waist or hips by tying the length of material itself or by means of a belt. The → E'ñepa traditionally used twined human hair as a belt.

hekura. Spirit helpers of the Yanomami shamans. The *hekura* are wild spirits tamed and domesticated by the shamans and then residing in their breast. The shaman heals and works his magic with the help of the *hekura* and sends them off against enemies to launch magical attacks against them. While in a trance, the shaman himself becomes a *hekura*.

Híwi, also Guahibo. Large Indian group of the region (approximately 15,000 to 20,000 people), most of them living in Columbia; in Venezuela, they have settled in the savannas of the Orinoco basin. Híwi means "people", some of them also call themselves Wayapopihíwi, "people of the savanna".

Hodï, also Hoti, Chicana, Chicano, Yuana, Yowana, Waruwaru. Small ethnic group (3000 to 4000 people) living in the middle Orinoco valley where little research has been done and whose living area is hard to reach via the river system. They speak their own language so far not assignable to any other language family. As a consequence of close contact with their neighbors, the → E'ñepa, they have largely adapted to the latters' material culture.

initiation. Maturity rite or festive promotion to a specific position, association or rank which is accompanied by a rite of passage. Through initiation, an adolescent is elevated to the status of an adult; in the course of the ceremony, the willpower of the initiates is challenged and strengthened, in some groups accompanied by, sometimes, painful ordeals.
The initiation of a shaman includes the spiritual teaching together with the chants and the magical techniques and most often is concluded with a ceremony of the ritual transfer of power.

Ischnosiphon aruma → *itirite*

itirite, also *itiriti, tirite* or *tirita* (*Ischnosiphon aruma*). Maranta plant, reed or rush; raw material to make baskets and other wickerwork.

kaimo, also *kaëmo* (E'ñepa). Smoked meat from game, ritually distributed and consumed together with → *casabe* on the occasion of specific feasts.

kanaima. Nature spirits of the → Ye'kuana who bring disease to the people.

kanowa, also *kanawa* (Carib language: Panare-E'ñepa; Ye'kuana). Large trough in the shape of a canoe in which → *chachiri* is fermented. The same term is also used for boat, dugout canoe. The word "Kanu" in German – and "canoe" in English – are derived from the word *kanowa*.

kapok → ceiba

karamatoimë, also *aramatoimë*. Clarinets played by the → E'ñepa in festive rituals.

kareru. Mythical tree of the → De'áruwa; drinking its sap brings wisdom.

Kurripako, also Curripaco, Kúrrim, Wakuénai → Arawak

Kuwai, → culture hero of the → Híwi

Lake Parima. Refers to the mythological concept of a large mass of water with an island in the middle. On this island or on its shores, the gilded man "El Dorado" is said to live. To find this kingdom of the "Gilded Man" and other treasures was the endeavor of numerous expeditions at the time of the → Conquista.

lingua geral, also lingua yeral. Tupi language with Portuguese influences. Introduced by the Jesuits as a lingua franca for trade between the → criollos and the Indians.

llanos. Grassy savannas in the Orinoco basin. A mainly very arid region but flooded by heavy downpours during the rainy season.

lord of the animals, also master of the animals or mother of the animals. In hunting societies, the concept of a mythical "owner", "protector" or "creator" of the hunted animals is widespread. He leads the animals to the people for the latter's nourishment. "Abuse" is mostly punished by "withdrawal". The people seek the goodwill of the animals through music and dance rituals and by appealing to the lord of the animals. In some societies, the concept of the lord of the animals merges with that of the highest being or → culture hero. The rarely described but just as frequent concept of a mother of the animals corresponds to the lord of the animals.

macana. Club or ceremonial weapon. Several groups of the South American Lowlands remember that, in former times, they did not hunt with bow and arrow but with clubs. In the region of the Upper Orinoco, carved flat or spade-shaped clubs are to be found, in some cases decorated with feather bushels. Some of the lancet-shaped clubs have sharp edges and also serve as a stabbing weapon. They are mostly made of palm wood. Some clubs may be used as a spear or a tool. They are often reserved for ceremonial use and displayed when entering a friendly village.

Among the Yanomami, internal conflicts are sometimes settled with ceremonial stick duels.

macaw. A large, colorful parrot up to 90 centimeters in length. The feathers of the shining red Arakanga (*Ara macao*) are used in many different ways for body and head decorations. In Venezuela, the name *guakamaya* is used.

Mako, also Maco. Small group (345) living on the territory of the Ye'kuana in the State of Amazonas. They are linguistically associated with the → De'áruwa (Piaroa).

Maku. Language group only represented in Venezuela by the → Puinave.

mamure (*Heteropsis spruceana; Araceae* fam). A creeping arum plant climbing many meters up trees, like a thin liana. Mainly used by the → Yanomami for basketry and for securing beams in house building.

manioc, also *mandioca, cassava, yuca*. A plant of the spurge family. The most important food plant in the Orinoco area. There are two kinds of manioc: the poisonous, so-called bitter manioc (*Manihot utilissima Pohl* or *Manihot esculenta Cratz*) and the non-poisonous, sweet variety (*Manihot aypi*). The bitter manioc contains the prussic acid glycoside *Linamarin* and has to be made edible by a process of detoxification. The tubers weighing up to five kilograms are peeled and then grated into a mush on a grating board. "Manioc cultures", such as for instance the → Arawak and the → Caribs on the Upper Orinoco, have developed a woven tubular manioc squeezer, → *sebucán*. The manioc mush is filled into the tube and, by stretching this, the liquid and thus also the prussic acid it contains are removed. In some societies, the toxic liquid is also pressed out by means of pressing mats, flat baskets or pieces of fabric or by kneading on a sieve. The extracted, dry manioc mass is strained and baked into → *casabe* loaves or roasted into manioc grains, → *mañoko*. Sweet manioc is simply cooked. The → De'áruwa, → Ye'kuana as well as the → Panare make a fermented drink out of manioc which has an intoxicating effect and is consumed at feasts.

manioc grater. A board studded with stone- or metal-splinters serving to grate the bitter → manioc. Traditionally, manioc graters were made and used by all the Carib groups and also passed on to neighboring societies such as the → De'áruwa or the northern → Yanomami. The stone splinters are arranged to form geometrical ornaments.

mañoco, also *mañoko* (Venez.), also *fahrinha* (Braz.). Grain-like food which keeps well, made from the grated tubers of bitter → manioc. After detoxification, the mass is roasted over the fire in large pans or on trays. It can be dissolved in water and consumed in broth or soup.

maraca. Rattle of the South American medicine man. The *maraca* is the most important ritual object which is often used in healing ceremonies. The term has been adopted from the → Arawak language into Spanish. In most cases, the body of the *maraca* is a dried calabash fruit. The calabashes are decorated with mythical patterns.The rattles are filled with fruit pips or seeds of wild plants; occasionally, they also contain splinters of magical crystals to which special effects are attributed. The → De'áruwa use rattles woven from plant fibers and filled with plant seeds or animal hooves.

Mareoka. → culture hero of the → E'ñepa

marginal societies. For a long time, the name marginal societies was given to those groups not belonging to the large culture areas of South America. They either lived in small, relatively mobile associations at the geographical "edges" of the large culture areas, or they had preserved a simple way of life. In some of these societies, the development from exclusively hunting to sedentary agricultural society has only been rudimentary. The question remains whether these societies have optimally adapted to the exterior ecological as well as economic pressures or whether they were fleeing from the Indian and later, above all, from the European invaders. Typical representatives of such societies in the Orinoco-Parima region are the → Hodï, the → Yanomami and, in many respects, also the → De'áruwa.

Menjeruwa. Ritual specialist of the →

De'áruwa and at the same time their medicine man. He is the keeper and transmitter of traditions as well as a master of mask carving and painting, a master of dance and of music. Menjeruwa literally means "man of the song".

Millenarianism. Movement characterized by the expectation of salvation, motivated by religion or politics, where Christian and traditional indigenous belief concepts come together. Millenarianism is sustained by people's hope for a fairer world order.

monkey. A frequent motif in South American mythology is animals taking possession of cultural assets or plants. For the → Ye'kuana, the → manioc today growing on earth was stolen from the sky by the monkey Kushu. For the → Sanema, it was a monkey that introduced baskets to the people, but at the same time also created numerous dangerous aquatic animals. The motif of the monkey is often to be found on woven basketry trays.

Napiruli. → culture hero of the → Arawak groups of the Rio Negro area.

New Tribes Mission (NTM, Misión Nuevas Tribus). Protestant missionary lay order from the USA.

nuclear family. Smallest social unit consisting of mother, father and children, in most human societies the intersection of all kinship relations.

ocumo (*Xanthosoma sagittifolium*). Tropical tuber.

Omao. → culture hero of the Sanema, a northern Yanomami group, corresponds to the figure of Omawë among the → Yanomami.

onoto, also *annatto* (Venez.), *urucu* (Braz.), (*Bixa orellana*). Aromatic red pigment surrounding the seeds of the tropical Bixa pods; used in body painting and to decorate baskets, arrows and other objects. In the plantations, the cultivated *onoto* plant also serves as protection from leaf cutter ants.

paca (Span.), (*Agouti paca*). Large rodent also called *lapa* in Venezuela.

Parima, Sierra. Wooded mountain range in the east of South Venezuela, up to 2450 meters high, where the watershed between the river systems of the Orinoco and the tributaries of the Rio Branco and Rio Negro is located. The ridge also forms the border between Venezuela and Brazil.

peccary, also baquiro (Venez.). A South American type of wild pig; a difference is made between the larger white lipped peccary (*Tayassu pecari*) and the somewhat smaller collared peccary (*Tayassu tajacu*). For the → De'áruwa, the peccary was formerly a sacred animal, a mythical ancestor.

pendare (*Couma caatingae*). Heavy hardwood used to make numerous objects such as dugout canoes.

peraman. Mixture of a yellowish tree resin (*Moronobea coccinea*), beeswax and pulverized charcoal; used as an adhesive. The mixture is filled into a hollowed branch while semi-liquid or left to solidify in the shape of a ball. Before application, *peraman* is softened in the embers and used to attach arrowheads, or to resinate strings and fishing lines, or to stiffen the ends of cords for stringing beads, as well as to caulk dugout canoes etc.

phratry. Union of several sibs or clans tracing their descent from a common ancestor.

piapoco, also *piapoko* (Venez.) (*Ramphastos tucanus*). Toucan. South American type of woodpecker. The members of a small ethnic group of the → Arawak also call themselves Piapoco (also Tsase).

Piaroa → De'áruwa

picure → agouti

pijiguao (*Guilielma gasipaes*). Cultivated palm with thorny trunk, bearing protein-rich fruits. The pijiguao palm is planted in gardens but only bears fruit after several years when, in most instances, the garden has already been given up.The Yanomami like to serve the cooked pijiguao fruits to their guests coming to visit them in large groups.

pottery. In the Orinoco region, clay pots are mainly made by women while basketry is mostly a man's job. The vessels are made without a wheel in → coiling technique and are only occasionally decorated with incised or impressed patterns. They are above all used as water containers. Calabash fruits or tin cups are mostly used for drinking and eating bowls as well as ladles. The painted, zoomorphic or anthropomorphic clay vessels made by the → Híwi women have only evolved over the last decades which means they were only recently adopted from other groups or copied from models originating in former times. They are mainly produced for selling to the → criollos.

Puerto Ayacucho. Capital of the Venezuelan federal state of Amazonas. Puerto Ayacucho was only founded in the 1920s. For a long time, it was the town farthest inland on the Orinoco and, at the same time, the last port for larger ships.

Puinave. Indian group estimated to number between 1800 and 3500 people, most of them living in Columbia. In Venezuela, the Puinave live in the state of Amazonas or on the Orinoco. They speak a language related to Maku and, over the last decades, often intermarried with the → Kurripako. Although they are linguistically isolated, they share a number of cultural aspects with the → Arawak groups of the Rio Negro region.

Saliva, also Saliba. Ancient Indian population group formerly living in the Orinoco area but displaced from there. Today, approximately 1000 to 2000 Saliva still live in Columbia. Some researchers see the → De'áruwa as surviving relatives of the Saliva group. Saliva is also the name of a language.

Sanema. Northern subgroup of the → Yanomami. The Sanema speak their own language and, for some time now, have been in contact with their neighbors, the Ye'kuana.

sarrapia (Dypterix punctata). Tree whose trunk supplies the aromatic substance cumarin used to make cosmetics, tobacco products and moth powder.

sebucán → tubular manioc squeezer

shaman, also medicine man, witch doctor. The name shaman is given to a personality with supernatural powers able to come into contact with transcendental beings by means of ecstatic techniques. His most important task is healing. As a mediator between this world and the next, he is able to journey through the skies. At ritual events, he often plays the role of the master of ceremonies. Among several groups, he is the one who knows how to appeal to the → lord of the animals from whom he receives his orders. In the South American Lowlands, qualifications to become a shaman are mostly acquired in a long apprenticeship culminating in the festive → initiation and an act of the transfer of power. In many ethnic groups, generally only one shaman is to be found in a village community (Ye'kuana), however, in some societies, for instance among the → Yanomami, it is possible for several men of a certain age to achieve the necessary leadership over the spirits.

shapono. Communal house of the → Yanomami; accommodates between 45 and 120 people. The lean-to roofs of the different families are grouped closely together around a cleared space creating the impression of a uniform, circular structure. At the back, the large lean-to roofs reach almost down to the ground and close the village off towards the forest. At the front, the roofs open and reach far into the central square. The individual living quarters are not divided laterally. Most shapono have four exits.

shapori. → shaman of the → Yanomami

skull flutes. Wind instruments made from animal skulls. The skull is covered with a layer of beeswax with only the cranial base remaining open. Via this main opening, the musician produces the sound. Among the → Híwi, such flutes are only made and played by men.

slash-and-burn agriculture, also swidden or shifting agriculture. A system of agrarian cultivation in tropical forest regions where the axe and the digging-stick are the most important tools. The garden area is roughly cleared of forest and bushes; larger trees are often left standing. After a phase of drying, the dried up brushwood is burned; the mineral-rich ashes left after the burning enrich the nutrient-deficient soil. Fertility is soon exhausted, making it necessary to shift the garden areas frequently.

subsistence techniques. Techniques ensuring the livelihood of the people and also their supplies, for instance fishing, hunting, horticulture, gathering, harvesting or animal husbandry.

SUYAO, (Shaponos Unidos de los Yanomami del alto Orinoco). Self-administered cooperative of the Venezuelan Yanomami as "United shaponos of the Yanomami of the Upper Orinoco".

tapir (Tapirus terrestris). Large herbivorous, uneven-toed ungulate living in South America and Asia. The tapir is the largest animal in South America. It plays an important role in the mythology of many societies.

tirite → itirite

tonsure, a bare patch at the back of the head caused by shaving; part of the typical look of the → Yanomami.

totuma → calabash vessel

tubular manioc squeezer (Venez.: sebucán). A tubular piece of wickerwork, one to three meters in length, made of → itirite, used for the detoxification of → manioc.

urucu → onoto

váquiro (Venez.) → peccary

Wahari. → culture hero of the → De'áruwa. He was born from the eye of his brother Buoka. The mythology of the De'áruwa contains numerous episodes about the rivalry between Buoka and Wahari. In the mythical stories, Wahari always emerges from critical situations as the winner: he is more intelligent, more skillful and more attractive, and he has created the important things and phenomena on earth. While Wahari creates the sun and the day, Buoka, for instance, only succeeds in bringing forth the dimly shining moon and the dark night. Wahari is responsible for the world as it is today.

Wanadi. → culture hero of the → Ye'kuana

Wakuénai, also Kurripako, Curripaco. → Arawak

wapa. → E'ñepa term for the round, tray-like basket. Wapa is a relatively recent cultural acquisition developed within a short time into an artistic form. Taken over from the Ye'kuana where it is called wana, the wapa basket is a trade article of E'ñepa men. Some of the wapa baskets stand out because of their artistic patterns. Over the last years, patterns from the world of the criollos have increasingly been integrated into the woven figurative representations, such as cats, cows and even trucks. (Henley/Mattéi-Müller 1978; Mattéi-Müller/Henley 1978).

warapa (Yanomami). Balsamic resin

Warekena → Arawak

warime. Dance ritual with masks of the → De'áruwa. In the warime ritual, the primeval event of the creation of the world is re-enacted. It contains the making and painting of the masks, the recital of the myths and songs as well as dancing and music as individual ritual acts.

yams (Dioscorea). Climbing plant with tubers, also called sweet potatoes, similar to potatoes in nutritional value and taste.

Yanomami. Largest ethnic group (20,000 people) of the northern Amazon Lowlands, distributed over Venezuelan and Brazilian territory. The Yanomami regard their origin as located in the highlands of the Sierra → Parima. Yanomami means "occupant of a house"; the language is thought to be isolated. Regular contacts with the non-Indian population only began in 1950, up until that time the Yanomami lived largely secluded in hard to reach settlement areas.

yaraque. Alcoholic festive drink on the basis of fermented → casabe. To produce it, manioc mass is mixed with water and boiled in large pots. Human saliva is used as a ferment.

yare. Sauce made of the toxic juice of the bitter → manioc. The liquid is extracted by means of the tubular manioc squeezer and detoxified by boiling. Then it is used as a supplement for food and also as a drink.

Ye'kuana, also Yekwana, Makiritare, Dekuana (subgroup). Ethnic group (approximately 4500 people) living in Venezuela and belonging to the → Carib language family. Ye'kuana means "boat people" or "canoe people". They live on the banks of the rivers Padamo, Ventuari, Paragua, Caura, Uraricuera, Uesete, Cunucunuma, Yatiti, Cuntiamo and Erebato.

yopo (Piptadenia peregrina Benth). A hallucinogenic snuff powder widespread in the Orinoco region and its environs. The active substances are the alkaloid Dimethyltryptamin (DMT) and Bufotenin. The → De'áruwa consume yopo through the nose by means of a forked tube mostly made of chicken or heron bones. Quick absorption through the nasal mucous membranes results in trances. Yopo is mostly consumed in a ritual context by the shamans or medicine men of the community, but at times also by non-initiated men at ceremonial events.

yucuta. Slightly sour drink made by dissolving → casabe or → mañoco in water.

Authors' Biographies

Stephan Andreae

Born in Cologne in 1952, freelance artist, organizer of exhibitions and author. Studied philosophy and theatric sciences, later graphic art and multimedia with Daniel Spoerri at the College of Art in Cologne. Since then, he has developed concepts and organized numerous exhibitions, above all for the Berlin Festival (*Le Musée sentimental de Prusse*, 1981, *Mythen der Neuen Welt*, 1982, *Berlin – Berlin*, 1987) and for the Kunst- und Ausstellungshalle der Bundesrepublik Deutschland (*Buñuel*, 1994, *Sarkis*, 1995, *Arktis – Antarktis*, 1997/98).

Luiz Boglár

Lecturer at the University of Budapest, conducted fieldwork among the De'áruwa (Piaora) in Venezuela in 1967, 1968 and 1974. Many years of anthropological studies in Brazil, currently research among the Botukudo Indians and Hungarian settlers in South Brazil on the concept of memory.

Lelia Delgado

Studied anthropology in Caracas, with main emphasis on archaeology at the Instituto Venezolano de Investigaciones Científicas (IVIC). Taught at the Institute of Anthropology of the University of Caracas. For many years she held a leading position in the research department of the Galeria de Arte Nacional, was responsible for numerous exhibitions and head of the Proyecto Orinoco of the Fundación Cisneros.

Gabriele Herzog-Schröder

Anthropologist, several anthropological research expeditions to the Yanomami Indians in South Venezuela starting in 1983. Since 1987, working as a scientist in the development and documentation of the human-ethological film archives at the Max Planck Society in Andechs. Ph.D. from the FU University of Berlin in 1999 with a study on the significance of gender in non-patriarchal societies. Collaborator in various exhibitions.

Marie-Claude Mattéi-Müller

Studies in literature and modern languages in Paris, ensuing specialization in linguistics and anthropological linguistics. For almost 20 years, research on American languages of Venezuela, with emphasis on Carib languages. Extended fieldwork among the E'ñepa Indians. Chief consultant for programs against illiteracy among the E'ñepa (Panare). In addition to her research, she works for the diplomatic service of France. Since 1977, member of the laboratory for American Indian languages of the CNRS in Paris. Since 1987, she has worked as a member and guest researcher of the Research Unit of Human Ethology in the Max Planck Society. Currently living in Caracas, Venezuela.

Ulrike Prinz

Studied anthropology, philosophy and Spanish philology in Munich and Madrid. Ph.D. from Marburg in 1998 with a study on poetry and the battle of the sexes in the Eastern Lowlands of South America with the title *Das Jacaré und die streitbaren Weiber*. Participation in the exhibition *Der geraubte Schatten – Frühe ethnographische Fotografie als Dokument*. Works as a freelance anthropologist in Munich.

PHOTOGRAPHIC ACKNOWLEDGEMENTS AND COPYRIGHTS